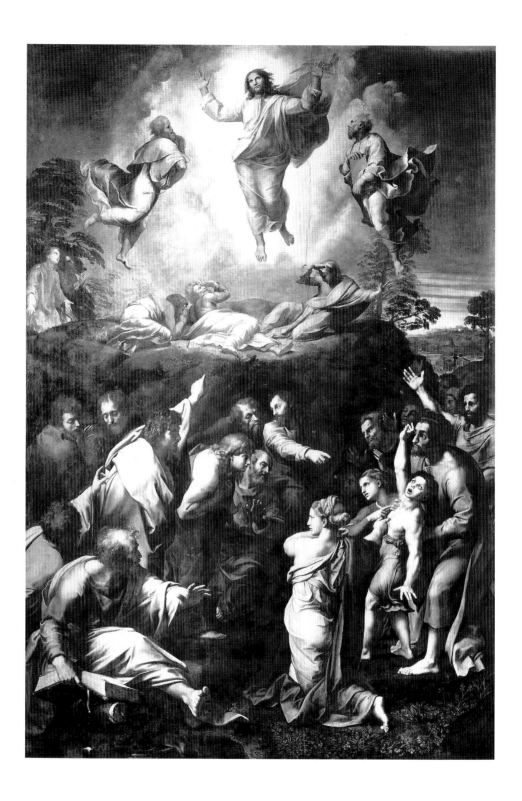

The Preference for the Primitive

Episodes in the History of Western Taste and Art

E.H.Gombrich

Phaidon Press Limited
Regent's Wharf
All Saints Street
London N1 9PA

Phaidon Press Inc.
180 Varick Street
New York, NY 10014

www.phaidon.com

First published 2002
© 2002 Phaidon Press Limited
Text © 2002 The estate of E.H. Gombrich

ISBN 0 7148 4154 4

A CIP catalogue record for this book is available from the British Library

Designer Wim Crouwel
Printed in Hong Kong

Frontispiece: Raphael, *Transfiguration*, *c.*1519–20. Pinacoteca Apostolica,
Vatican

Contents

I should like to dedicate this book to Lady (Caroline) Mustill, without whose unstinting and self-effacing help it could never have been completed.

E.H.G.

The Preference for the Primitive

It is difficult to say for what reason the very things that move our senses most to pleasures and appeal to them most speedily at first are the ones from which we are most quickly estranged by a kind of disgust and surfeit. How much more brilliant, as a rule, in beauty and variety of colouring are new pictures compared to the old ones. But though they captivate us at first sight the pleasure does not last, while the very roughness and crudity of old paintings maintains their hold on us.
(Cicero, De Oratore III.xxv.98)

7

This book is about a movement of taste that came to its climax during my lifetime and appears to have lost strength during the last few years. I am speaking of the kind of aversion Cicero expressed in the motto I have chosen. Every preference, one might argue, implies an aversion. Hence what I call the 'preference for the primitive' may be often tantamount to a rejection – a rejection of what? There is a word in my native German which has only been partly assimilated in English: it is the term '*Kitsch*'. During the days of my youth, critics and art-lovers resorted freely to this term of abuse. What 'schmalz' was to music – or perhaps a 'tear-jerker' to literature – was dismissed as nauseating 'kitsch' in the visual arts. Here it was most of all the works of official art chosen for display in the Salon which were condemned in these terms. But even some of the most renowned Old Masters were also pilloried as having manufactured insipid and sugary paintings that were offensive to good taste. I shall argue that many of the movements of twentieth-century primitivism are best understood as avoidance reactions. I hope to show that the opinions of the great orator continued to reverberate in the history of taste. What he observed is that the pleasure of the senses can lead to displeasure. If we indulge our inborn drives and appetites initial satisfaction will not only end in satiety but in downright disgust. We seem to have acquired an inbuilt warning signal that tells us 'enough is enough'. Apparently this acquisition is part of growing up – that painful process of education that imposes those disciplines of self-control civilization demands.

Cicero mentions all the senses as being subject to this passage from gratification to disgust. He includes all the arts, but though he specifically mentions painting (where garish colours soon repel), and later singing (when trills and slides inevitably lose their charm),[1] his real concern – as we shall discover – is the art of oratory, because the purpose of his digression is to warn his reader against trying to seduce the audience by means of verbal display.

What is relevant to the argument of this book is the fact that the development of all, or at least most, of the arts ran parallel – in other words, that it took time till they achieved that easy appeal to the senses which Cicero warned against.

Ancient teachers of rhetoric were perfectly aware of this parallelism and frequently referred to it in order to make a point. The weighty tone of early prose was explicitly compared with primitive architecture, which piled boulder upon heavy boulder in what were known as 'cyclopic' walls, and Cicero himself, in his earlier dialogue, *Brutus*, had drawn a detailed parallel between the history of oratory and that of the art of sculpture: from the hard and angular shapes of archaic art to the supple grace of Hellenistic masterpieces.

It so happens that in a later age this very passage came to serve as a framework for the most influential history of the visual arts, Vasari's *Lives of the most Excellent Painters, Sculptors and Architects*, published in 1550 and revised in 1568.[2] Vasari had no doubt that the arts had made progress from the time of their downfall in the Dark Ages to the glorious period of the Italian Renaissance – the age of Leonardo, Raphael and Michelangelo. It was a slow ascent from the clumsy and ugly manner of the Byzantines, via the skilful, but still hard and angular style of the quattrocento, to the polish and sophistication of his own time. Thus he held up for our admiration the work of Correggio, for its sweetness of colour and its incredible softness.

If Vasari and Cicero were right, we might come to the conclusion that the development of art moved in exactly the opposite direction to that of taste: one went from what Lovejoy and Boas would call 'hard' to 'soft', the other from 'soft' to 'hard'.[3] The 'hard' becoming associated with nobility, strength, innocence and sincerity, while the 'soft' was identified with vulgarity, effeminacy, corruption and meretriciousness.

The styles and the works which in the course of time had to serve as metaphors for these human qualities will be discussed in the pages that follow.

I remember hearing Herbert Read, reviewing Wittkower's monograph on Bernini on the radio, say that the sight of these sculptures made him feel sick. And when I first published *The Story of Art* and, naturally, included in it illustrations of the *Venus of Milo* and the *Apollo Belvedere*, an eminent archaeologist objected that these were surely works of a decadent period. I believe that neither of these verdicts could be repeated now. The allegedly 'Eclectic School'[4] of the Bolognese masters of the seventeenth century, who had been under a cloud for so long, have been gradually rediscovered, and even the so-called 'Salon Painters'[5] of the nineteenth century, whose ambitious works had been considered beyond the pale, have been rehabilitated in the last few years.

Maybe it is all the more timely now for someone who himself experienced this turn of the tide of taste to chronicle the origins and the vicissitudes of the preference for the primitive, a preference which, to a certain extent, I even shared. If I am asked to define any further what I mean by 'the primitive' I must refer the reader to the pages of this book, which will show that the term was associated in its time with early Greek vases, with quattrocento painting and with tribal art.

It was almost inevitable that this study carried me into so many fields that I

had trouble in keeping to the straight and narrow path of a chronological narrative. Luckily I was by no means the first to be interested in this cultural phenomenon, and I was happy to be absolved from certain investigations by the existence of a number of authoritative studies which I should like to mention at the outset:

There is, first and foremost, *Primitivism and Related Ideas in Antiquity*, a collection of Greek and Latin texts in the original and in translation (referred to above), by those great historians of ideas, Arthur O. Lovejoy and George Boas. There are, furthermore, two books in Italian which cover some of the ground I would have had to cover otherwise: Lionello Venturi's *Il gusto dei primitivi*[6] and Giovanni Previtali's *La fortuna dei primitivi dal Vasari ai neoclassici*.[7] A growing interest in the historiography of art and in the history of collecting has led to a number of studies relating to the appreciation of early Italian and early Flemish art which I have used with profit, without feeling obliged to repeat all the information to be found there. Finally, the vogue for tribal art and its influence on the twentieth-century avant-garde has also been documented in a number of books and exhibitions and it would be redundant for me to describe these developments in any detail.

The importance I attached, and still attach, to what I came to call 'Cicero's Law' should not be hard to explain: traditionally the history of art has been conceived and told in terms of a technical progress towards the imitation of X nature. Pliny in ancient times and Vasari in the Renaissance had built their narratives on this conception, and so did I, when I wrote *The Story of Art*, which was first published in 1950.

In 1956, when I gave the Mellon Lectures in Washington, I developed the theme of primitivism in more psychological terms. No wonder that I found it exciting and relevant to explore another psychological principle that ran counter to this dominant theme: the revulsion from that very perfection that art had been said to aim at. The historian of art, in other words, had to be aware of this duality and the tensions it created.

In a public lecture I gave at the Warburg Institute in 1959–60 on *Ancient Rhetoric and the Theory of Expression* I attempted to lay the groundwork for this approach as I did in Cambridge in a talk I called *Art and the Arrow of Time*, drawing attention to the retroactive effects of artistic innovations. By the time I was invited to give the Spencer Trask Lectures at Princeton in 1961 I felt ready to tackle the theme, calling the series *The Primitive and its Value in Art*.

Erwin Panofsky, who had honoured me by taking the chair, urged me to go into print and would not accept that the presentation still lacked a grounding in the theory of rhetoric. This at last I hoped to supply in 1963 in my article, 'The Debate on Primitivism in Ancient Rhetoric'.[8] On the opening page I stated that this paper was to be part of a study that I was preparing on these developments, and I listed a number of earlier treatments dealing with the growth of interest in

the early Italian masters. A revised version of this article is to be found in the following pages.

As a further instalment of my programme I gave a public lecture at the Courtauld Institute of Art in London in 1965 on *Joachim Winckelmann and the Rediscovery of the Italian Primitives,* intending to fill a lacuna in the traditional account.

I hoped to do justice to these polarities in a couple of lectures I gave at the Cooper Union in New York in 1971, entitled *Ideas of Progress and their Impact on Art.* They were published, for private circulation, but I was hesitant to spread them further, feeling that the sections dealing with the growth of primitivism (including the Winckelmann piece), had to be preserved for the major treatment of this book, while the section on progressivism was left hanging in the air. Actually, the series was published by Dumont in German, under the title *Kunst und Fortschritt,* in a pocketbook which was widely distributed and also translated into other languages.

As time went on and my notebooks filled with quotations and examples, it was but natural that I should use them as a quarry when asked to give odd lectures or contribute to memorial volumes. Invited to give a series of talks on the Third Programme of the British Broadcasting Corporation, I reverted to the theme of the Spencer Trask lectures, which, naturally, I revised, and I gave an expanded version of the series at Los Angeles in 1981. The text of the broadcast is now republished in *The Essential Gombrich,*[9] and may provide a conspectus of this book, but I have not felt obliged to incorporate all its sections here. To avoid getting drowned in material I have had to become selective, and so I have omitted a study of *The Rediscovery of the Romanesque,* published in the memorial volume for my former student Sixten Ringbom.[10]

What readers have before them now is therefore a recapitulation of earlier work, and the attempt to justify my starting-point with Cicero in a series of further chapters. It will be seen that the theme occupied me for more than forty years, a period during which other writers also took on the problem of primitivism. I can only hope that despite this competition I still have something to say.

Chapter 1
Plato's Preferences

The well-known dictum by the philosopher Alfred N. Whitehead, that the whole history of Western philosophy is but a series of footnotes to the writings of Plato, applies with special force to the philosophy of the arts. The very term 'academy' derives from the name of the building where Plato taught, and without his philosophy the aim which academic doctrine set the artist, to strive for the ideal of beauty, could not have been formulated.

Yet when Plato (Fig. 1), in the extant writings, speaks of beauty, he does not speak of art, and where he speaks of art, he never mentions beauty. For while he thought that the contemplation of beauty, such as is experienced in love, can lead to the realm of transcendent ideas, art can only flatter and deceive the senses and seduce the mind to feed on phantoms.

To understand Plato's real concerns the reader might do well to forget the teachings of his followers, who assigned such an exalted role to the arts, and rather remember the current debate about the influence of television, exposing us to 'sex and violence' and thus exerting a corrupting influence on our youth. Plato's overriding concern with the arts focused on their moral effect – their power over the human mind.

In the Greek city-states of Plato's time, this danger of seduction was most obvious in the power of oratory, which might enable a skilled speaker in the public assembly or in the law courts to sway the opinion of the voters or the jury. No wonder that any citizen who wished to acquire status or influence took steps to master the art of rhetoric, and that the teachers of this accomplishment were much in demand. These teachers were the Sophists, who owe their bad reputation to none other than Plato, who accused them of frequently replacing rational argument with 'sophistries' or verbal tricks.

It was for this reason that, in his vision of an ideal commonwealth – outlined in the *Republic* and in the *Laws* – Plato advocated strict censorship of the arts. This is a problem that would appear to be remote from a preference for the primitive, and yet it will be seen that such a preference could also be justified in the light of Plato's arguments, for, like the Puritans of the seventeenth century

12

1. Herm of Plato, Roman copy of a Greek original,
4th century BC. Staatliche Museen, Berlin

2. Portrait bust of Aristotle, Roman copy of a Greek
Original, 384–322 BC. Kunsthistorisches Museum, Vienna

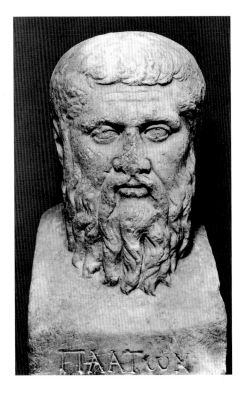

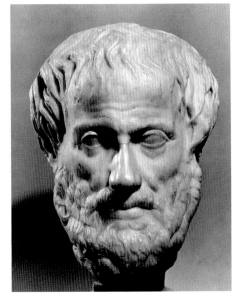

and many other moralists throughout the centuries, Plato frowned on any kind of indulgence of the senses as opening the gate to further corruption.

Admittedly, the passages in the *Republic* (III, 397B)[1] which enlarge on this danger focus on a special problem: they deal with the education of the 'guardians', the chosen élite to whom the welfare of the state is to be entrusted – men who must learn to be brave, sober and pious, and who must therefore shun anything unbecoming or shameful. In their manner of speaking, guardians must avoid histrionics and artifice and must practise an even tone and a regular rhythm in their diction. It would thus be misguided to expose them to any kind of music lacking the virtue of austerity. Since, in Plato's time, the education of a gentleman centred on rhetoric, gymnastics and music, it followed that the guardians, at an impressionable age, should only be allowed to listen to certain types of music. It is in this context that we learn of the Greek theory of musical *modes* (III, 398E, 399) (Pl. I), which was destined later to re-emerge in the writings of artists and art critics who wished to distinguish between various types or manners of artistic creation. In antiquity, as indeed in later times, the designation of these modes was derived from national musical traditions. Just as we speak of 'gypsy' music or 'New Orleans jazz', the Greeks spoke of 'Lydian' and 'Ionian' modes, the first of which Plato describes as mournful, the second as soft and convivial – in other words, as lax, and therefore unfitting for guardians. This leaves the Phrygian and the Dorian modes which reflect the accents of brave and temperate men – let us say, military marches rather than dance music.

Passages such as these have become notorious as anticipations of the excesses of modern totalitarian dictatorships. What must interest us more are Plato's attempts to generalize the principles he wished to enforce in his Utopia, for here the laws of aesthetics are seen to merge with political laws. In the passage concerned, the discussion returns to the problem of *rhythm* – what is described as the 'rhythms of a life that is orderly and brave'. We are told that 'seemly rhythms' are free from gratuitous complications and intricacies, since they conform to the 'good disposition of the soul'. Nor are these rhythms confined to speech or music, for 'there is surely much of these qualities in painting and in all similar craftsmanship – weaving is full of them, and embroidery and architecture and likewise the manufacture of household furniture … for in all these there is grace and gracelessness' (III, 401A). 'It follows', says Plato, 'that all these crafts have to be supervised, and any offenders against these norms must be forbidden to practise their art', so that the guardians 'may not be bred among symbols of evil' (III, 401B). In short, we learn that the general rule must be a striving for simplicity in all things, including food and hygiene.

This and other passages in which Plato expresses his concern with the moral effects of the arts, lead him to distrust all artistic innovation. He was convinced that the good citizen should be steadfast in his defence of the established canon, and should never join the fickle crowd who are constantly searching for novel

pleasures. The most explicit and extreme of these passages occurs in his later dialogue between Clinias and the Athenian, known as the *Laws*, where Plato attacks the (Athenian's) idea that:

> Men of poetic gifts should be free to take whatever in the way of rhythm, melody or diction tickles the composer's fancy in the act of composition and teach it through the choirs to the boys and lads of a law-respecting society, leaving it to chance whether the result prove virtue or vice.
>
> Clinias: To be sure, that does not sound rational; decidedly not.
> Athenian: And yet this is precisely what they are actually left free to do, I may say, in every community with the exception of Egypt.
> Clinias: And in Egypt itself, now – pray how has the law regulated the matter there?
> Athenian: The mere report will surprise you. That nation, it would seem, long enough ago recognized the truth we are now affirming, that poses and melodies must be good, if they are to be habitually practised by the youthful generation of citizens. So they drew up the inventory of all the standard types, and consecrated specimens of them in their temples. Painters and practitioners of [all] other arts of design were forbidden to innovate on these models or entertain any but the traditional standards, and the prohibition still persists, both for these arts and for music in all its branches. If you inspect their paintings and reliefs on the spot, you will find that the work of ten thousand years ago – I mean the expression not loosely but in all precision – is neither better nor worse than that of today; both exhibit an identical artistry. (II, 656D)[2] (Pl. II)

It might appear paradoxical that the great philosopher, whose lifespan coincided with the spectacular progress of Greek art towards the imitation (*mimesis*) of visual reality, should thus recommend the ritualistic images of the Middle East as the model for artists to emulate (however much he may have misconceived their purpose and real age), but it was precisely Plato's reaction to this revolution that accounts for his preference.

To justify his verdict, Plato enlarges once more on the variety of influences and of taste found among the inhabitants of a city: 'Children may like puppet shows … bigger boys comedies; the majority of cultivated women, youths, and perhaps the solid majority, tragedy; … but only the old and wise would recognize that recitations of Homer or Hesiod give the most pleasure. And it is their judgement that must count, and not that of the majority' (II, 658D). In short, Plato equated the very mastery of mimesis with the skills of the puppeteer – only good for entertaining children. His rejection of the artistic achievements of his time was grounded in his notorious disapproval of any kind of illusion that leads the mind

astray. His condemnation of such jugglery confirmed later writers (including those of the twentieth century) in identifying realism with vulgarity. What proved most lasting in Plato's teachings on the arts, however, was his obsession with the danger of corruption that attended any pandering to majority taste. It was a danger that was to be frequently invoked by the more austere writers on art. In fact this theme continued to be pursued even after Plato's real conception of art was transformed – or perverted – by the Neoplatonists, who lifted the stigma of jugglery from the arts and attributed to artistic genius the power of penetrating the veil of illusion to contemplate the world of ideas.[3]

Aristotle on Growth and Decay

The philosophy of Plato is rigidly dualistic. For him, the world of the senses is merely a pale reflection of the world of ideas, of which we can only have knowledge by *anamnesis*, the memory of the higher reality we perceived before our birth – that is, before our souls were imprisoned in our bodies. Plato's low opinion of the visual arts stemmed directly from this dualism: since an artist can only copy the sensual world that is itself a mere copy, he can only feed on illusions, and lead the mind further astray.

According to Plato's greatest pupil Aristotle (Fig. 2), however, a spiritual principle could be observed working within matter, much as leaven works in a lump of dough. Aristotle's vast body of writings largely concerns biology – the observation and exploration of the processes of life. It is to him that Western thought is indebted for the terminology with which we still describe the life-cycle of organisms. For him, the seed – let us say, the acorn – was endowed with the potentiality of developing into an oak tree.[4] What was active inside it was the aim (*entelechy*) of turning into the mature plant – a process by which the potential became actual. It is true that, working within inert matter, this potentiality could never be fully realized, so that all actual oak trees fall somewhat short of the perfect form (a tribute which Aristotle paid to his teacher, Plato). Moreover, having become actualized, the process would not rest, for soon matter would claim its rights so that decay and death were the inevitable outcome.

It was Aristotle himself who applied these ideas to the evolution of certain arts, notably the evolution of tragedy. The terms in which we find him describing the development of this art form lent themselves easily to a variety of explanations: 'Tragedy then gradually advanced, as men developed each element that came to light and after going through many changes, it stopped when it had found its own natural form.'[5] The analogy here is with the developing organism (plant or animal) that ceases to grow when it has reached the shape that we associate with that particular species. Aristotle adds only a few words of explanation, recalling that Aeschylus had innovated by raising the number of actors from one to two, and made speech play the leading role; three actors and scene painting came with Sophocles. Since, in what follows, Aristotle frequently

15

refers to the tragedy *Oedipus Tyrannus* as a demonstration of how the ideal tragedy should be constructed, we can infer that, for him, this was the end of its development. True, there is also a somewhat enigmatic remark in which he says that 'to consider whether or not tragedy is even now sufficiently developed in its types … is a separate matter'.[6] Even this qualification may be said to fit the analogy between the evolution of tragedy and that of organisms, for it is a matter of common experience that the process of maturation does not visibly come to a halt at a given point. Nor can we say exactly at what moment the forces of ageing and dissolution begin the decline that will end in death.

But these uncertainties cannot detract from the hold the organic metaphor was to maintain on Western thought. Most important was the idea that the evolution of any art reached, as it were, a terminal point, when the potentialities of the genre had been realized and had come as close to perfection as resistant matter would allow. This terminal point (such as Sophocles's *Oedipus Tyrannus),* was accorded canonic status.[7] Once critics had established such a canonic form by which development was to be judged, it followed not only that earlier phases were judged as relatively immature, or 'primitive', but that any development beyond the classic monument was likely to invite the censure of corruption or decadence. We shall find that this, in a nutshell, is the pattern repeated time and again in the story that follows.

This interpretation would hardly have proved so enduring had it not been rooted in the observation of all the arts. For if, as was suggested above, Plato's outlook on art was deeply coloured by cultural developments witnessed by himself, or which occurred within the living memory of his generation, the same surely applies to Aristotle. There can have been few periods in human history (except, perhaps, the most recent century) which experienced such rapid and dramatic changes as that between the Persian Wars and the conquests of Alexander the Great. Looking back to the period of his grandparents, Aristotle must have been impressed by the changes, not only in tragedy but in all the arts, from what looked like clumsy beginnings to triumphant perfection.

Unlike Plato, Aristotle shows no nostalgic preference for the earlier stages, yet – to repeat – without the analogy he perceived between the growth of organisms and the development of the arts, the very idea of the 'primitive' could never have taken root.

It should be clear that that attitude which Lovejoy and Boas have called 'chronological primitivism'[8] presupposes an awareness of the development of the arts over a certain stretch of time, and this in turn demands a knowledge of some monuments of the arts of the past. Aristotle plainly possessed this knowledge of works of dramatic art, and he can only have acquired it because those works were by then available in manuscripts, and sometimes even staged again.[9] In the visual arts such knowledge must have been widespread. Ancient buildings were seen everywhere, and works of sculpture – and possibly also of painting – were

16

collected and displayed in temples and shrines. Reading the guidebook written by Pausanias in the second century AD we become aware of the many statues crowding the precincts of the temples in Athens, Olympia and elsewhere. Many of them had inscriptions telling of their donors and of the occasion of their dedication, so that their age was easily established. No wonder that, in an age where the arts changed rapidly, this difference of style and skill caught the attention of the public and made them aware of what they called the uncouth clumsiness of early images.

The first writings on the history of sculpture and painting appeared in antiquity shortly after Aristotle's lifetime, for it was towards the end of the fourth century that artists appeared to have attained the aim towards which earlier generations had striven: the achievement of perfect mimesis.[10] Though these early texts are only known to us from later excerpts, it is clear that they regarded the development of the arts as having moved towards perfection. The sculptor Lysippus and the painter Apelles, both contemporaries of Alexander the Great, had overcome all difficulties in the rendering of nature, and by comparison, earlier works, however sublime, appeared rigid and immature.

Some of these texts must also have suggested that, once perfection of mimesis had been reached, the skill was capable of being abused by such painters as Pyreicus[11] – who was dubbed the 'dirt painter' for concentrating on subjects such as barbers' shops and cobblers, and provided later generations of critics, who had never seen his works, with a convenient term of abuse.

Rhetoric and the Visual Arts

The ancient world had no special term for what we call 'the arts'. These were comprised in the wider notion of any skill, a usage that still survives in terms such as 'the art of war' or 'the art of love'. This wider use did not exclude an awareness of the progress of skills in various fields, progress that was seen as an advance from primitive barbarism to the higher forms of civilization. As we have seen, one of the skills most prized in the ancient world was that of oratory, and writers on that skill frequently illustrated their meanings by comparing certain types of oratory with developments in other media, or what we would call the other arts.[12] For us these comparisons are enlightening because they reveal certain attitudes of taste, including the taste for more primitive modes than those that had been achieved in later years. Thus 'Demetrius', a Greek writer on rhetoric, whose work cannot be exactly dated, discusses the construction of sentences or periods:

> There are two kinds of style. The first is called the 'compacted' style, namely, that which consists of periods … which succeed one another with no less regularity than the hexameters in the poetry of Homer. The second style bears the name of 'disjointed,' inasmuch as the members into which it is divided are not closely united …
>
> The members in a periodic style may, in fact, be compared to the stones

18

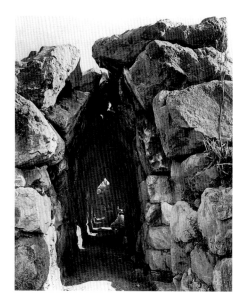

3. The 'disconnected' style: rough masonry, Tiryns, Greece

4. The 'periodic' style: vaulted dome, Mycenae, Greece

5. Irregular blocks, illustrated in Josef Durm, *Handbuch der Architektur: Die Baukunst der Griechen* (Leipzig, 1910)

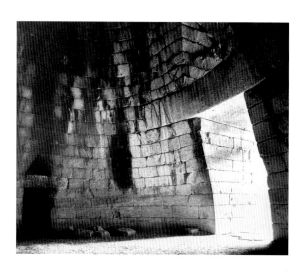

which support and hold together a vaulted dome [Fig. 4]. The members of the disconnected style resemble stones which are simply thrown about near one another and not built into a structure [Fig. 3].
So there is something trim and neat in the older method of writing. It resembles ancient statues, the art of which was thought to consist in their succinctness and spareness [Fig. 7]. The style of the writers who followed is like the works of the sculptor Pheidias, since it already exhibits in some degree the union of grandeur with finish.'[13]

There are similar passages in the works of Dionysius of Halicarnassus, a Greek teacher of rhetoric who lived in Rome in the first century BC, where, for instance, he makes a distinction between the austere and the smooth modes of composition. He writes:

The characteristic feature of the austere arrangement is this: it requires that the words should be like columns firmly planted and placed in strong positions, so that each word should be seen on every side, and that the parts should be at appreciable distances from one another, being separated by perceptible intervals. It does not in the least shrink from frequently using harsh sound-clashings which jar on the ear; like blocks of building stone that are laid together unworked, blocks that are not square and smooth, but preserve their natural roughness and irregularity [Fig. 5] … it is aristocratic, plain-spoken, unvarnished; an old–world mellowness constitutes its beauty …

The smooth (or florid) mode of composition, which I regard as second in order, has the following features. It does not intend that each word should be seen on every side, nor that its parts should stand on broad, firm bases, nor that the time-intervals between them should be long; nor in general is this slow and deliberate movement congenial to it. It demands free movement in its diction; it requires words to come sweeping along one on top of another, each supported by that which follows, like the onflow of a never-resting stream. It tries to combine and interweave its component parts, and thus give, as far as possible, the effect of one continuous utterance. This result is produced by so nicely adjusting the junctures that they admit no appreciable time-interval between the words. From this point of view the style resembles finely woven stuffs, or pictures in which the lights melt insensibly into the shadows [Fig. 6]. It requires that all its words shall be melodious, smooth, soft, as a maiden's face; and it shrinks from harsh clashing syllables, and carefully avoids everything rash and hazardous.[14]

Having thus seen the skill of building, of sculpture, of weaving and of painting used to illustrate certain characteristics of speech, we may add the same author's

20

6. *The Rape of Persephone*, c.366 BC. Central section of wall painting from royal tomb at Vergina, northern Greece

appeal to musical analogies when he contrasts the style of his hero Demosthenes with that of another famous orator:

> When I read one of Isocrates's compositions, whether it be a forensic or a political speech … I am filled with a high seriousness and my mind is completely calm, as though I were listening to the slow, solemn tones of the clarinet, or Dorian or enharmonic melodies. But when I take up a work of Demosthenes, I am as one inspired, I am swept this way and that, one emotion follows another, incredulity, anxiety, fear, contempt, hatred, pity, sympathy, rage, envy, a succession of all the passions that can sway the human heart. I think that at times I am in exactly the same state as the initiates at the mysteries of the [Great] Mother or the Corybantes, or the like, whether it be smell, or sound, or the actual breath of the divinity that arouses in these persons such a galaxy of varied visions. (p. 158–9)

It is clear that Dionysius expected the student of oratory to have studied and appreciated many of the extant texts of earlier masters, and to form his style by selecting appropriate models. He is particularly eager to dissociate himself from certain fashions or modes of oratory which derive from the very Sophists whom we found denounced in Plato, and who were known as representatives of the 'Asiatic' style.[15] His book opens with a violent tirade against what he sees as the corruption of oratory in his time:

> … we must be thankful to our own time both for the progress of other enterprises, and most of all for the great advance made in the study of civic oratory. For in the preceding period the ancient and philosophic rhetoric was flouted, grossly outraged, and debased. Its decline and gradual decay began with the death of Alexander the Great, and in our own generation it reached the verge of extinction. Another rhetoric sneaked into its place – one intolerably showy, shameless, and licentious, without any trace of philosophy or any other liberal art. Craftily it deluded the ignorant mob. It lived in greater wealth, luxury, and grandeur than its predecessor and fastened itself to those positions that should by right have belonged to the philosophic rhetoric … As when a riotous strumpet lords it in the household over a lawful, freeborn and virtuous wife, spreading confusion on the estate and claiming the property by stealth and intimidation, so the Attic Muse, of ancient and indigenous lineage, was stripped of her dignities and covered with shame in every city and centre, whereas her rival who had but yesterday emerged from the low dives of Asia, a Mysian or Phrygian prostitute or some Carian abomination, presumed to govern Greek states, driving the true queen from the council chamber – the ignorant ousting the learned, the wanton the chaste …

I believe it was Rome to whom we owe the present great transformation for the better, Rome, the mistress of the world, who drew all eyes upon herself, and in particular those who rule in that city, distinguished by their high character and by their conduct of public affairs ... I should not be surprised if, thanks to them, that former fashion for raving oratory failed to survive another generation.[16]

Cicero's Defence

What is characteristic in this outburst is the appeal to authority to stop the rot and the hope that Roman might will stamp out the offenders; the link with Plato's authoritarianism and his faith in the guardians of tradition could not be more clear. Yet this old quarrel of rival schools would easily have been forgotten had it not been for the fact that the greatest orator of the Roman world became involved in it and had to spend the last years of his life defending himself against the suspicion of Asiatic leanings. It was Cicero who was thus moved to defend his life's work against the accusations of a group of young Atticists, whose leader was Brutus. If there ever was a doubt whether Cicero was a great lawyer, these writings in his own cause must silence it. For in these two last dialogues, the *Brutus* and the *Orator,*[17] Cicero marshals all the arguments to defend his position and indeed, his reputation. Into this gathering of evidence he draws the visual arts, thus fortifying the link between the criticism of rhetoric and of art which made the debate so memorable for both traditions.

We have seen that this comparison was a familiar device in the schools of oratory. Cicero seized on it when he found his own style criticized for its concessions to Asianism. The writings of Brutus and his Atticist friends, containing their allegations, have been lost, but we can infer from Cicero's reply that his style was called 'too soft to be manly.'[18] The Atticists pointed to earlier models of artistic perfection, notably to the purity of the style of Lysias which was free from any striving for effect.

In one sense Cicero had an easy game. It was not very consistent to ask Latin orators to return to an Attic model – after all, Cicero's own self-confidence in his achievements and his place in history rested on his contribution to Latin speech, on his life-long work in bringing his native tongue up to the standard of suppleness for which the Romans envied the Greeks. It was this tangible achievement which had made Cicero aware of the possibility of real progress. It was thus tempting for him to ask his opponents in the *Brutus* whether they really wanted to put the clock back, and if so, why they did not propose to return to the plain and homely style of Cato who would represent the 'primitive' phase of oratory more adequately for a Roman than Lysias. For those who admired simplicity and roughness Cato would be an excellent model, since clearly his style had many virtues (xvii.67). But then it had to be admitted that, with all these virtues, he was not yet sufficiently polished and that greater perfection was

possible. He simply lived before the art had reached its height. 'No art ever comes to perfection the moment it is invented' (xviii.71). It is here that Cicero resorts to the comparison with sculpture and painting:

> What critic who devotes his attention to the lesser arts does not recognize that the statues of Canachus are too rigid to reproduce the truth of nature? The statues of Calamis again are still hard, and yet more lifelike than those of Canachus. Even Myron has not yet fully attained naturalness, though one would not hesitate to call his works beautiful. Still more beautiful are the statues of Polycleitus, and indeed in my estimate quite perfect. The same development may be seen in painting. In Zeuxis, Polygnotus, Timanthes, and others, who used only four colours, we praise their outline and drawing; but in Aetion, Nicomachus, Protogenes, Apelles, everything has been brought to perfection. (xviii.70)

We have here a perfect example of that interpretation of the history of art which was to be rejected by primitivism. When Vasari wrote his story of the progress of art from Cimabue to Michelangelo, he explicitly referred to this passage in Cicero's *Brutus* and marvelled at the exact parallel between ancient and modern developments.[19]

We cannot identify the artists mentioned by Cicero with any degree of assurance, knowing only copies of some works, but we have no difficulty in exemplifying the type of progress he had in mind from extant works of Greek sculpture. In fact there is no history of art in which some such sequence is not demonstrated. We know the type of sixth-century statue that is, in Cicero's words, 'too rigid to reproduce the truth of nature'. We can imagine the next phase, 'still hard but yet softer' as represented by one of the *kouroi* of around 500 BC. We have also a sufficient idea of the art of Myron, through copies and accounts of it, to appreciate what Cicero meant when he said, 'one would not hesitate to call his works beautiful', though they are not yet quite sufficiently close to the truth. We can see finally why he called Polycleitus more beautiful still and attaining perfection – an academic verdict which was no doubt also connected with the fame of Polycleitus as the sculptor who had established the canon of proportions. Praxiteles in the fourth century added grace; and Lysippus at the time of Alexander the Great brought the imitation of nature to its highest pitch (Figs. 7 – 10). We are less well able to appreciate the progress of painting, as described by Cicero, but it is noteworthy that he sees perfection here largely as a technical advance in the use of colours, and that he places the apex more than a century after Polycleitus.

Cicero looked at art in the light of its technical powers to achieve certain ends, those ends being truth and beauty. It is important to distinguish this instrumental view of progress from those interpretations with which we are

7. Polymedes of Argos, *The Youth Biton*, c.615–590 BC. Archaeological Museum, Delphi

8. Polycleitus, *Doryphoros*, Roman copy of Greek original, c.440 BC. Museo Nazionale, Naples

9. Praxiteles, *Apollo Sauroktonos*, Roman copy of Greek original, c.350 BC. Vatican Museum, Rome

10. Lysippus, *Apoxyomenos*, Roman copy of Greek original, c.330 BC. Vatican Museum, Rome

24

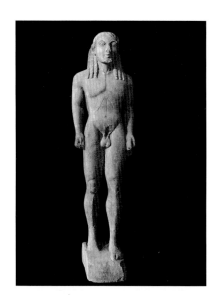

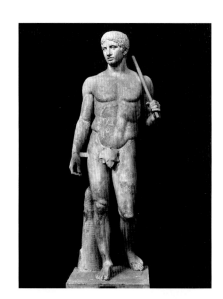

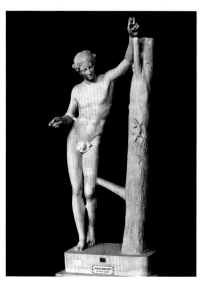

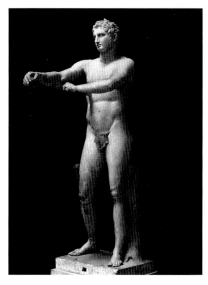

familiar in our own day. It is the organic view, as articulated by Aristotle, which postulates that the progress to perfection implies a limit beyond which no further improvement is possible, and indeed carries with it the seeds of its own decline. It was in this light that Cicero saw his own art, and he may be forgiven if he thought that as far as Latin oratory went, it was he who had brought it to this final stage. Posterity has endorsed his proud claim – be it under the hypnotic influence of Cicero's own propaganda or on an objective estimate of his powers. One thing is clear, he did not rest his claim on any vague or elusive idea of aesthetic excellence, but on the down-to-earth conception of oratory as an instrument of persuasion. As a practical man, a lawyer who had spent his life in the law courts, he opposed the '*l'art pour l'art*' aestheticism of his Atticist critics. The test of a speech is whether it works. If you visit the courts and see that the judge is bored and that his attention is wandering, you know that the speaker is failing in his purpose. The good speaker must be a spell-binder. He must be able to play on the emotions of the learned and the unlearned alike. Success is what counts (liv.200).

Cicero is careful here to distinguish his own art of persuasion from poetry, where very different standards apply. The poet writes for the few and elect. Cicero tells the moving anecdote of the flautist who consoled his pupil, disheartened by an unresponsive public, with the words: 'Play for me and for the Muses' (xlix.187), and of the poet who, seeing his whole audience stealing away while he read his work, said that he would read on, as long as Plato stayed (li.191). But if Brutus made a similar claim for a speech it would be ridiculous. Not that mediocre orators never have success, but when a better practitioner turns up he will draw the crowds. This apparently was Cicero's experience, and with this argument from progress towards perfection he hoped to silence his critics. Yet, in a way, he had only sidestepped their argument – the charge of corruption was quite compatible with the admission of popular success. No wonder, therefore, that Cicero had to return to the issue in a second dialogue, the *Orator,* in which he expounds the aesthetics of oratory, as distinct from its history.

In this dialogue Cicero returns to the classic preoccupation with the idea of perfection. It is an idea (as he knows) which cannot be realized here on earth, and for that very reason he spurns those who seek it in the past. Aristotle, he reminds us, was not deterred from pursuing philosophy by the existence of Plato, nor should we be by that of Aristotle. 'Even craftsmen' were not prompted to abandon their art because of the beauty of certain works by Protogenes, Apelles, Phidias or Polycleitus, but tried to find out 'what they could achieve and where they could progress' (i–ii.5).

Precisely because absolute perfection is unattainable there must always be room for some improvement. The perfect orator would be a master of all effects. We might say that he could play on the instrument of speech as an organist plays on his organ. The more stops he has on his instrument the closer he will be to

perfection. Cicero here expounds the old doctrine of the various manners of speech, the *genera dicendi*[20] which the orator must master. There are basically three such styles, ranging from the grand manner at the one extreme to the plain style at the other, with an intermediate level in between. Each of these has its place in the armoury of the orator and each can be used with effect, provided that its use is appropriate. This brings Cicero to elaborate on the classical rules of 'decorum': the orator must avoid bombast when pleading a trivial cause and casual speech when arguing issues of moment.

Ancient critics were fully aware of the significance of the different modes of speech, each of which had its place in their scale of values, thereby undermining the simplistic view of there being only one type of excellence in oratory. In this context Cicero made an important concession to his opponents. The Attic style does indeed represent one perfect mode, but it is only one stop on the grand organ of speech. What is wrong with the Atticists is their exclusiveness: 'In the case of painting, some like pictures rough, rude and sombre, others on the contrary prefer them bright, cheerful and brilliantly coloured. How can you draw up a rule or formula when each is supreme in its own class, and there are many classes?' (xi.36).

However, Cicero argues, we must make a sharp distinction between the critic and the creator. We can appreciate the rough style of Thucydides without wishing to write as he did: 'Are men so perverse as to live on acorns after grain has been discovered?' (ix.30–1). Some may delight in the limited palate of the early painters, but that is no valid reason for emulation, let alone the rejection of later developments. Certain devices to which the Atticists object, such as rhythmical cadences, should not be decried as corrupt, since they have been universally adopted. True, you cannot use the grand manner all the time without becoming ridiculous. A speech must not consist of climaxes. In this respect, Cicero implies, the grand manner has indeed more pitfalls than the plain or medium styles. An orator who cannot say anything plainly or calmly will scarcely look sane. He will be 'like a drunken reveller in the midst of sober men' (xxviii.99).

In making this concession, Cicero showed that he knew very well what had caused the reaction against that indulgence in effects which was identified with Asianism. The orator had to keep a delicate balance between striving after effect and cultivating simplicity. And yet Cicero would not have admitted that this concession was in any way damaging to his case, for in his eyes this need for restraint was not a moral problem at all. It had nothing to do with avoiding corruption. It was quite simply a matter of craftsmanship, for it, too, was concerned with the mastery of effects. The good orator must above all be a psychologist who knows how to manipulate the hearer's emotions. It was a matter of simple observation that a surfeit of effects could create resistance and even disgust. This being so, the true artist among orators will use the effects of restraint as he will use those of abandon.

Cicero had expounded this psychological theory even before he had come into open conflict with the Atticists. We find the crucial passage in his dialogue *De Oratore*, which is the most complete and most serene of Cicero's expositions of the art of oratory. These meditations on the limits of effects and the unexpected vagaries of taste must rank among the most important reflections on the topic of primitivism – important precisely because they brush aside the argument between progress and corruption in which these debates normally become entangled. The passage I used as a motto must find its proper place here:

> It is difficult to say for what reason the very things that move our senses most to pleasure and appeal to them most speedily at first are the ones from which we are most quickly estranged by a kind of disgust and surfeit. How much more brilliant, as a rule, in beauty and variety of colouring are new pictures compared to old ones. But though they captivate us at first sight the pleasure does not last, while the very roughness and crudity of old paintings maintains their hold on us. In singing, how much softer and more delicate are glides and trills than firm and severe notes. But not only people of austere taste but often even the crowd protest if such effects are too much repeated. The same is true of the other senses. We enjoy ointments prepared with an extremely sweet and penetrating scent less long than those that are subdued, and even the sense of touch wants only a certain degree of softness and lightness. Taste is the most pleasure-loving of the senses and more easily attracted by sweetness than the others, yet how quickly it rejects and dislikes anything extremely sweet ... Thus in all things disgust borders immediately upon pleasure. (III.xxv.98)

With a clarity unsurpassed in critical discussions, Cicero has here analysed the reactions which are almost inevitably bound up with an increasing mastery of effects. The more the artist knows how to flatter the senses, the more he will mobilize defences against this flattery. The very progress of his skill will lead to a longing for the appearance of less skill and more honesty. It is this subjective reaction, this contrast in effects, which will tend to surround earlier phases of art or of speech with an aura of moral superiority. Of the existence of this aura Cicero had no doubt. He knew that antiquated speech could sound solemn or forceful, but he also knew that to pull out this stop on the organ of language was as risky as any other effect not carefully restrained: 'In trying to avoid an effeminate softness of tone some people go to another extreme and deliberately use the rustic accent of yokels to give their speech a greater flavour of antiquity. This is all the more sure to misfire as these people usually do not really master the genuine flavour of earlier ages ... and talk like boors when they want to speak like yeomen' (III.xi–xii.42,46).

What makes these discussions so relevant to our topic is the implicit transition

28

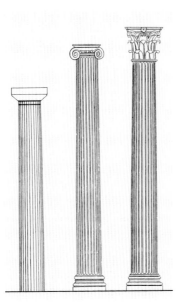

11. The Greek orders: Doric, Ionian and Corinthian

12. Archaizing relief, illustrated in J. Winckelmann,
Geschichte der Kunst des Alterthums (Dresden, 1764)

from an evolutionist view of the history of art to a relativist conception that sees every phase as an example of a particular stylistic mode – later art, in other words, is not better than the earlier phase, it is only different. This difference, moreover, is psychological rather than technical. The same evolution which, looked upon historically, appears as a progress from rigidity to softness, can also be seen as a gamut of possibilities between stern vigour and sweet grace. From this point of view, the earlier phases of art can never be superseded by later ones, because they represent forms of expressions which remain valid to later ages. Cicero himself, who was later to put forward the model of progress when it suited his polemical context, had shown more catholicity of taste in the earlier dialogue:

> There is one art of sculpture, in which Myron, Polycleitus and Lysippus were outstanding, all of whom differed from each other but in such a way that you would not wish any of them to be otherwise than he was. There is one skill and principle of painting and yet Zeuxis, Aglaophon and Apelles differ from each other: but none of them appears to lack anything in his art. (III.vii.26)

The Choice of Modes

If we today can still make some sense of Cicero's passage, if we have a mental picture of Myron, Polycleitus and Lysippus, we owe this to the fortunate fact that Cicero's compatriots shared his catholicity of taste, and liked to decorate their houses and gardens impartially, with copies of works representing these different styles. The most striking illustration of this attitude to the panorama of the past is to be found in architecture. It is Cicero's presumably younger contemporary, Vitruvius,[21] who deals with the succession of architectural styles – Doric, Ionian, Corinthian – as a range of orders available for the architect's choice, according to the character of the building with which he has to deal (Fig. 11). Here too the evolution is interpreted in terms of expressive features. The Doric order is compared with the beauty of the stocky male body, the Ionic reflects the proportions of the female body, while the third imitates the lithe delicacy of young girls (IV.i. 5–7). Accordingly the temples for Minerva, Mars or Hercules should be built in the Doric style, those for Juno, Diana and Bacchus in the Ionic, while Venus, Proserpine or the Nymphs are most suitably honoured by temples in the Corinthian order (I.ii.5).

With this transformation of history into a succession of modes, the way was clearly open for the appreciation of archaic art and primitive styles. That the ancient world went some way along this road can be inferred from the copies of archaic sculpture extant, particularly the work of the so-called 'neo-Attic' school which exploited the charm of tiptoeing maidens, with their carefully pleated draperies and their angular movements (Fig. 12).[22] Literary testimonies to this preference are absent from the time of Cicero – indeed, the only explicit reference to archaizing taste in the arts brings us to the polemics of the later orators.

29

To writers such as Tacitus and Quintilian, Cicero represented one of the possible models available for choice in the schools of oratory. Contrasting opinions about the value of his art anticipate the discussions about the claims of Raphael in the nineteenth century. In Tacitus's *Dialogue on Oratory*, a speaker protests against the adulation of old models: it is Cicero who has by now become old-fashioned, and indeed archaic. His speeches, once accused of effeminacy, now strike the progressivist as 'like rough buildings … Granted that their walls will last, but they are surely lacking in polish and lustre' (22). Progress has continued since those days, and teachers who want to return to Cicero after this lapse of time commit the same mistake which the reactionary Atticists committed in Cicero's own time. Another speaker leaps to Cicero's defence: He may not have been free from blemishes but he lived in a healthy age, before corruption was rife. At any rate, such failings as these earlier authors may have had are preferable to the meretricious licence of modern showmanship – in the eyes of Tacitus's speaker, the direct result of political conditions. Where free speech has languished, the instrument has ceased to serve its purpose, and all that is left is empty virtuosity practised for its own sake. It is, however, Quintilian (*c*.35–*c*.100AD), the urbane author of the *Institutio oratoria* (pub. *c*.95), who correctly diagnoses the variety of critical verdicts passed on Cicero's style. He knows that the progressivists of his age dismissed this style as 'jejune and arid' and reminds those critics that this was the very style which the Atticists had found 'too florid' (XII.x.13). One man's Asianism is another man's Atticism.

The Preference for the Primitive

A sane 'middle-of-the-roader', Quintilian fights on two fronts, against modernism and against archaism. He despises the frills of the 'corrupti' (VIII.iii.7), and deplores the folly of the primitivists. These, he tells us, 'want to banish all care for style and plead that unpolished speech as it chances to bubble forth is much more natural and more manly' (IX.iv.3). Such a view would be subversive of the whole art of oratory. If it was wrong to introduce improvements in oratory, then it must also have been wrong 'to exchange houses for huts, clothing for furs, and cities for forests and mountains … No!' Quintilian exclaims, 'that is most natural which nature allows best to be done' (IX.iv.5). Sane words, no doubt, but notoriously hard to translate into practical criticism. Is rhythm natural? Is rhyme? Must we respect the 'nature' of the medium, the colour of marble, the fibre of wood in sculpture, and how far must we carry this respect?

And so, when Quintilian comes to recount the story of the progress of sculpture in Cicero's wake, he gives a more complex interpretation of the life cycle of that art:

> Calon is rather hard, Calamis less rigid, Myron softer. Polycleitus surpassed all others for industry and beauty, but it is said that he is lacking in weight. For while he is said to have added more beauty to

the human form, even beyond the truth, he does not seem to have endowed the gods with enough authority. It is true that Phidias had what Polycleitus lacked, but he in his turn was more successful with gods than with men. They say that Lysippus and Praxiteles came closest to the truth, while Demetrius is accused of having gone too far in this direction and having been more enamoured of truth than of beauty. (XII.x.9)

We see how for Quintilian the ideal recedes from his grasp. There is always too little of one thing or too much of the other in every artist. As beauty comes in, dignity goes out; as truthfulness increases, beauty suffers. The result is a cautious pluralism which is aware of the variability of taste.

31 It is in this context that we receive an explicit hint of the existence of primitivist leanings among art lovers. There are people, we learn, who prefer the promise of an art to its fulfilment: 'The first famous painters whose works are worth seeing for other reasons than their antiquity are Polygnotus and Aglaophon, whose simple colouring nevertheless has such admirers that they prefer these rude beginnings of a future skill to the greatest works that came after' (XII.x.3). It is true that Quintilian professes to doubt the honesty of this admiration. He suspects an admixture of snobbishness in such a preference: 'Such people, I think, want to show off their connoisseurship.'[23]

Whatever the truth of Quintilian's accusation, we must see it in context, the context of the psychological effect of language in oratory. It is the avoidance of sweetness which drives the orator back to the use of harsher sounds and rhythms. We learn from Quintilian that one orator 'so much shrank from the soft delicacy of voluptuous modulations that he interposed obstacles to inhibit the flow of these rhythms' (IX.iv.31). 'Antiquity', says Quintilian, 'imparts dignity' (VIII.iii.24). Old words can give our speech 'an air of sanctity and majesty'. He especially commends Virgil for the skill and tact with which he makes use of this device, 'which gives his work that inimitable authority of antiquity which is also so very attractive in paintings' (VIII.iii.25).

For Virgil we may substitute T.S. Eliot:

> In that open field
> If you do not come too close, if you do not come too close,
> On a summer midnight, you can hear the music
> Of the weak pipe and the little drum
> And see them dancing around the bonfire
> The association of man and woman
> In daunsinge, signifying matrimonie-
> A dignified and commodius sacrament.
> Two and tow, necessarye coniunction,

Holding eche other by the hand or the arm
Which betokeneth concorde … ('East Coker')

Quintilian was certainly sensitive to the spell of these archaic modes. His characterization of the style of the early Roman poet Ennius foreshadows in mood and imagery the Romantic champions of medieval poetry: 'Let us worship him, as we do sacred groves, hallowed by age, where the grand old oak trees are perhaps not as beautiful as they are awe-inspiring' (X.i.88). But such appreciation can lead to affectation when the attempt is made to tap these effects in a modern context. Seneca scornfully speaks of orators who want to 'talk like the twelve tables'[24] (of the most ancient Roman laws). Here, as in Cicero, we see the limits of the transposition of a historical sequence into one of expressive possibilities.

32

The Sublime

This is the central problem to which the most influential of all ancient treatises on rhetoric addresses itself, the fragment known as *Longinus On the Sublime*.[25] Ostensibly it is merely a monograph on one particular effect or mode of style, one of the stops the orator can pull out. But it soon becomes apparent that in the author's eye this mode requires special treatment, for the 'sublime' is one of the most tricky effects in the orator's armoury. One false step and it degenerates into the frigid or bombastic. The study of the great models of the past serves to show how these masters achieved the truly sublime without falling victim to bathos. Homer is his favourite instance, but it is noteworthy that the treatise includes among its illustrations of true sublimity the account of 'the Jewish Lawgiver' in Genesis: 'God said – what? "Let there be light", and there was light. "Let there be earth", and there was earth' (IX.10).

But such grandeur is not at everybody's beck and call. Indeed, it cannot be achieved by a simple act of will. 'Longinus' comes out against the conception of oratory as a skill. Speech is expression and expression cannot be feigned. The true sublime is not a manufactured effect, it is, in his famous phrase, 'the ring of the noble soul' (IX.2). This stand in favour of an 'expressionist' theory of style secured for Longinus his mounting prestige after his rediscovery in the late Renaissance.

Denouncing Corruption

The preceding pages have shown how psychological reactions were used and rationalized in the schools of rhetoric, and to what extent they underlay the divisions between opposing camps of criticism. Reference to the visual arts in these debates is usually incidental, but such allusions as were made are not only illuminating in themselves but also served later critics to equate problems of style in ancient oratory with problems in the visual arts. That dread of corruption that goes with the classical ideal was able to feed on the denunciation of Asianism all the more easily given the authority of an ancient writer: it was Petronius who

had blamed the deaths of oratory and of painting on the same kind of foreign corruption:

> Recently that puffed-up and monstrous verbosity invaded Athens from Asia and filled the mind of aspiring youngsters like an epidemic, and thus eloquence was corrupted, came to a full stop and expired …
> Painting died in the same way after the impertinence of the Egyptians had invented a short cut for that great craft … (*Satyricon, 2*)

There has been much discussion as to what the 'impertinence of the Egyptians' really was, and in what way their vicious short-cut methods can have contributed to the decline of painting. We may never know, but what matters in our context is only that some new-fangled trick is being contrasted with the painstaking seriousness of honest craftsmanship. And in this respect the tone and tendency of Petronius's complaint is strangely similar to Vitruvius's famous attack[26] on the fashion for painted grotesques, which, in his days of 'declining morality' ('*iniquis moribus*') had supplanted the earlier style of murals showing simulated architectural prospects. According to Vitruvius, 'these new, absurd and illogical plays of fancy have even led bad judges to condemn solid craftsmanship as dull!' The downfall, alas, is easy to explain:

> The aims which the ancients sought to realize by their painstaking craftsmanship, the present attains by coloured materials and their enticing appearance. The dignity which buildings used to gain by the subtle skill of the craftsman is now not even missed, owing to the lavish expenditure of the client.[27]

The complaint about luxury and laxity could thus be used with effect to account for the feeling that the great days of art were over and that the classic period was receding into the remote past. It was antiquity itself which bequeathed to posterity the myth of its decline through a loss of moral fibre. The idea of the Romans of the decadence indulging their appetites while vigorous Teutonic tribes made ready to inherit the earth was fostered by Roman moralists. That corruption which Plato had dreaded as a danger to the state now seemed to have overtaken their civilization. And thus the very prestige of the ancient authorities helped to preserve the seeds of primitivism, together with the classical heritage.

When, in the seventeenth century, the Dutch humanist Franciscus Junius, secretary to the Earl of Arundel, collected the testimonies on *The Painting of the Ancients,* it was natural that his book should culminate in a summons to ancient virtue, as expressed in the theory of art. In reading the following extract, we can see how such a collection must have affected Winckelmann, the prophet of Greek virtue, no less than the champions of the Age of Faith:

> Dionys. Halycarnassensis[28] giveth us one reason, when he maintaineth,
> That the antient pictures in a wonderfull simplicity of colours drew

their chiefest commendation from a more accurate and gracefull designe. The new pictures on the contrary being but carelessly designed, stood most of all upon the manifold mixture of their colours, and upon an affectation of light and shadowes. See Themistius[29] also, Orat. de Amic. where he toucheth the very same point. The other reason seemes to flow out of the former: for as the first reason preferreth the antient workes before the new, in regard of their gracefulnes, so doth the second attribute unto the old workes a certaine kind of majesty, yet so, that it was their simplicitie made them majestical. Porph.[30] sayth, That the new images of the gods are admired for the dignity of the work, but the antient are reverenced for the simplicity of the worke, as being more sutable to the majesty of the gods. Pausanius[31] likewise speaking of Daedalus, sayth that his works were not very handsome to looke on, but that there was in them a certaine kinde of divine majesty which did become them very much. Silius Italicus[32] doth also note this peculiar property in the antient images of gods, That they kept as yet the godhead bestowed upon them by art.[33]

Interlude – Progress or Decline?

We call the years extending from about 400 to 1400 AD the 'Middle Ages' because they appeared to later historians to lie between two peaks of high achievement, classical antiquity and the Renaissance which ushered in the modern age. For a long time the arts of these intervening years were seen as a symptom of that decline in civilization ushered in by what later became known as 'The Dark Ages', when artists were unable to match the standards of ancient art in the imitation of nature and in the achievement of beauty. We have seen in the previous chapter that, even in antiquity itself, these standards had not remained wholly unchallenged, and the question arises whether this challenge was the ultimate cause of the end of classical art.

Some time ago such a question might have sounded absurd, but after all, we have seen a similar challenge in the past century, when the standards of the Academy and the Salon were undermined and annihilated by primitivist modes. It is certainly not the type of question which historians of the past were inclined to ask. They were satisfied with the conviction that nothing lasts for ever under the sun. Vasari speaks of 'the turning of the heavens' and reminds the reader that 'like human beings, the arts are born, have their growth and decline' – a reminiscence, as we have seen, of Aristotle's emphasis on the organic metaphor which satisfied historians for a long time.

It was the Austrian art historian, Alois Riegl (1858–1905),[1] who proposed to make a clean sweep of such comparisons. For him, to speak of a rise to perfection and subsequent decline was wholly unscientific. The historian should refrain from 'value judgements' and simply describe the changes he observes in history. Riegl denied that these changes could be attributed to developing or failing skills – on the contrary, they were for him the manifestation of changing intentions (*Kunstwollen*), which we have no right either to praise or to blame. If the sculptors of the Arch of Constantine (Figs. 13 and 14) turned away from mimesis they were simply responding to a change of intention to which we cannot, or need not, assign a cause. For Riegl the very idea of the 'primitive' had lost all meaning. There is little doubt that Riegl himself was responding to the crisis of values that shook the world of art at the turn of the century.[2]

The late Kenneth Clark once called comparison with the present 'the art historian's brandy-bottle'. Max Dvořák (1874–1921) – like Riegl a member of the Vienna school – frequently resorted to this bottle, and in his writings we find the most emphatic demands for a revision of the art historian's frames of reference: 'nothing is more misguided', wrote Dvořák in his chapter on the paintings of the catacombs, 'than to speak of an artless and primitive character of these paintings [Pl. III]. This only makes sense as long as they are measured with the yardstick of the artistic realism and religious materialism of pagan classical art, but such a yardstick is out of the question, since it rests on values that Christian artists did

36

13. *Repose after a Lion Hunt* and *Sacrifice to Hercules*, 130–8 AD. Hadrianic roundels from the Arch of Constantine, Rome

14. *The Emperor Delivering a Speech from his Rostrum*, *c.*315 AD. Constantinian frieze from the Arch of Constantine, Rome

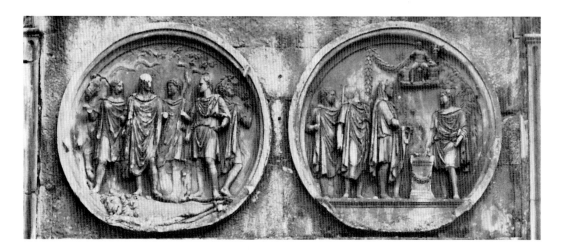

not aim at, but fought and replaced with new ones … In this respect the catacomb paintings mark a spiritual and artistic progress that points to the future.'[3] Dvořák is here claiming that it was indeed a preference for the primitive that dominated late antiquity and led to the new conception of art characteristic of the Middle Ages.

This is an interesting hypothesis, but I believe it to be untenable. It too blatantly contradicts the views expressed by classical authors. In the course of his compilation about the history of painting in the ancient world, Pliny remarks, not without bitterness, that by his time painting was 'a dying art'.[4] But far from attributing this crisis to the triumph of spirituality and humility he blames it on the tendencies of his time to impress the beholder with pomp and splendour. Murals no longer sufficed for that purpose, since gleaming mosaics were more impressive and more durable (XXXV.7).[5]

Painting as a Dying Art

Brief as are Pliny's remarks they can direct our attention to a social factor which is rather implied than openly stated in his 'encyclopedia': I refer to the factor of competition. In his lectures on Greek Cultural History, Jakob Burckhardt came to stress what he called the *agonale Prinzip*, the principle of contest in Greek civilization. By way of example it is hardly necessary to remind the reader of the role of the Olympic Games as a manifestation of this tendency, or of the feast of the Dionysiaca, at which playwrights competed for the prize. We might add the literary form of the dialogue, favoured by Plato, as a contest in which the Platonic Socrates emerges as a winner. What matters to us are the indications that the principle also prevailed in the arts. There is a vase in Munich by the painter Euthymides (Fig. 15) that bears the inscription '*hos oudepote euphronios*' ('Euphronios, [a rival vase painter] has nowhere done this'). The painting to which this refers shows figures in complex movement which allegedly the rival had never mastered. We need not accept all the anecdotes Pliny tells as gospel truth to see that artists were expected to compete with each other in the imitation of nature, the achievement of perfect mimesis. Thus we hear how Parrhasius trumped Zeuxis with his painted curtain (XXX.65), and how Apelles defeated Protogenes in their contest of fine lines (XXXV.81–3). In a sense, the whole history of painting or sculpture as conceived by Pliny's sources turns out to be a chronicle of triumphs by artists over difficulties which it took generations to overcome. It is only when we see Pliny's account in this light that we can make sense of his remark that these arts are now dead.[6] Nobody cares for mimesis any more because what is now in demand is costly display – maybe it was not for nothing that Nero's palace was known as the *Domus aurea*, the Golden House. This striving for pomp and splendour appears to have survived the victory of the Christian Church. Far from aiming at humility and spirituality as Max Dvořák had made us expect, early Christian art revelled in gold and glitter. We need only

15. Amphora by Euthymides, *c*.510–500 BC. Staatliche Antikensammlungen und Glyptothek, Munich

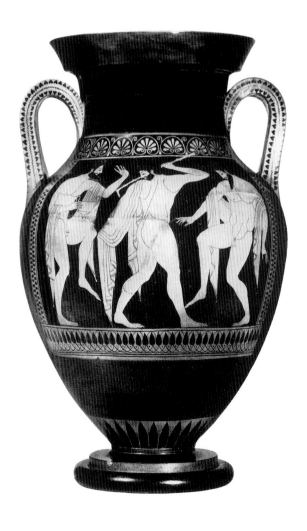

remember the church of Santa Maria Maggiore, or the mosaics of Ravenna, to realize that the last thing the Church wanted was a return to primitive techniques and devices. There is every indication that this tendency continued both in East and West. Whatever the style the aim seems to have been to achieve the maximum splendour. I have referred elsewhere[7] to the famous passage in Dante's *Purgatorio* where a miniature painter is punished for his pride and ambition, and where Oderisi da Gubbio admits to Dante he now realizes that the pages illuminated by Franco Bolognese 'smile more' ('*piu ridon*') – i.e. they are more splendid than those he painted.

The Cult of Splendour

No student of medieval art can ignore the ever-present influence of the text of the Scriptures, where descriptions of existing ritualistic artefacts, such as the breastplate of the High Priest or the Ark of the Covenant, or in the imagined realm of the heavenly Jerusalem (Pl. IV), continued to colour the ideal of the sacred, as we see in the following description in Revelation:

> And the foundations of the wall of the city were garnished with all manner of precious stones. The first foundation was jasper; the second sapphire; the third, a chalcedony; the fourth, an emerald;
> The fifth, sardonyx; the sixth, sardius; the seventh, chrysolite; the eighth, beryl; the ninth, a topaz; the tenth, a chrysoprasus; the eleventh, a jacinth; the twelfth, an amethyst.
> And the twelve gates were twelve pearls; every several gate was of one pearl: and the street of the city was pure gold, as it were transparent glass. (21:18–22)

As far as humanly possible it was hoped to realize these visions here on earth. There is also a good deal of evidence from the Middle Ages to show princely ambition and civic pride in the game of outdoing your neighbour. Statistics of cathedrals cited in a book by Jean Gimpel speak for themselves: 'In 1163 Notre Dame de Paris began its record construction to result in a vault 114 feet 8 inches from the floor. Chartres surpassed Paris in 1194, eventually reaching 119 feet 9 inches. In 1212 Rheims started to rise to 124 feet 3 inches, and in 1221 Amiens reached 138 feet 9 inches. This drive to break the record reached its climax in 1247 with the project to vault the choir of Beauvais 157 feet 3 inches above the floor – only to have the vaults collapse in 1284.'[8]

Not that sheer size or costliness was the only object of competition. It is well known how much importance was attached to the possession of holy relics or miracle-working images which attracted pilgrims from across the frontiers. It cannot surprise us that what may be called the competition in holiness also had an indirect influence on artistic developments, as when the tradition of the miracle-working image lived on in the local style of a shrine.[9]

Needless to say these remarks are not meant to present an exhaustive analysis of the social conditions in which the great art of the Middle Ages developed. They merely serve to focus on the question of whether a preference for the primitive is likely to have manifested itself in this atmosphere. The idea of the primitive, as we have seen, implies the possibility of technical progress, and this in its turn may depend on the kind of competition we encountered in Pliny's chapters on ancient art.

Art as Skill

The reader will scarcely be surprised to find the return of this tradition equated with the movement that came to be known as 'the rebirth of the arts' – the movement associated with Giotto. It may indeed be argued that the words with which Boccaccio characterized Giotto's achievement suit the argument I have attempted to develop: Boccaccio tells of Giotto that he was able with his brush to depict anything created by nature to the point of deception: 'He thus recovered that art that had lain buried for many centuries because of the errors of some who painted more for the sake of delighting the eyes of the ignorant than of satisfying the judgement of the knowledgeable.'[10] Here the achievement of mimesis is contrasted with the taste for splendour, of feasting the eyes, the very taste to which Pliny had attributed the 'death of painting'.

The reader does not have to be told that the revival of the arts as chronicled by Vasari in the sixteenth century deliberately mirrored the progress towards mimesis witnessed in the ancient world. The task which Vasari set himself thus excluded the very idea of a preference for the primitive. He was so convinced of his standards that he apologized for paying any attention to the early masters, whose works had been crude and clumsy, and indeed laughable.[11] And yet the same impulse that drew him to trace and tell the history of the rebirth of the arts also prompted him to look at these early products, if not with approval, at least with interest.[12]

In the context of the present investigation it is clearly vital to emphasize this distinction between antiquarian interest and aesthetic appreciation. The first, which has many antecedents even before the sixteenth century, continued to grow apace in the course of subsequent centuries – a development admirably traced in Francis Haskell's book on *History and its Images*. But it is just the point that the antiquarians saw no reason to deviate from the standards of the classical canon. In the early eighteenth century Bernard de Montfaucon, the leading chronicler of antiquities, urged the copyist of the Bayeux tapestry to imitate the 'barbarous' style because, in his opinion, the decline of the arts was a very important historical fact.[13]

During the very years that Montfaucon explored and published medieval monuments the critic Roger de Piles amused himself (as he put it) by evaluating the achievements of the most famous painters, imagining a contest between them

in the four principal elements which he considered vital for mastery: composition, drawing, colour and expression.[14] De Piles was no narrow academic – he was in fact the leader of the faction known as the 'Rubenists' which exalted Rubens over Poussin, championed by the 'Poussinists'. Though Raphael achieved top marks in the total of scores (17 for composition, 18 for drawing, 12 for colour and 18 for expression), Rubens achieved the same total (18 for composition, 13 for drawing, 17 for colour and 17 for expression); Rembrandt achieved 15 for composition, 6 for drawing, 17 for colours and 12 for expression, while Michelangelo went down to a total of 37 (8 for composition, 17 for drawing, 4 for colour and 8 for expression). What makes this experiment noteworthy is that no master is even mentioned whose œuvre did not at least partly fall into the sixteenth century or later. This observation must serve as our justification for resuming the history of the preference for the primitive not earlier than the eighteenth century.

41

42

Chapter 2
The Ascendency of the Sublime

In the terminology of modern market research, what I call the 'preference for the primitive' would probably be described as a matter of consumer choice. It is the consumer of art, the art lover, who prefers one kind of style or of art over others. On a journey to Italy he will seek out the so-called 'primitives', and turn away from the products of later periods.

The Birth of Connoisseurship in England

This is a relatively new development. We owe its analysis and explanation to a seminal lecture by M.H. Abrams, the great American critic, who had also explained in his volume *The Mirror and the Lamp*[1] the profound changes involved in the conceptions of art which we associate with the Romantic movement. Abrams's lecture is entitled *Art-as-such: the Sociology of Modern Aesthetics.*[2] While earlier centuries, he points out, spoke of individual arts and their intrinsic rules, it was only towards the turn of the eighteenth century that people began to refer to what he calls 'art-as-such', meaning painting, poetry and music, as products to be enjoyed and contemplated. He stresses that 'the theory and vocabulary of art-as-such was introduced, quite abruptly, only some two or three centuries ago.' Earlier critical literature had 'assumed the maker's stance toward a work of art' (p. 137), whereas the new paradigmatic assumption is one in which 'a lone perceiver confronts an isolated work, however it happened to get made' (p. 138). Abrams thus poses the question:

> Was there, just preceding and during the eighteenth century, a radical alteration in social conditions and social uses of the diverse products that came, during that period, to be grouped as fine arts? … This is, broadly speaking, a question concerning the sociology of art (p. 141) … What we find, then, beginning late in the seventeenth century, is the emergence of an astonishing number of institutions for making a diversity of human artefacts public – as commodities, usually for pay – in order to satisfy a burgeoning demand for the delights, but also for the social distinction, of connoisseurship. (p. 151)

Abrams mentions the admission of the public to collections and museums, and public auctions, as well as public concerts, and the expanding readership of journals such as *The Spectator* and *The Gentleman's Magazine*. The new term 'tourist' was coined in these contexts.

Where Abrams stresses that these developments originated in England he does not say – as he might have – that as far as the visual arts were concerned England during the previous two centuries might be described as a 'consumer nation'. The Puritan revolution had all but killed the indigenous craft tradition, so that the Court relied for its needs on artists from abroad such as Holbein, Rubens, van Dyck and Kneller. It was in this situation that the upper class and the courtier travelled abroad to satisfy the needs of visual pleasure.

We have a number of important witnesses from early eighteenth-century England showing that this development happened in clear daylight, as it were. Thus, Anthony Ashley Cooper, Third Earl of Shaftesbury, in his *Letter Concerning the Art, or Science of Design* (dated 6 March 1712), comments on the changes he has observed all around him:

> As to painting, tho' we have as yet nothing of our own native growth in this kind worthy of being mentioned, yet since the publick has of late begun to express a relish for engravings, drawings, copyings and for the original paintings of the chief Italian schools (so contrary to the modern French), I doubt not that, in very few years, we shall make an equal progress in this other Science. And when our humour turns us to cultivate these designing arts, our genius, I am persuaded, will naturally carry us over the slighter amusements, and lead us to that higher, more serious and noble part of imitation, which relates to history, human nature, and the chief degree or order of beauty.[3]

The Revival of Platonism

Shaftesbury was an out-and-out Platonist, and, like Plato, he was convinced that the young men of his time should not be seduced into pleasure and indulgence by the arts, but should learn from them a moral attitude of austerity and probity. Plato, it will be remembered, decided that certain musical forms or musical modes – the Lydian and the Ionian – were relaxing and soft, and should therefore not be heard by the growing guardians. Shaftesbury applied this austere view to the decoration and furnishing which he saw in the country houses of his time, and which he thoroughly disapproved of, because they were just pleasant knick-knacks from anywhere in the world. The very idea that these decorations pleased the aristocracy he found outrageous:

> Grotesque and monstrous figures often *please*. Cruel spectacles and barbarity are also found to please, and in some tempers, to please *beyond all other subjects*, but is this pleasure *right*? – and shall I follow it, if it presents, not strive with it, or endeavour to prevent its growth or

prevalency in my temper? … Effeminacy pleases me. The *Indian* figures, the *Japan*-work, the enamel strikes my eye. The luscious colours and glossy paint gain upon my fancy [Fig. 16]. A *French* or *Flemish* style is highly liked by me at first sight, and I pursue my liking. But what ensues? – do I not for ever forfeit my good relish? (Advice to an Author, vol. I, p. 229)

In other words, in Shaftesbury's mind, such taste, if it is indulged, prevents the person under this influence from ever understanding the true greatness that is reserved for art, for he was convinced that real art, great art, was not so easily understood, that it needed an effort to make us respond to it:

> One who aspires to the character of a man of breeding and politeness, is careful to form his judgement of arts and sciences upon right models of *perfection*. If he travels to Rome, he enquires which are the truest pieces of architecture, the best remains of statues, the best paintings of a Raphael, or a Carache. However antiquated, rough or dismal they may appear to him, at first sight; he resolves to view 'em over and over till he is brought himself to relish 'em and find their hidden *graces* and *perfections*. He takes particular care to turn his eye from everything which is gaudy, luscious and of a *false taste*.
>
> Tis not by wantonness and humour that I shall attain my end, and arrive at the enjoyment I propose. The *art* itself is severe: the *rules* rigid. (pp. 228–9)

The modern reader may be struck by the fact that, for Shaftesbury, the paintings of Raphael and Carracci looked 'antiquated, rough or dismal' at first sight. If we turn to the footnote of this particular page we find that Shaftesbury is anxious to drive home the Platonic message that all good art must be severe and austere, rather than superficially pleasing. He takes his text from the writings of Pliny, who, he claims, recommended only the severe and austere style: 'Thus *Pliny*, speaking with a masterly judgement of the dignity of the then declining art of painting (*de dignitate artis morientis*) shews it to be not only *severe* in respect of the discipline, stile, design, but of the characters and lives of the noble masters: not only in the effect, but even in the very materials of the art, the colours, ornaments and particular circumstances belonging to the profession.' Shaftesbury here dwells on Pliny's strictures of the taste of his time which were mentioned in our preceding chapter: 'One of the mortal symptoms upon which Pliny pronounces the sure death of this noble art, not long survivor to him, was what belong'd in common to all the other perishing arts after the fall of liberty; I mean the *luxury* of the *Roman* court, and the change of *taste* and *manners* naturally consequent to such a change of government and dominion. This excellent, learned and polite critick represents to us the *false taste* springing from the court itself, and from that

45

opulence, splendour, and affectation of magnificence and expence proper to the place. Thus in the statuary and architecture then in vogue, nothing cou'd be admir'd beside what was costly in the mere matter or substance.' According to Pliny: ''Twas in favour of these court-beautys and gaudy *appearances*, that all good *drawing*, just *design*, and *truth of work* began to be despis'd … the materials were too rich to be furnish'd by the painter, but were bespoke, or furnish'd at the cost of the person who employ'd him … So great and venerable was simplicity held among the antients, and so certain was the ruin of all true elegance in life or art, where this mistress was once quitted or contemn'd!' (pp. 229–30).

Here the moralized account of the development of ancient art from austere severity to luscious luxury concerns us, reflecting as it does an emphatic preference for earlier styles of art over later ones.

The Profits of Connoisseurship

We find a similar bias in Shaftesbury's contemporary, Jonathan Richardson, whose writings also confirm the point made by Abrams that a general taste for the visual arts was something new in eighteenth-century England. Unlike Shaftesbury, however, Richardson is not out to improve his country's morality. His aims are much more mundane. He wants to put across his conviction that a taste for the arts should be regarded as an indispensible accomplishment of any gentleman – an accomplishment that has been strangely lacking in the past and that would benefit the whole nation:

> It is remarkable [he opens his book of 1719], that in a country as ours, rich, and abounding with gentlemen of a just, and delicate taste in music, poetry, and all kinds of literature: such fine writers! such solid reasoners! such able statesmen! gallant soldiers! excellent divines, lawyers, physicians, mathematicians, and mechanicks! and yet so few! so very few lovers, and connoisseurs in Painting!
>
> In most of these particulars there is no nation under Heaven which we do not excel; in some of the principal most of them are barbarous compared with us; … and yet the love, and knowledge of Painting, and what has relation to it bears no proportion to what is to be found not only in Italy, where they are all lovers, and almost all connoisseurs, but in France, Holland and Flanders … My present business then in short is to endeavour to persuade our nobility, and gentry to become lovers of painting, and connoisseurs; which I crave leave to do (with all humility) by shewing the dignity, certainty, pleasure, and advantages of that science.
>
> …We know the advantages Italy receives from her possession of so many fine pictures, statues, and other curious works of art: if our country becomes famous in that way, as her riches will enable her to be if our nobility, and gentry are lovers and connoisseurs, and the

47

16. English lacquered cabinet with brass mounts on carved
and silvered stand, 1660–86. Victoria and Albert Museum,
London

sooner if an expedient be found (as it may easily be) to facilitate their importation, we shall share with Italy in the profits arising from the concourse of foreigners for the pleasure and improvement that is to be had from the seeing, and considering such rarities.

If our people were improved in the arts of designing, not only our Paintings, carvings, and prints, but the works of all our other artificers would also be proportionably improved, and consequently coveted by other nations, and their price advanced, which therefore would be no small improvement of our trade, and with that of our wealth.[4]

Richardson encapsules his conception of good taste in art in an important paragraph intended to guide the budding connoisseur in the formation of his taste:

> When it [painting] first began to revive after the terrible devastations of superstition, and barbarity, it was with a stiff, lame manner, which mended by little, and little till the time of Masaccio, who rose into a better taste, and began what was reserved for Rafaelle to complete. However this bad style had something manly, and vigorous; whereas in the decay, whether after the happy age of Rafaelle, or that of Annibale one sees an effeminate, languid air, or if it has not that it has the vigour of a bully, rather than of a brave man: the old bad painting has more faults than the modern, but this falls into the insipid. (p. 204)

For all its brevity and lack of historical awareness, this passage does anticipate much of what became the general opinion among art lovers in the subsequent two centuries. Ultimately this interpretation derives from the idea of the life-cycle of the arts, which was underpinned philosophically by Aristotle's idea of the rise to perfection of innate qualities, which come to the fore, and which in the end must yield to decay and death.

Like Shaftesbury, Richardson is concerned to warn the man of taste against the seduction of a corrupted style. Like Shaftesbury, but more explicitly, he takes account of the prejudices of his contemporaries which have stood in the way of their admiring the products of 'popish' Italian art, and he is anxious to reassure the public that he is well aware of the dangers of corruption which are inherent in the love of the arts such as they are practised in Catholic countries: 'If, when I see a Madonna, though painted by Rafaelle I be enticed and drawn away to idolatry; or if the subject of a picture, though painted by Annibale Caracci pollutes my mind with impure images, and transforms me into a brute; or if any other, though never so excellent, rob me of my innocence, and virtue, may my tongue cleave to the roof of my mouth, and my right hand forget its cunning if I am its advocate as it is instrumental to such detested purposes ...' (p. 189). Richardson stresses with pride that he is a Protestant, and so a member of the Church of England: '...

indubitably the head of the reformed churches … the best national church in the world … a body of free men … all connoisseurs as we are Protestants' (p. 260).

Denouncing Corruption

M.H. Abrams, in his paper (referred to above), has stressed very convincingly that this new attitude towards art derived from the tradition of religious thought and emotion, and that the contemplation of a work of art became akin to a religious experience. We may perhaps add that these religious overtones make themselves felt more readily in Protestant countries – notably England and Germany. The dread of corruption which we had noticed in Shaftesbury and in Richardson may also be said to be prefigured in the religious preoccupations of these countries, for the Reformation originated in the charge of corruption levelled at the Roman Church. A passage from Martin Luther dating from 1524 may be extreme in its violence, but it exemplifies the attitude that I have in mind: 'The Pope now sits instead of Christ in the Church, and he shines like filth in a lantern. He, with his bishops, his priests [*Pfaffen*] and his monks, it is they who have darkened our sun, and, instead of the true divine service have established a service of sheer idolatry [*einen Götzen- und Potzendienst*], with vessels and cowls, vestments and pipes, tolling and jangling and singing [*läuten, klingen, singen*], … Oh darkness, darkness!'[5]

I do not think it is an accident that throughout the eighteenth century the countries in which the turn towards primitivism occurs were originally Protestant, even though some of their representatives later converted. One of the leading figures associated in our minds with the turning away from civilization is, of course, Jean-Jacques Rousseau, and though it has been shown that he was not an out-and-out primitivist,[6] Rousseau certainly represents the abhorrence of the Calvinists against the Catholic Church. What he writes in his *Confessions* is explicit enough: 'I have that aversion to Catholicism which is peculiar to our city. It was represented to us as the blackest idolatry, and its clergy were depicted in the most sordid colours. This point of view was so strong in my case that in my childhood I had never peeped inside a Catholic church, never met a priest in his vestments, and never heard a processional bell without a shiver of terror and alarm.'[7]

What Rousseau preached in his message of a return to nature was the virtue of self-sufficiency, and this also applied to his view of art: 'So long as men remained content with their rustic huts, so long as they were satisfied with clothes made of the skins of animals and sewn together with thorns and fishbones, adorned themselves only with feathers and shells, and continued to paint their bodies different colours, to improve and beautify their bows and arrows, and to make with sharp-edged stones fishing boats or clumsy musical instruments – in a word, so long as they undertook only what a single person could accomplish and confined themselves to such arts as did not require the joint labour of several hands, they lived free, healthy, honest and happy lives …'[8]

In his famous response to the question of the Dijon Academy, whether the Sciences and Arts had contributed to the welfare of mankind, Rousseau stirred the uneasy conscience of his readers, for was not the effect of corruption palpable in the arts of the age, as much as in other fields of life?

> Every artist wants to be praised … what will he therefore do if he has the misfortune of being born among a people and in an age where the fashionable critics have given a frivolous generation of young people the opportunity of setting the tone? … What will he do, gentlemen? He will lower his talents down to the level of his age and will prefer to create commonplace pieces which are admired in his lifetime, to marvels which will be admired when he has long been dead … If there really happened to exist a genius today who possessed the strength of mind to refuse to compromise with the spirit of the age or to demean himself with puerile trifles, woe to him! He would die destitute and unknown; I wish it were a prophecy rather than experience of which I speak. Charles [Carle Van Loo?], Pierre [Jean-Baptiste-Marie Pierre?], the moment has come when your brush that was destined to enhance the grandeur of our temples with sublime and holy images will either drop from your hands, or will be prostituted to decorate the panels of a coach with lascivious paintings …[9] [Fig. 17]

Rivalry with France

One more element must still be considered in what might be called the intellectual situation of Europe round about 1700: namely the position of France at that time. France considered itself, and was considered by others, the leading cultural nation, the nation of the '*Roi Soleil*' and of Versailles. It was the source of all fashions, in clothing no less than in architecture and other aspects of culture. Needless to say, this claim to pre-eminence of the French in matters of elegance, polish and beauty caused resentment among their neighbours, particularly in Germany and in England. And it was perhaps precisely because the French looked down on the literature and the poetry of the neighbouring nations as uncouth and almost barbaric, that these nations searched for autonomous values which they could pit against the scornful French.

The famous essay by Dryden, *Of Dramatic Poesy*, sets a key for subsequent critical discussion of national literature. He stresses, in his brief address to the reader, that 'the drift of the ensuing discourse was chiefly to vindicate the honour of our English writers, from the censure of those who unjustly prefer the French before them.'[10] It is in this context that we encounter his eulogy of the great national poet of England, William Shakespeare: 'He was the man who of all modern, and perhaps ancient poets, had the largest and most comprehensive soul. All the images of nature were still present to him, and he drew them, not laboriously, but luckily; when he describes anything, you more than see it, you

51

17. Antoine Watteau, *The Love Lesson*, decorated coach panel, *c*.1716–17. Swedish National Art Museum, Stockholm

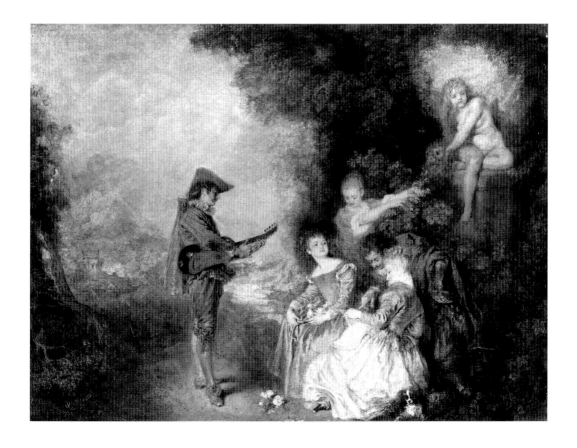

feel it too. Those who accuse him to have wanted learning, give him the greater commendation: he was naturally learned; he looked inwards, and found her there' (p. 40). Even Shaftesbury the Platonist, whose aesthetics is entirely on the side of beauty, order and rationality, reveals a certain yearning for an understanding of the rough side of nature, and indeed there is an early reference there to the Romantic taste: in a rhapsody called *The Moralists*, he declares: 'I shall no longer resist the passion growing in me for things of the *natural* kind; where neither *art*, nor the *conceit* or *caprice* of man has spoil'd their *genuine order*, by breaking in upon that *primitive state*. Even the rude *rocks*, the mossy *caverns*, the irregular unwrought *grottos* [Fig. 18], and broken *falls* of waters, with all the horrid graces of the *wilderness* itself, as representing Nature more, will be the more engaging, and appear with a magnificence beyond the formal mockery of princely gardens.'[11] Shaftesbury adds significantly, and perhaps prophetically, that 'those who are deep in this *romantic* way, are looked upon … as … either plainly out of their wits or overrun with melancholy and enthusiasm' (p. 256). We are close to the roots of the Romantic Movement which was to undermine the certainties of classical aesthetics.[12]

This respect for what nature produces, rather than the rules of art, accounts also for Shaftesbury's estimate of the earlier poets:

> The British muses, in this dinn of arms, may well lie abject and obscure; especially being as yet in their mere infant-state. They have hitherto scarce arriv'd to any-thing of shapeliness or person. They lisp as in their cradles: and their stammering tongues, which nothing beside their youth and rawness can excuse, have hitherto spoken in wretched pun and quibble. Our *Dramatic* Shakespear, our Fletcher, Johnson, and our *Epick* Milton preserve this stile. And even a latter race, scarce free of this infirmity and aiming at a false *sublime*, with crouded simile, and *mix'd metaphor* … But those reverend bards, rude as they were, according to their time and age, have provided us however with the richest ore … [13]

Isaiah Berlin, in his book *Vico and Herder*, has shown that a number of European critics, such as Bodmer and Breitinger, 'placed Shakespeare and Milton and the old German Minnesingers far above the idols of the French Enlightenment'. As early as 1725, 'Beat. Ludwig von Muralt in his Letters on the English and the French had … drawn a contrast between the independent spirit of the Swiss and English, particularly English writers, and the conventional mannerisms of the French.'[14] In emphasizing this contrast there was a convenient aesthetic category at hand, which derived from classical antiquity – the notion of the sublime (see above, p. 32).

The Sublime

In his chapter 'Of the Sublime', Jonathan Richardson refers to the authority of Longinus, who wrote that 'Hyperides … had no faults, and Demosthenes many; yet whoever had once read Demosthenes could never after taste Hyperides;

52

53

18. Isaac de Caus, grotto design depicting Diana and
Callisto, mid-18th century. Victoria and Albert Museum,
London

for Hyperides with all his virtues could never rise above mediocrity, but Demosthenes possessed some in a sovereign degree.' And Richardson continues: '… the sublime wherever it is found, though in company with a thousand imperfections, transports and captivates the soul; the mind is filled, and satisfied; nothing appears to be wanting, nothing appears amiss, or if it does it is easily forgiven.'[15] Richardson uses Michelangelo's frescoes in the Capella Paolina at Rome (Fig. 19) as an example of a work which may infringe many rules, but which still exhibits 'a wonderful, astonishing greatness of style' (p. 101).

The very example Richardson uses suffices to show that the notion of the sublime is by no means identical with what we call the primitive – indeed, what must be interesting to the historian is that what was considered a sublime poem was something very different from what was considered a sublime painting or sculpture. It is only in the field of poetry that the sublime can sometimes be equated with the primitive, while we shall see that in the visual arts it was frequently associated with very different styles.

This difference of usage confronts the historian of the taste for the primitive with a problem of presentation: he cannot avoid paying attention to the vogue for the sublime in criticism, though we must take care not to confuse this intellectual fashion with the subject of our quest, the taste for the primitive in the visual arts.

Two Sources of Aesthetic Pleasure
It is noteworthy that in the seminal book by Edmund Burke, *A Philosophical Enquiry into the Origin of our Ideas of the Sublime and Beautiful*,[16] the visual arts are scarcely mentioned. The author is concerned with the contrast between these two aesthetic reactions, for which he suggests a biological explanation grounded in human nature, and indeed in that of all organisms. If the experience of beauty could be linked with erotic charm, it could be derived from the human instinct for propagation and the preservation of the species. The feeling of the sublime, the opposite reaction, which he found to be close to our sensation of awe and fear, was connected with the instinct of self-preservation: an attractive woman is beautiful, a thunderstorm sublime. The menu of choice for the man of taste, in other words, now had two main categories: that of beauty, on the one hand, which could be enjoyed in perfect art, and that of the sublime, the awe-inspiring, which came much closer to the hard, austere character so often attributed to earlier styles. Admittedly Edmund Burke did not take his examples very much from the visual arts, any more than Longinus had done in classical antiquity. The only references to individual works of the visual arts – if we so want to call them – is one about Stonehenge as a 'sublime monument' (Part II, Section 12, p. 139), and the remark that darkness has a character of sublimity, and that the temples of the American Indians tend to be dark (Part II, Section 3, p. 100).

Burke's mastery lies in the analysis of the effects of language, and here hidden polemics against the ideals of the French also come to the fore. On the last page

55

19. Michelangelo, *The Crucifixion of Saint Peter*, 1546–50. Capella Paolina, Vatican

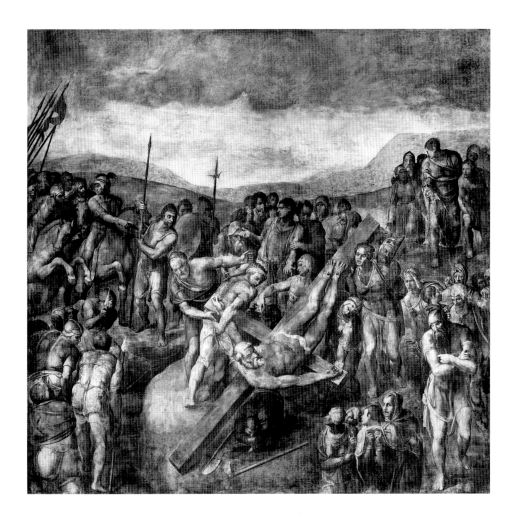

56

20. Raphael, *The Vision of Ezekiel*, c.1516–18.
Palazzo Pitti, Florence

21. Parmigianino, *Moses*, c.1535–9.
Detail from vault of Santa Maria della Steccata, Parma

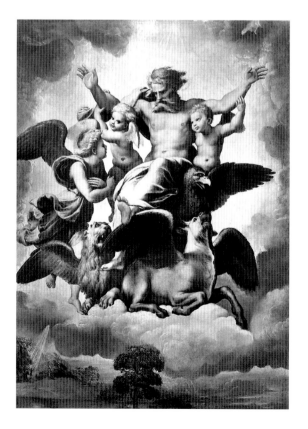

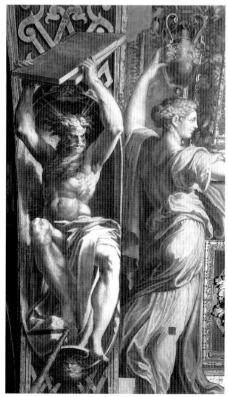

of the book we read: 'It may be observed that very polished languages, and such as are praised for their superior clearness and perspicuity, are generally deficient in strength. The French language has that perfection and that defect. Whereas the oriental tongues, and in general, the languages of most unpolished people have a great force and energy of expression, and this is but natural. Uncultivated people are but ordinary observers of things, and not critical in distinguishing them, but for that reason they admire more, and are more affected with what they see, and therefore express themselves in a warmer and more passionate manner' (Part V, Section 7, pp. 340–1).

The Sublime in Poetry

Burke's book was published in 1757, a time in which the vogue for ancient poetry was taking hold. In the same year Thomas Gray wrote his rhapsodic poem, 'The Bard', which shows all the characteristics of an imaginary bardic past – to quote just the first antistrophe:

> On a rock, whose haughty brow
> Frowns o'er old Conway's foaming flood,
> Robed in the sable garb of woe,
> With haggard eyes the Poet stood;
> (Loose his beard, and hoary hair
> Stream'd, like a meteor, to the troubled air)
> And with a Master's hand, and Prophet's fire,
> Struck the deep sorrows of his lyre.
> 'Hark, how each giant-oak, and desert cave,
> 'Sighs to the torrent's aweful voice beneath!
> 'O'er thee, oh King! their hundred arms they wave,
> 'Revenge on thee in hoarser murmurs breathe;
> 'Vocal no more, since Cambria's fatal day,
> 'To high-born Hoël's harp, or soft Llewellyn's lay.[17]

We have the poet's own word for it that he would like the Bard to be imagined very much like some paintings he had seen when he accompanied Horace Walpole on his tour of Italy. One of them was Raphael's *Vision of Ezekiel* (Fig. 20) – the figure of the Almighty on the throne of the Four Beasts is the vision of Ezekiel – and the other, even more surprisingly, a figure of *Moses*, from a fresco by Parmigianino (Fig. 21).[18] For us, the stylistic characteristics of these paintings could hardly be equated with primitive modes of expression, but for Thomas Gray they shared with primitive poetry precisely the character of the sublime.

In the same years, 1758–60, James Macpherson caused a sensation in publishing what purported to be rediscovered fragments of ancient poetry of the Scottish Highlands, usually referred to as 'Ossian'. Though some early doubts were raised about the authenticity of these poems they were hailed all over Europe as

proof that the Nordic peoples also had their Homer. Popular as they became, their reflection in the visual arts proved disappointing, precisely because artists groped in vain for a style that would do justice to the heroic vigour of this ancient world, and generally fell back on the muscular figures of Michelangelo and the Italian Mannerists.[19]

This discrepancy in the styles of different arts associated with the idea of the primitive warrants a digression, since it throws welcome light on the usage of the term. By and large the term is applied to the early stages of those aspects or institutions of civilizations which have undergone marked changes in the course of history. Here we think first of all of technology which has developed so conspicuously in the course of time. We all know what is meant by a 'primitive' plough, or a 'primitive' loom, since the techniques of ploughing or weaving have demonstrably progressed under the pressure of social needs.

In the various arts the ingredient of technology differs markedly, whether we think of the technique of vaulting in architecture or of the development of keyboard instruments in music. It is characteristic of the visual arts that they have undergone the most dramatic changes, and their history records a series of inventions – such as those of the rendering of light and shade and of foreshortening, of perspective and of various graphic techniques – which allow us to date individual works with a fair amount of confidence. There are few analogues of this kind of development in the art of poetry: the Homeric epics or the Psalms are not felt to be technically inferior to later creations, however much they may differ in 'style'. That is the reason why Gray's analogy between bardic poets and Renaissance painting strikes us as somewhat bizarre. The sublimity of the poem rests on very different characteristics from the sublimity of Raphael's vision. Thus the argument that the Homeric poems were not only sublime, but actually primitive in a historical sense, marks an important stage. Here we have to refer to yet another seminal work, which forms a bridge to the preference for the primitive in art, but which scarcely ever refers to painting or sculpture: *The New Science* (*De' principi d'una scienza nuova d'intorno alla comune natura delle nazioni*) (Fig. 22) by Giambattista Vico, which appeared in succession in three rather different editions, the last, from which I quote, in 1744.[20] It was Vico who taught – putting the matter in modern terminology – that the sublimity of the Homeric poems is the direct manifestation of a primitive mentality, the earliest stage in human history.

The Discovery of Primitive Mentality

Vico's book has a strong polemical edge. He was convinced that his fellow historians – and particularly his fellow historians of law – had a totally wrong idea of the early ages of mankind. They attributed to early man the same mentality, the same rationality as they could boast of, and therefore reconstructed the past in a way that Vico found totally unacceptable:

To discover the way in which this first human thinking arose in the gentile world ['gentile' as distinct from sacred or biblical], we encountered exasperating difficulties which have cost us the research of a good twenty years. [We had] to descend from these human and refined natures of ours to those quite wild and savage natures, which we cannot at all imagine and can comprehend only with great effort. We find that the principle of these origins both of languages and of letters lies in the fact that the early gentile peoples, by a demonstrated necessity of nature, were poets who spoke in poetic characters. This discovery, which is the master key of this Science, has cost us the persistent research of almost all our literary life, because with our civilized natures we [moderns] cannot at all imagine and can only understand by great toil the poetic nature of these first men. It is … beyond our power to enter into the vast imagination of those first men, whose minds were not in the least abstract, refined, or spiritualized, because they were entirely immersed in the senses, buffeted by the passions, buried in the body. That is why we said above that we can scarcely understand, still less imagine, how those first men thought who founded gentile humanity.[21]

He calls them 'poetic' because they were ruled entirely by their imagination rather than by their reason. The key to the thought processes of primitive man Vico found in what we would describe as the projection of the self into other experiences – what we call the 'pathetic fallacy': 'the sun smiles', 'the clouds threaten', 'the wind howls'. All this Vico subsumes under his idea of primitive man relating inanimate things to his own experience:

The farmers of Latium used to say that the fields were thirsty, bore fruit, were swollen with grain; and even our rustics speak of plants making love, vines going mad, resinous trees weeping. Innumerable other examples could be collected from all languages. All of which is consequence of our axiom that man in his ignorance makes himself the rule of the universe, for in the examples cited he has made of himself an entire world. So that, as rational metaphysics teaches that man becomes all things by understanding them (homo intelligendo fit omnia); this imaginative metaphysics shows that man becomes all things by not understanding them (homo non intelligendo fit omnia), and perhaps the latter proposition is truer than the former, for when man understands he extends his mind and takes in the things, but when he does not understand he makes the things out of himself and becomes them by transforming himself into them. (ibid.)

In other words, when modern literary critics write of poetics and discuss metaphor as a special trick of adorning the language, they have got hold of the wrong end of the stick altogether. Metaphor is the natural form of expression of

primitive man, which only gives way later to more rational discourse.

Vico's book returns again and again to Homer. He was convinced that Homer was not an individual poet but really the collective name of this early phase of civilization. He calls the poetry 'so sublime that the philosophies which came afterward, the arts of poetry and of criticism, have produced none equal or better, and have even prevented its production. Hence it is Homer's privilege to be, of all the sublime, that is, the heroic poets, the first in the order of merit as well as in that of age' (p. 79).

While he thus attributed to primitive men a natural bent towards the sublime, Vico was sceptical about their capacity to apprehend beauty: '… the natural beauty which is apprehended by the human senses, but only by those men of perception and comprehension who know how to discern the parts and grasp their harmony in the body as a whole, in which beauty essentially consists. This is why peasants and men of the squalid plebs understand little or nothing of beauty' (pp. 159–60). All this leads Vico to his central thesis that poetry comes before prose, prose being a later development of poetic speech (p. 111).

It must be admitted that Vico's grand conception of the evolution of the human mind and civilization nowhere refers to the development of human skill in the visual arts. There was as yet no obvious link between the sublimity of language and the early styles of painting and sculpture. This link was forged, hesitantly at first, by Johann Joachim Winckelmann (1717–68), the German prophet of neo-classicism.

Largely self-taught while he was working as a librarian, Winckelmann had read Shaftesbury and even annotated his writings, and there is little doubt that the moral fervour of his earlier work owes something to Shaftesbury's educative and pedagogical aims. What Shaftesbury had so eloquently denounced as the depraved taste for the so-called pleasing work of japanned lacquer, or other grotesque figures from the East, was characteristic of Dresden, the city where Winckelmann's first publication saw the light in 1755; for it had been in Dresden that manufacturers had for the first time succeeded in imitating Chinese porcelain, and china figures and other such knick-knacks dominated the style of the city (Fig. 23), together with the exuberant Baroque architecture of M.D. Poppelmann. It was in strict reaction against this taste that Winckelmann wrote his *Thoughts on the Imitation of Greek works in Painting and Sculpture*.

Uncorrupted Art

It is unlikely that this essay would still be mentioned in history if it were not for the fact that its author later became the great pioneer of art-historical studies. In this rambling work Winckelmann is mainly concerned with beauty – the beauty of Greek statues, but most of all, the beauty of healthy bodies – which would not concern us, if it were not for the fact that he preached against the decadence of the age in which he lived. A characteristic passage must suffice to give the flavour:

61

22. Frontispiece to Giambattista Vico's *Scienza nuova*, (Naples, 1744)

23. Meissen figure of shepherdess, *c*.1755. Victoria and Albert Museum, London

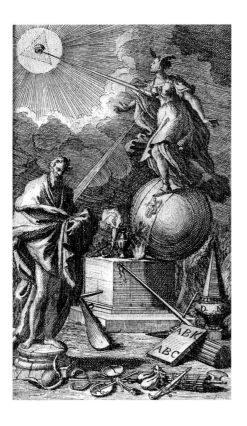

'Behold the swift Indian who runs after a stag, how his humours are quickening and his muscles and tendons become agile and supple. That is how Homer described his heroes'.[22] Winckelmann makes much of the fact that the Greeks had the opportunity to see healthy, naked bodies, and that because of this opportunity their statuary was far superior to that of the moderns who work from models which lack this strength and virility. Modern works of sculpture show the folds of the skin. Their excessive sensuality in the veins and dimples of the body contrasts unfavourably with the simplicity and economy of means found in the renderings of nudes in ancient art. Hence, we conclude, modern artists should go to the statues, rather than to live models, to retrieve the ideal of beauty embodied in the works of the Greeks.

Winckelmann had no knowledge of the development of Greek art from its beginnings. He knew slightly more about the history of Greek literature (after all, everybody had the model of Aristotle's *Poetics* in mind), and thus he postulated that the development of Greek sculpture and painting must have run parallel to that of great literature. The following paragraph thus constitutes the first attempt to solve the problem mentioned before, the forging of a link between the development of literature and that of the visual arts:

> The fine arts, no less than human beings, have their youth, just as humans have, and the beginning of these arts seems to have been like the early works of artists, where only the impressive and the astounding pleases. This was the way of the tragic muse of Aeschylus, and his Agammemnon became, through its hyperbolic language, even darker than everything that Heraclitus had written. Maybe the first Greek painters drew exactly as their first good tragedians wrote. In all human actions the impetuous and sketchy comes first. The well-considered, the thorough, comes last. But this last quality requires time to be admired. It only belongs to the great masters. Violent passions are an advantage also for their pupils. Whoever understands art knows that what looks easy to imitate is in fact very hard to achieve. (p. 43)

After a Latin quotation underlining this fact, Winckelmann surprises us by referring, not to any early masters (whom he clearly did not know), but to the French seventeenth-century draughtsman La Fage, who, as he claims, could not equal the ancients: 'In his works, everything is in motion, and in looking at them we become divided and distracted as at a party where all persons want to talk at the same time' (ibid.) (Fig. 24).

It is at this point that Winckelmann comes up with his famous definition of the hallmark of Greek art: 'The noble simplicity and quiet grandeur [*die edle Einfalt und stille Grösse*] of noble statues is also the true hallmark of Greek writings of the best period – the writings of the school of Socrates' (ibid. – the reference is to the works of Plato and Xenophon).

63

24. Raymond de La Fage, *Camillus and the Schoolmaster of the Falerii*, late 17th century. Louvre, Paris

64

25. Greek coins, illustrated in J. Winckelmann,
Geschichte der Kunst des Alterthums (Dresden, 1764)

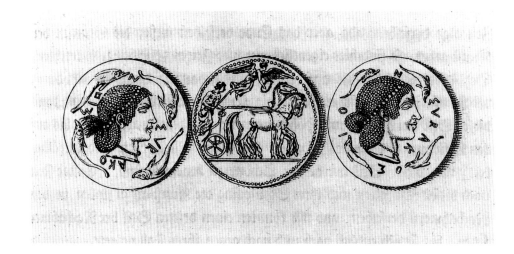

It is little short of a miracle that the author of this vague and inconclusive characterization of the alleged development of Greek art was able to publish a massive *History of Ancient Art*, in 1764, less than nine years later, though even in that famous work he still had very little to go by when it came to describing the phases of Greek art.

Winckelmann's idea of the sequence of styles that mark the development of Greek art turns out to be little more than a construct based on a priori principles. These principles are announced in general terms in the opening pages of the book: 'Like all other inventions, the arts depending on drawing began with the necessary. There followed the quest for beauty, and finally there followed the superfluous. These are the main phases of art.'[23] The passage recalls a statement by Vico, who, in his *New Science* announced as a proposition: 'Men first look for what is necessary, then for the useful, soon for the comfortable, later they enjoy what is pleasant, and so sink into luxury whence they squander their possessions. The character of nations is first rude, then severe, then benign, then delicate, and finally dissolute.'[24]

The Road to Beauty

It is possible that Winckelmann knew of Vico's work, but both of them may also have picked up this logic of progress and degeneration from the classical tradition which frequently stressed the dangers of wealth and of ease. Winckelmann used this scheme freely to arrive at the date of works of antiquity for which he had no other evidence. He knew some of the early coins, which confirmed to him that the artists of the early style rendered their figures in violent actions or positions. In general he characterized the features of this stage as follows: 'The drawing was emphatic but hard, powerful but without grace, and a strong expression detracted from beauty'[25] (Fig. 25), and concluded that this early style lasted for a long time, so that the later works must have been very different from the earliest.

Winckelmann regards the quality of this early style as a preparation for what he calls 'the lofty style' ('*der hohe Stil*'), that led to 'strict accuracy and lofty expression', because, so he claims, 'the harshness of the style revealed clearly marked exact contour, an assured knowledge where everything is revealed to the eyes.' We notice that Winckelmann no longer talks of the 'impetuous and sketchy character' of early art, as he did in the 1755 essay: 'Just as in learning music and speech, the sounds, syllables and words must be clearly articulated, drawing leads to the truth and beauty of form, not through deft touches or slight adumbration, but through manly, exactly delineated contours, even if they appear to be somewhat harsh.' Winckelmann is convinced that this early phase of Greek art shared these characteristics with the early phases of post-medieval art: 'The direct predecessors of the greatest masters in painting finished their works with incredible patience. It is on these foundations that Greek art developed to greater freedom and sublimity, which must have characterized the work of the famous

masters Phidias, Polycleitus … This style may be called "the grand style", for, apart from beauty, grandeur seems to have been the foremost intention of these masters …' (p. 224). Among works which have come down to us which show these characteristics, Winckelmann only singles out two examples: the *Pallas Albani* and the *Niobe* (Figs. 26 and 27), both of which are now dated later. The next style, which he calls 'the beautiful style', he dates from the approximate period of Alexander the Great. What matters to us is that, despite his professed admiration for the grace and beauty of these works, Winckelmann still sees the 'beautiful' style as leading to decadence: 'Through their efforts to avoid all apparent harshness and to render everything soft and delicate, those parts which earlier artists had rendered powerfully became more rounded, but blunt; more charming, but insignificant. This is the way in which literature was corrupted at all times – and music too abandons the manly character and lapses into the effeminate' (p. 236). Interestingly enough, Winckelmann came to the conclusion that this very decadence led to a reaction among certain masters who attempted to return to the grand manner of their ancestors. He correctly diagnosed certain reliefs as 'archaicizing, rather than archaic' (Fig. 12) – in other words, he attributes to the ancient world something like a preference for the primitive. Indeed, he refers at this point to the teachers of rhetoric, who recommend harshness in sound for the impression of grandeur (ibid.).

Winckelmann did his best to find support for his general scheme in the other arts, such as literature and music, and also in the development of post-classical art which Vasari had outlined. There is a characteristic passage in the *Remarks on the History of Ancient Art*, which he published three years after the *History*:

> The origins, progress and growth of Greek art can be more easily imagined by those who have had the rare opportunity of seeing paintings, and in particular, drawings, ranging from the first Italian painters to those of our own day. In particular one can gain a clear conception of the road to perfection taken by the ancients, when one can look through and compare an unbroken sequence of drawings covering more than three hundred years in one glance, which is the purpose of part of the great collection of drawings made by the Roman sculptor Bartolomeo Cavaceppi. These enable one to see the steps of modern art which correspond to those of the ancients. The comparison shows that, just as the path of Virtue is rough and narrow, so the road to Truth must also be strict and free of licentiousness.[26]

'Licentiousness' was the byword of a corrupted art, and in the same publication Winckelmann meditated on the parallels of this presumed corruption in antiquity: 'In the last century a damaging pestilence swept across Italy and the rest of the civilized world, filling the brains of scholars with noxious vapours and making their blood rush in feverish heat, which turned their literary style into bombast

67

26. *Pallas Albani*, Roman copy of a Greek original, *c.*440 BC. Museo Nazionale, Naples

27. *Niobe*, Roman copy of a Greek original, 4th century BC. Galleria degli Uffizi, Florence

68

28. Gianlorenzo Bernini, *Apollo and Daphne*, 1622–5.
Galleria Borghese, Rome

29. Giuseppe Arpino, *Prophets and Sibyls*, 1592.
S. Prassede, Rome

30. Francesco Borromini, Cupola, 1650.
S. Ivo della Sapienza, Rome

and forced effects. The same pestilence also spread among artists: Giuseppe Arpino, Bernini and Borromini (Figs. 28 – 30) abandoned Nature and antiquity in painting, sculpture and architecture, no less than Marino and the rest had done in their poetry' (p. 20). Who, confronted with this alternative, would not follow in seeking the path of Virtue, which, as he always stressed, was the path of effort and precision?

This moral interpretation of the development of ancient and modern art certainly did not quite chime with Vico's vision of the early forest dwellers and their power of imagination. It was Johann Gottfried Herder who introduced this point of view into the debate on the character of primitive literature, though his exact debt to Vico has proved hard to establish.

The Values of Early Poetry

'You laugh about my enthusiasm for the savages rather as Voltaire laughed about Rousseau for liking so much to walk on all fours. But do not believe that I despise for this reason our own advantages in morality and civilization in whatever sphere. The human race is destined for a progression of scenes, of cultures and customs. Woe to the man who dislikes the scene in which he has to appear, to act and to live! But woe also to the philosopher whose subject is mankind and its customs and who regards his own scene as the only one.'[27] In these words from the *Correspondence concerning Ossian and the Songs of Ancient Peoples*, Herder admitted to his primitivism, but defined its limits. His bias was for primitive poetry, not for primitive life. Once more we are led back to the criticism of language and of style which had led Vico to the conviction that poetry and rationality were mutually exclusive.

Neither Vico nor Herder wished to exalt this phase over that development of rational abstract thought. But if their conclusions were right, the progress of civilization spelled the death of poetry. Herder never quite accepted this consequence of his philosophy of language and it is lucky that he did not, since fate was to cast him in the role of one of the greatest inspirers of a poet. It was his encounter with the young Johann Wolfgang von Goethe in Strasbourg, when Herder was 26 and Goethe 21, from which dates the young poet's self-discovery. The passage from Herder quoted above forms indeed part of the pamphlet in which Goethe published his first essay, on Strasbourg Minster, to which we shall have to return (see p. 73). By that time, Herder's philosophy of language and of art had already solidified. We find it in process of formation in the earlier Fragments of 1767, which might be described as a series of marginal notes on the principal issues of literary criticism which engaged German intellectual life at that time.

The most urgent and most topical question was that of French dominance. Irked by the unquestioning adherence of Frederick the Great to French ideals and his contempt for German language and literature, an aspiring German writer,

such as Herder, could not but look for intellectual ammunition with which to breach the walls of this fortress of taste. This led him to investigate the links between language and poetry, to insist that poetry was rooted in a thousand ways in the traditions, beliefs and expressions of a culture. Whether we imitate biblical Latin or French poetry, the result will always be a frigid and hybrid mixture. Images which were once charged with religious feeling are now used as barely intelligible decoration. What was once emotion has become pedantic erudition. It is in particular in his discussion of modern German imitations of Pindar's dithyrambic poetry that Herder first comes to the conclusion that such imitation will never work:

> A nation in its wild state is strong in its language, its images and its vices – drunkenness and violence are the favourite vices of a nation which still holds manliness (*arete*) to be a virtue, and drunken frenzy to be pleasure. All the refined weaknesses did not yet exist which nowadays make for our good and bad qualities, our happiness and unhappiness, rendering us pious and cowardly, cunning and tame, learned and leisurely, compassionate and voluptuous. It was this drunkenness that gave rise to savage revelries, a wild dance, a rude music and in the unpolished language of the age, a rude kind of song.
>
> Thus it was not by the altar, but in wild dances of joy that poetry was born … It was this drunken poetry that was led to the altars for expiation. Here it was religion that commanded drunkennesss in wine and in love and thus drunkenness submitted to religion: its song was full of the animal sensuality that informs the language of wine, and the wine in its turn raises it to a certain mystic sensuality that is the language of the gods … Why do I tell all this? Only to show that the dithyramb derives its origin and its life from the ages of savagery and drunkenness and that we must therefore judge it by the qualities of that age … Should we therefore find our way back to the dithyramb? Here the little question would first have to be answered whether we could produce them if we did not possess the Greek models? It is this little matter, I believe, on which everything else depends, and anyone who knows the Greeks would raise his eyebrows at this question.
> (vol. I, pp. 303–14)

A German dithyramb, in other words, is a monstrosity in Herder's opinion. It is written, not sung, calculated, not felt. It does violence to the spirit of the language which has learnt to obey the rules of logic.

Time and again Herder returns to this central theme of his life – the interdependence of language and culture, and the futility of all attempts to prise language or poetry out of this living context. This basic conviction explains Herder's attitude to Winckelmann; the discoverer of primitive poetry profoundly

admired the prophet of Greek classicism. For had not Winckelmann tried to demonstrate precisely how naturally and almost inevitably Greek art arose out of the conditions of Greek life? Had he not taught his generation to look at works of sculpture as reflections of the Greek spirit? It is for this reason that Herder commends Winckelmann's approach to art to the student of literature, as early as the Sixth Fragment of 1767 (vol. I, p. 399), and after the tragic death of Winckelmann he published a tribute, in 1778, which had partly been written earlier (vol. VIII, pp. 437–83).

Genuine as Herder's admiration is, he sees perhaps more clearly than others that what Winckelmann offered was a system of doctrines, rather than a history (vol. VIII, p. 465). To write a real history of Greek art was impossible for Winckelmann, as it would be impossible for anyone else, we simply lack the evidence to do so. What he gave us instead were the categories by which to group and judge the monuments of antiquity.

Much as Herder praises and endorses Winckelmann's pioneering work, as far as the understanding of Greek art is concerned he has one interesting reservation which has an immediate bearing on our problem. Winckelmann failed where he used his system of doctrines to judge the works of other cultures, notably those of the Egyptians. This reveals to Herder that Winckelmann was not a true historian. He offended against the spirit of history by claiming that the Greeks owed nothing to their Egyptian predecessors. For Herder, the question is not whether the Greeks could have invented art but whether in fact they did so: 'Analogy tells us that men or nations invent only exceedingly rarely, where they are not forced to do so, and that they always prefer to fall back on tradition, heritage, imitation, learning ... Whether or not this redounds to the honour of mankind it is still true, we observe it in ourselves, we see it in all children and in all nations ... Both literary traditions and stylistic comparisons reinforce this assumption that Greek art derived from Egypt' (vol. VIII, pp. 472–4).

If we approach the problem as historians rather than as the propagators of a system of beauty, we must admit 'that the Egyptians are older than the Greeks, and must not be judged by Greek standards but by their own. We must ask what they considered art, how they invented it at so early a period, and what they intended with it. If in all these questions they had nothing in common with the Greeks, then one must not press both their works into the same system, but let each of them serve its own place and its own time, for, after all, originally the Egyptians hardly wanted to work for the Greeks or for us' (vol. VIII, p. 476).

Herder here reverts to a hypothesis which he had developed earlier (vol. VIII, p. 95), according to which Egyptian art can only be understood as an outgrowth of funerary customs. The Egyptian statue probably originated from the mummy, and this explains the strange qualities of Egyptian work. Where the impression of rest and death was the artist's aim, it would be absurd to expect Greek fencers and jumpers. 'If an ancient Egyptian entered a Greek gallery, he would be startled,

wonder and perhaps turn away in disgust. What turmoil, he would say, what licence! Fencer, how long will you stand in the pose of attack ... and you, Venus, will you for ever step out of the bath, you, wrestlers, did you never win? How different things are with us, we only give shape to what lasts eternally, the posture of rest and of sacred silence' (vol. VIII, p. 477).

To a critic so minded, the notions of good taste prevalent in the eighteenth century were bound to be ludicrous, if not harmful. In 1733, Herder actually submitted a prize essay in answer to the question of the Berlin Academy concerning *The Causes of the Decline of Taste among the Various Nations Where it once Had Flourished*.[28] To Herder, taste is a regulative principle which can only function when there is first something to regulate. His argument deserves a full description: first there must be genius, invention, creation. Taste is nothing but order in the use of one's strength, and so it is nothing without genius. Only a genius can call a genius to order. It has been said that geniuses have corrupted taste. That is true, in so far as it needs a genius even to misapply his strength. There is no contradiction, no conflict between genius and reason. Greek genius was tamed by reason. Once more Herder appeals to Winckelmann's analysis to show that in ancient Greece taste had become second nature and was part of the age, no less than their constitution, their way of life and their climate. The connection between good oratory and the spirit of freedom in the Greek constitution had been demonstrated by Longinus. Even Greek language declined with the decline of the Greek polis. The Romans never had taste in this sense; Roman poetry is a transplanted flower, and Roman oratory, like that of Greece, only flourished as long as it had a political function. The Romans themselves were very well aware of the reasons for this decline. Where taste loses living contact with the life of an age no rules and no sermons can restore it. Neither Quintilian nor Seneca could halt the collapse of antiquity (pp. 617–31). As with antiquity so with the modern age. It is customary to attribute the 'restoration of good taste' to the period of Leo X, and this is true if we are careful to distinguish genius and taste. The geniuses who shaped the Italian language in poetry and prose did not wait for the Medici to do so. They fulfilled their mission in wretched periods, and even the famous pope rewarded clowns and Latin imitators rather than the genius of Ariosto. By that time, Petrarch, Dante, Boccaccio, Cimabue, Giotto had long done their work. Nor is it true that in all those Dark Ages beauty and art had as completely vanished from the earth as is sometimes believed. The Medici only reaped a harvest that had been sown earlier. Now the ancients were rediscovered, they were taken as models for the polishing of language and for imitation. It was their own ancestors whom the Italians imitated, but even they came to grief in the process. For once the imitation had succeeded there was nothing left to be done – the tools had been polished and were hung up or broken. That, in short, is the history of Italian taste (p. 634–5). What is true of poetry is true of painting. Imitation alone is not sufficiently serious or urgent

a motivation for art. Art lacked a living purpose and the very stimulus that aided the earlier painters, the spirit of adventure, the light of novelty now deterred or seduced them. One no longer saw beauty in its most striking features, because one had seen it too often. The sated hen neglected the corn and pecked at colours. What corrupted good taste was quite simply the fact that good taste was not needed (p. 637).

Taste, in other words, cannot be created by fiat or imposed by a ruler. It can only spring out of a new conception of life, nurtured by education and a sense of true values.

It was thus more than an accident that a critic with these ideas and preoccupations was to become the mentor and inspirer of Germany's future artistic legislator. As Herder was lying in his darkened room at Strasbourg after a series of painful eye operations, the young Goethe with his half-baked ideas and his ready enthusiasm must have been just the right kind of disciple on whom to try out his insights. For Goethe it must at first have been a difficult encounter. Herder made fun of the young poet's admiration for Ovid, the accomplished but derivative virtuoso of Latin versification. Instead he sent him out to collect the folk songs of the Alsace, as Macpherson and Percy had collected – or forged – the songs of Scotland and the ancient relics of English ballads.

The Sublimity of Gothic Architecture

When Herder published his pamphlet *Of German Character and Art*[29] – devoted, hardly logically, to Ossian and Shakespeare – he included in it Goethe's first essay, *Of German Architecture*,[30] that prose hymn to the semi-legendary creator of the Strasburg Minster, Erwin of Steinbach, to which we now return. It was to become one of the most influential manifestos of the anti-classical movement, the first wave of primitivist ideas which assailed the classicist fortress. Yet the ideas it contains are not in themselves novel or true. What is novel is the new tone that Goethe elicits from the instrument of German prose, his translation of Herder's ideas into memorable images and pregnant aphorisms. The intoxicating splendour of this prose-poem, however, need not blind us to the sober truth that its message is born of resentment and nourished by ignorance. The author presents himself as the first champion of the Gothic style, the true German style, against its foreign detractors.

His manifesto derives its vehemence and sweep from the injured pride of a German indignant not to find any monument in Strasbourg to the master who designed the towering structure of the Minster (Fig. 31) . '"Its taste is petty", says the Italian, and walks past. "Childish stuff", echoes the Frenchman and triumphantly snaps his snuff box à la Grecque. What have you two achieved that gives you the right to despise us?'[31]

Goethe's indignation fastens on the expression 'Gothic', which he has learned to use as a synonym for bad taste. He describes with dramatic intensity how he

74

31. West façade of Strasbourg Minster,
19th-century engraving

had approached the Gothic Minster filled with such prejudice, and how the scales fell from his eyes as he stood in front of the famous façade. The exalted language with which he recaptures the great impression that filled his soul, recalls Winckelmann's almost religious exultation in the face of Greek masterpieces. But there is one decisive difference. Winckelmann worshipped at the shrine of beauty; Goethe can only justify his enthusiasm by rejecting, or at least modifying, the dogma of beauty.

We have seen that such an alternative ideal had gradually been taking shape in the minds of critics. All the experiences that clustered round the notion of the sublime have acquired an aura of high moral worth and dignity, compared with which beauty might appear sensuous and effeminate. Goethe still slightly equivocates, but the passage in which he opposes his own vision of beauty to modish prettiness is a decisive, pivotal point which consistently culminates in an exultation of primitive art. It deserves to be quoted in full:

> Let me be your companion and guide, my dear young friend, whom I see standing there, deeply moved and yet unable to reconcile the contradictions clashing in your mind as you feel at one moment the irresistible power of the grand total impression and then again you rebuke me as a dreamer because I claim to see beauty where you see nothing but strength and roughness. Do not let a misunderstanding divide us, do not allow this soft doctrine of modish beautymongering to spoil your taste for the significantly rough, lest in the end a sickly sentimentality can only tolerate smooth mediocrity. They want you to believe that the fine arts owe their existence to an alleged urge, said to be inborn in us, to beautify the things around us. That is not true. For in the sense in which it might be true it may correspond to the usage of the common man or the artisan but certainly not to the terminology of philosophers.
>
> Art is creative long before it is beautiful and yet as truly and greatly art, indeed often more true and more great than when beautiful. For there is inborn in man a creative urge which manifests itself as soon as he has safeguarded his life. As soon as the demi-god is free of care and of fear he becomes active in his leisure and gropes for matter into which to breathe his spirit. And thus it is that the savage shapes his coconuts [*so modelt der wilde … seine cocos*], his feathers and his body with weird designs, horrifying figures, loud colours – and yet, however arbitrary the shapes composing this creation, it will harmonize even without proportions for one emotion fused it into a characteristic whole. It is this characteristic art that is the only true art. (*Of German Architecture*, pp. 116–17)

What is remarkable in this first manifesto of primitivism in art is its almost complete isolation and lack of immediate consequence. It took almost another

140 years till Goethe's doctrine was taken literally, and moulded coconuts – if there are any – were considered 'the only true art'.

There are many reasons which contributed to this delay. Most important among them must be the fact that Goethe's challenging outburst was hardly based on any acquaintance with tribal art. He probably derived the image of the savage happily decorating his body (Fig. 32) from the passage in Rousseau which insists at least on the moral superiority of a civilization in which every man is his own artist; but the true impulse that turned this moral superiority into an aesthetic advantage came from Herder. Herder's concern, as we have seen, was with poetry and language, not with art. But in the very essay that accompanied Goethe's – that devoted to Ossian's poetry – Herder had exalted the superiority of uncivilized nations in the vividness of their expression and the concreteness of their imagination: 'When the Greenlander tells of his seal hunt he does not talk but rather paints with words and gestures every circumstance and every movement for they are all part of the image in his mind' (Suphan, vol. V, p. 197).

Writing as he did about art rather than poetry, Goethe had to cast around for a visual counterpart to the Greenlander's poetic mind, and thus he hit upon the creative savage of Rousseau. It was in all probability a purely literary conceit, for in this sphere of the criticism of visual art, Winckelmann's dominance could not be shaken off as easily as all that. Indeed, if we analyse Goethe's account, we find that it is not in contradiction to Winckelmann's doctrine. We have seen that for Winckelmann, too, beauty is a comparatively late fruit of artistic development, preceded by the grand and the lofty; and we have also seen that Winckelmann was at least as anxious to castigate and repudiate the Rococo predilection for prettiness and sensuality as Goethe was in his defence of Strasbourg Minster. Goethe had himself grown up in this world. He had had to pose as a pretty shepherd in the family portrait which his father commissioned Seekatz to paint in 1762 (Fig. 33). All the revolt of youth is compressed into such passages: 'How utterly I detest our painters of made-up dolls. I do not even want to declaim. They have caught the eyes of the women folk with their theatrical postures, their feigned complexions and their gaudy dresses. Manly Albrecht Dürer [Fig. 34] whom our moderns mock, I had rather set eyes on the most wooden of your figures!' (*Of German Architecture*, pp. 117–18). The great German painter begins to emerge as a moral antidote to corruption, a manly figure to shame an effeminate age.

For all its verve and splendour it is not easy today to read Goethe's first publication without a certain embarrassment. We cannot help remembering with hindsight what consequences the injured pride of the Germans was to have in later years. Admittedly Goethe could not know the evidence proving beyond cavil that the Gothic style was developed in France, but the thesis of the German character of Gothic could hardly have been taken seriously, even in 1772, except perhaps by those who relied on the etymology of the name. And as to the

32. Theordor de Bry, *Aztec Natives as the Spanish Conquistadors Found them*, engraving, *c.*1519

33. Johann Seekatz, *Goethe Family Portrait*, 1762. Goethe-National Museum, Weimar

34. Albrecht Dürer, *Saint Christopher*, woodcut, *c.*1501

appreciation of this manner of building, we now know that the very Italians and French who are lashed by Goethe for their purblind admiration of classical canons had paved the way to a fresh understanding of the Gothic style.[32]

The Gothic Revival
In England, John Milton had gone further in his association of the medieval style with the pleasures of melancholy:

> But let my due feet never fail,
> To walk the studious Cloysters pale,
> And love the high embowed Roof,
> With antick Pillars massy proof,
> And storied Windows richly dight,
> Casting a dimm religious light.
> There let the pealing Organ blow,
> To the full voic'd Quire below,
> In Service high, and Anthems cleer,
> As may with sweetness, through mine ear,
> Dissolve me into extasies,
> And bring all Heav'n before mine eyes.
> (*Il Penseroso*, lines 155–66)

The English attitude to the Gothic style, heralding the Gothic revival, was notoriously complex.[33] In the case of Horace Walpole it was largely a whim that made him build his villa at Strawberry Hill in a Gothic idiom, yet there are significant utterances by the same Horace Walpole which suggest that his apparent playfulness was a portent of things to come. A typical product of the age of Locke, he reflected on the attractions which the Gothic idiom exercised on him and found it in the associations it evoked: 'I, who have frequent difficulty of not connecting every inanimate thing with the idea of some person, or of not affixing some idea of imaginary persons to whatever I should see, should prefer that building that furnished me with most ideas, which is not judging firmly of the building abstractedly. And for this reason, I believe, the gloom, ornaments, magic of the hardiness of the buildings, would please me more in Gothic than the Simplicity of the Grecian'. He also hints that the 'approbation' of the Grecian style ' … would in some measure flow from the impossibility of not connecting with Grecian and Roman architecture, the ideas of the Greeks and Romans, who imagined and inhabited that kind of buildings'.[34]

In such utterances we can see the identification of a 'style' with a 'mode' – a family of forms evoking a cluster of ideas. Even in the ancient world, as we have seen (see p. 29), Vitruvius had advocated that the orders chosen for certain temples should harmonize with the character of the gods to whom they were to be dedicated. Once this approach had become general – as it did in the

nineteenth century – architectural styles were no longer preferred as pure form, but for the associations they were intended to evoke.[35]

Turning to Michelangelo

To return to the eighteenth century, using the Platonic terminology of 'modes', we might say that what we have observed in this chapter is the gradual ascendency of the mode of the sublime over that of beauty. We find this ascendency in the most surprising places. Sir Joshua Reynolds, the President of the Academy, had proclaimed in the ninth Discourse: 'The Art which we profess has beauty for its object; this it is our business to discover and to express.'[36] Ten years later, in the fifteenth and last of his Discourses, Reynolds's attitude has markedly changed, showing an increasing preoccupation with the superior virtues of the sublime as an antidote to the corruption of the age: in this account Michelangelo becomes the embodiment of the sublime, the true counterpart to Homer and to Shakespeare, the two idols of the anti-classical revolution. Like the other critics who preceded him, Reynolds used the traditional tools and terminology of ancient rhetoric:

> That the Art has been in a gradual state of decline, from the age of Michael Angelo to the present, must be acknowledged; and we may reasonably impute this declension to the same cause to which the ancient Criticks and Philosophers have imputed the corruption of eloquence. Indeed the same causes are likely at all times and in all ages to produce the same effects: indolence, – not taking the same pains as our great predecessors took, – desiring to find a shorter way, – are the general imputed causes. The words of Petronius are very remarkable [see above, p. 33]. After opposing the natural chaste beauty of the eloquence of former ages to the strained inflated style then in fashion, 'neither', says he, 'has the art of Painting had a better fate, after the boldness of the Egyptians had found out a compendious way to execute so great an art.' (Discourse XV, p. 280)

Michelangelo is thus cast in the role of the severe Attic orator, and it is consistent if Reynolds compares the modifications of this grand style at the hand of later artists with Dr Johnson's verdict on Pope's Homer that: '… though the real dignity of Homer was degraded by such a dress, his translation would not have met with such a favourable reception' if the poet 'had clothed the naked majesty of Homer with the graces and elegancies of modern fashion' (Discourse XV, p. 275).

And thus the way is prepared for the demotion even of Raphael: 'The sublime in Painting, as in Poetry, so overpowers, and takes such a possession of the whole mind, that no room is left for attention to minute criticism. The little elegancies of art in the presence of the great ideas thus greatly expressed, lose all their value, and are, for the instant at least, felt to be unworthy of our notice. The correct

judgement, the purity of taste, which characterizes Raffaelle, the exquisite grace of Correggio and Parmegianino, all disappear before them' (Discourse XV, pp. 363–8).

The 'Sansculottes'

Reynolds's pronouncements have a polemical ring. The more closely we read the Discourses, the clearer it becomes that they are the echoes and the outcome of discussions which must have been going on ceaselessly in the intellectual circles in which Reynolds moved. But it is only since 1952 that we have been able to fully appreciate and document the polemical edge of Reynolds's last lectures, for it was only then that the 'Ironical Discourse' of 1791 was published which had been found among the Boswell papers. This parody of all the views Reynolds detested was to form a kind of satyr play after the serious Discourses, and was intended to pillory the wild talk of revolutionary art students referred to by Reynolds as 'sansculottes', at a time when revolution was no longer an innocuous word. This 'Ironical Discourse' follows up to an absurd degree certain tendencies, which cannot have been entirely unsympathetic to Reynolds in a milder form. Of course he is out to ridicule the prevailing wild talk of his day by showing up not only its silliness, but also its inconsistencies. And yet many of the opinions he attributed to his opponents were in fact to become ingredients of nineteenth-century doctrine – both the insistence on literal naturalness without regard for ideal standards, and the emphasis on untutored originality, which irked Reynolds even more. Yet, as in all good parodies, there is an element of self-parody in the 'Ironical Discourse' which just pushes the thesis of the valedictory address over the edge of ridicule:

> It is necessary that you should be aware that our art is in a corrupted state and has been gradually departing from simple first principles ever since the time Michael Angelo, the first grand corrupter of the natural taste of men …
>
> It is not easy to account for the tame submission of mankind, either in first adopting this new style, or for its authority continuing to this present age. We can only put it to the account of a prejudice, which perhaps originated from his being highly favoured by the popes and great men of his time and is handed down to our time. But shall we in these enlightened times tamely adopt and inherit their ignorant prejudices? No! Let us examine everything by the standard of our own reason, renounce all prejudices for the reputed wisdom of others.[37]

Here the political note becomes unmistakable: those who claim the right to condemn Michelangelo for his lack of realism are the same as those who claim the right to judge everything else by the light of their own reason. Small wonder that their presumption ends in destructive radicalism:

Let the works in the Capella Sistina – or to refer to what we have in our own nation, the vaunted cartoons – let them be examined by the criterion of nature, and we shall be convinced how much the art has swerved from truth. Does any man, when he looks at those pictures, recognize his neighbour's face? Does anybody mistake the drapery, as it is called, for real stuff such as they are intended to represent? Is it silk, satin, or velvet? What a falling off from the ancient simplicity of art! Let us imitate the great Mirabeau. Set fire to all the pictures, prints, and drawings of Raphael and Michael Angelo; *non tali auxilio*.

Destroy every trace that remains of ancient taste. Let us pull the whole fabric down at once, root it up even to its foundation. Let us begin the art again upon this solid ground of nature and of reason. (pp. 140–2)

81

Reynolds had admirably caught the tone of violence and menace that he associated with the French Revolution on the other side of the Channel. He sensed the trend of the radicalism that had taken hold of the nation.

The French Revolution

Writing in distant Königsberg, in the year 1794, Immanuel Kant put down his reflections on the French Revolution – an event he had followed from the start with passionate interest: 'Such a phenomenon in human history can never be forgotten, because it reveals a disposition and a capacity for improvement in human nature such as no politician could have inferred from the previous course of events … Even if the intended purpose of this event would not now be achieved, if the revolution or reform of a nation's constitution were to fail in the end … that philosophical prediction would not lose its validity'.[38] What Kant had in mind was a justification of a belief in progress which he based on the achievement of freedom, the freedom of choice open to human beings to better their circumstances; a faith that he considered valid even if the revolution collapsed in bloodshed and terror. History has confirmed Kant's prediction in many unexpected ways. If our political thought is dominated by the idea of a spectrum extending from the extreme left to the extreme right, we are still under the spell of the seating order of the Constituent Assembly of 1790, when the delegates arranged themselves according to their attitude towards traditional values. The Revolution had indeed confronted everyone with a choice which nobody could, or can even now, escape.

In the sphere of art, the analogy to the choice of political allegiance may be said to have been the choice of modes. It will be remembered that we have had occasion before to use the term borrowed from the theory of ancient music. We have observed the availability of choice in the practice of architecture in England, and also to some extent in Reynolds's later Discourse. As was to be expected, the situation in France was more radical: the Revolution wholly rejected the artistic

modes or fashions of the *ancien régime*, opting for the austere, neo-classical style that had been popularized by Jacques-Louis David.

The Cult of the 'Primitifs'

In 1797 David had published a pamphlet advocating the novel practice of artists exhibiting their own works and charging a small entry fee.[39] Referring to an alleged precedent for such a practice in antiquity, and to the example of England, where the Royal Academy arranged annual exhibitions, David claimed that this departure from custom would help to relieve artists of their material needs, since any worthwhile work took a long time, during which they had no means of support. In words recalling those of Rousseau (see p. 50), he argued that the world might have lost many masterpieces which poverty prevented artists from completing: '… how many honest and virtuous painters, who would never have lent their brushes except to noble and moral subjects, have made them serve degraded and unworthy ends because of their need? They have prostituted themselves for the money of Phrynes and Laïses:[40] it is their poverty alone which has made them guilty, and their talent, born to strengthen the respect for good conduct, has helped to corrupt it' (pp. 5–6).

David's new work is sometimes referred to as *The Rape of the Sabine Women* (Fig. 36), but its theme is really the plea of the women to stop the fighting. This theme of reconciliation had an explicit political purpose with obvious bearing on the events of the *Directoire*. However, it appears that David had overlooked the fact that 1797 was also the year when, according to his former pupil Delécluze,[41] the fashion of Graecomanie reached its height, and replaced the enthusiasm for the Roman past in vogue during the year of the Revolution. David seems to have boasted that in this new work he would follow the austere Greek ideal more conscientiously than before, but when his students were allowed to see the painting they were disappointed. To quote Delécluze, they found in the painting: 'no grandeur, no simplicity, in short nothing *primitif*,[42] for that', so we hear, 'had become *le grand mot* – a word to conjure with, as when talking about Greek vase paintings' (Fig. 37). Compared with this ideal, the work of their master, for all his good intentions, still showed traces of corruption and sensuality. With the partiality and exaggeration of the young condemning the older generation, they declared that what David had produced deserved all the epithets of opprobrium they were used to hurling against the frivolous art of the *ancien régime* (Fig. 38). The work was 'Van Loo, Pompadour, Rococo'.[43] It is the first time that we hear the word Rococo, a term of ridicule and abuse for the *style rocaille*, a fashion fostered by the meretricious Pompadour, under whose auspices Carle Van Loo had been head of the Académie (Fig. 35).

The context in which Delécluze relates this episode in his memoirs is rather whimsical: he was interested in fashions, and passed in review the various eccentricities of fashions he had witnessed in his life, including that of beards. He

83

35. Carl Van Loo, *Resting from the Hunt*, 1737.
Louvre, Paris

84

36. Jacques-Louis David, *The Rape of the Sabine Women*, 1799. Louvre, Paris

37. Theatrical scene from a Greek vase painting, illustrated in D'Hancarville, *Antiquités étrusques, grecques et romaines* (Paris, 1787)

38. Pierre-Nolasque Bergeret, *The Studio of David*, caricature of a confrontation between David's students and a marquis-like exponent of the Rococo, *c*.1816. Staatliche Museen, Berlin

recalled a group of David's students who were known as 'les Barbus', or (and this matters to us), 'les Primitifs', who left no works worth speaking of, but were led by a lovable young artist, Maurice Quay (1779–1804), an eccentric of whom the writer grew very fond, though he could never share his views: 'This was the origin of the 'sect' of 'les Penseurs', or 'les Primitifs', for the two names were interchangeable … They were all agreed that they had to reject the customs, manners and excesses of modern times, and preferred to dress in the manner of the Greeks, and in particular of the early Greeks, because they considered Pericles another Louis XIV, and his century the beginning of decadence … Their number was not large – perhaps no more than five or six – but they aroused curiosity by their appearance … One of them dressed as Paris, in Phrygian costume, while another [their leader Maurice Quay] posed as Agamemnon … About twenty years of age, tall, slender, his black beard and hair unkempt, his gaze fierce and yet kindly', he reminded Delécluze of Mohammed, or even of Jesus Christ, 'two figures for whom "Agamemnon" had a profound veneration' (pp. 422–3).

His early artistic promise was not however fulfilled. Visiting Quay later in his own atelier Delécluze saw only a thirty-foot canvas hung diagonally, and on it a rough drawing of Patroclus returning Briseis to Agamemnon. This work never progressed any further, leading Delécluze to conclude that, 'having abandoned David's studio and proclaimed himself leader of his sect, the young man's eccentricities, becoming increasingly exaggerated and confused, had carried him ultimately into madness' (p. 424). Even before this catastrophe Quay had made it known that, in his opinion, the Louvre should be burnt and only a handful of statues and a dozen or so paintings conserved. Just as among classical works he valued only vase-paintings and certain monuments of the earliest styles, so in literature only the Bible, Homer and Ossian passed muster – he knew the French version of the last almost by heart: 'But when I made the mistake of mentioning Euripides', recalls Delécluze, 'my painter friend leapt up in a rage shouting: "Euripide? Van Loo! Pompadour! Rococo! c'est comme M. de Voltaire!" He would tolerate no criticism of the poems of Ossian which he insisted surpassed in grandeur Homer, and even the works of the Old and New Testament. Of all of these Ossian was supreme, because he was "plus primitif!" "Homer? Ossian?" he mused; "The sun? the moon? … When all's said and done, I think I prefer the moon. It is simpler, it is grander. It is more primitif!' (p. 428).

Delécluze is aware that, but for his recollections, we would not know of Quay's existence, let alone his opinions; yet, considering what has gone before we can appreciate the relevance of this episode in which so many of the tendencies of the eighteenth century came to fruition.

Chapter 3
The Pre-Raphaelite Ideal

The genesis of the pre-Raphaelite ideal, to which much of this chapter will be devoted, can be interpreted as the inevitable consequence of the cyclical view of history. The organic metaphor of birth and death, of growth and decay which Aristotle imposed on the history of the drama, postulated a basic asymmetry in the life-cycle of the art, between its first and its second half. The first is analogous to the childhood and youth of the organism, leading to full mastery; the second may be described as downhill all the way, from corruption to extinction. The crucial ambiguity of this view is to be found in the interpretation of the transition from the positive to the negative development. At what point did virtue turn into vice? Where did perfection become indulgence?

We have seen that the eighteenth century had become increasingly sensitive to the charge of effeminacy, a sensitivity that prompted many writers to take refuge in the safer category of the sublime. The bias was bound to render sensuous beauty suspect – indeed, we will remember that Richardson warned the budding connoisseur against the 'effeminate, languid air' of the paintings after Raphael (see p. 48).

The Path of Virtue

But maybe the main impulse came from Winckelmann, since he was the first to establish a regular sequence of artistic styles that was to be observed in ancient Greece, no less than in the Italian Renaissance. It will be remarked that he was convinced that the perfect in art could not have been achieved without the diligent efforts of preceding generations to conquer the difficulties of mimesis, by faithfully attending to a detailed study of nature. It was only after these firm strictures had been observed that art could transcend the reality of nature by aiming at the ideal of beauty.

Yet, even in Winckelmann's account, this final achievement is shown to contain the seeds of decay. Departure from nature led to licence and licentiousness, and so the brief moment of perfection inevitably leads to its own disintegration. No wonder that art lovers began to look with special interest at

88

39. Andrea Mantegna, *Saint James on the Way to Execution*,
*c.*1455. Destroyed, formerly church of the Eremitani, Padua

40. Titian, *The Miracle of the Jealous Husband*, 1511.
Scuola del Santo, Padua

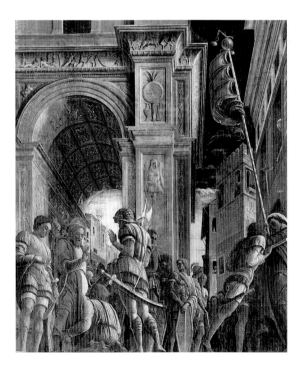

the phase of art that had mastered the problems of perspective and anatomy. To generations of art lovers who found it difficult to appreciate any image which appeared ill-drawn or distorted, the art of the quattrocento, notably the mastery of its final period, offered welcome examples of mimetic skill as yet untainted by any licentious striving after effects.

When Goethe arrived in Italy and first set eyes on the frescoes of Andrea Mantegna, he found these convictions confirmed:

> In the church of the Eremitani I have seen paintings by Mantegnia [Fig. 39], one of the earlier painters, which astonish me! It is quite impossible to describe the precise and truthful reality presented in these paintings. It was from this all-encompassing, correct (not merely showy, deceitfully lying and pandering to the imagination) but robust, clean, bright, detailed, conscientious, delicate and circumscribed presence that also partakes of the strict, industrious and laborious, that the later masters took their starting point, as I saw yesterday when looking at paintings by Titian [Fig. 40], and thus they were able, through the liveliness of their minds, the energy of their nature and the inspiration of the ancients, to rise higher and higher, till they lifted themselves up at length and created heavenly but truthful figures. This is the history of art and that of every single great and serious artist after the barbaric age.[1]

The final sentence is significant, since it implies that Goethe had indeed accepted the conclusion of the cyclical theory. The same applies to one of the most influential historians of art of the period, who had set himself the daunting task of expanding and supplementing Vasari's account – the Abbate Luigi Lanzi, whose *History of Painting in Italy*[2] deservedly became a standard work for years to come.

Lanzi certainly follows Vasari in paying eloquent tribute to the leading masters of the fifteenth century – indeed he writes in a felicitous metaphor that '… the works of those Florentine painters who are closest to the Golden Age are sometimes suffused by its colour' (vol. I, p. 72). 'True', he writes, 'their drawing is somewhat dry, but it is pure and correct, thus offering an excellent education to the subsequent century. It has been very justly observed that art students find it easier to give a certain fullness to the meagre outlines of their models than to pare down their excessively heavy contours. For this reason some teachers of art believe that it would be much better at first to accustom the young to the precision of the quattrocento than to that certain exuberance introduced in later periods' (vol. I, p. 83).

It is advice pregnant of things to come, but it certainly does not imply a preference for these painters as such. Lanzi still makes it clear that for him 'Raphael is by common consent placed at the head of his art, not because he excelled all others in every department of painting, but because no other artist has ever possessed the various parts of the art united in so high a degree' (vol. I, p. 380).

89

Filling the Gap

Even more significant in this respect is that great pioneering effort of Jean-Baptiste-Louis-Georges Seroux d'Agincourt,[3] who set out to fill the gap between Winckelmann's *History of Ancient Art* and Vasari – in other words, to explore the history of medieval art. D'Agincourt's influence on the knowledge of earlier artistic movements must not be underrated. Though his publication was delayed by the French Revolution it became the standard account of medieval art, which is treated with respect, without ever claiming that its creations were to be preferred to the glories of the Renaissance.

In his important book *La fortuna dei primitivi*, Giovanni Previtali has shown that d'Agincourt's influence extended far beyond his publication. He had employed a team of artists whom he sent out to draw significant monuments. These artists, who included Humbert de Superville, the sculptor John Flaxman and William Young Ottley, certainly developed a taste for the earlier styles – a taste, but not really a preference. Thus Ottley writes in the preface to his book, *An Inquiry into the Origin and Early History of Engraving* (London, 1816), referring to his work for d'Agincourt: 'It happened that the painting and sculpture of the early Italian schools, and especially the school of Florence had occupied much of my previous attention and that I had more than once visited Florence, Pisa, Orvieto, Assisi and Siena for the express purpose of collecting drawings faithfully copied from the original frescoes and *bassi relievi* of the earlier artists with a view to illustrate the history and progress of the arts of design from the dawn of their improvement in Italy in the thirteenth and fourteenth century to the era of their meridian splendour under Julius II and Leo X.'

Clearly there is no hint in this appreciation of the earlier schools of a claim to their superiority. The same is true of Flaxman's *Lectures on Sculpture* of 1829 where he says of the sculpture of Wells Cathedral: 'This work is necessarily ill-drawn and deficient in principle and much of the sculpture is rude and severe. Yet, in parts, there is a beautiful simplicity, an irresistible sentiment and sometime a grace excelling more modern productions.'[4] This is roughly how far these lovers of earlier periods were ready to go.

What applies to the historians also applies to the collectors. We know that Winckelmann's friend, the restorer and dealer Cavaceppi, had assembled a collection of drawings which may have rivalled the earlier collection brought together by Giorgio Vasari. If we are to believe Winckelmann, the collection contained many earlier examples, but they were assembled like other similar collections to document and demonstrate the slow rise of the arts to perfection. Maybe there were collectors who bought such works for their own sake. We know that the Englishman H. Ignace Hugford assembled in Florence a number of early Italian paintings, and that another English artist, the engraver Thomas Patch, set about to engrave and publish heads from the fresco cycle by Masaccio and the reliefs of Ghiberti's Porta del Paradiso, of which he even brought back a plaster

cast to England. However it is always necessary to stress again that an interest is not necesarily a preference. The very effects of the French Revolution go to show this difference. It is notorious that the vandalism of the Revolutionaries, who vented their fury on the monuments of the monarchy and all symbols of the hated regime, produced a reaction among the educated. The most remarkable was the museum assembled by the Frenchman Alexandre Lenoir (1765–1839).[5] But, strange to tell, Lenoir was not a medievalizer. He still held fast to the ideals and standards of the classical creed embodied in the French king, François I. In general there is no reason to equate antiquarian interest with a desire to extol the past over later periods. There were, no doubt, many collectors and eccentrics with antiquarian interests who gladly would have swapped the most interesting piece in their collection for a work of Raphael, who was still considered the prince of painters.

91

But which Raphael? This crucial question arose among the foreign artists who foregathered in Rome to absorb the standards of perfection embodied in the works of the great masters, that very perfection that had always been seen to be uneasily poised between strenuous effort and culpable decadence. The question of where the line ought to be drawn between the ascending and the descending curve of art became a matter of acrimonious debate, particularly in relation to Raphael. Once more it may have been Vasari himself who had prepared the way, by distinguishing three manners in Raphael's development: his early works, when he was still a follower of the style of Perugino; his learning period in Florence, and his mature achievement that owed much to the example of Michelangelo. We hear that not all artists were willing to accept this reading of Raphael's development. Some of the earlier works, notably the *Entombment* (Fig. 41) and the *Disputà* (Fig. 69), seemed to them more pure and more lovable than the works of his last years, such as the *Heliodorus* (Fig. 42) and the *Transfiguration* (Fig. 53).

The Choice of Modes

We must here hark back to that aspect of the impact of the French Revolution briefly discussed in the previous chapter, where it was suggested that the problem of choice in front of the individual – whether politician or artist – had suddenly assumed a new urgency. Could it not be argued that the softness and innocence of Raphael's earlier manner should not be regarded as a sign of imperfection, but as an alternative mode, much as David's rebellious students had regarded the primitive style of Greek vases as the most appropriate of modes?

Here as elsewhere the notion of style as the manifestation of skill gave way to the conception of a variety of legitimate modes – the idea, in other words, that the creator has the choice and ability to *adopt* a particular style for a particular context (for which, as we have seen, Greek musical theory offered a model). It would be interesting to trace the rise of this phenomenon in the various arts in the preceding years. Even in the early eighteenth century, J.S. Bach could write a

92

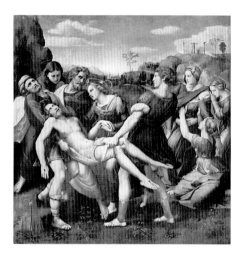

41. Raphael, *The Entombment*, 1507.
Galleria Borghese, Rome

42. Raphael, *The Expulsion of Heliodorus*, c.1512.
Stanza d'Eliodoro, Vatican

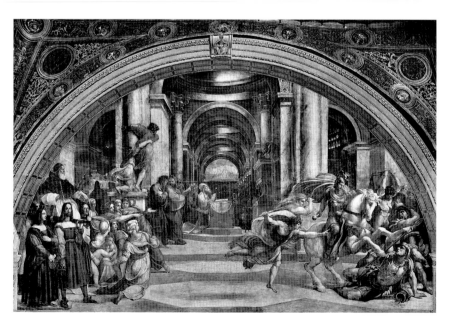

concerto 'in the Italian gusto', and compose 'English' and 'French' suites. Later he would insert 'all' ongharese' in one of his trios. Mozart adapted a Lutheran chorale for the hymn of the two men in armour accompanying the ordeal of the lovers in *The Magic Flute*, and Beethoven was to compose his thanksgiving hymn in the quartet op. 132 'in the Lydian mode'.

It was in the same period that Goethe's lyrical poetry exhibited the astounding heading 'approaching antique form' ('*antike Form sich nähend*') to his exercises in the oriental vein, and that architects practising in England began to consider style a matter of choice. There was one clear-eyed critic who saw the significance of the new approach. He was Friedrich Schiller, who in 1795 and 1796 published a critical essay in two instalments under the title *On Naïve and Sentimental Poetry*.[6] Certainly, Schiller's was not the first attempt to clarify the terminology of criticism by introducing two contrasting categories. The beautiful and the sublime, and Atticism and Asianism are earlier examples mentioned. But what distinguishes Schiller's system from such earlier efforts is that he regards the absence or presence of choice as a criterion by which to classify the two main kinds of poetic production. What he calls 'the naive' is an instinctive and natural mode of creation that marks the productions of the classical period. The 'sentimentál' – with the stress on the last syllable, which should not be confused with the English 'sentimental', with the stress on the penultimate – is a mode of creation that springs from reflection, in other words, from the awareness of choice. What emerges is an attempt to justify an art which is not 'naïve', and indeed to suggest that our unqualified admiration for the earlier state of mind is one of nostalgia, the longing for a lost paradise of innocence that makes us warm to the mentality of children and to the naïve charm of folksongs. It is only an apparent paradox that in these broad categories the classic is grouped together with the naïve – or what we might call the 'primitive' – while the modern and un-classical is revalued and accorded 'its right to independent existence'.[7]

The New Tolerance

The most significant expression of this new tolerance is the pamphlet published towards the end of 1796 entitled *Outpourings from the Heart of an Art-loving Monk*. Its author was Wilhelm Wackenroder, a young man of 23, who was shortly after to die of typhoid, a tragic fate that makes one feel more charitable towards the absurd title and the gushing tone of his youthful effusions. The lyrical language and the artful confusion of this manifesto have tended to somewhat obscure its real message. Despite appearances to the contrary, the art-loving monk does not advocate a preference for the primitive. In fact, in one of his other studies, Wackenroder even praises Watteau. The main thrust of the pamphlet is his plea for love and tolerance. In other words, he takes his stand against neo-classical orthodoxy in general and the cult of ideal beauty in particular. Like Goethe, who had directed his attack on current aesthetics 25 years earlier, Wackenroder

wants to abolish this shibboleth that stands in the way of a broader understanding:

> Beauty, what a wondrously strange word. First invent new words for every single artistic feeling, for every single work of art. Every one of them glows in a different colour and for each of them there are different nerves in the structure of man. But you apply the artifice of reason to weave out of this word a strict system and you want to force all men to feel according to your rules and precepts … We, the children of this century, have been granted the advantage of standing on the peak of a high mountain so that many countries are spread out to our eyes all around and our feet. So let us make use of this good fortune and let our eyes roam with a friendly gaze over all the ages and all the nations intent on sensing in all this variety of feelings and creations what is human in all of them.[8]

That characteristic awareness of choice that André Malraux described as our 'musée imaginaire' found here its first formulation. There is much in Wackenroder's text that reflects the earlier ideas of Herder in his anthology *The Voice of the Nations in their Songs*.[9] In his writings on the philosophy of history, Herder too had liked to dwell on the richness and variety of human creativity. But Herder combined his respect for the individuality of historical and natural styles with a firm belief in the progress of mankind which, strictly speaking, excludes a preference for the primitive.

In the very year in which Wackenroder's effusion appeared, Herder vigorously defended himself against any suspicion of such a preference in his preface to a collection of medieval legends:

> No man with an honourable brow will slanderously impute to this publication a desire to foster a taste for legends, least of all this wretched collection of legends. But they are intimately connected with the institution of Christianity within the culture of Europe, and even if they were nothing but documents of the aberrations of the human heart and mind, they would be noteworthy as such. However they are more than that: In the Christian and dark centuries we meet with personalities of such noble simplicity, such pure dignity and beauty, that they stand in no need of alien adornment. To what purpose the whimpering fears that readings of this kind might corrupt our taste? A taste that can be corrupted in that way cannot have been very firm.[10]

For Herder, as a member of the older generation, there can have been no freedom of choice in such matters of taste. It is different for Wackenroder. For precisely because the art of the Middle Ages can be seen as an outflow of Christian piety, Wackenroder exalts the style or mode for its moral value. It is for this moral

inspiration, rather than aesthetic enjoyment, that he turns to art, as he turns to poetry and music, for to him all the arts, no less than all nature, are 'a divine language'. Here the development of a new aesthetic attitude – so convincingly sketched by M.H. Abrams – comes to fruition.

It was Wackenroder who first applied the budding Romantic theory of 'self-expression' to painting. He physiognomizes the style of an artist, much as Winckelmann had physiognomized the styles of nations and periods: the soul which Winckelmann found reflected in Greek sculpture was a collective soul. Wackenroder looked in art for contact with individuals he could admire and worship. This indeed must have been one of the reasons why Vasari's biographies seemed such a godsend to him. The anecdote about the artist takes its place beside the legend about the saint as an aid to contemplation and an incentive to love. Hence the disguise of the 'art-loving monk', who relates some of the best-known anecdotes as a precious tradition told him by a venerable father:

> Know, my son, that several worthy men have chronicled the history of art and have described the lives of the painters in detail; the earliest and in all likelihood the most noble of these was called Giorgio Vasari by name … Consider how wonderful it is for you to get to know the men whom you have known so far by their different ways of wielding the brush, by their different characters and customs. Both fuse for you in one image, and if you only take in the stories he tells in a few dry words with the right and fervent feeling, you will see arising before the eyes of your mind a wonderful spectacle, the artist's character. Each of these characters will become a separate painting for you.[11]

It is clear then that what Wackenroder looked for in art was very different indeed from the ideals which the classical and academic tradition had sought. Their concern had been with the work of art itself, and with the degree to which it realized the purpose of painting or sculpture. Wackenroder wants to look across the work of art into the soul of the artist. We are reminded of the verdict of Longinus, according to which the sublime is 'the ring of the noble soul', and Longinus is, in fact, mentioned in the correspondence between Tieck and Wackenroder, but now the emphasis has changed. Wackenroder, to put it crudely, knew little about art and probably did not care for it all that passionately. What mattered to him was to find an argument with which to combat – and if possible, to rout – the rationalism of the Enlightenment. He found it in the conviction that art depends on religion, and that masters lacking in religion never produce good art. It is in Wackenroder that we find for the first time that idealized and sentimentalized image of the medieval craftsman which was to dominate the historical imagination of the nineteenth century:

> Those venerable men, many of whom were clergymen and monks, devoted the skill of their hands that God had given them exclusively to

divine and holy stories, and imparted such a serious and sacred spirit and such a humble simplicity to their work as is appropriate to consecrated objects. They made the art of painting into a faithful servant of religion and knew nothing of the vain pomp of colours which is the pride of artists today ... (pp. 103–4)

The 'pomp of colours', the 'pride of artists': clearly the rhetoric behind Wackenroder's advocacy of a morally superior age and art was in no way original. We have encountered similar denunciations of the modern age in Shaftesbury, in Rousseau, in Winckelmann and in Goethe's paean on Gothic architecture, no less than in the fulminations of the Barbus against 'Vanloo, Pompadour, Rococo'. 'Our moderns', wrote Wackenroder, '... work for refined gentlemen who do not want to be moved and ennobled by art, but merely tickled and dazzled as much as possible. So these artists turn their paintings into a showpiece of plenty, of charming and deceptive colours, they strain their wit in the distribution of light and shade – but the human figure is mostly seen to be there for the sake of colour and the light – Woe, I must exclaim over an age that practises art merely as a frivolous plaything of the senses' (p. 55).

We have seen how easily these sermons against effeminacy could serve the glorification of a more manly, more vigorous and heroic art, the ideal of Winckelmann's 'noble simplicity' and of Goethe's 'rugged Dürer'. In Wackenroder the emphasis is subtly changed. Once more we are reminded of the distinction made by Lovejoy and Boas between 'hard' and 'soft' primitivism. Previously the recoil from the alleged frivolities of the modern age had generally led to an emphasis on the hard, heroic and savage styles of an uncorrupted mode of existence. Wackenroder's art-loving monk found his ideal in the spirituality of the Age of Faith. Winckelmann's 'noble simplicity' ('*edle Einfalt*') thus became the 'pious simplicity' ('*fromme Einfalt*') of the Romantics.

There is every indication that this mutation was also connected with the aftermath of the French Revolution. The leader of the Primitifs, Maurice Quay, was described as an artist of exceptional piety, whose favourite episode in the Gospel was the story of Christ blessing the little children. It is surely not far-fetched to regard this outlook as a reaction against the rationalist radicalism of the Revolution which undertook to turn the cathedral of Notre Dame into a temple of Reason, but signally failed in its attempt to create a new cult and a new religion. Since the French Revolution in all its phases and transformations had adopted the style of an austere classicism, it is doubly understandable that its critics and enemies should look for an alternative ideal in the art and style of the Age of Faith.

It is all the more important not to over-emphasize the contrast between these two attitudes. The preference for the primitive can be given free scope in both styles, for both of them seek to avoid the same alleged vice: the display of

virtuosity and artifice. Wackenroder is explicit in this preference, as Winckelmann had been. In his *Monument in Honour of Albrecht Dürer* (which contains the attack against the corruption of the age quoted above), Wackenroder turns again on the academic critics: 'They also count it as a grave infringement of the rules, my beloved Albrecht Dürer, that you place your human figures so comfortably side by side without intertwining them artfully to form a proper *gruppo*. I love you in your unselfconscious simplicity and naturally turn my attention first to the soul and profound significance of your figures' (p. 57) (Fig. 43).

By no stretch of the imagination can such a plea for the recognition of Dürer be described as a preference for the primitive in any modern sense. All the less in the case of Wackenroder, who merely wanted to place a German master on a pedestal, side by side with the universally admired Raphael. We might say that what Wackenroder wished to proclaim was a reform of art, not a revolution. And as far as style was concerned, the reform differed hardly from those inaugurated by the neo-classical movement – rejection of artifice and affectation in favour of simplicity and purity.

The debates we have encountered in the eighteenth century and early nineteenth century may be characterized as debates about the canon of perfection in the visual arts. Wackenroder, as we have seen, criticized the narrowness of some of these so-called rules of art, and though he never made good his claim that what he pleaded for was a universal tolerance, it was this new tolerance that he hoped to champion.

The very word and notion of tolerance can serve to remind us of the role of England in this important aspect of the Enlightenment. True, the debates discussed in the previous chapter – the opinions of Shaftesbury, Richardson, down to Reynolds – were also predominantly debates about the canon, but we must not forget that it was particularly in England that artists began to rebel against the narrowness of the notion of the perfection only to be found among the Old Masters.

It was in England that an artist arose to challenge the monopoly of taste cherished by the connoisseurs, and to introduce an entirely novel viewpoint within the critical debate. This artist was William Hogarth, who despised the connoisseurs and challenged their narrow canon. As a creative artist he was responsible for the series of *Modern Moral Subjects*, for which he had secured the copyright, and as a critic he proposed the canon in his *Analysis of Beauty. Written with a View of Fixing the Fluctuating Ideas of Taste*. Always eager to score a point against the wealthy collectors, he dismissed the claims of the Old Masters by insisting that their art had largely been based on conventions rather than on the true study of nature.[12] He thus favoured an awareness of the conception of various modes, freely adopted by artists in his own country. Indeed, looking at imagery in eighteenth-century England, we become aware of the growth of an alternative world of artistic modes independent of the classical canon.

98

43. Albrecht Dürer, *Bishops Nicholaus, Ulrich and Erasmus*,
woodcut, 1507–8

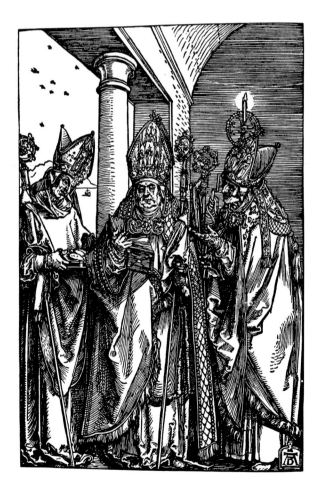

One of the consequences of this new outlook was the increasing popularity of outline drawing in the graphic arts.[13] Winckelmann, of course, had commended the early masters for their precision of contour and had no good words for the effects of chiaroscuro and of colour. Moreover the images of ancient art, of murals and vases, mostly reached the interested public in the form of outline illustrations.

The Mode of Outlines

The English artist John Flaxman – whom we have met as an assistant of Count d'Agincourt (see p. 90) – scored an immediate success with his outline illustrations of Homer, in which he deliberately adopted the style or mode of 'Etruscan' vase paintings (Fig. 45). We here remember the preference of David's pupils for these early images, which they described as 'primitif'.

If proof were needed that for Flaxman this mode was a matter of choice, we would find it in the illustrations of a medievalizing legend, *The Knight of the Blazing Cross* (Fig. 44), which he copied for his wife as a birthday present in 1796. Without being distinctly medieval in style, these illustrations are clearly intended to reflect the new Romantic ideal of pious innocence and the absence of showmanship. One of England's most prolific illustrators, Thomas Stothard, excelled in this manner of outline illustration which anticipates in many ways the Victorian ideal of devout imagery. Stothard's biographer (who also happened to be his widowed daughter-in-law, Mrs Bray) quoted him as having defended the autonomy of this mode in a fragment of a letter: 'I am led to apprehend, you think an outline an inferior effort, requiring less care than a finished picture. Outlines are not the trifles the public generally conceive them to be; they have no shadows wherein to hide their defects, or fine colours to compensate for the want of energy, which ought to be the prime quality of outline; and, if well done, will never be without it. Shadows and colours can only give substance to what outline can alone produce.'[14] Stothard is also reported as having 'thought the study of Gothic antiquity likewise useful' and having been 'an admirer of many of the works of the Middle Ages'. Mrs Bray continues: 'He considered that several of the Monumental Effigies of Great Britain (a fine work on which, was most originally conceived and executed by his son Charles) were examples of a pure and beautiful style of art ... Some of the paintings of the Middle Ages, he considered possessed great merit. There is frequently seen in them so much of nature; the draperies are good, the finish high; though the total want of knowledge in perspective, and in the chiaroscuro, showed an uneducated state of the art; their accuracy was also commendable – you could rely on the truth of their portraits of individuals or things ... Yet I am convinced', continues the same source, 'that he would have greatly disliked the present growing fashion among some of our young artists, of imitating the hard style and quaint attitudes and devices of the Gothic ages', since he is praised for having 'detested all *conceits in Art*' (pp. 79–80).

100

44. John Flaxman, illustration to *The Knight of the Blazing Cross*, 1796. Fitzwilliam Museum, Cambridge

45. John Flaxman, *Thetis Bringing the Armour to Achilles*, engraving from Homer's *Iliad*, 1793

There is a letter by John Hoppner[15] which well sums up this ideal of a neutral style of representation, allegedly free of all period character. The subject is Stothard's composition of the *Canterbury Pilgrims* (Fig. 46), about which Hoppner writes in 1807: 'In respect of the execution of the various parts of this pleasing design it is not too much praise to say that it is wholly free from that vice which the painters term manner and it has its peculiarity, besides which I do not remember to have seen in any picture ancient or modern that it bears no mark of the period in which it was painted, but might very well pass for the work of some able artist of the time of Chaucer. This effect is not of any association of ideas connected with the costume, but appears in a primitive simplicity and a total absence of all affectation either of colour or pencilling.'[16]

Nobody who looks at Stothard's painting today is likely to endorse the verdict that it is entirely free of manner, and indeed of a period style. Thus Hoppner's opinion only confirms the truth that the ideal of an art without artifice is a will-o'-the-wisp. If that were not the case, two artists as utterly different as Stothard and – as we shall see later – John Constable could not be connected with the same ideals. Nor could they be joined with yet another contemporary of even stricter views, William Blake.

It is somewhat ironic that it was precisely Stothard's painting of the *Canterbury Pilgrims* that is associated in our minds with the accusation of plagiarism levelled against it by William Blake, who claimed – probably rightly – that he had thought of the subject before, and blamed the engraver with having commissioned Stothard to supply the invention. In exhibiting his rival scheme (Fig. 47) Blake presented his own artistic creed: 'Clearness and precision have been the chief objects in painting these pictures … The Venetian and Flemish practise is broken lines, broken masses, and broken colours. Mr. Blake's practice is unbroken lines, unbroken masses and unbroken colours. Their art is to lose form, his art is to find form and keep it'.[17] For Blake, the mode of virtuoso oil painting was evidently a symptom of corruption, but the most characteristic and influential application of the idea of stylistic mode is, of course, to be found in the realm of architecture, in the Gothic Revival.

Chateaubriand and his 'Génie du Christianisme'

The ideal of purity, and of innocence, is here applied to one of the incunables of Romanticism. Maybe it is not an accident that the work in question was created in England. Characteristically, it was in England also that a book took shape which passionately commended the choice of Gothic architecture to the Romantic opponents of the French Revolution. This was Chateaubriand's *Génie du Christianisme*, which caused a sensation when it appeared in Paris in 1802.

We know from his memoirs that Chateaubriand had spent the early years after his emigration in England. He tells us that he lived for some months as a tutor in the house of an English clergyman, member of a circle of Suffolk antiquarians

and, according to Chateaubriand, 'a great Hellenist and mathematician'. Indeed, we would love to have been able to overhear their conversation at that time, when they 'drank as English men of old and remained at the table for two hours, after the ladies had departed'.[18] That episode of his life was the setting for a tragedy when he fell in love with the clergyman's daughter, for he had failed to reveal that he was in fact a married man. We also learn (pp. 413–15) that Chateaubriand was once locked into Westminster Abbey while studying its tombs, and it has been shown convincingly[19] that his chapter on Christian tombs – which ostensibly refers to those of St-Denis – was really inspired by Westminster Abbey, just as his emotional chapter on Gothic cathedrals and their kinship with the forests of the North was no doubt inspired by the theories of Warburton, which had recently been published.

102 Chateaubriand tells us that the first chapters of his seminal book were drafted in England, in 1799.[20] No doubt, however, it needed the specific situation of post-Revolutionary France to propel these themes into such prominence. The moment was opportune: Napoleon, the first Consul, was about to re-establish contact with Rome, and within days of the publication of the *Génie du Christianisme* on 5 April 1802, the new concordat was celebrated at Notre Dame with tremendous pomp. A political act had turned archaeology into a tool of propaganda.

It was inevitable that the assaults on monuments which characterized the French Revolution were felt by many thinking people to imperil the very sense of history on which civilization rests. The acts of deliberate vandalism against the relics of the monumental past of Paris – notably in St-Denis – caused regret. As an aristocrat returning from exile, Chateaubriand's deepest emotions were aroused by the kinds of devastation that he encountered. 'It was among the ruins of our temples', he was to write 20 years later, 'that I published the *Génie du Christianisme*, in order to re-evoke in these temples the splendour of the cult and its service of the altars. St-Denis was abandoned, everywhere one saw remnants of churches and of monasteries which were marked for demolition. It was even considered a kind of amusement to go for a walk within these ruins … However', as the author recalls, 'the time felt the need for a faith, one longed avidly for the consolation of religion because one had been deprived of these consolations for such a long time.'[21]

The thesis defended and reiterated in this book is announced in the Preface. It is 'that of all religions that ever existed, the Christian religion is the most poetic, the most humane, the most favourable to liberties, to the arts and letters, and that the modern world owes it everything from agriculture to the abstract sciences; from the hospices for the unfortunate to the temples built by Michelangelo and decorated by Raphael' (p. 10).

Since, strictly speaking, there are no such temples, it is obvious that Chateaubriand was stronger in rhetoric than in a knowledge of the history of

103

46. Thomas Stothard, *The Pilgrimage to Canterbury*, 1806.
Tate Gallery, London

47. William Blake, *Sir Jeffrey Chaucer and the Nine and
Twenty Pilgrims on their journey to Canterbury*, 1809.
Pollock House Museum, Glasgow

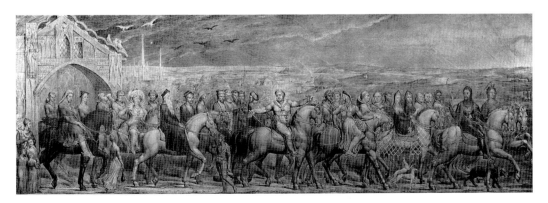

art. As a matter of fact, Chateaubriand had very little to say about painting. What appealed to his imagination was the splendour and mystery of the cult which he had also found embodied in the churches and tombs of the Middle Ages, which he described indiscriminately as 'Gothic'.

In any case, it is not the technical terminology that matters to the author, but the conclusion which he draws – his conviction that 'painting, architecture, poetry and the grand style of oratory have always degenerated in philosophical ages. It is the reasoning spirit which, by destroying the imagination, saps the foundation of fine art' (p. 358).

As far as the art of painting is concerned, he confines himself to establishing three general points: (1) that owing to its spirituality and mysticism, Christianity provides painting with a most perfect ideal of beauty; (2) that in correcting the ugliness of passion it gives more sublime character to the human figure; and (3) that the subjects it has offered to the arts are more beautiful, richer, more dramatic and more moving than mythological subjects. Concentrating on the last point he dwells on the tenderness of the stories from the Gospels, and concludes: 'Walk through the galleries of the Louvre and repeat if you can that the spirit of Christianity does not much favour the fine arts' (p. 360).

'Walk through the galleries of the Louvre ...' It was a German disciple of Wackenroder, just recently arrived in Paris, who followed this advice, and thus contributed to the dissemination of a new canon: this was Friedrich Schlegel.

The New Canon

Schlegel had not gone to Paris in order to study art. There was another reason for his move: he was married to a member of Mendelssohn's family, who as a Jewess had to pay special taxes in some parts of Germany, while France was free of such indignities. Moreover, as an archetypal Romantic, Schlegel was profoundly attracted to the proverbial wisdom of the mysterious East, and Paris would provide him with the opportunity of learning Sanskrit, the sacred language of India, which had only recently been made known to the West. But he also had to earn a living, and it was for this reason that he founded a new journal, significantly called *Europa*, through which he hoped to inform his countrymen of intellectual and cultural events in Paris, including, of course, the artistic treasures made available in the Louvre just a month or so before his arrival, in the early Summer of 1802. This opportunity was also closely connected with the aftermath of the French Revolution: the dissolution of the monasteries and convents in all areas under the jurisdiction of the Revolution had inevitably brought to light many altars and church furnishings which had previously been inaccessible, and any prospective collector could pick up interesting bargains in this discarded jumble. We hear that a dealer on the Piazza Navona in Rome had a store of no fewer than twenty thousand paintings derived from secularized monasteries, and that Napoleon's diplomats enjoyed this opportunity to enrich their collections

from these ample resources. We shall see that similar conditions in the French-occupied Rhineland enabled the brothers Boisserée, pupils of Schlegel, to form their famous collection of fifteenth-century Northern paintings which they later transferred to Heidelberg. But these incidental collections were put in the shade by the systematic pillage carried out by Napoleon's agents in Italy during the victorious campaign of 1794–8. The avowed intention of this extraordinary enterprise was to turn Paris into the new Rome, the cultural centre of Europe and of the world. True, the majority of works despatched to France were famous classical statues and works of the Italian Renaissance, but even so, the Musée Napoléon in the Louvre, which displayed the large collection, also contained a great many paintings by earlier masters. Thus if Wackenroder's knowledge of the earlier masters was mainly literary, here was an opportunity to study the whole course of the history of painting in front of famous masterpieces.

Quite near the beginning of the account of his visit, which he published in *Europa*, Schlegel forcefully declared his interest and his preference:

> I only respond to early painting, it is this alone which I understand and can grasp, and this alone about which I can speak. I do not want to talk about the French School and all the later Italians, but even in the school of Carracci I very rarely find any painting which means something to me ... I must confess that Guido's frigid Graces [Fig. 48] have nothing very attractive for me, and that the flesh of Domenichino [Fig. 49], with its rose and milk tints, cannot charm me at all. When we come from the French, Flemish or quite modern works, the style of these paintings appears to us to be grand and noble. But coming from the contemplation of early Italian and German paintings it is difficult to linger in front of them. I cannot judge these painters, unless you would call it a judgement that painting in their time had ceased to exist. Titian, Correggio, Giulio Romano, Andrea del Sarto etc., these are the last painters for me.[22]

As soon as he goes into detail, however, one gains the impression that Schlegel had derived his convictions rather from Wackenroder than from any intimate contact with actual paintings. It is Wackenroder who speaks through him in the subsequent paragraphs, where he defines his preferences:

> No confused crowds of people, but rather a few isolated figures, but finished with that application that springs naturally from the feeling for the dignity and sacredness of the most exalted of our hieroglyphs, the human body. Severe, even spare forms in sharp outline in clear relief, no painting of chiaroscuro and dirt with gloom and cast shadows, but pure proportions and areas of colour with lucid chords, draperies and costumes which seem to belong to these people as simple and naïve as they are in their heads where the light of divine artistic inspiration

shines most brightly. I want to see everywhere despite the necessary
variety of expression and individuality of feature, everywhere and in all
respects that childlike, kindhearted simplicity and confined personality
that I am inclined to regard as the original character of man. That is the
style of early painting, the style which, to confess my one-sidedness,
pleases me alone, unless some great principle justifies an exception as
in the case of Correggio and of Raphael. (p. 14)

It is always revealing when examining a critic's reaction to pay attention to the
actual terms he uses. What Schlegel singles out in the works he likes is their
'childlike, kindhearted simplicity' which he is 'inclined to regard as the original
character of man'. In other words, man before the fall, primitive man, in the
widest sense of the term. But if that judgement is to be upheld, it must be
admitted that the fall from grace must have happened very suddenly, for the
masters he singles out for superior excellence are Giovanni Bellini (Fig. 51) and
Perugino (Fig. 52), the first the teacher of Titian, who died in 1516, the second
the teacher of Raphael, who survived him and only died in 1525. Indeed,
Schlegel has some difficulty in reconciling his enthusiasm for actual paintings
with his general theories. Who would expect him to devote so many pages to the
charm of Correggio, and, more astonishing still, to reserve his highest praise for
Sebastiano del Piombo's *Martyrdom of Saint Agatha* (Fig. 50), a work that borders
on the sadistic, and is certainly not conspicuous for its childlike good-natured
simplicity? And yet, it turns out, with all his inconsistencies, it was Friedrich
Schlegel, with his report from Paris, who dared to express the first doubts about
the artistic supremacy of Raphael. In our irreverent and relativistic age it may not
be quite easy to recapture the sense of sacrilege that this criticism implied, for
Raphael, 'the Prince of Painters', had really been the analogue, in the realms of
art, to the divinely ordained monarch whom the French Revolution had dared
to dethrone and to judge.

Schlegel's piece entitled *On Raphael*[23] was written early in 1803, barely a
year after his arrival in Paris, and it too was occasioned by the exhibition in
the Louvre of one of the master's works carried off from Rome, his great altar
painting of the *Transfiguration* (Fig. 53). Schlegel assures his readers that it would
be useless for him to add to the chorus of praise bestowed on this masterpiece,
but in point of fact he rather dwells on his own reservations. He has to admit that
this large composition resembles, in its colour, grouping and expression, the kind
of art represented by Carracci – in other words, a style he really detested, though
he refrains from saying so explicitly. What he says is that 'the mere art-lover
[*der blosse Kunstfreund*] will easily prefer the earlier period of the Italian School',
but, in Schlegel's opinion, 'the practising painter cannot afford to be so exclusive'
because the style of painting Raphael inaugurated continued to be practised
by later masters such as Poussin and Mengs, and was still dominant, 'while the

107

48. Guido Reni, *The Toilet of Venus*, 1622.
National Gallery, London

49. Domenichino, *Saint Agnes*, *c.*1620.
Royal Collection

mentality and technique of the earlier painters was no longer understood, and their methods were as good as lost' (p. 50).

The unspoken appeal to practising artists to remedy this deplorable situation must have struck a chord among Schlegel's readers. It must have been given greater urgency by the strictures Schlegel inserts in his description: the Apostles do not seem to him to be sufficiently dignified. 'A painter of the earlier period would not have represented them in this way … He might have grouped them less artfully but their stern figures would have inspired us with awe' (p. 51). Turning to the scene on the mountain, Schlegel criticizes the 'theatrical' postures of the figures on the ground, another term of criticism that had a long run. Again he finds Raphael deficient in that simple and strict earnestness, the calm thoroughness which a profound religiosity is always able to visualize. True, Schlegel makes amends for these strictures in the descriptions of Raphael's madonnas, but he rejects some of the terms of praise conventionally bestowed on the artist. What he commends instead is his universality, which he obviously sees in terms of Vasari's famous account of the artist's development and achievement. He knows from this source that in many of his paintings Raphael was still close to the manner of the earlier school, and that he first marked the transition to a newer style. It is precisely for this reason that Schlegel welcomes it if painters of the present age select him almost exclusively as their most perfect guide, because, 'if only they strive to understand him and all his works completely, they will inevitably be led to the right source, that is to say to the old school which we do not scruple absolutely to prefer to the new one' (p. 55).

For all its convolutions, this is the utterance that deserves to be called the 'foundation charter' of the preference for the primitive. We may call it so precisely because it implied a compromise with traditional values and practice. Unlike the Primitifs, Schlegel does not suggest that the Louvre should be burnt or that artists should not go on studying Raphael: they should, but selectively. The early works of Raphael (Fig. 54) remain the guide to perfection. and it was only in the last phase of his short career that his works showed signs of corruption. This was the view which was to become the new orthodoxy among artists within the next decade.

The Model Style

At this point, it is important to take cognisance of a slight shift in the topic at issue: while in the earlier account Schlegel speaks of his own preference – that is, of his taste – here he is increasingly concerned with the models budding artists should select for imitation. It was this didactic issue that was to arouse most passion in the decades to come, and not surprisingly, for what was at stake was no more and no less than the schooling of artists in the craft of naturalistic representation. We too easily forget that this craft had always to be learnt, and that in this learning process copying had played a central role, at least since the

108

109

50. Sebastiano del Piombo, *Martyrdom of Saint Agatha*, 1520. Palazzo Pitti, Florence

110

51. Giovanni Bellini, *Madonna with Saints*, San Giobbe altarpiece, *c.*1487. Gallerie dell'Academia, Venice

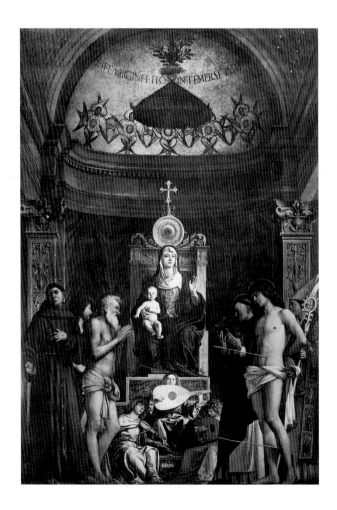

111

52. Perugino, *Madonna with Saints*, 1495–6.
Pinacoteca, Vatican

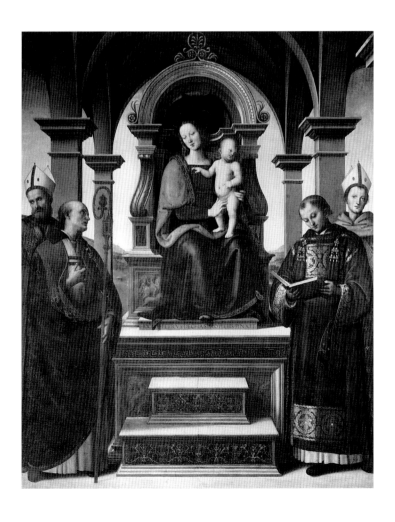

112

53. Raphael, *Transfiguration*, c.1519–20.
Pinacoteca Apostolica, Vatican

54. Raphael, *Virgin and Child*, 1502.
Staatliche Museen, Berlin

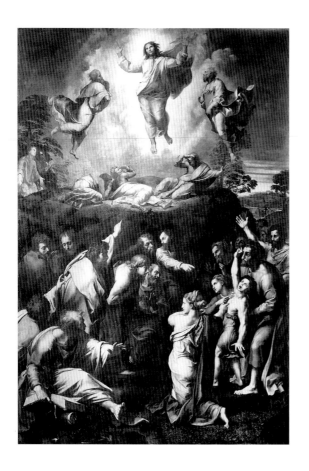

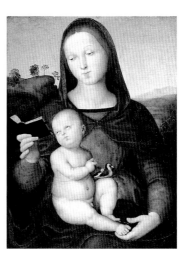

time of the Renaissance. It was through drawing from the antique, and after recommended masterpieces, that the apprentice learned to handle the vocabulary of his art: the treatment of light and shade, of drapery, of perspective, of the human figure at rest or in movement. No admiration for earlier styles could compensate for deficiencies in these skills.

Thus the distinction which we find Schlegel making between the art lover, who can freely declare his preference, and the artist who has to acquire his craft from a master, is highly significant. For, after all, Schlegel was right. He was right at least as long as the imitation of nature was seen as a necessary skill. It goes without saying that, for societies in the eighteenth century, a painter was a person who could represent a human figure, a hand, a foot, with unerring accuracy, and that if he were unable to do this, he would be considered a laughable bungler. This is the moment, in other words, to remember that the term 'primitive' is always relative to a skill. The time had not yet come when the scrawls of the untutored would be elevated into the realm of art under such designations as '*art brut*'. Hence the emotional attacks on the routine of the academies were bound to fail.

Art historians who have been curious to find out what happened to the rebels at David's studio have found little to go on. No work by Maurice Quay can be identified with certainty, and it is only in the writings of critics that we find some evidence of their strivings and their failures. At the turn of the century one of them reminded some of Quay's former associates, who had exhibited neo-classical compositions of awkward severity, that even 'the purest and the sternest simplicity has its limits'.[24] Even so, it is likely that his words of wisdom fell on stony ground. What Edmund Burke had discussed in his *Reflections on the Revolution in France* (1790), that, in the realm of politics, societies could not do without a tradition, also applies to art. No wonder that in both realms we encounter both rage and despair.

Even more telling, because more generalized, are the remarks contained in the *Rapport sur les Beaux Arts* submitted to Napoleon in 1808 by the Institut de France. The author, Joachim le Breton, warns against the influence of a crazy sect (no doubt a reference to the Primitifs), and warns other painters that, by wanting to introduce naïvety into their manner of painting, they are regressing to the infancy of art.[25] It is well known that one of the early compositions by Ingres (Fig. 55) was attacked by the critic Chaussard in 1806, with the words: 'Here in another manner no less hateful for being Gothic, M. Ingres endeavours nothing less than to push art back by four centuries to return us to its infancy and resurrect the style of Jan van Eyck' (p. 130).

Needless to say, Ingres never adopted this style as his model. What he had studied was indeed one of the ideals of the Primitifs: Flaxman's illustrations of Homer, a fact which reminds us that, even in the search for a mode, artists needed a ready-made vocabulary. Even the radical reformers accepted the need for such a

113

114

55. Jean-Auguste Dominique Ingres, *Mme Rivière*, 1806.
Louvre, Paris

vocabulary, and what they rejected was consequently no more than any excesses or frills which painters of the Academy or outside may have used to catch the eye. It is against these self-conscious exercises in virtuosity that the artists of the early nineteenth century protested so loudly, sometimes giving the misleading impression that their aim was indeed to return to a style before the achievement of visual accuracy. Perhaps we could describe their real aim as that of an art without artifice – however paradoxical it may sound.

The German Reformers

In 1808, two young artists in far-away Vienna proclaimed their conversion to the same ideal by founding the Lukasbund, the Confraternity of Saint Luke, as a challenge to academic teaching. Their names were Franz Pforr and Friedrich Overbeck. It so happens that the decisive account of this conversion is a long report written somewhat later by Pforr to his guardian in 1810.[26] He tells of the impression made on him and on Overbeck by the paintings in the Vienna Gallery in the spring of 1808. The gallery had been closed for several years and now was reopening. There they found to their own surprise – but not, perhaps to the surprise of the historian, who has the advantage of hindsight – that they were often repelled by the paintings of Tintoretto, Veronese, and even Correggio and Titian. Too often these revealed to them 'cold hearts behind bold brushstrokes and fine colours'. Worse still, they suspected them of arousing sensual emotions. On the other hand, they could hardly tear themselves away from Pordenone's *Santa Giustina* (Fig. 56) (today attributed to Moretto da Brescia), and from 'a few paintings by Michelangelo, Perugino, and one from Raphael's school'; but most of all it was the Old Masters of the German school who made them see the errors of their former ways. If they once regarded them as stiff and rigid, they now had to admit that their judgement had been warped by an overdose of paintings with exaggerated and ridiculously affected poses. 'Their noble simplicity and their firm characterization spoke out loudly to our hearts. Here there was no bravura of the brush, no bold handling, everything stood there simply as if it were not painted but drawn. We remained in that room for a long time and left it with admiration and respect.'[27] Returning to their colleagues who were copying, they were more than ever repelled by their use of bold brushes and brilliant colours: 'since brushstrokes are only necessary evils and means to an end we found it ridiculous to boast of them and to attach any value to the boldness with which they are applied. We also found that only a lack of respect for the purpose of art can lead to this kind of abuse, since it will divert the beholder's attention from the subject of the picture and wants him to concentrate on the cleverness with which a great subject has been played about with' (pp. 35f).

All this may sound familiar enough. What makes Pforr's words remarkable is that he had the courage of his convictions. In 1809 he painted two scenes from the life of Rudolf von Habsburg, in which he deliberately seeks to recapture the

116

56. Moretto da Brescia, *Santa Giustina*, *c*.1530.
Kunsthistorisches Museum, Vienna

simplicity of the early German masters (Fig. 57). Whether any of these masters would have approved of Pforr is a different matter. The paintings are perhaps less primitive than awkward. The Emperor, in strict profile, seems to offer his mount, with a limp gesture, to the priest, who looks at him with an expressionless stare (Fig. 58). The second painting, representing the Emperor's entry into Basle (Fig. 59), shows perhaps a little more understanding of the virtues of German Renaissance art. There is a certain awkward loquacity in this pageant, which recalls the minor masters of the sixteenth century, but of course, these masters did not live in the Middle Ages. One cannot help feeling that in these and other paintings the young Pforr made a virtue of necessity and exploited his own lack of skill in these childlike compositions. Even so, the degree to which his works – such as the *Saint George* (Fig. 60) – anticipate the neo-Gothic art of the Victorian period is astonishing. Pforr died in Rome in 1812, of consumption; he had gone there with Overbeck in May 1810 and joined forces with a group of young German artists who had taken up quarters in the cells of a secularized monastery, that of Saint Isidore. These earnest young men were jokingly known by local Italians as 'the Nazarenes', a name they were happy to adopt.

We have a precious document for the ideas and catchwords circulating in Rome in 1811 in a letter written by Count Üxküll, who was in touch with these artists:

> A group of artists with rare talent has banded together here in order to paint almost exclusively sacred or legendary themes. Everything must be severe. Only the early artists between Giotto and Raphael are the true adepts of art. Early Germans of before the 1520s they find acceptable, but even Raphael's manner of painting after he had abandoned the style of Perugino is considered an aberration of the great man. As to Giulio Romano, some of them no longer look at him. They have renounced the advantages of oil painting, use sharp outlines [so] that one believes one is seeing a painting from an ancient Missal. Linear and aerial perspective are deliberately neglected, for the ancients did not have them either. The colours are loud and the figures frequently flushed. Golden crowns, golden haloes, golden hems, and the skirts in multicoloured splendour, angels with golden harps, are used as by the artists before 1500. As with Dürer and Brueghel, we are treated to herbs, butterflies, toads, and lizards, not to speak of flowers in the foreground.[28]

There is clearly an element of satire in Üxküll's account. Indeed, when we come from these descriptions of the actual productions of the Nazarenes, we frequently discover what we found in examining Wackenroder and Friedrich Schlegel: their primitivism was mainly negative. It was confined to the elimination of those features which were considered corrupt, meretricious or pagan. In fact, their

118

57. Albrecht Dürer, *Adoration of the Trinity*, 1511.
Kunsthistorisches Museum, Vienna

58. Franz Pforr, *Rudolf Von Habsburg and the Priest*, 1809. Städelsches Kunstinstitut, Frankfurt-am-Main

59. Franz Pforr, *Entry of Rudolf Von Habsburg into Basle in 1273*, 1809. Städelsches Kunstinstitut, Frankfurt-am-Main

120

60. Franz Pforr, *Saint George and the Dragon*, 1809–10.
Städelsches Kunstinstitut, Frankfurt-am-Main

formal ideal differed from that of the classicists by a mere nuance. Yet it is this nuance, this shift in accent, that ultimately determined the character and fate of the movement with which we are concerned. This is confirmed by a letter dated 12 March 1812, written by an artist who had joined the group in the previous year. This was Peter von Cornelius.

The letter, written to a painter friend, shows the degree to which the language and the tone of Wackenroder had become *de rigueur* among young artists of the new persuasion. And yet, a new element is perceptible, an element due to the events of the time. None of the Romantic painters took part in the so-called 'wars of liberation' against Napoleon, but the fever of German nationalism certainly affected them more than it had Wackenroder, whose plea was for tolerance. Cornelius finds that he grows more fond of German art the further he is from Germany and he all but regrets having left his fatherland: 'I am a German to the very marrow of my bones. However, it cannot be denied that much can be got here as far as the means of arts are concerned. But there is also much to seduce us. The most subtle seduction is in Raphael himself. Here lies the worst poison and the true spirit of insurrection and Protestantism, more than I ever thought it. One could weep tears of blood that a man who had gazed upon the face of the Most High, like the mighty angel at the throne of God, that such a man could betray the cause. But about this I will write another time.'[29]

It does not seem that Cornelius kept his promise here. It is not too difficult, however, to reconstruct his opinion of Raphael. The betrayal lay precisely in the fact that the artist had seen God face to face and had still worshipped success and effect. He had become a great virtuoso, rather than a simple monk of Wackenroder's persuasion. Cornelius goes on to describe the society of the Klosterbrüder, of whom five are in Rome and one in Vienna. It is a real confraternity, united by a bond of love and common aspirations. The aims of this confraternity are outlined with greater force in a letter Cornelius wrote to the German Romantic critic, Joseph Görres, in 1814. Once more it is the fight against corruption that stands at the centre: 'A small band of German artists inspired, as it were, by divine illumination, with an awareness of the true majesty and divinity of their art, have begun to restore the overgrown path to their sacred temple, in order to prepare the way for Him who will come to cleanse it of those who buy and sell. This small band awaits its moment, burning with the desire to show the world how Art may once again step gloriously into our lives, if only She will cease to be the meretricious servant of self-indulgent aristocrats, a shop girl and base serving maid of fashion' (pp. 354–5). Cornelius rails against the academies and their protectors, who have 'drunk too deeply from the chalice of the Babylonian whore', and against 'the lying soul of contemporary art, with its negative eclecticism and its insistence on machine-measured correctness. As long as academies have existed, nothing has been created that endures … yet with all this inner void, the tall Philistine from the Academy still appears, clad in the

armour of all the civic dignities, unassailable and invincible behind a thousand battlements and crenellations of centuries-old authorities; Ever invoking Nature, Raphael and the Ancients, just as the Pharisees did Moses and the Prophets' (p. 355). Cornelius is not pessimistic, however, he is sure that 'the Philistine Goliath will be laid low by a pebble from David's sling' (p. 356). He also notes how to bring about this much-needed regeneration of art:

> The most effective, and I would say certain means to lay the foundations for the German art of a new and great age would be the revival of fresco painting as it was practised from the time of the great Giotto, to that of the divine Raphael in Italy. Since I have seen the works of those ages … and compared them with those of our own ancestors, I have had to admit that ours were at least as exalted, true and pure, and perhaps even more profound in the original intention, but that that other … developed more freely, more perfect and more grand in its own nature … If my proposal were accepted, I think I could predict that it would become a flaming beacon on the mountain tops, raising the signal for a new noble rebellion in art. Schools would arise as in times of old, which would infuse their truly great art with effective power into the hearts of the nation and right into the people's life to adorn it, till the walls of ancient cathedrals, silent chapels and lonely monasteries, of town halls, market halls, and even shops would be populated by figures from the old, familiar, national past, resuscitated to the full vigour of life, who could proclaim to the living in the language of fair colours, that the old faith, the old love and the old strength of their fathers had returned and that the Lord, our God, was thus reconciled with his people. (pp. 356–8)

Stripped of its rhetoric, the programme of the Klosterbrüder amounted thus to a plan to reform the arts by rejecting the whole development of the preceding three hundred years. The carrier of corruption was the easel picture, with its technique of oil painting that favoured blurring, smudging and the idle display of brushwork.

It is this very technique which, five years earlier in England, Blake denounced in his *Descriptive Catalogue*, where he favoured the restoration of fresco painting. He wrote that he had dreamt of frescoes that could speak to the nation and enhance the people's patriotic fervour (Fig. 61):

> The Artist wishes it was now the fashion to make such monuments and then he should not doubt of having a national commission to execute these two Pictures on a scale that is suitable to the grandeur of the nation, who is the parent of his heroes, in high finished fresco, where the colours would be as pure and as permanent as precious stones, where the figures were one hundred feet in height.

123

61. William Blake, *The Spiritual Form of Nelson Guiding Leviathan*, *c.*1809. Tate Gallery, London

62. Peter von Cornelius, *Joseph Interprets Pharaoh's Dreams*, from the Casa Bartoldi, Rome, 1816–17. Staatliche Museen, Berlin

63. Friedrich Overbeck, *Peter of Amiens Nominates Godfrey of Bouillon as the Leader of the Christian Army, Preparations for the Attack on Jerusalem*, 1825. Casino Massimo, Rome

All frescoes are as high finished as minatures or enamels, and they are known to be unchangeable.[30]

The continued power of this tradition can also explain that it was in that same year of 1808, when Blake proclaimed his aversion to the sketchy outlines of the loaded brush (see p. 99), that the *Rapport sur les Beaux Arts* in Paris complained about the tendency of young painters to exaggerate what they call 'finish'. It was also the year in which Artaud de Montor drew the attention of art lovers to the predecessors of Raphael, in his *Considérations sur l'état de la peinture en Italie dans les quatre siècles qui on précédé celui de Raphael* [31] – that very book which reappeared in 1843, under the name *Les Peintres primitifs.*

It is well known that the Nazarenes, unlike Blake, got that chance in 1815. They were commissioned as a group to decorate the Casa Bartoldi (Fig. 62) , and two years later, the Casino Massimo (Fig. 63). Commenting on these most significant products of the group, the historian of the Nazarene movement, the late Keith Andrews, writes in his book on the subject: 'When one examines these frescoes stylistically, and relates them to previous works and what was still to come, one is struck by their "traditional" nature. The artists had overcome the stifling Academy training without, however, losing the academic virtues they had acquired, and there can be no question of a violent volte-face from the accepted academic style, however much they themselves might have been convinced of the contrary. Both they and the neo-classicists recognized Raphael as their prime source, and one cannot detect any decisive difference in style from the manner Mengs[32] had advocated.'[33]

Style as a Badge

The idea of deliberately changing the proportions of the human figure or of distorting its outline – except for the purpose of caricature – never entered their minds. The figurative arts of the Middle Ages seemed quite unacceptable as models to be imitated. What was felt to be attractive, in the real or imaginary Middle Ages, was the childlike faith in fairies or in goblins. Here was a new world of images to be tapped by the new generation of artists who wished to escape the stranglehold of the classical tradition. The terrible words written by the young German painter, Philipp Otto Runge, in a letter from Dresden of 9 March 1802, still recall the radicalism of the French Primitifs: 'I once thought of a war which would turn the whole world upside down, and that such a war should really come about.' He went on to regret that, unfortunately, this was no longer possible, and that 'there is no people anywhere, or nation, which might massacre the whole of Europe, the whole of the civilized world, as the Germans had done with the Romans, when the spirit had left that nation.'[34]

Runge's choice of subjects was indeed original and paved the way towards the early nineteenth-century illustrations of fairy tales in 'keepsakes' (Fig. 64)[35] and

126

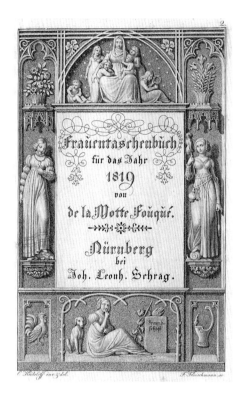

64. Title page of book of keepsakes, *Frauentaschenbuch für das Jahr* (Nuremberg, 1819)

65. Karl Friedrich Schinkel, *Medieval City beside a River*, 1815. Staatliche Museen, Berlin

66. Heinrich Olivier, *The Holy Alliance*, 1815. Anhaltische Gemäldegalerie, Dessau

similar publications. As far as architecture was concerned, the Gothic Revival in England and Chateaubriand's enthusiasm for it offered a viable alternative to the classical style of building, and since Napoleon's empire had espoused the classical style we still describe as 'Empire', it was almost to be expected that his German opponents should opt for the radical alternative of medieval Gothic. The Prussian architect Friedrich Schinkel became an expert in two rival modes of building – one represented by the Brandenburg Gate in Berlin with its Doric severity, the other representing his architectural fantasies, such as his vision of an ideal medieval city surmounted by a cathedral (Fig. 65) which summed up the Romantic dream of the Age of Faith. If proof were needed of the use which the opponents of France made of this cluster of associations, it may be found in the allegory of *The Holy Alliance* (Fig. 66), the alliance against Napoleon, painted by Heinrich Olivier. It glorifies the political leaders of the reaction, the emperors of Austria and Germany and the King of England, in the guise of medieval knights, swearing the oath of allegiance in a pseudo-Gothic structure.

 This type of medievalism can hardly be considered a preference for the primitive; its purpose was only too transparent. It was justly ridiculed later by Heinrich Heine in his satirical poem *Deutschland. A Winter's Tale:*

> The Middle Ages, anyhow
> The true ones, such as they were,
> I am ready to bear them, but save us, oh God
> From this utterly hybrid affair,
>
> From this bogus kind of chivalry,
> That is a disgusting mesh
> Of Gothic delusion, and modern fraud
> That is neither fish nor flesh.
>
> (Das Mittelalter, immerhin,
> Das wahre, wie es gewesen,
> Ich will es ertragen – erlöse uns nur
> Von jenem Zwitterwesen
>
> Von jenem Gamaschenritterthum,
> Das ekelhaft ein Gemisch ist
> Von gothischem Wahn und modernem Lug,
> Das weder Fleisch noch Fisch ist.)[36]

Storm in a German Teacup

Though the greatest German poet watching these developments from afar, the aged Goethe, would never have expressed himself so forcefully, it is obvious that he also saw this development with growing misgivings. In fact, he found himself

128

67. Friedrich Overbeck, *The Finding of Moses*, 1820–4.
Kunsthalle, Bremen

enmeshed in a conflict of loyalties. Goethe, who in his early years had sung the praises of the Gothic Minster in Strasbourg, wavered in his attitude to the movement. His Italian journey had converted him, and he had assembled a circle of friends around him in Weimar who saw the salvation of German art in the adoption of classical values. At the same time he had conceived a personal liking for Sulpiz Boisserée, one of the disciples of Schlegel, who collected medieval paintings and propagated the rebuilding of Cologne Cathedral as a manifestation of Germany's national regeneration. The ambivalence of Goethe's feeling clearly comes out in his letter to Boisserée of 1814: 'The Schlossers have got me stupendous things by Cornelius and Overbeck [Fig. 67]. This is a first case in the life of art that great talents desire to develop backwards, to return to their mother's womb and thus to found a new artistic epoch. It was left to the honest Germans to do this, though admittedly it was the effect of the spirit that seized not only individuals but the whole mass. Your collection, your cathedral, after all, have the same effect and for the same reason.'[37]

129

This preference for the primitive was to Goethe a consequence of political events that had stirred the Germans in their war of liberation against Napoleon. Goethe saw the connection, but he did not really like what he saw. In the end he decided to intervene through his journal, *Aus Kunst und Alterthum*, but stayed aloof himself. He entrusted his friend Heinrich Meyer[38] to write an article that takes issue with the new trends viewed from the perspective of Weimar. It appeared under the signature of the 'Weimar Friends of Art' in 1817, under the title *Neu-deutsche religiös-patriotische Kunst*, and caused a certain furore. In a sense, Meyer has never been forgiven for this attack on some of Germany's most gifted and most promising artists. However, returning to its text, it must be admitted that it is not as hostile, nor as unjust as its detractors will have it. If it was felt to be offensive it was no doubt for its patronizing tone, for applying its strictures more in sorrow than in anger. The opening pages set the key:

> All those who are concerned with the visual arts must be familiar with the prevailing passion among many valiant artists and intelligent art lovers for the honest, naïve, if somewhat uneducated taste that reigned among the masters of the fourteenth and fifteenth centuries. This bias is bound to remain remarkable in the history of art since it must have important consequences; of what kind they will be, remains to be seen. Will it – as is the hope of those who favour the old, resurrected taste – will it make art flourish again? will its devout spirit rejuvenate and revive it? – or rather, as those opposed to it fear, by exchanging the style of beautiful forms for an attenuated, meagre manner, lucid and pleasing representations for abstruse and melancholy allegories, will not more and more of what is characteristic, robust and healthy be lost?'[39]

Meyer proposes to trace this trend, at least in its German manifestation, to its

68. Garofalo, *Virgin and Child*, 1524,
Pinacoteca, Ferrara

69. Raphael, *Disputà*, 1510–11.
Stanza della Segnatura, Vatican

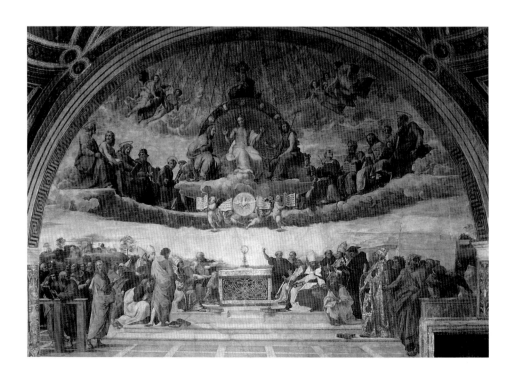

origins. He begins with the early 1780s, when the French taste – which we might describe as Rococo – still dominated German art, until it submitted to the influence of the 'almost timid' classicism of Mengs (p. 98). This was also the time when artists universally preferred mythological and heroic subjects to religious ones (p. 99). Indeed, it is in the weakening of this general preference that Meyer sees the first symptom of a movement he wishes to trace, mentioning Fuseli's compositions for Boydell and Tischbein's illustrations of a historical episode from the Middle Ages as cases in point. It is to Tischbein and his friends, too, that he attributes the growing taste for painters such as Perugino, Bellini and Mantegna, and other quattrocento masters. 'A more serious portent of things to come', Meyer continues 'was the inclination of younger artists to deny that Raphael's art had progressed during his life, and that they preferred to copy his earlier compositions, such as … the *Disputà* [Fig. 69], rather than the later ones … and to admire Garofalo [Fig. 68] rather than to esteem the Carraccis and the Guido Renis whose prestige declined …'(p. 101). At that time art lovers in Germany had slowly become reconciled to the awkwardness of such early masters as Schongauer and Altdorfer, and had come to forgive Dürer his angularity. Indeed, when the sculptor Fernkorn lectured in Rome in 1796, his opposition to Christian taste aroused much resentment. The publication in 1797 of Wackenroder's 'effusions' and subsequently that of Tieck's novel *Franz Sternbald's Wanderings* reinforced the trend, no less than the political circumstances that occasioned the occupation of Rome by the French in 1798, prompting many artists to go to Florence, where they used the opportunity to get to know Giotto, Orcagna and the lesser masters, which they even chose as models. They failed to see that the outstanding characteristics of the Old Masters, their attractive simplicity and touching innocence, were not due to their intention but to their time, and were thus bound to remain inimitable. The confusion of religious with artistic ideas increasingly aroused the passions, till the well-tried rules of art were neglected and the zeal for disciplined studies noticeably cooled (pp. 98–107).

According to Meyer, the majority of the German public never warmed to the taste for the early Italians. Meanwhile a cause had arisen that prompted a preference for a national tradition in a patriotic nationalist form. Meyer here carefully omits the true cause, which was, of course, the fight against the French: 'The purely external features of an allegedly superior earlier age were valued to the point of exaggeration. There was above all a desire to return to the Germany of old. Hence', he says, 'the vogue for … knightly romances … and all Gothic grotesqueries, extending even to home furnishings and dress.' Meyer dismisses much of this as idle play, but concedes that 'the underlying spirit was undoubtedly the same as that which, in recent years, has wrought the miracles we all enjoy.' (p. 107).

With this cautious allusion to the background to the rise of German nationalism, he moves to the discussion of Schlegel's article in *Europa*. He

132

70. Franz and Joseph Riepenhausen, *Count Siegfried Departs from Genoveva*, 1806. British Museum, London

71. Peter von Cornelius, *Walpurgis Night – Faust Led by Mephisto*, 1811. Illustration to Goethe's *Faust*

72. Friedrich Overbeck, *Madonna vor der Mauer*, 1811. Museen für Kunst und Kulturgeschichte, Lubeck

attributes to its influence the symbolic compositions of Philipp Otto Runge and the landscapes by Caspar David Friedrich, again concentrating on their choice of religious subjects. He also instances a series of prints of the *Life of Genoveva* (Fig. 70) by the brothers Riepenhausen and illustrations of works by Schiller and Goethe by Pforr and Cornelius, who receive high praise for their illustrations of *Faust* (Fig. 71). Meyer bestows equal praise on Overbeck, who, 'keeping to the manner of the old Italian masters, knows how to impart to his figures, particularly the female ones, much grace and delicacy' (Fig. 72). He is sure that both Cornelius and Overbeck have the skill to create pleasing works, easy on the eye, which would probably be more readily accepted by the paying public, but they prefer to follow their own convictions (pp. 108–14).

133

Meyer concedes that the group of artists has one virtue – that of meticulous care for detail – which it owes to the imitation of the earlier masters. Nevertheless, he insists, the deliberate renunciation of all the advantages of a developed art is indefensible The disciples of the art-loving monk will never succeed in persuading anyone that a painting can be made more edifying or more patriotic simply by neglecting light and shade and pictorial effects. This is why it is the drawings of the early masters that have been most admired, and why sculpture has been less affected by these reprehensible trends. Not that Meyer denies the attraction of the early Italian and German masters, it is just that he doubts they can be considered to hold the monopoly of sentiment. Classical art is by no means devoid of emotion and feeling, hence the contrast between Christian and Hellenic art is not as stark as it had been postulated (pp. 114–16).

Meyer concludes the pamphlet in a conciliatory manner, commending the newly awakened interest in the past and its concern for the preservation of monuments. He pays tribute to the enthusiasm with which these young artists have cast off the yoke of foreign tyranny, and hopes that this aim having been achieved, patriotic fervour will now give way to decent self-esteem, and that art and religion will henceforth refrain from excess (pp. 116–20).

No doubt, Meyer's historical narrative picks out a few salient points that played a part in this chapter and usefully supplements our previous account. Even so, it should be clear that it is too biased to be of value as an independent source. As luck will have it, we have a critical evaluation from the pen of one of Meyer's most knowledgeable and intelligent contemporaries, Carl Friedrich von Rumohr (1785–1842), one of the founding fathers of art-historical studies.[40] He inserted his critique in a travel diary, published in Leipzig in 1832 under the title *Drey Reisen nach Italien*, fifteen years after Meyer's essay. Rumohr could here speak with authority, for he had been in Rome at the relevant time and had been a friend of many of the leading Nazarenes. He had commissioned work from Overbeck and even attempted an appeal to the city of Lübeck, hoping to interest the city fathers in the major project of decorating the ancient buildings of that medieval city with frescoes by members of the group. Looking back on the

Weimar circle's abortive attempts to influence the artistic movements of the time, he dismisses Meyer's scholarship as faulty and his arguments as unjust. In his view, Meyer's gratuitous attack overlooked the many different shades of opinion which existed among the artists it wished to criticize:

> As a contemporary eyewitness I can only emphasize that, before the appearance of that polemical pamphlet many of the finest talents worked together in Rome and were united in friendly emulation to come as close as possible to the great age of Raphael, Buonaroti and Titian.

Writing of the works of these artists Rumohr continues:

> It was only in the bizarre clothing and headdress that a certain, albeit very general, acquaintance with earlier forms of art might be discerned. I dare not speak of imitation, for these oddities, where they did occur, were due for the most part to the personal whim and invention of the artists [fig. 74] … Later, I must admit artists of the second and third generations displayed a more pronounced preference for the bizarre. (p. 28–9)

But Rumohr attributes this character less to the imitation of earlier styles than simply to technical incompetence and a failure to study nature, for which he was inclined to blame the Weimar classicists as much as other literati. In any case, he found the account Meyer gave of the rise of the taste for earlier masters wholly mistaken.

Rumohr's criticisms of Meyer's account have meanwhile been amply confirmed by Previtali who has shown, moreover, that Italian art lovers had already, long before, turned their attention to the earlier masters. But we have also seen in the preceding pages that Italy had no monopoly of this opinion. The fact is that the reaction against the cult of virtuosity was a European phenomenon which took different, but related forms in the various countries. We need not recall the battle cry of the Primitifs: 'Vanloo, Pompadour, Rococo!', nor is there need to emphasize once more the growing resistance in England to the vice which was called 'manner'.

Maybe it was the lack of a strong tradition in England that appeared to make the choice of a mode more urgent. We had occasion to refer to John Flaxman and his adoption of neo-classical or Romantic modes in his outline drawings. Reynolds frequently reminded his students of the need to study the Old Masters, but would they not thereby succumb to the vice critics described as 'manner'?

The Avoidance of 'Manner'

The roots of the sentiment can be traced back as far as Hogarth (see p. 97). With the hated admirers of Italian painting in mind, he had written in the *Analysis of*

Beauty: 'What are all the *manners*, as they are call'd, of even the greatest masters, which are known to differ so much from one another, and all of them from nature, but so many strong proofs of their inviolable attachment to falsehood, converted into establish'd truth in their own eyes, by self opinion?'[41] Later in the century, James Barry, in an Academy lecture, warned against the danger of manner, to which even artists such as Ghiberti and Michelangelo had succumbed.[42]

I was able to pivot *Art and Illusion* on John Constable's unequal struggle against this invidious enemy. In 1802 he wrote: 'For the last two years I have been running after pictures and seeking the truth at second hand ... I shall return to Bergholt, where I shall endeavour to get a pure and unaffected manner of representing the scenes that may employ me.'[43] In many years of work and reflection, he came to learn that, as he put it in one of his last lectures, 'even the greatest painters have never been wholly untainted by manner' (p. 323).

'Untainted' – the very word he used indicates that he still considered the recourse to artifice a kind of artistic sin. In this respect, as has often been pointed out, his fight against the artifices of style can be paralleled with those which William Wordsworth waged at the same time, against what he called 'poetic diction'. To quote Wordsworth's own words, 'There will also be found in these volumes little of what is usually called poetic diction. As much pains has been taken to avoid it, as is ordinarily taken to produce it.'[44]

We will not go far wrong if we associate the bravura Constable wished to avoid with Blake's pet aversion (see p. 101). The broken lines and broken colours suggest sketchiness – indeed, cheating – while unbroken lines recall the style of Flaxman, which had been based on the early Greek vases admired by the Primitifs in David's studio. It had been Winckelmann who singled out that feature as the hallmark of true and honest mastery that united the Greek craftsmen even with Raphael.

We must beware of the conventional concept of national schools that still dominates our art books and our museums. We tend to think of the Nazarenes as German, but once Overbeck had settled in Rome his studio became a centre of pilgrimage for those foreign artists who shared his hope for a regeneration of Christian art. Among them were a number of French artists and art lovers who paid homage to his piety and to the purity of his ideals.

An impartial visitor to Rome in these years up to 1820 would have found an international community of artists, who, for all their different ideals, still strove after the same aim, the aim of an art without artifice – what might be called a 'virtuous' style, free of sensuality and meretricious effect. Ingres, who had been accused in his youth of wanting to bring back the manner of Jan van Eyck (see p. 113), could easily fall in with the manner of the Nazarenes. His ideals of figures and the whole tenor of his painting from Rome of 1820 could have come from that same circle. The same applies to the leading sculptor of the circle, the Dane Bertel Thorvaldsen.

135

136

73. Bertel Thorvaldsen, *Hope*, 1817.
Thorvaldsen Museum, Copenhagen

74. Friedrich Overbeck, self-portrait wearing 'Florentine'
cap. Staatliche Museen, Berlin

Thorvaldsen had been brought up in the tradition of Winckelmann's neo-classicism, the tradition of Canova and Flaxman, but an early experience brought him in contact with the sculpture of the Greek Temple of Aegina, found in 1812, which he was asked to restore for an exhibition in Munich. There certainly was an affinity between the late archaic style of these sculptures and the style of certain quattrocento masters, and, in 1817, Thorvaldsen fell sufficiently under that spell to create a monument in the style of the early fifth century entitled *Hope* (Fig. 73). This work goes about as far in the direction of the primitive as Overbeck or Schnorr von Carolsfeld in their most Nazarene mood. Like these painters, Thorvaldsen returned to the ampler forms of classicism in his series of *Christ and His Apostles* made for a church in Copenhagen, and yet even these Christian images reflect to the full the ideals and aspirations of the Roman colony of artists.

137

Rome of course had been a magnet for artists ever since the Renaissance, but now the greater ease of travel and the foundation of art institutes and the French Academy in Rome turned the Eternal City into a market of ideas where artists from all over Europe could meet and debate their aims.

The Catholic movement produced an eloquent spokesman in the Comte de Montalembert, who in 1839 published a pamphlet characteristically entitled *On Vandalism and Catholicism in Art*. In his text the author berates the vulgar taste of tourists in Venice who prefer the sensuality of Titian to the purity of Giovanni Bellini. A pair of illustrations contrast an eighteenth-century image of the Holy Virgin by Bouchardon with a work of the nineteenth-century Austrian, Eduard von Steinle. The caption reads: 'The Blessed Virgin according to so-called sacred art in France since the time of Louis XIV and the Blessed Virgin according to the revived art in Germany in the nineteenth century' (Figs. 75 and 76).[45] Steinle's image is certainly not primitive, but it is purged of those elements of sensuality and affectation to which the author objects in Bouchardon's art.

The Pious Mode

It may be argued that the conventional categories of 'style' and 'subject-matter' fail to capture the most conspicuous characteristic of the works under consideration, a characteristic which might best be described as their artistic *conception*. By this I mean the way the personages of a scene or legend live in the artist's mind. As yet we have no terminology to describe the changing ways of conceiving these events which make up the history of Western art, the difference, say, between the conception of Correggio and of Rembrandt, but it is evident that the period under discussion was responsible for a novel vision of the biblical story that was to dominate religious imagery for the whole century. What I have called the 'virtuous' style, the style shunning artifice and sensuality, also demanded an avoidance of nudity, of violent movement or the extremes of dramatic expression. Figures are characterized by the noble fall of the drapery, and, strangely enough,

by the well-groomed appearance of the head, with the long hair parted in the middle and falling over the shoulders (Fig. 77). We may well wonder why Christ and the Apostles were so frequently pictured in this guise. Maybe the choice of the type derived from the same need to compromise that marked the 'virtuous' style. These personages were to be seen as simple folk, simple but pure, so they had to be carefully distinguished from tramps and vagabonds. Unlike the saints and gurus of history, they were envisaged as having been careful of their appearance, always brushing their hair and trimming their beards.

No doubt there were precedents for these types in the earlier periods of art admired at the time, most of all the Apostles on Peter Vischer's Sebaldus Tomb (Fig. 78). It was not only the high artistic quality of this monument that made it a favourite of the nineteenth century, but also its stylistic position exactly at the point of transition between medieval and Renaissance art. If Nuremberg was cherished as the cradle of late Gothic German craftsmanship, the home of Dürer, Adam Kraft and Veit Stoss, Vischer in this monument had absorbed enough of the classical conventions (which largely reached him through the arts of the Lombardi in Venice) to be easily acceptable to nineteenth-century art lovers, who still shrank away from angular lines and arbitrary proportions. The degree to which these dignified and well-groomed Apostles of the tomb became the ancestors of the nineteenth-century forms of devotional art has still to be assessed in detail, but there is no doubt that the prints after the tomb which were published around 1820 served as models for many artists and craftsmen, and reinforced the prevailing conception of holy types (Fig. 79).

The practical consequences of that preference are still with us. Countless churches in Europe were stripped of their Baroque furniture and fittings in favour of neo-Gothic altars and images. In this respect it is hardly possible to exaggerate the success of that alleged regeneration of religious art in the name of purity and simplicity. Indeed, I believe that art historians have so far failed to pay sufficient attention to the impact and the success of this style. They have neglected it because, understandably, they have found it unappealing, and because in any case it left the summit of art virtually untouched. Where it ruled almost unchallenged was in the devotional art of the period, not only in the furnishings of restored churches, but also on their refurbished porches. Everywhere in Europe, whether in France, Germany or England, you are likely to encounter the offspring of Peter Vischer's Apostles. If our civilization ever suffers the fate of the ancient world, future archaeologists digging in the rubble may form a very different picture of the art of the nineteenth century from that offered by our histories of art. It is much less likely that they will discover a statue by Rodin than that they will find replicas of the Christ of Sacré Coeur (Fig. 80) opening his chest to show the burning heart, or, most of all, of the Madonna of Lourdes (Fig. 81), representing the Virgin as she appeared to Bernadette in 1858.

In any case, we are entitled to remark that the search for an art without artifice

139

75. Eduard von Steinle, *The Holy Virgin*, illustrated in Comte de Montalembert, *Du vandalisme et du Catholicisme dans l'art* (Paris, 1839)

76. Edme Bouchardon, *The Holy Virgin*, illustrated in Comte de Montalembert, *Du vandalisme et du Catholicisme dans l'art* (Paris, 1839)

140

77. Ary Scheffer, *Christ the Redeemer*, 1846. Centraal Museum, Utrecht

78. Peter Vischer, detail from the tomb of Saint Sebaldus, 1507–19. Nuremberg

that had sparked off the revolt against academic teaching has ended in a manner more stereotyped and more artificial than any it wished to replace.

The Pre-Raphaelite Brotherhood

To be sure, attempts were not lacking to remedy this shortcoming, and to lead the 'virtuous' style back to the study of nature. The most prominent of these movements is, of course, that of the Pre-Raphaelite Brotherhood, whose very name proclaimed the preference which is the subject of this study. The ideological links with the movements here discussed hardly need documenting. Suffice it to quote the words of their champion, John Ruskin – some of the language he uses will sound almost over-familiar to the reader: he speaks of the resistance by these artists to 'that spurious beauty, whose attractiveness has tempted man to forget, or to despise, the more noble quality of sincerity'. He claims that they regard prettiness 'with a contempt and aversion approaching to disgust' (shades of Cicero!). 'Pre-Raphaelitism has but one principle, that of absolute, uncompromising proof in all it does, obtained by working everything, down to the most minute detail, from nature, and from nature only.'[46] Consequently Ruskin was particularly anxious to clear the group of the misunderstanding caused by the name they had adopted. What they wanted was to return to the principles of earlier ages, not to bring back the ignorance of the early ages. He regards it as a calumny that these painters did not draw well, and did not draw in perspective.

The sentiments, the arguments and the rhetoric must now sound familar to the readers of this chapter, but this déjà vu will not prepare them for the actual style cultivated by these self-styled 'Pre-Raphaelites'. It is a style as far removed from the modes of the German Nazarenes as it is from the modes of the quattrocento, to which it is supposed to pay tribute. Neither in subject-matter, nor in their bright clear colours or narrative manner do these painters display a preference for the primitive, which those words may imply.

We are told that the artists were inspired to adopt their name – at first kept secret – when looking at Lasinio's prints of Benozzo Gozzoli's frescoes in the Campo Santo in Pisa (Fig. 82). No doubt his attention to detail and his realism exerted a strong appeal, but it need hardly be said that Gozzoli would have been nonplussed to see *The Hireling Shepherd* (Fig. 83) or *The Last of England*. Unlike some of Overbeck's compositions, these paintings are in no way reminiscent of fifteenth-century art. Nor do they express any preference for the primitive as yet.

But though it is true that even the most enthusiastic of the medievalizers among artists were rarely carried away by their preferences to depart from the standards of academic accuracy in the rendering of visual appearances, they still weaned the public off its insistence on these standards. Art lovers had become reconciled to the style of earlier masters which were found to be all the more appealing because they were felt to be 'primitive'. Thus the preference for the

141

142

79. Saint Simon, engraving after Peter Vischer, from *Frauentaschenbuch für das Jahr*, (Nuremberg, 1819)

80. Christ of the Sacré Coeur. Replica

81. Madonna of Lourdes. Replica

82. Benozzo Gozzoli, *The Youth and Sacrifice of Isaac*, *c.*1473–7, detail from Carlo Lasinio, *Pitture a fresco del camp Santo di Pisa* (1812)

83. William Holman Hunt, *The Hireling Shepherd*, 1851. Manchester City Art Galleries

143

primitive expressed itself more emphatically in the taste of travellers and tourists of the first half of the nineteenth century than it did in the studios of painters and sculptors. It is to this reform of the canon of artistic excellence which elevated Fra Angelico over Raphael that we must now turn.

Chapter 4
The Quest for Spirituality

The dethronement of Raphael, or rather the emphatic rejection of his later works in favour of his early creations, shocked the adherents of the academic creed as it might have shocked the first chronicler of Italian art, Giorgio Vasari. Yet this heresy did not really undermine the guiding principle that Vasari had adopted as the scaffolding of his work – the conviction I have quoted that 'the way in which the arts rose from small beginnings to the utmost heights and from such a noble state tumbled to utter ruin, becomes intelligible to us if we realize that these arts, like human bodies, have their birth, their growth, their ageing and their death'.[1]

Vasari had seen this organic cycle in the progress of mimesis, that skill in the rendering of the visible world that had marked the great art of the ancients, and had been reborn in his own time in the works of Leonardo, Raphael and Michelangelo.

None of the writers and critics discussed in the preceding chapter doubted that this skill was necessary for painting or sculpture, and in fact artists protested loudly when critics accused them of deliberate departure from visual accuracy. The crime of which they accused Raphael was rather that he had sacrificed such honest accuracy in favour of a showmanship that, in their view, had spelt the ruin of art.

This interpretation is not in conflict with Vasari's analogy of the organic cycle. Organisms, too, grow to perfection, age and die; the question is only at what point in the cycle we detect the beginning of the downward trend. That the arts had in fact declined after achieving perfection was not doubted by Vasari, nor by later critics.

What we have seen in the preceding chapter is the effect of a slight shift in Vasari's paradigm. If the rot had really set in where he saw perfection, attention was bound to shift to the art of the earlier generation, the masters of the quattrocento, who by their honesty and diligence had conquered all the difficulties of mimesis. In fact, in the Introduction to Part II, Vasari is almost carried away when he praises the mastery of those artists in the imitation of nature: '... one might be so bold as to say that these arts had not merely

advanced, but had also been brought back to the flower of their youth [*nel fiore della lor' gioventù*] and carried the promise of that fruit that they were later to bear' (p. 107). This had also been the opinion of Winckelmann and of Goethe, no less than that of Schlegel and the Nazarenes.

The Charge of Paganism

As the nineteenth century progressed, however, this scale of values was no longer universally accepted. The attack came from the worshippers of the 'Age of Faith', who believed the Renaissance to have been a disaster for art and for civilization. Was not Vasari's scale of values thoroughly pagan? Did he not praise the masters of antiquity whose glorification of the human body so inspired the artists of the Renaissance? Was not the art of that period, with its sensual nudes, thoroughly corrupt and corrupting? If that were so, had not artists taken a wrong turn in the quattrocento when they began to study natural appearances, rather than concerning themselves with the spiritual message the Church had asked them to convey?

It must be clear from the preceding chapter that this was an entirely novel issue that could not have entered the minds of Winckelmann or of Goethe, who were indeed accused of being 'pagan'. Yet it was these issues that came to dominate the literature of art of the nineteenth century. I remember a lecture by Boas, in which he criticized the notion of a *Zeitgeist*. What characterized ages, he argued, was not convictions shared by the majority of articulate contemporaries but *issues* which caused divisions, and debates that never led to a consensus.

Rarely have contemporary issues lain more closely to the surface than in nineteenth-century studies of Italian art. Winckelmann in the eighteenth century had proclaimed his vision of Greek art so as to call his contemporaries to order and wean them from the frivolities of the Rococo. We may well assume that many travellers on the Grand Tour began to see the ancient statues through his eyes and treasured their message of a serene and carefree existence. But a century later the growing pains of industrial Europe had intensified, and the coming of the railways enabled many more travellers to visit Italy for refreshment and instruction. 'All history is contemporary history', said Benedetto Croce, and what the tourists looked for was confirmation of their biases and prejudices. The issues raised by the French Revolution – discussed in chapter two – had not gone away. No more and no less was at stake than the possibility of human progress. Those on the political right, who doubted its benefits, found in the real or imaginary testimonies of the Age of Faith a haven of mental peace and consolation. Those on the left, who joyfully accepted emancipation from the trammels of the Church, liked to participate vicariously in the first steps towards the freedom which they admired in the Italian Renaissance. Nor were those wanting who succeeded in having it both ways, because to them the early Renaissance seemed to combine the charm of youth and the vigour of manhood.

146

The Claims of Christianity

The issue that haunted the minds and the consciences of the Victorians above all others was that of the place of religion in an increasingly secularized society. No wonder that the evaluation of the Renaissance and its art was drawn into this debate, since what the great Jakob Burckhardt came to call (after Michelet) 'the discovery of the world and of man' could also be seen as the rise of humanism and secularism – what looked like liberation for some writers was seen by others as an affront to the spiritual nature of man.

We can trace the gradual emergence of this issue by concentrating on some of the significant authors of the period: among them we have already met Carl Friedrich von Rumohr as a critic of Meyer's verdict on the Nazarenes. Rumohr ranks, in fact, as one of the founders of the history of art, notably in his *Italienische Forschungen* (1827–31),[2] in which he checked Vasari's account against the documents he was able to find.

But however frequently and however justly he criticized Vasari's inaccuracies, Rumohr also regarded the progress of representational skills as the guiding trend of his history. He had no more patience with primitivist tendencies than he had with the idealizers. True, he proposed a distinction between those skills which he found relevant to the appreciation of the earlier masters (p. 46), one between the observation of individual motifs and the mastery of the laws of optics and anatomy. It is to the first of these that he gives pride of place, adducing Fra Angelico, Gozzoli and Ghirlandaio as masters who strove to render nature in all its wealth and detail, and so compensated for a somewhat inadequate knowledge of anatomy. He even hints that Michelangelo's conquest of that skill counted less in his eyes than that wealth of vivid detail which Vasari had singled out as Raphael's achievement, and he never wavered in his conviction that Raphael stood at the peak of art (p. 47).

From all this, it should be clear that Rumohr would have rejected the equation of spirituality with the departure from natural appearances which was to become so popular later, and yet there is at least one passage in his book where he comes close to admitting that naturalism might be in conflict with the Christian religion. Discussing the remarkable influence which the artists of the Netherlands exerted on the Florentine painters of the late quattrocento, Rumohr dismisses the allegation that it was pleasure in attractive incidentals that had deflected the Florentine artists from taking their subject-matter sufficiently seriously. This, he suggests, confuses cause and effect. While conceding that the artists showed little understanding or sympathy for the mystical or religious themes which they were treating, Rumohr saw this as no more than the consequence of a general estrangement from the Christian view of life.

A declining enthusiasm for Christian themes may indeed have somewhat extended the scope of naturalism, but Rumohr rightly reminds us of the fact that Fra Angelico had himself been a pioneer in the true rendering of human

84. Benozzo Gozzoli, *Angels Worshipping*, c.1459.
Palazzo Medici Riccardi, Florence

physiognomies. In any case, the lack of interest in the teachings of the Church left artists of the period only one way of excelling: that of surrendering to the charm of natural appearance. Luckily their period offered beautiful and cheerful outdoor scenes, picturesque costumes, attractive types, smiling countryside and a tidy and prosperous city (Fig. 84), and thus it was not difficult for receptive minds to profit in many ways from such a favourable environment (pp. 388–9).

Whether intentionally or not, and despite an instinctive sympathy for the conservatism of the Sienese tradition, Rumohr finally came down on the side of the Florentines, who, he thought, celebrated life at the expense of religion. And thus he opened the way to those who alleged that indulgence in sensual pleasure was a direct consequence of a loss of spirituality. It was not Rumohr, however, who imported this concern with the spirit into the history of art. To find the origin of this preoccupation, we are not likely to go wrong if we look to the philosophy of G.W.F. Hegel.

Manifestation of the Spirit

The term 'spirit' and the opposition between the spirit and the flesh are part and parcel of Christian theology; but it was not until the rise of Romantic aesthetics that the relation of art to the Spirit (*Geist*) became a dominant issue. We find it so in the philosophy of F.W.J. Schelling, but even more influentially in the system of aesthetics propounded by Hegel in a course of lectures repeated several times between 1820 and 1829, but not published before 1835.[3]

The Spirit was the hero in that epic of human history that Hegel presented to his audience. In his elaborate system, art is conceived as a kind of incarnation of the Spirit, its manifestation in sensory form. He was thus able to rationalize the exaltation of classical sculpture he had inherited from Winckelmann, because in the masterpieces of the Greeks (such as the *Apollo Belvedere*), the idea of the divine was rendered visible in the beauty of the human body. Before the Spirit had reached this decisive phase, real art, in Hegel's sense, did not yet exist. All there was – for instance in the ancient Orient – was a kind of proto-art, an art of inadequate symbols or pictographs that hinted at the spiritual without really embodying it.

What Hegel had to say in this context about 'primitive' images is worth quoting, for though he certainly shows no preference for these works, his diagnosis and his terminology may have retained their influence over many generations – not so much for his evaluation, as for his psychological analysis:

> The attempts children make in drawing or modelling the human figure result in mere symbols, as they only hint at the living form which they wish to represent, but are quite unfaithful to their motifs and their meanings. In this respect art is at first purely hieroglyphical, not any fortuitous or arbitrary sign but a vague representation of the object for the mind [*für die Vorstellung*]. For this purpose a poor figure is adequate,

provided only it remind one of the subject it is intended to signify. For this reason piety is also satisfied with poor images and will always worship Christ, Mary or any saint, in the most abject daub, though these figures are merely individualized by their special attributes such as a lantern, a millstone or a grill, etc. ... Because piety wants merely to be reminded of the subject, the rest is added by the mind. (*Ästhetik II*, vol. 14, p. 375)

After this, it may come as a slight surprise that Hegel's commitment to the progress of the Spirit through history leads him still to place the peaks of Christian art above those of classical Greece. To be sure, in Christian art, that perfect balance between Spirit and matter had to give way to another imbalance which he finds the hallmark of the Romantic age. The spiritual demands of Christianity were bound to transcend the world of the senses, and it is thus fitting that in that phase sculpture, the solid medium, was superseded by painting, which makes its appeal by more spiritual, more subjective effects. For Hegel as for most art lovers of his time these effects resided in the facial expressions of the painted figures. As a spiritualized art, painting in the Age of Faith had to concentrate on the convincing expression of religious devotion. Thanks to this conviction Hegel did not quite share with his Romantic contemporaries their admiration for the Northern masters of the fifteenth century. His comments on the much admired painting of the *Adoration of the Magi* (Fig. 85) in the Boisserée Collection (then believed to be a work by the van Eycks, and now attributed to Rogier van der Weyden) are characteristic: of the two of the Magi that were considered portraits of Burgundian dukes, he remarks that they make it apparent that they have other business besides going to Mass on Sunday. 'Not that they are lacking in piety, in heartfelt sentiments, but it is not the song of love that pervades their whole nature, because this ought to be more than mere exultation, more than a prayer of thanks for benefits received, they should have no other life, as we may say of the nightingale' (*Ästhetik III*, vol. 15, pp. 55–6).

What comes to the fore here is Hegel's bias for Italian art, which he shared with many of his contemporaries. His tributes to the harmony and beauty of Italian painting are among the most eloquent pages of these lectures. Thus it is quite consistent that Raphael's Madonnas, with their beauty of form and their moving expression of maternal love, represent for him the peak of Romantic sensibility. In this respect also he takes issue with the preferences of the Nazarenes and their friends:

> Italian painting did not arrive at the standard of perfection from the outset; to reach it it had to travel a long road. True, the pure and innocent piety, the grand sense of the whole conception and the unselfconscious beauty of forms and soulful inwardness are frequently most manifest in the works of early Italian masters, despite all their

151

85. Rogier van der Weyden, *Columba Altarpiece*, *c.*1460.
Alte Pinakothek, Munich

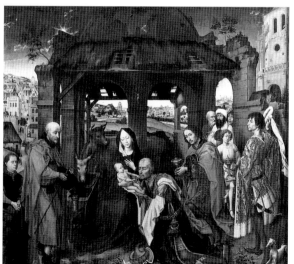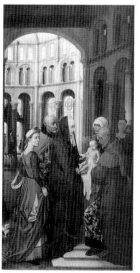

technical imperfections. In the last century these early masters were not much appreciated, but rejected as awkward, dry and poor. Only in recent times have they been rescued from oblivion by scholars and artists, only to be admired and copied with an exaggerated bias that wanted to deny that further steps were subsequently taken towards more perfect conceptions and representations, and this was bound to lead to opposite errors. (*Ästhetik III*, vol. 15, p. 115)

Despite his demand that art should reflect the Spirit, therefore, Hegel did not advocate that reassessment of values that concerns this study. He could not, since his whole metaphysical theory of history represented a justification of the belief in the progress of mankind.

152

The Catholic Reaction

It should not be surprising, therefore, that the decisive impulse for the preference for the primitive came from France, the country that had undergone the trauma of the French Revolution. It was a French Roman Catholic, François Rio,[4] who battled throughout his life to convince his contemporaries of the superiority of a true, Christian, over a pretended, paganizing art. Even so, the life and literary fortunes of that strangely uneven writer illustrate to the full the European character of that movement of taste with which this study is concerned: France, Italy, Germany and England all come into his story.

Born in 1797, the son of a strictly royalist family, Rio trained for the priesthood, but at 25 became a professor of history at the Collège Louis-le-Grand. In 1828 he published an ambitious work, *Essai sur l'histoire de l'esprit humain*, dedicated to his fellow Breton, Chateaubriand. The Preface characteristically refers to the many interpretations of universal history printed in German since the days of Herder. Like the work of Hegel (which he could not yet have known), the account takes us through a discussion of the civilizations of China, India, Persia, Egypt and Judaism to the Greeks and Romans, tracing their rise and decadence, which he attributes to the corruption of power. In this he can hardly lay claim to originality.

Rio's career took a very different turn in 1830, when Comte de la Ferronays,[5] who had previously befriended him, was appointed French Ambassador to Rome in succession to Chateaubriand, and invited Rio to accompany him as tutor to his children. It was here that Rio became interested in Italian art, read Rumohr (though he never met him), and encountered members of the Nazarene circle who encouraged him to visit Munich so as to study German philosophy at the source. He debated with Schelling, and was much impressed by the mystic philosopher Franz Benedict von Baader.

His Italian travels came to a temporary halt when he met a wealthy Roman Catholic lady of Welsh extraction who became his wife and caused him to move

to England at the end of 1832. His romantic personality and his considerable magnetism made an instant hit. Having been elected a member of the Athenaeum, he made full use of the opportunities offered. His letters to his wife read like a *Who's Who* of the period: Samuel Rogers, Hallam, Macaulay, Carlyle, Tennyson, Wordsworth, and above all, Gladstone became his friends or acquaintances. He attended receptions at Holland House and was active everywhere as a champion of Roman Catholicism, and also of the Celtic revival in Wales, which appealed to him because of his Breton extraction.

It must be said that his literary career lagged behind his social success. When in 1836 he published the first fruits of his Italian studies under the somewhat misleading title *On Christian Poetry,* he found to his mortification that after five months only twelve copies had been sold. It is all the more remarkable that the thesis he propounded in that rambling work had a lasting effect on subsequent debates. Briefly, Rio rejected the view of the German Nazarenes and of his friend Montalembert, that the decline of the arts should be dated to the period soon after 1500, when Raphael and Titian produced their mature work, which was felt to be tainted by the corruption of success. For Rio, the rot had set in a full century earlier, and the cause of that decline was that very weakening of the Christian faith to which Rumohr had attributed the growth of naturalism in the quattrocento.[6]

As we read on page 147 of his book: 'In consequence of a development that might almost be called fatal, the unity of art was broken as early as the beginning of the fifteenth century, and the painters, split by a kind of schism, shared, so to speak, their domain among themselves. Some continued to receive inspiration from above, while others who formed the majority fell into the snare spread out for them by naturalism.' It need hardly be said that in this interpretation Rio was not much hampered by factual knowledge – witness the survey of the relevant chapter from his table of contents: 'Chapter IV. *Christian art loses its unity – Naturalism of Paulo Uccello and of several artists who succeeded him, up to the time of Masaccio – Influence of the sculptures of Ghiberti – Painting is invaded by paganism.*'

Mystical Art

But whatever the shortcomings in Rio's knowledge of the chronology of Italian painting, he was sure that he was in possession of a special divining rod that enabled him to separate the worthless from the valuable. His chapter on what he calls the *École Mystique* opens with the challenging words: 'At this point the competence of those who are vulgarly called "connoisseurs" comes to an end. The particular organ needed for the appreciation of the kind of works of which we want to speak is not the same as that which is able to judge ordinary works of art. Mysticism is to painting what ecstasy is to psychology … only those who have a strong and profound sympathy with certain religious ideas are able to understand mystical paintings.'[7]

The reader will not be surprised to learn that the artist elevated into a special position is Fra Angelico, but the schools of Siena and Umbria also deserve commendation, in contrast with those of Florence where, he insisted, the paganism which prevailed at the court of the Medici was as much the result of the general corruption of morals as of the progress of erudition. In keeping with this bias, Rio devotes a full chapter to the figure of Savonarola, whom he sees as trying in vain to stem the tide of sensuality and worldliness.

Despite its rather confused organization Rio's book was translated into Italian and English and already enjoyed a certain influence on other writers before the author revised and enlarged the whole plan and published his second edition in four volumes, to which I shall have to return. Nothing is more characteristic of Rio's influence than the words written by Théophile Gautier in his obituary of Flandrin in 1864: 'Jamais talent plus pur, plus chaste, plus élevé ne fut mis au service d'une inspiration plus religieuse … il avait, dans sa nature quelque chose de cette timidité tendre, de cette délicatesse virginale et de cette immatérialité séraphique de Beato Angelico.'[8] Even before the publication of that second edition, Rio's main thesis had been taken up in an influential book by that great bibliophile and scholar, Lord Lindsay[9] (1812–80), *Sketches of the History of Christian Art* (1847).

154

Christian Values

Unlike Rio, Lindsay was a Protestant, but he too had fallen under the influence of the Romantic philosophy of universal history cultivated in Germany. Like Rio, he had published a philosophical interpretation of the course of human history before he took to the study of art. Whether or not he had read Hegel he certainly thought along similar lines, as can be seen from his essay *Progression by Antagonism, a General Law of the Moral Government of God*,[10] published in 1846, which places the ascent of the spirit in the microcosm and macrocosm – a development again exemplified by snap judgements on the culture of the Chinese, the Egyptians, the Phoenicians and the Indians. The *Sketches,* which must have been written concurrently, though they were published a year later, apply this schematism to the history of art:

> … the Architecture of Egypt, her pyramids and temples, cumbrous and inelegant but imposing from their vastness and their gloom, express the ideal of Sense or Matter … But the Sculpture of Greece is the voice of Intellect and Thought, communing with itself in solitude, feeding on beauty and yearning after truth: – While the Painting of Christendom … is that of an immortal Spirit, conversing with its God … You will not now be surprised at my claiming superiority for Christian over Classic Art … If Man stand higher or lower in the scale of being according as he is Spiritual, Intellectual or Sensual, Christian Art must excel Pagan by the same rule and in the same proportion.[11]

Within this scheme of the ascending spirit, Lindsay wants us to distinguish the 'age of youth' (the thirteenth and fourteenth centuries) from subsequent 'opening manhood' (vol II, p. 3), comparing the first to the peace of Paradise, the other to the turmoil that succeeded the Fall. It is the first, of course, the age of Giotto that inspires his most nostalgic praise, tinged, it is true, with the warning that such a pure expression of spirituality could not last:

> There is in truth a holy purity, an innocent naïveté, a child-like grace and simplicity, a freshness, a fearlessness, an utter freedom from affectation, a yearning after all things truthful, lovely and of good report, in the productions of this early time, which invests them with a charm peculiar in its kind, and which few even of the most perfect works of the maturer era can boast of, and hence the risk and danger (which I thus warn you of at the outset) of becoming too passionately attached to them, of losing the power of discrimination, of admiring and imitating their defects as well as their beauties, of running into affectation in seeking after simplicity and into exaggeration in our efforts to be in earnest – in a word, of forgetting that in art, as in human nature, it is the balance, harmony and coequal development of Sense, Intellect and Spirit, which constitutes perfection. (vol. II, p. 4)

The touchstone of any Victorian's attitude to what we still call the 'Italian Primitives' is always their response to Fra Angelico. Wackenroder had extracted from the pages of Vasari the story of that devout monk who never took up his brush without a prayer to God, and this alone made him a cult figure among the Nazarenes. But only Rio placed him resolutely at the peak of art. Lindsay pays tribute to him as 'the especial voice and exponent in painting of that religious rapture or ecstasy produced by the action of Spirit, or of the moral principle, on Sense through the medium of the Imagination …' (vol. II, p. 222). But he also remarks that he 'has recently been as unduly extolled as he had for three centuries past been unduly depreciated' (vol. II, p. 244).

Referring, in footnotes to 'the eloquent and elegant Rio' and to Montalembert, he takes issue with the former's notion of a mystic painting: 'Pure mysticism', as he rightly remarks, '… despises and abhors imagery of every kind'. Fra Angelico represented merely 'all that Spirit could achieve by herself, anterior to that struggle with Intellect and Sense which she must in all cases pass through in order to work out her destiny' (vol. II, p. 244–6). As a devout Christian, it is true, Lord Lindsay had no imaginative sympathy with the next phase which he thought that art had to go through, because all Fra Angelico's pupils belonged to the Second Period, the struggle between Christian art and paganism, 'when Paganism, like a loosened glacier, broke down on Italy' (vol. II, p. 68).

We cannot follow Lindsay along the way on which he tries to work out his principle of *Progression by Antagonism*. He clearly had difficulty fitting in a detailed

discussion of the art 'North of the Alps':[12] '... we may be permitted to look on the early Teutonic School as of equal importance with the early Italian ... The one, it is true, walked with its gaze fixed on heaven, the other on earth, but like the astronomer and geologist, two distinct worlds were thus revealed to them, and they gave glory to God accordingly' (p. 381). It was only in the third period, the period of Leonardo, Raphael, Michelangelo, Correggio, Giorgone and Titian, that the author finds perfection, but after this crowning achievement he ends his book assuring the reader that in the great struggle of the cinquecento 'the rival hosts of Imagination and Reason' are again 'drawn up in battle array' (p. 387).

It is clear from the above that the unqualified preference for the primitive was not supported by Lindsay, and yet he is typical of that emotional attitude that coloured the reaction of so many art lovers of the time when confronting works of the 'Italian Primitives': 'I would not be a blind partisan, but, with all their faults, the old masters I plead for knew how to touch the heart. It may be difficult at first to believe this; like children, they are shy with us – like strangers, they bear an uncouth mien and aspect – like ghosts from the other world, they have an awkward habit of shocking our conventionalities with home truths' (p. 391). And so he ends with a plea, after all, that the artists of his time should disregard the technical faults of the earlier masters and in studying them imbibe the spirit of a true Christian art to come.

'Make them forget there's such a thing as flesh'

These psychological conflicts are memorably illustrated by Robert Browning's poem 'Fra Lippo Lippi', from the series *Men and Women,* written in the 1840s and 1850s: Filippo Lippi, one of the leading Florentine masters of the quattrocento (Fig. 86), lent himself to a ventilation of the issue because Vasari had dwelt on his licentious habits. In the poem Browning tells of a commission to paint murals in a cloister which met with much applause for its realism, till the Prior of the Monastery intervened:

> The Prior and the learned pulled a face
> And stopped all that in no time. 'How? what's here?'
> Quite from the mark of painting, bless us all!
> Faces, arms, legs and bodies like the true
> As much as pea and pea! it's the devil's game!
> Your business is not to catch men with show,
> With homage to the perishable clay,
> But lift them over it, ignore it all,
> Make them forget there's such a thing as flesh
> Your business is to paint the souls of men.
> Paint the soul, never mind the legs and arms!
> Rub it all out, try it a second time.

156

157

86. Filippo Lippi, *Saint Stephen's Martyrdom and Funeral*,
*c.*1453–61. Cathedral of Santo Stefano, Prato

158

87. Lorenzo Monaco, *Coronation of the Virgin*, central panel of an altarpiece, *c.*1414. National Gallery, London

To the best of our knowledge there never was such a prior in fifteenth-century Florence who asked a painter to rub out his realistic painting. The opinion the poem reflects is surely that of Rio and his followers, a guess which is confirmed by another person who advises poor Fra Filippo:

> You're not of the true painters, great and old;
> Brother Angelico's the man, you'll find;
> Brother Lorenzo[13] stands his single peer. (Fig. 87)

Browning's poem makes it easy to focus on the central question that concerns us, looking back at nineteenth-century criticism: was the progress in the means of representation chronicled by Vasari really in conflict with the religious function of art, as was generally assumed?

159

The Loss of Innocence

In no other writings are these complexities and even contradictions more apparent than in the vast œuvre of John Ruskin, whose passionate involvement with the problems of the industrial age speaks from every line he wrote. It must be said at once that Ruskin was no more an out-and-out primitivist than Rousseau had been, or indeed than Lord Lindsay himself. As a champion of Turner, the author of *Modern Painters* was, and remained, committed to the cause of naturalism, the loving study of natural appearances, and this made it impossible for him to deplore the growth of the realist movement in the fifteenth century as an aberration, a departure from spirituality, as Rio and even Lord Lindsay had done.

In the long and searching review of Lindsay's book which Ruskin published in the *Quarterly Review* of June 1847, he shows himself much concerned with the dangers threatening contemporary art through the cult of the early masters, however much he admires these products of the 'childhood of art': 'About the faith, the questioning and the teaching of childhood there is a joy and grace, which we may often envy, but can no more assume: – the voice and the gesture must not be imitated when the innocence is lost … The visions of the cloister must depart with its superstitious peace.'[14]

The more Ruskin was tormented by his guilt feelings about social injustice and the ugliness of capitalist England, the more did he stress the lost virtues of innocence in the manifestations of the past. Thus, turning from his criticism of painting to that of architecture, in his *Seven Lamps of Architecture* and in his monumental three-volume study *The Stones of Venice*, the more nostalgic he became. Like Rio and Lindsay, he was inclined to condemn the alleged paganism of the Renaissance, but now he shifted the blame from painting to architecture. It was the regularity of classicizing architecture that symbolized for him the enslavement of the craftsmen and the sin of pride. In his famous chapter on 'The Nature of Gothic' (vol. X, p. 180), which I have discussed elsewhere,[15]

160

88. Detail of angel from the tomb of Doge Jacopo Tiepolo, 13th century. SS. Giovanni e Paolo, Venice

89. Paolo Veronese, *Solomon and the Queen of Sheba*, c.1580–2. Pinacoteca, Turin

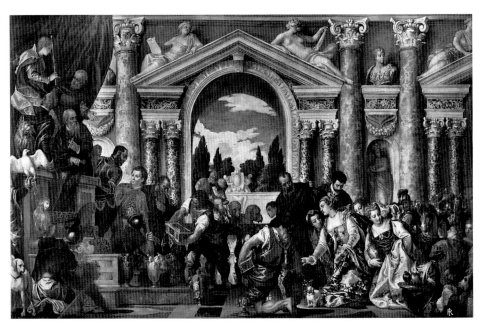

he celebrates the independence of the medieval mason and even his 'savageness' (vol. X, p. 184), which he so vastly prefers to the dead perfectionism of Renaissance buildings. We are reminded of the distinction made by Lovejoy and Boas between 'soft' and 'hard' primitivism. If Lindsay's vision of the Paradise of medieval innocence was soft to a fault, Ruskin dreamt of robust savages who nevertheless remained untouched by pride, for the vicarious experience he looked for in the art of the past was that of humility. It was for this reason that he also turned against the interpretation of medieval art that had been popularized by the Romantics. He came out into the open in a footnote of volume II of *Modern Painters* :'The art which, since the writings of Rio and Lord Lindsay is specially known as "Christian", erred by pride in its denial of the animal nature of man; – and, in connection with all monkish and fanatical forms of religion, by looking always to another world instead of this. It wasted its strength in visions, and was therefore swept away, notwithstanding all its good and glory, by the strong truth of the naturalist art of the sixteenth century. But that naturalist art erred on the other side; denied at last the spiritual nature of man, and perished in corruption' (vol. VII, p. 264).

161

This was surely written after Ruskin had put away his 'evangelical beliefs … to be debated no more' on that memorable day in front of Paolo Veronese's painting in the gallery of Turin (Fig. 89), so movingly described in his *Praeterita* (vol. III, pp. 460–1). His recognition of the 'animal nature of man' which, in a sense, is part of hard primitivism, made him more tolerant towards sensuality than towards pride. 'Pride, being wholly a vice, and in every phase inexcusable, wholly betrayed and destroyed the art which was founded on it. But passion, having some root and use in healthy nature, and only becoming guilty in excess, did not altogether destroy the art founded upon it. The architecture of Palladio is wholly virtueless and despicable. Not so the Venus of Titian, nor the Antiope of Correggio' (vol. V, p. 93).

There is a story about Ruskin told in Kenneth Clark's introduction to *Praeterita*. When, after one of his lectures, a member of the audience tried to tell him how much he had enjoyed his works, Ruskin replied:'I don't care whether you enjoyed them; did they do you any good?'[16] What he hoped of works from the childhood of art was that they would do us good and shame us into the recognition of our own depravity. Describing an early Greek coin and the relief of an angel from the thirteenth-century tomb of Jacopo Tiepolo in Venice (Fig. 88) he spelt out what he considered to be their lesson:

> In both examples, childish though it be, this Heathen and Christian art is alike sincere, and alike vividly imaginative: the actual work is that of infancy; the thoughts, in their visionary simplicity, are also the thoughts of infancy, but in their solemn virtue they are the thoughts of men. We, on the contrary, are now, in all that we do, absolutely without sincerity; – absolutely, therefore, without imagination, and without

virtue. Our hands are dexterous with the vile and deadly dexterity of machines.[17]

In a sense, as we have seen, Ruskin's preference for the primitive was largely negative. He did not really say that he enjoyed the Greek coin or the Venetian tomb, but he thought it was good for us. It is notorious how capricious and unpredictable he was in his aesthetic enthusiasm. He admired Tintoretto no less than he loved Fra Angelico; Turner no less than the Pre-Raphaelites; he thought Landseer's *The Old Shepherd's Chief Mourner* (Fig. 90) the most beautiful picture ever painted, but responded intensely to Carpaccio's *Saint Ursula* cycle in Venice. His lectures and writings certainly prompted travellers to study and enjoy Giotto, but he did not want them to admire Brunelleschi's marvellous dome of the Florentine cathedral. As for the *Apollo Belvedere*, he found it totally lacking in spirituality, thus contradicting the whole tradition of German aesthetics. Nor is this opposition fortuitous. In a special appendix to volume III of *Modern Painters*, he explains why he never spoke of German philosophy 'but in depreciation': he was 'continually brought into collision with certain extravagances of the German mind' by his own 'steady pursuit of Naturalism as opposed to Idealism', and so he comes to dismiss the study of German philosophical systems with scorn (vol. V, p. 424). No wonder he was one of the few critics of the nineteenth century not touched by the influence of Hegel, whose system had certainly coloured Lord Lindsay's view of history, and continued to exert its spell over the history of art elsewhere.

162

We had turned to Hegel earlier in these pages to trace the idea of the Spirit manifesting itself in art. We have seen that this notion could be used to justify a preference for the primitive, but also an acceptance of progress. The progressivists among the art historians of the second half of the nineteenth century are relevant to our story mainly as a kind of counterpoint to Rio and Ruskin, but their influence on the taste for the so-called 'Italian Primitives' was so overriding that it must still be accounted for.

The Progressivist Bias

It was with the express intention of shaping the taste of German-speaking travellers that Burckhardt published in 1855 his *Cicerone*, explicitly subtitled *A Guide to the Enjoyment of the Works of Art in Italy*. Burckhardt was certainly not a medievalizer of the stamp of Rio. Discussing the Byzantine types prevalent in Italy before Cimabue, he remarks that 'they attempted to achieve the impression of holiness by looking morose, since art was unable to arouse the idea of the supernatural by the sublime majesty of form.'[18] Unlike Rio and Lindsay, he warms to the dawn of naturalism in fifteenth-century painting, analysing the problems it posed for the tradition of religious art with his unfailing clarity:

In the first decade of the fifteenth century a new spirit entered Western

163

90. Edwin Landseer, *The Old Shepherd's Chief Mourner*, 1837. Victoria and Albert Museum, London

164

91. Fra Angelico, *Prophets*, 1447.
Cathedral Orvieto

painting. Remaining in the service of the Church, painting still was to develop principles which stood in no relation to the tasks set by the Church. In one respect the work of art now offers more than what is demanded by the Church; apart from the religious meaning it now offers an image of the real world; the artist becomes engrossed in the study and rendering of the outward appearance of things ... Beauty, hitherto striven for and also frequently achieved as the highest attribute of holiness, now gives way to significant characterization ... but where it still breaks through it is a newborn sensual beauty which must have its full share in the earthly and the real since it would not find a place otherwise within the world of art.

In this respect the work of art now offers less than the Church demands or might demand. The religious content cannot thrive without claiming exclusive dominance, and that for a simple reason which is not always clearly admitted: it is that this content is essentially of a negative kind and consists in excluding anything reminiscent of worldly life. As soon as this life is deliberately drawn into the sphere of art as happened at that time the picture will no longer look devout. It is worth reflecting how few are the means by which art can directly arouse devotion; it can depict exalted calm and grace, it can express dedication, longing, humility and grief in heads and gestures, but these are all elements which are part of general humanity and are not limited to Christian emotions. (pp. 750–1)

Not that Burckhardt lacked an organ to appreciate the art of Fra Angelico, an appreciation which I have called the touchstone of the preference for the primitive (see p. 155), but the remark which he inserts in his appreciation throws a vivid light on the polarization that had occurred in his period between the two camps of medievalizers and classicists: 'Anyone who is altogether repelled by Fra Angelico is unlikely to have a true understanding also of ancient art.' He reminds the doubters that these paintings are at any rate of immense value as documents of religious history. It is through them that we know best how heaven, the angels, the Saints and the Blessed were seen by the devout of that time. But Burckhardt does not stop there. He asks his readers to pay attention to the master's artistic achievement, and singles out the pyramidal group of prophets from the vault of Orvieto (Fig. 91), asking whether any work of art anywhere can be more perfect (p. 749).

We can infer the same bias in the single page Burckhardt devoted to Botticelli, who was admittedly not yet a cult figure among art lovers. Keeping strictly within Vasari's framework, he wrote that Botticelli 'never quite achieved what he strove for. He desired to express life and emotion in violent movement, and frequently merely represented uncouth haste. He aimed at an ideal of beauty and remained

stuck with an ever-repeated, easily recognized type of head that is occasionally very attractive but often stiff and lifeless.' True, Burckhardt concedes that Botticelli's *Birth of Venus* (Fig. 92) achieves 'a very pleasing fairy-tale-like mood that substitutes itself unnoticed for that of ancient mythology' (pp. 758–9).

In Burckhardt's masterpiece of 1860, *The Civilization of the Renaissance in Italy*, we find his most considered views on this much-debated issue of 'spirituality'. The book was destined to become favourite reading among the secularized middle classes, not least for the author's determined rejection of medieval Christianity. But Burckhardt can never be summed up in a single phrase. His account of the period culminates in a deeply felt commendation of Lorenzo de' Medici's Neoplatonic religious hymns: 'Echoes of medieval mysticism here flow into one current with Platonic doctrines, and with a characteristically modern spirit. One of the most precious fruits of the knowledge of the world and of man here comes to maturity, on whose account alone the Italian Renaissance must be called the leader of modern ages.'[19]

There could be no starker contrast between Rio's execration of Lorenzo's paganism and Burckhardt's response to his search for a new type of spirituality. But Burckhardt's passage refers to literature, not to art – indeed, it was not before the middle of the twentieth century that art historians tried to seek an expression of Neoplatonic spirituality in the visual arts of the period.

Divided Minds

Yet it turns out that Rio's reading of fifteenth-century art met with a lasting echo, even among those writers who were averse to his uncompromising clericalism. I believe it was the second and much expanded edition of Rio's book, published between 1861 and 1868, that exerted this influence. Not that the author had changed his point of view and his emphatic rejection of paganism, but while in his earlier account he had spoken of the split that the new allegiance to antiquity had occasioned in the art of the quattrocento, Rio now located this split in the soul and œuvre of some of the leading masters of Florence, knowing well how to attract the attention and curiosity of his readers in a period increasingly concerned with the psychology of the artist: 'The history of the artists who found themselves pulled and buffeted by these two different sources of inspiration – that of the City of God and that of the city of the world – offers an almost dramatic interest, and needs a kind of self-denying renunciation to suppress the less relevant details.'[20]

The masters whom Rio had especially in mind were Ghirlandaio and Botticelli. The first, because the apparent worldliness of his ecclesiastical fresco cycles seemed to clash so obviously with their purpose; the second, because the master who had been persuaded, or forced, by the sinful Medici to paint the archetypal pagan subject – a naked Venus – had been described by Vasari as an

166

167

92. Sandro Botticelli, *Birth of Venus*, c.1485.
Galleria degli Uffizi, Florence

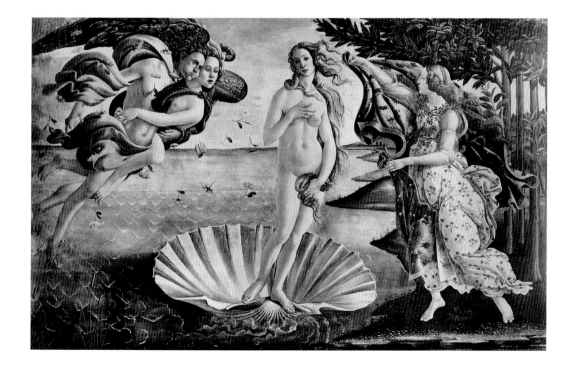

168

93. Sandro Botticelli, *Madonna of the Pomegranate*, c.1487. Galleria degli Uffizi, Florence

94. Domenico Ghirlandaio, *Birth of the Virgin*, 1491. Sta Maria Novella, Florence

ardent disciple of Savonarola. True, Rio also followed Vasari's interpretation in criticizing the style of the quattrocento masters for its harshness and lack of grace. He found it 'difficult to pardon the dryness of Botticelli's contours and the monotony of his figures'. But such qualifications did not interfere with his enthusiastic response to the special charm of Botticelli's Madonnas (Fig. 93), which had begun to enjoy a great vogue, particularly in England. 'As a work of art', he writes about one of the master's Madonnas, 'the painting is not very attractive because of the lack of grace in its composition and the harshness of its drapery, but these are amply compensated for by the tenderness of the gestures and the facial expression of the mother.' No other artist', we read, 'could achieve that sweet and mysterious expression of melancholy as well as Botticelli' (pp. 473–7).

169 Both Botticelli and Ghirlandaio, it turns out, owed this special charm precisely to the relative immaturity of their style when held against the perfection of a Leonardo or a Raphael. It was this quality which marked the masters as the last of the 'primitives', that proved so captivating to art lovers sharing this ideological allegiance. In fact it was a convinced secularist and anti-clerical, Hippolyte Taine, whose *Voyage en Italie* popularized Rio's interpretation of quattrocento art in a new setting.

There may also be an echo of Hegel in Taine's interpretation of the art of the trecento: 'If you enter into the spirit of that age you discover that what they wanted to see represented was not *beings* but *ideas*.'[21] In a footnote, Taine (who had translated Hegel's *Philosophy of History* into French) remarks that this corresponds to the spirit of modern German art, and that this correspondence accounts for the admiration German critics have for painters of that period.

'Paganism' accepted

'The mysticism of the cloister and the philosophy of the schools have peopled the heads of these masters with abstract formulas and exalted emotions … the physical shape hardly interests them … they demand no more than a symbol and a suggestion' (pp. 122–3). Hence Taine lays it down that it was not before the world had again become pagan that painting revived. Yet, in his enthusiastic description of the classical revival in Florence under the Medici, he makes the point (probably against Rio), that they were 'not simple voluptuaries or vulgar pagans' (p. 129), but he celebrates the departure of art from ecclesiastical symbolism to realism with fervent enthusiasm. His loving description of Ghirlandaio's fresco cycle in Santa Maria Novella (Fig. 94), visibly influenced by Rio, was later to inspire Warburg,[22] though what he saw in the artist was less the realist than the naïve searcher for truth: 'the charming moment, the delicate dawn of the youth of the soul when man discovers for the first time the poetry of real objects … that is why I love the paintings of that age so much … they are

frequently awkward, always stiff, they lack movement and colour. It is the Renaissance in its dawn, a grey and sombre chilling dawn, as one sees it in springtime' (pp. 147–8). And here Taine again echoes Rio in a reading of the art of Botticelli that remains canonic throughout the century, as he speaks of 'the tenderness, the humility, the haunted reveries of his pensive Virgins', 'their frail and meagre forms', 'the trembling delicatesse of his naked Venuses', 'the suffering and restrained beauty of his precocious and nervous creations', 'all soul and all spirit' – the later painters will do better, but they will be less original (pp. 148–50).

Taine's response to Botticelli's type of beauty marks a new phase in the preference for the primitive. What Fra Angelico had been for the 'spiritualizing' primitivists, Botticelli came to be for their 'sensualist' opponents, throughout the second half of the nineteenth century. His art apparently represented for them the same kind of compromise that had led to earlier preferences. Looking back on the movement of taste described in an earlier chapter, we find that it was invariably a matter of a delicate balance, a mere nuance. The Nazarenes, who rejected the mature works of Raphael, exalted his earlier manner in which they could enjoy the pure beauty of his vision, free, as they thought, from the corrupting influence of meretriciousness.

The earlier art of Fra Angelico offered itself for a similar reconciliation of opposites. For all the spirituality manifested in his subject-matter and in his expressive figures, his art did not, in fact, reject the advances of naturalism let alone 'deny the body'. Witness his masterpieces such as the *Descent from the Cross* (Fig. 95), which show him in full command of the achievements of Renaissance realism. What marks his style, therefore, is again a matter of nuance, a refusal to follow Masaccio all the way, and this refusal – if we may call it so – sufficed to make him the idol of the spiritualizers who still failed to respond to the art of the earlier Middle Ages.

The case of Botticelli is somewhat similar. He endeared himself to the sensualists not only for having painted a naked Venus, but altogether for his celebration of youthful beauty. It seems, however, that the charm of this beauty was experienced as doubly attractive because it was felt to be just on the threshold of full-blown sensuality. Unlike Leonardo's *Leda,* or Raphael's *Galatea,* his type seemed virginal, indeed somewhat gawky, and all the more seductive for appearing to be innocent. Spirituality, after all, is only one ideal with which to oppose sensuality; innocence is another. In falling for the alleged innocence of Botticelli's vision, the art lover could again have it both ways. He could vicariously experience the awakening of the senses in what was felt to be the 'springtime' of the Italian Renaissance. What was seen as the slight technical immaturity of Botticelli's style proved irresistible to a whole generation for whom his paintings look like the very embodiment of a primitive charm.

171

95. Fra Angelico, *The Descent from the Cross*, 1433–4.
Museo di San Marco, Florence

The Apotheosis of Botticelli

Botticelli's apotheosis came a mere four years after the publication of Taine's assessment, in the famous essay which Walter Pater devoted to his art in *The Renaissance*, published in 1873. Pater, too, identified the Renaissance with 'the outbreak of the human spirit', its 'care for physical beauty, the worship of the body, the breaking down of those limits which the religious system of the Middle Ages imposed on the heart and the imagination'.[23]

In a generation of naturalists, Botticelli might have been a mere naturalist, but that was not enough for him; he was a visionary painter: 'perhaps you have sometimes wondered why those peevish-looking Madonnas, conformed to no acknowledged or obvious type of beauty, attract you more and more, and often come back to you when the Sistine Madonna and the Virgins of Fra Angelico are forgotten' (p. 53).

We need not follow Pater into his dreams of what these Madonnas are feeling, nor need we quote the whole of his appreciation of Botticelli's *Venus*, where again he stresses the 'quaintness of design' which he considers 'a more direct inlet into the Greek temper than the works of the Greeks themselves … Botticelli meant all this imagery to be altogether pleasurable; and it was partly an incompleteness of resources, inseparable from the art of that time, that subdued and chilled it … He has the freshness, the uncertain and diffident promise, which belonged to the earlier Renaissance itself and make it perhaps the most interesting period in the history of the mind' (pp. 58–62).

No doubt the anxiety, conflicts and hesitancies Pater so eloquently describes in his essay on Botticelli belong more to the Victorian critic than to the Florentine painter. But the history of taste would not be so interesting a topic if it did not allow us to study this mechanism of projection that may well be inseparable from a genuine response to works of art.

We find it again when turning the pages of the monumental history of the Italian Renaissance by John Addington Symonds. The old Hegelian themes are here intoned with a new personal fervour: 'The first step in the emancipation of the modern mind was taken thus by art, proclaiming to men the glad tidings of their goodliness and greatness in a world of manifold enjoyment created for their use. Whatever painting touched, became by that touch human; piety, at the lure of art, folded her soaring wings and rested on the genial earth. This the Church had not foreseen'.[24]

Symonds, if anybody, took the contrast between spirit and flesh seriously. He concedes more readily than Ruskin ever did that 'the spiritual purists of all ages – the Jews, the iconoclasts of Byzantium, Savonarola, and our Puritan ancestors – were justified in their mistrust of plastic art. The spirit of Christianity and the spirit of figurative art are opposed, not because such art is immoral, but because it cannot free itself from sensuous associations' (pp. 17–18). To him, all religious art was the result of a compromise. Indeed, referring to Rio's

conception of mystic art, he discerns in the 'semi-sensuous, semi-pious raptures of the mystical nuns' 'something psychologically morbid' (note, p. 22)

Characteristically Symonds recognizes also, in the novel 'hero worship' of Botticelli, '... our delight in the delicately poised psychological problems of the middle Renaissance' (note, p. 181).

> For us he has an almost unique value as representing the interminglement of antique and modern fancy at a moment of transition, as embodying in some of his pictures the subtlest thought and feeling of men for whom the classic myths were beginning to live once more, while new guesses were timidly hazarded in the sphere of orthodoxy ... The very imperfection of these pictures lends a value to them in the eyes of the student, by helping him to comprehend exactly how the revelations of the humanists affected the artistic sense of Italy. (pp. 181–2)

In the eyes of Symonds, 'this combination or confusion of artistic impulses in Botticelli, this treatment of pagan themes in the spirit of medieval mysticism, sometimes ended in grotesqueness' (p. 183), and he instances *Venus and Mars* (Fig. 97) in the London National Gallery as an example of this failure. Thus, like Lord Lindsay and like Taine, Symonds is moved in his summing-up to commend the painters of the late quattrocento for their aims rather than for their achievement: 'Their achievement, indeed, is not so perfect but that they still make some demand upon interpretative sympathy in the student' (p. 195). In other words, Symonds still experienced these masters as in some sense 'primitive'.

The Historical Approach

Strictly speaking, Symonds's attitude to quattrocento painting did not differ significantly from that of Vasari: he had admired the skills which these masters had achieved, but he still found them inadequate to the tasks they had set themselves. It was Heinrich Wölfflin who formulated this general reaction in the preface to his epoch-making study of *Classic Art* at the turn of the century with the telling phrase: 'We so like to admire and to smile at the same time.'[25] To admire the skill, but still allow ourselves a patronizing smile at the mistakes of anatomy and perspective which they perpetrated in their work.

This patronizing attitude set Aby Warburg's teeth on edge. As a young exile in Florence he had plenty of opportunities to listen to the reactions of enthusiastic travellers to the art of his favourite masters, Botticelli and Ghirlandaio, and he filled his notebook with expressions of disgust. What enraged him was the conviction that the work of these masters represented an attitude of innocence, an expression of naïve enjoyment, which many found irresistible. Warburg, who had devoted his years in Florence to an analysis of the trends and mentalities of Medici Florence, could only treat this cliché with contempt. He rejected the

facile equation of artistic immaturity with Burckhardt's 'discovery of the world'. For him, the multiplicity of idioms Ghirlandaio was seen to adopt – classical motifs and Netherlandish realism – mirrored the complexity of the age, and Warburg's successors have tended to follow him.

In an essay of 1898 Warburg took issue with the sentimental cult of the master that thrives on the melancholy pervading Botticelli's *Magnificat* (Fig. 96). 'The small number of Sandro's friends who do not want so much to admire sentiment but to understand and to follow are not so frequently found in front of the *Magnificat*: they congregate in front of the *Realm of Venus*.'[26] These art lovers, we may infer, are neither spiritualizers nor paganizers but genuine historians who would like to unriddle the master's secrets. In his incomplete study of the figure of the *Nympha* in Ghirlandaio's frescos, Warburg lashed out against both camps:

174

> The modern languid art lover who has gone to Italy to refresh himself feels greatly superior to so much trivial realism and turns away with a discreet smile. Ruskin's word of command sends him to the cloisters, to a mediocre Giottoesque fresco, where he must discover his own primitive mentality in the charming, unspoiled and uncomplicated trecento work. Ghirlandaio is not that kind of rural bubbling brook for the refreshment of Pre-Raphaelites, nor is he a romantic waterfall which inspires that other type of tourist, the superman on Easter holiday with Zarathustra in the pocket of his tweed cape, seeking fresh courage from its mad cascadings for his struggle for life ... (p. 111)

There is no doubt that Warburg's own analysis of the conflicting forces battling for dominance in quattrocento art still owed a good deal to the tradition we have traced, and yet his quest for detail shifted the problem away from the issues of spirit versus body or sensuality versus innocence. In asking for the significance which classical relics had for the artist of the Renaissance, he bypassed these stale old questions, introducing new psychological puzzles, which were in their turn inspired by his own personal problems. At least, however, they allowed art historians of the twentieth century to regard the old polarities with some scepticism. Was it ever true, what Browning took for granted in his 'Fra Filippo Lippi', that the Prior of a monastery would have asked a painter to 'rub out' his figures because they reminded him of the flesh? Are there not countless works of art both north and south of the Alps which were painted in a spirit of piety without shunning the representation of the nude – whether we think of Jan van Eyck's *Ghent Altarpiece* or Rogier van der Weyden's *Last Judgement,* or even of Johan Huizinga, who, in an essay on 'Renaissance and Realism',[27] questioned the traditional equation of these two notions? Is it not time for the equation of unrealistic art with spirituality to be also laid to rest?

175

96. Sandro Botticelli, *Madonna of the Magnificat*, *c*.1480–1. Galleria degli Uffizi, Florence

97. Sandro Botticelli, *Venus and Mars*, *c*.1483. National Gallery, London

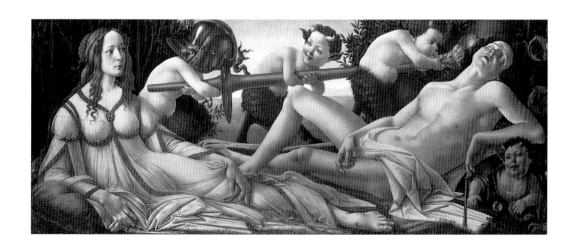

The Claims of Spirituality

In the winter of 1977–8, an exhibition of early medieval art was shown at the Metropolitan Museum of Art in New York under the title *The Age of Spirituality*. Readers need hardly be told that this title still reflects the conviction, first formulated at the dawn of the nineteenth century, that, for all its perfections, the art of the Graeco-Roman world embodied those pagan values that were to be superseded by the spiritual concerns of the Age of Faith. A glance into the Preface of the catalogue confirms this general diagnosis, though we are now asked to consider that this spirituality was not the monopoly of Christianity alone: 'Over the centuries ... one can notice a gradual change from the realism of bodily forms to the abstraction of more spiritual forms, but no single religion can claim to have instigated this trend. The inclination towards more spiritualized form and content was inherent in all creations of this period.'[28]

176

To be sure, the writer of these lines might not accept the view that the contrast he draws by implication between 'bodily forms' and 'more spiritual forms' involves a preference for the primitive, for the whole thrust of his argument aims at the exaltation of the art of the Dark Ages, and the final rejection of the view that they were a result of a decline in representational skill.

There are many reasons other than its alleged greater spirituality which may make us prefer the art of the Dark Ages to the arts of the Greeks or of Renaissance Italy – one of them will be the subject of the next section.

I. Music Lesson: a Pupil Learns to Play the Lyre,
Greek red figure vase painting, early 5th century BC.
Kunsthistorisches Museum, Vienna

II. Egyptian wall painting from the tomb of the Nebamun,
c.1550–1295 BC. British Museum, London

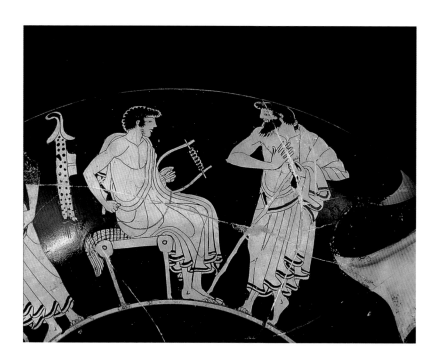

III. Three Men in a Fiery Furnace, *wall painting, 3rd century AD. Catacomb of S. Priscilla, Rome*

*IV. Manuscript illumination of the heavenly Jerusalem,
Trinity College, Cambridge, Ms. R.16.2, fol. 25v*

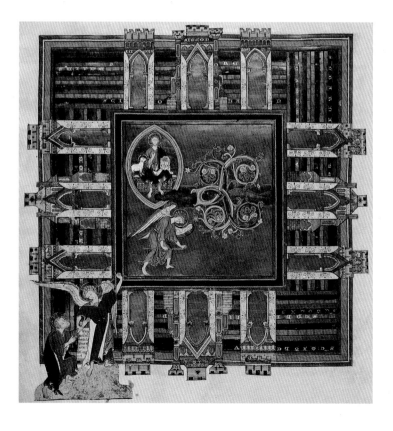

V. The Magi Following the Star, *Poor Man's Bible Window, Canterbury, 13th century*

VI. Paul and Barnabas at Lystra, *Kings College Chapel, Cambridge, 1526–31*

VII. John Constable, Wivenhoe Park, *1816. National Gallery of Art, Washington DC*

VIII. Child's copy of Constable's Wivenhoe Park

IX. Bernardino Luini, The Burial of Saint Catherine, 1530. *Brera, Milan*

X. Child's copy of Luini's Burial of Saint Catherine

XI. E.H. Gombrich at his Music Lesson, *1923. Drawing presented to the author on his 14th birthday by Elise the cook*

The Emancipation of Formal Values

The title of this chapter may sound somewhat strange to modern art lovers. They are likely to have learnt that formal values, the manifestation of an orderly mind, are precisely what distinguishes a work of art from a mere representation of reality. The historian knows, however, that an awareness of this distinction does not go very far back in history, indeed it has recently been proposed in a wide-ranging book by Bernard Smith that it is this preoccupation with form that marks the avant-garde style created during the late nineteenth century and attaining dominance during the first half of the twentieth – the style we tend to call 'modern' and which the author designates as 'formalesque'.

Professor Smith, who makes the proposal in *Modernism's History*,[1] has also undertaken to trace the history of this artistic movement which contributed so much to the appreciation of exotic and 'primitive' art. He locates its first stirrings in the philosophical system of aesthetics – notably of Kant and Schelling – in which the notion of form plays an important role.

Standards of Perfection

It so happens that when that book came out this present chapter had long been written. I have read *Modernism's History* with much profit and admiration, but I wonder whether this theory offers a sufficient explanation for the momentous change in orientation the very notion of art underwent in the period concerned. I should like to argue that the philosophical speculations to which Bernard Smith refers did not arise in a void, as it were. They were connected with what Karl Popper calls the 'logic of situations', the situation in which artists find themselves. As long as the mastery of appearances presented a challenge to the artist he had to give priority to the solution of this problem. It was no use arranging the figures of a story in a pleasing pattern if they appeared to be badly drawn and insufficiently realized, that preoccupation had to wait till mimesis was achieved. You cannot easily pay attention to two conflicting demands. While the rendering of appearances monopolizes your thoughts you must leave the pursuit of formal values to one side.

178

98. Hagesandros, Athenodoros and Polydoros of Rhodes,
Laocoön and his sons, c.175–50 BC.
Museo Pio Clementino, Vatican

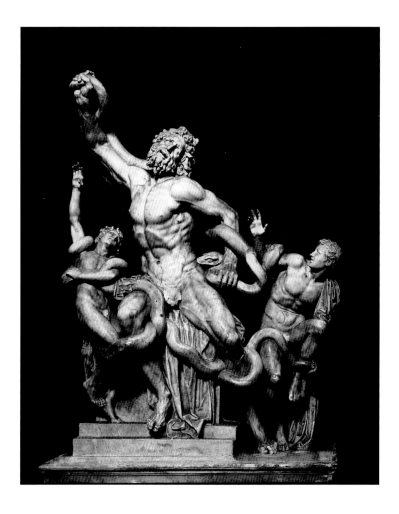

We know that Pliny in antiquity, and Vasari in the Renaissance, devoted their histories of painting and sculpture almost entirely to the successive stages of the mastery of the representation of reality. Even great artists like Leonardo wrote their treatises mainly to instruct the young painters in the study of appearances, and called to their aid the science of optics, of anatomy (including human proportion), and of morphology, but what we call 'formal values' are not referred to in Leonardo's notes.

It had been the claim of Vasari that artistic perfection had been attained by the great masters of the High Renaissance, and it was indeed to those masters that subsequent teachers and critics drew the attention of young artists in search of models. Looking back at the achievement of Raphael and his contemporaries it was not hard to see that their perfection transcended mere mimesis. Perfectly realized as were the figures and settings of their stories, they were also combined in harmonious compositions of immediate appeal. To bring out and articulate these values became the concern of the French Academy of the seventeenth century, and henceforth it was tacitly assumed that an artist had to observe the dual standards of mimesis and of formal harmony.[2]

Only after this conflict was brought into the open did it become possible to assign priority to formal values even at the expense of mimetic fidelity. It is to this development that this chapter will be devoted. Interestingly enough, it was not a champion of the 'primitive masters' who was one of the first to discern and articulate this conflict of values, but that most determined defender of classical standards, Goethe.

New Priorities

In an essay (*c.*1808) on the *Laocoön* (Fig. 98), that paradigm of classical art, Goethe ventured to claim that the group exhibited all the marks of artistic perfection, including charm (*Anmuth*). Admitting that this verdict was likely to be found paradoxical, considering the terrible subject-matter, Goethe went on to explain that the ancients were far removed from the modern delusion that a work of art had to look like a work of nature. Instead they marked their creations by an orderly arrangement that enabled the eye to grasp it easily. Thus any work of art, even if seen from a distance from which the subject-matter was no longer visible, would still impress us as a decoration, a quality which the earliest vase paintings shared with the Laocoön group.

The same argument was to serve Goethe to defend the Byzantine tradition of art,[3] which since the days of Vasari had been seen as a foil against which the progress of the arts was to be measured. Such a rehabilitation of the Byzantine tradition would not only call into question the whole traditional picture of the rise of the arts from Cimabue to Raphael, but would also offer critics new standards by which to judge the claims of the Romantics in favour of the newly discovered Northern masters. Goethe felt the need of such standards when he

99. Engraving after the frescoes in the chapel of St Sylvester, Rome, as an example of 'Greco-Italian', i.e. Byzantine style, from Seroux D'Agincourt, *Histoire de l'Art par les Monuments* (Paris, 1811–20)

180

came in contact with the brothers Boisserée. While feeling attracted to the young enthusiasts, who must have reminded him of his early defence of Strasbourg Minster, Goethe still was unwilling to give aid and comfort to those gushing Romantic extremists who threatened to undermine the artistic values in which he passionately believed.

True to his character and to his outlook he decided to arrive at a more balanced view, a view that did justice also to the conflicting values that great masters had reconciled in their creations. Thus, when in his late sixties he had to redeem his promise of presenting the newly discovered treasures of early Northern painting to the readers of his journal *Aus Kunst und Alterthum,*[4] he struck a note of caution that disappointed his friends and enraged his enemies. To be sure, the achievement of the early Netherlands in such works as the *Columba Altarpiece,* then attributed to the brothers van Eyck (Fig. 85), was remarkable in its fidelity to material appearances, even though the brothers 'failed to satisfy the highest demands of art'. For, having discarded the imperfections of their predecessors, they had also jettisoned their unobserved perfection, the idea of a symmetrical composition. Such one-sidedness, he conceded, lay 'in the nature of exceptional minds who failed to realize that … every advance from a rigid, obsolete and artificial manner towards an uninhibited truth to nature must also imply a loss which can only be restored by and by in later ages' (pp. 214 and 319).

What Goethe expressed in this passage was certainly not a preference for the primitive, but he warned against a simplistic concept of artistic progress that considered only the value of mimetic skill and neglected a respect for formal values. It was these formal values, he explained at some length in his article, which the revolution of van Eyck had threatened to destroy, the values that the Byzantine tradition had preserved from classical antiquity. That tradition had been called 'mummified', but after all even a mummy preserves the skeleton of the body. Repeating the claim that the Greeks and Romans had mastered the highest task of visual art, that of decorating a space, he explained once more that any decoration must consist of mutually related parts: it must have a centre, an above, a below, a right and a left resulting in symmetry. Turning to Seroux d'Agincourt's newly published history of medieval art (Fig. 99), Goethe observed that Byzantine art had always maintained just such a rigid symmetry, and though this might make those images look stiff and unpleasant, there were cases where the variety in the posture of figures standing opposite each other had resulted in a certain charm – an advantage that their craftsmen had spread throughout the world.

It was this traditional skill, we learn, that the revolutionary masters of the Netherlands had discarded, and that led Goethe to prefer an earlier work of the German school. In his description of the painting of *Saint Veronica* (Figs. 100 and 101), Goethe offered a truly remarkable analysis of what he saw as a conciliation between the Byzantine tradition and the new feeling for nature:

> Perhaps it will be discovered one day that as far as the composition and

design is concerned, this painting followed a traditional Byzantine religious idea. The dark brown countenance with its crown of thorns, probably also darkened with age, conveys a wonderfully noble expression of pain. The corners of the cloth are held by the saint, who emerges from behind it, hardly one third of life-size. Her expression and gestures are both exquisitely graceful. The cloth rests on the merest adumbration of a floor, while in the corners on either side we see, sitting, three tiny singing angels, who, were they standing, would be hardly a foot high. So beautifully and skilfully are they grouped that they perfectly satisfy the highest demands of composition. The whole points to a traditional, elaborated practice of art. What a degree of abstraction must have been necessary to represent these figures in three different scales, and to turn the whole composition into a symbol. The little bodies of the angels, particularly their little heads and hands, are so well related to each other that one could not ask for more. If all this gives us the right to postulate a Byzantine origin for the image, the charm and tenderness with which the Saint and the children are painted entitles us to date the execution of the picture into that period of the art of the lower Rhine which we are discussing. Combining, as it does, the dual elements of a strict convention and a pleasing execution, the painting exerts an incredible power over the beholder, an effect to which the contrast between the fearful Medusa-like countenance [of the Christ] and the delicate gentleness of the Saint and the charm of the children make no small contribution. (p. 209)

182

Compared with the *Outpourings from the Heart of an Art-loving Monk* and with the gush of the other Romantic medievalizers, Goethe's analysis may sound cool. But it was precisely his reluctance to be carried away by the fashionable emotionalism which led him to consider the balance of formal values in the development of art. For him art is a matter of balance, of adaptation to various functions: decoration demands formal symmetry, realism must reject it. The critic must appreciate both but the practical artist must decide what he wants.

In thus attempting to spell out Goethe's position I may have overdrawn his importance, but it may be no accident that it was in Germany that historians of art first began to ponder the profit-and-loss account of the progress of art as traditionally attributed to the masters of the Renaissance.

The Laws of Style

Goethe's approach was closely followed by that of Rumohr, that pioneer of the documentary study of Italian art history, whose *Italienische Forschungen* were published in the 1820s, still in Goethe's lifetime. We have seen that he, like Goethe, had tried hard to maintain a balance between traditionalism and

183

100. Anonymous, *Saint Veronica*, 1410. Alte Pinakothek, Munich

101. Engraving of *Saint Veronica* from Goethe, *Kunst und Alterthum*, (Stuttgart, 1816)

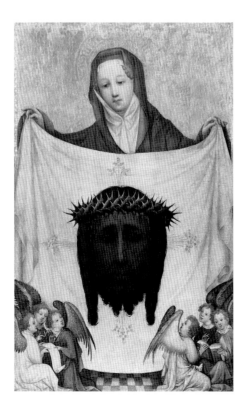

progressivism in his critical evaluations. But he never wavered in his insistence that the first and indispensable law of painting derives from the demand that the arrangement and distribution of representational or decorative forms and lines must always observe the rules of proportion and of internal relationships. Rumohr spoke in this connection of the 'law of style', and he did not hesitate to accuse Giotto of having infringed this law, and thus of having endangered the values of the tradition. There is a certain analogy between Goethe's evaluation of the nature of the pictures of van Eyck and Rumohr's doubts about Giotto. It is important to note, however, that neither Goethe nor Rumohr would have granted priority to the formal laws of composition over the demands of correct representation. In their eyes no appeal to the exigencies of balance and symmetry could excuse doing violence to natural appearances.

184

The recognition that there were two independent systems of values to which the perfect work of art had to conform – the value of mimesis and that of formal harmony – was bound to affect the appreciation of primitive art in a number of ways. For critics such as Goethe and Rumohr, as we have seen, mimesis remained an indispensable, but not a sufficient criterion of excellence; but the very existence of rival demands still raised the question, in what order should they be ranked? To those who accepted the traditional identification of art with skill, it seemed obvious that the successful imitation of nature presented a task infinitely more difficult than the pleasing arrangement of decorative forms. The mastery of the first, therefore, was rightly regarded as the culminating achievement of the civilized nations, while a certain skill in decoration could also be observed in the artefacts of savages and barbarians. This was the conclusion the neo-classical sculptor John Flaxman presented to his hearers in one of his Academy lectures:

> And here we may remark, that as by the term style we designate the
> several stages of progression, improvement, or decline of the art, so
> by the same term, and at the same time, we more indirectly relate
> to the progress of the human mind, and states of society; for such as
> the habits of mind are, such will be the works, and such objects as the
> understanding and the affections dwell most upon, will be most readily
> executed by the hands. Thus the savage depends on clubs, spears and
> axes for safety and defence against his enemies, and on his oars or
> paddles for the guidance of his canoe through the waters: these,
> therefore, engage a suitable portion of his attention, and, with incredible
> labour, he makes them the most convenient possible for his purpose;
> and, as a certain consequence, because usefulness is a property of beauty,
> he frequently produces such an elegance of form, as to astonish the
> more civilized and cultivated of his species. He will even superadd to
> the elegance of form an additional decoration in relief on the surface
> of the instrument, a wave line, a zig-zag, or the tie of a band, imitating
> such simple objects as his wants and occupations render familiar to his

observation – such as the first twilight of science in his mind enables him to comprehend. Thus far his endeavours are crowned with a certain portion of success; but if he extend his attempt to the human form, or the attributes of divinity, his rude conceptions and untaught mind produce only images of lifeless deformity, or of horror and disgust. … we consequently find in most countries attempts to copy the human figure, in early times, equally barbarous, whether they were the production of India, Babylon, Germany, Mexico, or Otaheite. They equally partake in the common deformities of great heads, monstrous faces, diminutive and misshapen bodies and limbs. We shall, however, say no more of these abortions.[5]

185 The conviction which Flaxman here expressed came to be shared by many art lovers of the nineteenth century. Though it accorded a relatively low rank to the creative activities of 'savages', it still conceded a certain autonomy to the art of decoration, an autonomy that attracted increasing attention and respect in the course of the years. Among the pioneers of this interest was the French graphic artist, Charles Meryon. Many of his drawings dating from *c.*1848, after Maori carvings from New Zealand, are kept in the British Museum (Fig. 102).[6] Sooner or later the question would arise whether this art was really inferior to the art of mimesis, and if it was still seen to be inferior, how could it be explained that civilized nations appeared to have so largely lost this skill?

The Autonomy of Decoration

This issue arose in a severely practical context, the decline of the craft tradition in consequence of the Industrial Revolution. It was in England that the development was felt most poignantly, so that the reform of design became a matter of public debate.[7]

The ball was set rolling by Augustus Pugin (1812–52) who extolled the superiority of medieval tiles and wall decorations over the more recent styles. What his argument amounted to was that the values of decoration were not only distinct from those of mimesis but they were really incompatible with them. Mimetic art aimed at the illusion of depth while decoration should emphasize the plane. Expressed in other terms, familiar from previous chapters, the purity of decoration had been corrupted by irrelevant mimetic skills much as the spirituality of medieval art had been corrupted by pagan sensuality.

There was no need, however, to look at this matter in moral terms. It was the increasing mastery of those skills which itself was responsible for the decline of decoration. Just as the ancients admired the restraint and dignity of archaic speech as a matter of decorum, so the Victorian critics were led to approve the tact and economy of means manifested in tribal decoration. There were plenty of opportunities to test this observation in the Great Exhibition of 1851. There were

products in that exhibition from practically all over the world, splendidly arranged in the Crystal Palace. These exhibits provoked much heart-searching: 'It was but natural', wrote Digby Wyatt, 'that we should be startled when we found in that consistency of design ... those we had been too apt to regard as almost savages were infinitely our superiors.'[8] When, in 1856, Owen Jones gathered the harvest of the Exhibition in a sumptuous tome entitled *The Grammar of Ornament*, he altogether recommended the 'admirable lesson in composition which we may derive from an artist of a savage tribe' (Fig. 103).[9]

The emotional Ruskin was almost driven to depair on discovering what he took to be a link between savagery and decorative skill.[10] His great contemporary in France, Viollet-le-Duc, in his *Dictionnaire raisonné de l'architecture française du XIe. au XVIe. siècle* wrote:

186

> There are two radically different operations of the mind: one is to achieve a striking effect in a picture by means of cunning sacrifices, the exaggeration of certain tones found in nature, the very delicate blending of half-tones, as a Titian, a Rembrandt or a Metsu were able to do. The other is to produce a Tibetan shawl. There is only one Titian, one Rembrandt and one Metsu, while all the weavers of India succeed in producing woollen scarves which, without exception, give a harmony of colours. It needs an extremely civilized environment for a Titian or a Rembrandt to develop; while the most ignorant Tibetan who lives in a wooden hut with a family as poor as he is will weave a shawl whose rich assemblage of colours will charm our eyes, of which even our best-organized factories can only produce an imperfect imitation. What we consider the more or less barbarous condition of a nation is therefore no obstacle to the development of certain aspects of the art of painting applied to monumental decoration ... The only conclusion to be drawn from these observations is that the art of painting an easel painting and the art of painting when applied to architecture proceed very differently; the desire to mix the two arts is to attempt the impossible ... for what is an easel painting? ... An easel painting presents a scene to the beholder as if the frame were an open window. There is only one point from which it should be viewed, witness the excruciating effects of the illusionistic stage seen from a wrong position.[11]

The conclusion follows that wall decoration must not be illusionistic because it has to be seen from many points.

Thus Viollet-le-Duc was by no means out to deny the values of mimesis that had triumphed in the paintings of Titian, Rembrandt or Metsu. He readily admitted that the refinement and sophistication of these masters had no parallel in the arts of other civilizations. But despite this admission, he drew attention to the fact that the mimetic art of easel painting was only one of the visual arts and that

187

102. Charles Meryon, *Sketch of Maori canoe prow*, 1842–6.
British Museum, London

103. Bark cloth from Tongatabu, illustrated in Owen Jones,
The Grammar of Ornament (London, 1856)

its scope was somewhat limited. Other artistic tasks were bound to pay more attention to the alternative values of decorative composition.

Stained Glass

The great art of the stained-glass window soon became the standard example of the need to keep the devices of mimesis under control. After all, it was only too apparent to visitors of Gothic cathedrals that the glories of twelfth- and thirteenth-century Chartres had never been surpassed, and that later examples of the craft declined in quality the more the examples of easel painters were followed (Pls. IV and V). Again it was Viollet-le-Duc, who, in his extensive article 'Vitrail', diagnosed the causes of this 'decadence': 'the search for realism and for dramatic effect' contradicted the principle of 'la peinture translucide'; and though new devices, such as the doubling of panels, contributed to the technical perfection of later windows, these could not save an art that had abandoned its true principles. 'The latest fine windows of the Renaissance that one can see at Bourges and Paris ... are nothing but the cartoons used by painters transferred to stained glass; such works might have great qualities of composition, of design and modelling, they have none from the aspect of decoration. They look blurred, pallid or harsh. The eye searches painfully for a design that it would prefer to see on an opaque surface ... Perspective, the recession of planes, fail absolutely in their desired effect and merely result in fatigue.'[12]

It was John Ruskin who formulated these convictions with memorable clarity when he laid down as 'a practical matter of immediate importance, that painted windows have nothing to do with chiaroscuro ... If you care to build palaces of jewels', Ruskin went on, 'painted glass is richer than all the treasures of Aladdin's lamp; but if you like pictures better than jewels, you must come into broad daylight to paint them. A picture in coloured glass is one of the most vulgar barbarisms ...'[13] Thus, slowly but surely, the art of figure painting as applied to murals or stained-glass windows was seen to approximate the principles of ornament in giving priority to formal values.

Of course in ornament proper the rules and values of mimesis had never held sway – on the contrary, artists were enjoined by the reformers to study the way plants or flowers could be stylized in a variety of manners to fit them for inclusion in a variety of patterns. This very demand of submitting natural shapes to the formal discipline of stylized design prepared the way for a fresh appreciation of exotic art. Discussing an oriental design on silk, in 1866, the German art historian Jakob Falke is anxious to tell his readers that the shapes of these graceful animals are due to intention, not lack of skill: 'it would have been easy for these masters to approximate these forms of nature, but this was far from being their intention.'[14] The remark again reflects the profound doubts which had been raised by the Arts and Crafts movement about the aesthetic standards of mimetic naturalism.

One of the most vocal spokesmen of this movement was Walter Crane. In one of his essays he describes the reaction of a designer who has decided to turn for a moment from his all-engrossing studies in stained glass and tapestry to visit an exhibition of painting. He is appalled by the futility of an 'aimless, and therefore inartistic, imitation',[15] by the witchery of imitative skill which leads painters astray. Crane never ceased to drive home the distinction between the imitation of accidental effects and the constructive art of the decorator, depending for its beauty on qualities of line, form and tint. What gives this pursuit its fascination is precisely that there are no scientific rules to determine its success: 'The way is perpetually open for new experiments, for new expositions, and new adaptations and applications.'[16]

189 *Japonisme*

Among experiments that notoriously fascinated and finally convinced artists of the late nineteenth century that the mimetic tradition had had its day were the examples of Japanese prints which reached Europe in ever greater numbers. It may be a moot point whether it was this alternative style that ultimately led to the demise of the academic tradition, or whether the seeds of doubt that had been planted by the developments sketched above led to the vogue of Japonisme. I know no more moving testimony to the dilemma with which it presented the academic masters than the final of six Lectures on Painting given to students at the Royal Academy of Arts, in London in January 1904, by George Clausen.

Having discussed aspects of Realism and Impressionism, Clausen comes to touch briefly on the art of Japan:

> which has influenced Western art in the last fifty years ... There is something disquieting in the fact that Japanese art is so beautiful, and at the same time so altogether different from ours, so much so as to cause a momentary thought whether it is not finer. But whether or no, we must keep on our own road, for our traditions and practice do not lead us to render nature like the Japanese ...
>
> Our art appeals through representation or imitation, creating an illusion of nature in its three dimensions; while Japanese representation of nature is not imitative, but selective, certain things being chosen and the rest ignored. And their art seems, in this respect, to have developed to its final perfection on the lines of the earliest forms of art, without changing its direction. If we go back to the beginnings; to the Egyptian wall-paintings, to the Greek vase-paintings, or to the earliest Italians, or even if we look at the drawings of children, we find they are alike in this, that they draw the thing they want to express, and leave out the rest. The Japanese make their selection in the same way; their art has developed, but has not changed.
>
> But in our art this simple method of selection is no longer possible;

figures must have their backgrounds and surroundings, and the appearance of nature must be studied in order to give, by light, shade, or colour, the necessary emphasis to the principal parts. We agree that this is the proper way to represent nature, but the art of the Japanese brings home to us the fact that it is not the only way.[17]

By the time these lectures were delivered many Western artists had been converted to the decorative values of Far Eastern art. Not that the vogue for Japanese art or the cult of the decorative can be equated with a preference for the primitive – least of all since the most popular masters of the genre, Hokusai and Hiroshige, were precisely those who had most successfully absorbed the Western skills of perspective rendering. But what is particularly significant in this taste is that this comparatively Westernized art could form a bridge to the understanding and appreciation of more remote art forms. Just as the appreciation of pre-Renaissance art began with the immediate predecessors of Raphael, and slowly led through Perugino to Fra Angelico and Giotto, so these Japanese masters of the colour print led art lovers gradually to the more 'authentic' styles of Asia, before arriving in Oceania and Africa.

In other words, Japonisme comes into our story mainly because it undermined and subsequently broke the resistance to the appreciation of non-naturalistic styles.[18] For, once mimesis was no longer accepted as an indispensable value, there was no reason why even the human figure could not be made to obey the alternative rules of formal discipline, at the expense of organic laws. True, it was only the younger generation who were ready to jettison this achievement of Western art. It is well known how deeply van Gogh was impressed by the art of the Japanese colour print, with its flat, loud colour areas and its absence of shading and modelling. It appears that he even arranged a little exhibition of Japanese prints, and of course, he copied some of them in the late 1880s. But it was his ambivalent friend, Paul Gauguin, who made the step from this form of exotic art to a form of primitivism which caught the imagination of the twentieth century.

It is significant in this context that a Japanese woodcut appears in the background of one of Gauguin's still lifes of 1889 – not a graceful geisha, or a flowering tree, but one of the highly simplified and stylized portraits of an actor in his mask. But evidently Gauguin looked for even more emphatic simplification beyond the two-dimensional arabesque of Japanese prints. He found it in the folk art of Brittany, where he had gone with other artists in search of a new idiom untainted by the cleverness of Salon art and the restlessness of the Impressionists.

Folk Art

Gauguin would have been classed by Lovejoy and Boas as a cultural primitivist, who set out in vain to seek his happiness in the never-never paradise of the South Sea Islands. But in my context he must figure as one of the artists who broke

through the barrier of the Pre-Raphaelite compromise and discovered the power of earlier, more primitive styles to which the Japanese may have shown him the way. His composition *Green Christ* (Fig. 104) embodies memories of Breton Romanesque calvaries in all their simple majesty (Fig. 105). Note that here the fidelity to natural appearances is abandoned, if only in the background quotation. It was but a small step from this recognition of the values of rustic sculpture to his habit of incorporating in his paintings from the South Seas real or imaginary works of the natives, whose style of life he coveted. Even in his paintings from the South Seas, however, Gauguin never stylized or distorted his models. The studies he made of tribal carvings were not intended to modify his way of representing the human figure in his paintings. Only in his sculpture and in some of his woodcuts did such an extreme assertion of formal values affect the human form. But the taboo had been broken, and with it the whole achievement of classical and Renaissance art was called into question. The very years when Gauguin represented his Breton calvary also witnessed the full admission of Romanesque medieval sculpture into the canon of great art.

191

I do not want to give the impression that Romanesque sculpture in France, Italy and Germany had aroused no attention before that time. Indeed, these relics were eagerly studied by historians and antiquarians, but mainly as monuments and documents; the general public passed them by as too primitive for comfort. They were felt to be clumsy and grotesque, precisely because, in these massive works, the human figure was treated so cavalierly.[19]

The Intrinsic Values of the Romanesque

Maybe it was easier to tolerate stylized figures in murals and stained glass than in solid stone, but the trends we saw favouring such licence in two-dimensional media were almost bound to be applied to sculpture – if only, initially, to sculpture in the service of architecture. I believe some credit for having applied it consistently for the first time should go to the German art historian Wilhelm Vöge,[20] who was to become one of Erwin Panofsky's admired masters. In 1894 Vöge published his first book entitled *The Beginnings of the Monumental Style in the Middle Ages* - meaning the great art of cathedral sculpture, both Romanesque and Gothic. The art-historical conclusions of this book have not stood up to later criticism, but the aesthetic sensitivity with which Vöge analysed the great western porch of Chartres Cathedral should not therefore fall into oblivion (Fig. 106).[21] The foundation of his analysis is the conviction that figurative decoration and architectural structure must be seen as two sides of the same artistic process: whatever the shape of individual figures they were not allowed to obscure the architectural organization of the whole. This insight leads him to reconstruct what the stonemason's procedure must have been, to look at the individual building blocks and visualize the structure before its sculptural treatment. The task of the sculptor was, in fact, simply to create his figures within these stereometric shapes.

192

104. Paul Gauguin, *Green Christ*, 1889. Musée Royal, Brussels

105. Romanesque Calvary at Nizon, Brittany

193

106. West porch, Chartres Cathedral, 1145

But this constraint was not felt as a limitation, it was rather the starting point for his creativity. He made a virtue of necessity and thus established a style of his own. We need not follow Vöge in his detailed description of this process. What matters is the aesthetic relevance of his historical reconstruction. Instead of triumphing over the stone, as modern sculptors had done, the masters of Chartres had submitted themselves to its formal values, and the result was great art.

Truth-to-Material

Vöge's analysis harmonized with the aesthetic creed of 'truth-to-material' that came to dominate the art of sculpture in the early twentieth century – a slogan which was intended to devalue the variety and virtuosity of Auguste Rodin's dazzling creations. The contrast between Rodin's group of *The Kiss* (Fig. 108) and that of his erstwhile pupil Constantin Brancusi (Fig. 107) has been paradigmatic of this revolution.

194

Brancusi's *Kiss* was made for a tomb in the Paris cemetery of Père Lachaise – in other words, it was destined for a context in which what we referred to in the preface as 'kitsch' was generally allowed to run riot. Whatever we may think of this innovative conception, sentimentality is not a failing it can be accused of. Within the context of this book the sculptor's reference to primitive traditions may therefore be explained as an avoidance reaction. Indeed, I would venture to propose that what Bernard Smith calls the 'formalesque' might be seen in terms of this artistic motivation. Conceivably Smith even underrated the support this movement received from examples of other styles and traditions. The genre of devotional art might almost be considered a testing ground for this hypothesis. What I have called the 'virtuous' style (see p. 135) that governed the types and figures of nineteenth-century church art no longer seemed to satisfy the demands of more sophisticated circles. Remember the contrast Montalembert made between the seventeenth-century image of the Virgin by Bouchardon and that of the nineteenth-century Austrian, von Steinle (see p. 137). In the twentieth century a man of his piety would probably have looked for a paradigm among the images of the Romanesque or those of the Byzantine tradition. He would have been impressed by the hieratic figures, not so much for their devout expression as for their solemn otherworldliness. Twentieth-century artists learned indeed to tap that source of awe and mystery, the contrast between monumentality and the sentimentality of the 'virtuous' style. Remember, by way of example, Epstein's tomb of Oscar Wilde, or his *Lazarus*. Henry Moore in England was also a past master in conjuring up the mysterious aura of primitive images and so was Graham Sutherland in the tapestry for the choir of Coventry Cathedral. It appears that the Catholic Church had all but turned away from the sweet and 'kitschy' devotional aids distributed at Sunday schools in favour of more austere, Byzantinizing pictures, preparing the ground, intentionally or not, for the preference for the primitive.

195

107. Constantin Brancusi, *The Kiss*, c.1912.
Philadelphia Museum of Art

108. Auguste Rodin, *The Kiss*, 1882.
Musée Rodin, Paris

Interlude – New Worlds and New Myths

'What a comfortable mental furniture the generalizations of a century ago must have afforded! What a right little, tight little, round little world it was when Greece was the only source of culture, when Greek art, even in Roman copies, was the only indisputable art, except for some Renaissance repetitions! And now, in the last sixty years, knowledge and perception have poured upon us so fast that the whole well-ordered system has been blown away, and we stand bare to the blast scarcely able to snatch a hasty generalization or two to cover our nakedness for a moment.'[1] These words, with which Roger Fry prefaced an enthusiastic review of *Negro Sculpture* in 1920, presented a challenge to the historian of ideas (Fig. 109). Basically, Fry was right in speaking of 'hasty generalizations' current in his time. We need only glance at the hefty catalogue entitled *Africa, the Art of a Continent*,[2] published in 1995, to discover how badly these generalizations fared in the seventy-five years after the publication of Fry's review; indeed, how all generalizations about 'negro art' have proved, in the light of more detailed ethnological and archaeological research, to be little more than myths.

196

The reader of the preceding chapter, on the other hand, will realize that Fry was remarkably accurate in dating the breakdown of the classical canon. Sixty years before 1920 takes us back to 1860, nine years after the Great Exhibition, which was both a symptom and cause of the new knowledge that 'blew away' the old system and drew attention to the artistic gifts of so-called 'savages', at least in the field of decoration.

Fry's diagnosis can also be confirmed by statements from the period itself, such as an article by the great critic Théophile Thoré (W. Bürger), published in 1855 after another such exhibition, the *Exposition Universelle* of Paris:

> While formerly – yesterday – each people shut itself off within the constricting limits of its territory, of its special traditions, of its idolatrous religion, its egotistical laws, its dark and shadowy prejudices, its customs and its language, today each tends to expand outside its narrow limits, to open its frontiers, to generalize its traditions and mythology, to humanize its laws, and to enlighten its ideas, enlarge its habits, blend its interests, to distribute everywhere its activity, its language, and its genius. This is the present tendency of Europe and of the other areas of the world as well.[3]

It was the dazzling speed of technological progress that had wrought this transformation: the coming of the railways, of the steamship and the telegraph, no less than the development of weaponry that facilitated the colonial conquests of the Western powers and brought the white man in contact with the remotest regions of the globe. Nor were the exhibitions the only new sources of information about the products and monuments of distant lands. The recent

197 109. Negro sculpture, illustrated in Roger Fry, *Vision and Design* (London, 1923)

110. Peruvian room, illustrated in Emile Soldi,
Les Arts méconnus, (Paris, 1881)

111. Indian chamber, illustrated in Emile Soldi,
Les Arts méconnus, (Paris, 1881)

invention of photography was put into the service of such ambitious enterprises as the archaeological survey of India, and after the middle of the nineteenth century, books with photographic plates also came increasingly on the market. In the nineteenth century too the technique of the plaster cast that had previously been used for spreading the classical canon was systematically placed in the service of art-historical studies. Thanks to the inspiration of Viollet-le-Duc, casts of the monuments of medieval France were assembled in the Trocadéro, which opened its doors in 1878.

The Trocadéro

Here the visitor could study in a relatively small space the great statuaries of the medieval cathedrals, often from remote provincial cities, and what is even more significant, the sculpture of exotic countries which had generally lain beyond the horizon of educated art lovers. A book by Emile Soldi based on these collections was published in 1881, and bears the significant title *Les Arts méconnus* – the neglected, or misunderstood arts – and its many chapters explicitly challenge the supremacy of classical art. The French, of course, dominated Indochina, and Soldi devotes an enthusiastic account to the great sculpture of Angkor Wat, casts of which had been displayed in the Château de Compiègne, and were now assembled in the Trocadéro, together with a model of the temple made by the author of the book. Other plates show us *The Peruvian Room* (Fig. 110) and *The Indian Chamber* (Fig. 111) – 'Indian' meaning American Indian.

Hand in hand with the growing awareness of the riches and variety of exotic civilizations and the treasures still to be discovered on the vast surfaces of the globe, the age also experienced a sudden expansion of the dimension of time. At the end of the eighteenth century, the great polymath William Jones,[4] pioneer of Sanskrit studies, had still felt compelled to cram his reconstruction of Indian history into the biblical time-frame suggested by Bishop Ussher, commencing in 4004 BC with the Flood. Now the geological researches of Sir Charles Lyall proved beyond cavil that the foundation of rocks, the development of fossils must have extended over millions of years, and his friend Charles Darwin, in 1859, confronted the world with his theory of the *Origin of Species* which reduced to a few tail-end millennia the existence of *Homo sapiens* on this globe.

Evolution and Recapitulation

It was the theory of evolution that gave a new meaning to the term 'primitive', which now came to denote the beginnings of human civilization. Exploring the globe, it appeared that the cultures encountered by travellers could be graded according to their mastery of nature – from the migratory hunter-gatherers (such as the bushmen), to the beginnings of farming and on to the organizational and technical achievements of the ancient oriental kingdoms, with the white man of modern Europe and America right at the top of the ladder.

Unhappily these undeniable facts also gave rise to a powerful myth: it seemed tempting to equate these cultural developments with the biological evolution of species of which Darwin had spoken, ignoring the radical differences in the time-scales of the two chains of events. In other words, it was uncritically assumed that members of more 'primitive' societies also exhibited a more primitive mind, one far below our own. This wholly unproven assumption was buttressed by an alleged law of evolution, known as the 'law of recapitulation', postulating that the development of the individual from childhood to maturity repeated the development of the species. That is that primitive man – the aborigine of Africa or America – resembled the European child in his skills and in his outlook. Hence his first primitive attempts at rendering reality were expected to be like those of a toddler who had not yet learnt to use his eyes, but who relied on what were known as *conceptual images*. When psychologists turned their attention to the drawings of children, it was thus thought that they had also discovered a fresh access to the art of our own past, that of our primitive forebears.

In his book on *The Cult of Childhood*, George Boas quotes from a standard work of 1904 on the drawing of children:[5] 'The development of the child mirrors the development of the race, and whoever doubts it may be convinced by the following pages. They were written in order to prove that, generally speaking, our children follow the same path taken by our forebears, and which the primitive peoples today still tread.'[6]

No wonder that the first discoveries of prehistoric cave-painting were greeted with incredulity, proving as they did that people of the Stone Age were splendid observers. This is not the place to clarify how the myth of primitive man was dispelled. It turned out that some 'primitive' tribes possess astounding techniques in navigation, while we are still learning about the medicinal properties of plants from others, and we have had to learn to our cost how vulnerable our much-vaunted civilization has proved to waves of irrationality and barbarity. But these developments lay in the future. What the next chapter will indicate is the potency of what I have called the 'myth' – and its attraction for artists seeking to escape the tarnished tradition of Western civilization.

The Twentieth Century

201 *'Primitivism' in Twentieth Century Art* was the title of a large, comprehensive exhibition mounted in 1984 in the Museum of Modern Art of New York, and commemorated in a catalogue of two heavy folio volumes, with contributions by many specialists, which will surely remain the standard work on the subject.

 The organizer and principal author, William Rubin, showed himself aware of the fact that the term 'primitive art' was open to criticism on the part of those who saw in the designation a somewhat patronizing attitude, symptomatic of Eurocentric prejudice. He defended his choice, however, since no valid alternative had been suggested. Readers of the preceding pages, moreover, will long have realized that the term 'primitive' had been used without condescension, at least since the end of the eighteenth century. Rubin asks the question: 'what happened, within the evolution of modern art, that suddenly in 1906–7 led artists to be receptive to tribal art? No doubt', he continues, 'there is more than one right answer, but the most important reason, I am convinced, had to do with a fundamental shift in the nature of most vanguard art from styles rooted in visual perception to others based on conceptualization'.[1]

 Admitting that such contrasts must always be relative, the author rightly stresses the concentration of the Impressionists – and indeed, of Cézanne – on the minutiae of visual sensation. In the author's view, 'it was Gauguin … who took the first step towards a conceptual, and thus more "synthetic", more highly "stylized" art', blending the realism of the Impressionists with 'flat decorative effects and stylized forms' derived from 'non-illusionistic arts as diverse as Egyptian, Medieval, Persian, Peruvian and Breton (folk) painting and decorative arts … and Cambodian, Javanese and Polynesian sculpture' (p. 12). The author concedes that this shift from the perceptual to the conceptual had already been 'signalled by Manet and reflected in the "Japonisme" that took hold in the 1860s' (p. 13).

 Return to 'Cicero's Law'
Having travelled along a similar route, we can only endorse this verdict, but,

202

112. William Bouguereau, *The Birth of Venus*, 1879.
Musée d'Orsay, Paris

113. Pablo Picasso, *Les Demoiselles d'Avignon*, 1907.
The Museum of Modern Art, New York

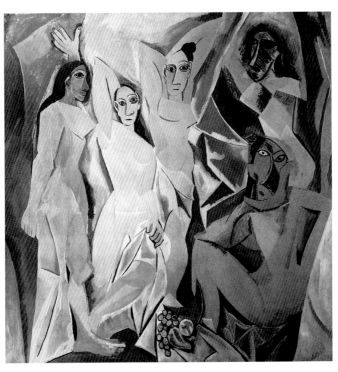

strictly speaking, it offers a description of stylistic developments rather than an explanation of the primitivist revolution documented in such detail in the exhibition catalogue.

There are many historians who eschew the notion of explanation in history and prefer the chronicling of events to speculating about causes, but it so happens that this book would never have been written if I wholly shared that opinion. In fact I proposed at least a partial explanation of the primitive revolution in a lecture I gave as long ago as November 1953, one which ultimately expanded into the present study. I am referring to the Ernest Jones Lecture on *Psychoanalysis and the History of Art*,[2] given to an audience largely composed of psychoanalysts. In that lecture I confronted a painting of the *Birth of Venus* by Bouguereau (Fig. 112) – a typical Salon painting – with the first monumental work of art that embodied reminiscences of tribal masks: Picasso's *Demoiselles d'Avignon* (Fig. 113) – a juxtaposition that implied that, without the first, the second might never have been painted. In other words, I saw in twentieth-century painting a reaction against the meretricious art of successful virtuosos. I do not want to pretend that this was all that was contained in the lecture, but I hope the contrast of the two illustrations will suffice to convince the reader in what respect the lecture anticipated the argument of this book.

I no longer know whether I remembered at that time that it was Aby Warburg who attached such importance to negative reactions in the development of styles,[3] perhaps since he had lived in the period which reacted so strongly against the art of the Salon. Later I found in Cicero confirmation of the hypothesis which I had presented to the psychoanalysts: namely that an excess of sweetness is felt to be cloying, and that we tend to mobilize our defences against what is too obviously seductive. In that passage, which I chose as the motto for this book, was an explanation for the preference for the primitive which I found worth exploring.

In retrospect, the preceding chapters will be found to offer a variety of examples of this psychological reaction. Antiquity gives us many instances – from Plato's censorship of the musical modes, which were felt to be too sensuous and relaxing, to the accusation of the corruption of oratory by the seductive tricks of the Sophists, which were countered by deliberate harshness or studied simplicity.

Turning to the eighteenth century, we encountered the Platonist Shaftesbury inveighing against effeminacy and luscious colours to exalt the austerity of early styles and we found Richardson contrasting the 'manliness' of the style before Raphael with the effeminacy that followed him and rating the virtue of sublimity higher than faultless mastery.

Winckelmann's slogan of 'noble simplicity and quiet grandeur' was directed against the playfulness of the Rococo, and led him to commend the lofty style of early Greek art. Goethe expressed contempt for the beauty-mongering of the French, and even Reynolds was to lay it down that 'the sublime in Painting, as in

204

114. Edouard Manet, *Olympia*, 1863.
Musée d'Orsay, Paris

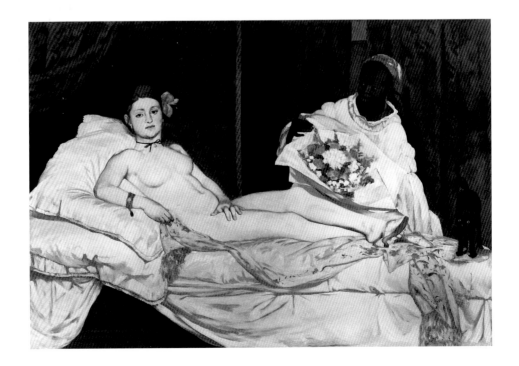

Poetry, so overpowers, and takes such a possession of the whole mind, that no room is left for attention to minute criticism. The little elegancies of art in the presence of the great ideas thus greatly expressed, lose all their value, and are, for the instant at least, felt to be unworthy of our notice. The correct judgement, the purity of taste, which characterizes Raffaelle, the exquisite grace of Correggio and Parmegianino, all disappear before them.'[4]

We are close in time to the sect of *les Primitifs* in David's studio, with their battlecry of contempt for Van Loo, Pompadour and Rococo. A similar reaction led Cornelius to say that the 'worst poison' was in Raphael, and Rio to prefer the works of Fra Angelico to the art of the High Renaissance.

In the movement I described as 'The Emancipation of Formal Values', the antagonistic character came, if possible, even more into the open. The polemic about ornament and decoration – which I described more fully in my book *The Sense of Order* – arose from alleged lapses in taste exemplified by industrial products, and called for a reform of decorative design in which the values of tribal and exotic works were emphasized. To quote what I wrote there in summing up: 'The doctrine that it was vulgar for decoration to look like pictures was easily grasped and easily applied; there was but one stop from here to the conviction that paintings which did not conform to the laws of decoration were also vulgar. Illusionism in art had had its day.'[5]

The Bifurcation of Nineteenth-century Art

The term 'vulgar' which Ruskin had used in this context throws plenty of light on the social aspect of this movement of taste. It reminds us of the radical transformation which society had undergone in the wake of the Industrial Revolution. While at the beginning of the eighteenth century it was the concern of the critic to propagate a refined taste among the members of the upper classes entering on the 'Grand Tour', now the middle class – the bourgeoisie – took it for granted that their taste and predilections should be respected by the market. The division that resulted between the connoisseurs and the general public dominates the history of the art of the nineteenth century, but it still deserves to be analysed and explained.

I know no clearer description of this bifurcation in taste than the passage Zola wrote about Manet's *Olympia* (Fig. 114) in *Mon Salon*, in 1866:

> For the public, and I do not use the word in the derogatory sense – for the public a work of art, a picture, is an agreeable thing which moves the heart to delight or to horror; it is a massacre where the gasping victims whimper and drag themselves beneath the guns which threaten them; or else it is a delightful young girl all in snowy white who dreams in the moonlight, leaning on a broken column. I mean to say that most people see in a canvas only a subject … and they demand nothing further of the artist than a tear or a smile.

To me, and I hope to many, a work of art is, on the contrary, a personality, an individual.

I don't ask that the artist give me tender visions or horrible nightmares, I ask him to give himself, heart and body … In a word, I have the most profound disdain for the little tricks, for the scheming flatteries, for that which can be learned at school …

It is no longer a question here, therefore, of pleasing or of not pleasing, it is a question of being oneself, of baring one's breast …

I am not for any one school … The word 'art' displeases me. It contains, I do not know what, in the way of ideas of necessary compromises, of absolute ideals … that which I seek above all in a painting is a man, and not a picture …

For it is another good joke to believe that there is, where artistic beauty is concerned, an absolute and eternal truth. … Like everything else, art is a human product, a human secretion; it is our body which sweats out the beauty of our works. Our body changes according to the climate and customs, and, therefore, its secretions change also.

That is to say that the work of tomorrow cannot be that of today; you can neither formulate a rule nor give it a precept … you must abandon yourself bravely to your nature and not seek to deny it.[6]

I have always considered this declaration of faith one of the formative documents of what we call 'modern art', but in a sense, it is even more: it helps us to see the difference between modernist attitudes and the attitudes against which they rebelled. For there is no doubt that Zola was correct in the view he attributed to the general public. What was valued by them was the subject-matter of a painting and the emotional response to it which the artist achieved. Practising artists resented this bias since they naturally desired to impress the beholder not by their choice of subject, but by their mastery of the medium of painting. No wonder they took pleasure in baiting the complacent middle class, and enjoyed the sport of *épater le bourgeois*. In their minds, to aim at success with the jury of the Salon was tantamount to selling their soul, for such success could only be achieved by pandering to the tasteless bourgeoisie.

Later usage has coined for this kind of Salon painting the derogatory term 'anecdotal', but it may be more fair and more correct to call it 'dramatic', or possibly 'operatic', since in the librettos of the grand nineteenth-century operas – such as Verdi's and Wagner's – this attitude remained alive. The librettist of an opera must think of a plot that gives the composer the maximum of opportunities to express the passions – not his own passions, of course, but those of the *dramatis personae*.

Henceforth the world of art was divided between the traditionalists, whose work pleased the public, and the avant-garde, who looked for success among the

élite. To analyse this momentous development would take us far beyond the limits of our chosen subject, but without an understanding of its roots its reverberation in the twentieth century cannot be understood.

Here, no less than in the discussion of the early eighteenth century, we can rely once more on M.H. Abrams. Long before he wrote his essay on 'Art-as-such', from which I profited in chapter two, Abrams had gained a deserved reputation from his book *The Mirror and the Lamp*,[7] in which he analysed the profound changes which the notion of art had undergone during the birth of the Romantic movement. What that book documented so convincingly was precisely the shift in the notion of 'expression'. While in the ancient world, no less than in the eighteenth century, artists regarded it as their task to *depict* the passions objectively and accurately, the Romantic artist was out to *express* and communicate his own emotions with absolute sincerity.

It was in the medium of poetry that this shift wrought the most radical change. The love sonnets of the Elizabethan age are mostly descriptions, rather than expressions, of love. To the nineteenth century a love poem that was 'insincere' would have been dismissed as hypocrisy. It is clear that the visual arts proved less responsive to the novel demand. Yet, if the reader returns to the passage cited from Zola's *Mon Salon*, he will find that what the author extols is precisely that quality of sincerity that the Romantics associated with poetry: '… I ask him to give himself, heart and body … it is a question … of baring one's breast … that which I seek above all in a painting is a man, and not a picture … you must abandon yourself bravely to your nature and not seek to deny it.'

Not that Zola was the first to make such demands of the artist, but he was perhaps the first to make them so explicitly and exclusively. Once we have focused on his attitude in terms of Abrams's book, we will not find it too hard to find his predecessors in the nineteenth century. But this cannot be our concern. What must matter to us is the bifurcation of artistic practice into two virtually irreconcilable camps.

While the traditionalists firmly believed that there were objective standards by which a painting could and should be judged, the progressives of Zola's conviction conceived of painting, like poetry, as the expression of subjective reactions. The objective standards, based on the accurate rendering of natural appearances, led the traditionalists to dismiss any artist's departure from visual truth as a symptom of incompetence, of bungling: if a contemporary artist was found to infringe the rules and conventions of representation the only possible reaction was laughter.

The Licence of Humour

This is indeed what Zola tells us in the next of his articles on Manet, where he describes what he takes to be the majority opinion of the artist: 'After he has

207

208

115. Cook's Feather Heads, illustrated in J.P. Malcolm,
An Historical Sketch of the Art of Caricaturing (London, 1813)

116. Anglo-Saxon manuscript, illustrated in J.P. Malcolm,
An Historical Sketch of the Art of Caricaturing (London, 1813)

drunk several kegs of beer the dauber decides to paint some caricatures and exhibit them that the public may make sport of him and remember his name … he holds his sides in front of his own picture …'[8] Everyone was familiar with such distortions from the pages of the humorous weeklies, since caricature enjoyed the fool's licence of playing fast and loose with natural appearances for the sake of provoking laughter.

Where exotic or primitive images were concerned it was obviously less easy to decide whether the perceived distortion resulted from a humorous intention or from sheer incompetence. It is fitting therefore that J.P. Malcolm's *Historical Sketch of the Art of Caricaturing*, of 1813 – the first book on the subject ever written – devotes the first two introductory chapters to what the author describes as 'subjects unintentionally distorted' (p. 13). He writes that:

209

> A savage cannot transfer just conception to wood or stone; on the contrary, he seems to lose all recollection that he had ever viewed the human species, and creates monsters from his own disordered imagination – a fact very difficult to account for, as imitation is an impulse of Nature almost in every other pursuit.
>
> The British Museum contains ample illustrations of the total departure of savage sculptors or carvers from the outlines of man and beast, when attempting to represent bipeds and quadrupeds; and of others, who, though not uncivilized, were incapable of giving forms true resemblances, probably through want of encouragement and the observations of criticism … It is remarkable, that some of the rude sculptures profusely scattered over our most antient Saxon buildings resemble the capricious fancies of these untutored artists; which tends to prove that the first native conceptions of genius at all times and in all places are a confused chaos, which may be compared to the frightful dreams that sometimes torture our minds when the body is at rest: in both cases phantoms float before the perception, ghastly and terrible to the imagination … the unfortunate savage, or half-civilized sculptor or carver, appears to act under some powerful impulse, and perpetuates his waking dreams.[9]

Looming large among Malcolm's illustrations are the famous feather heads brought home from Cook's first voyage (Fig. 115), and also some pages of Anglo-Saxon manuscripts (Fig. 116).

The way in which the grotesque shapes of tribal art were seen did not change materially in the course of the nineteenth century – witness Flaxman's remarks quoted earlier.[10] In his novel, *L'Oeuvre*, Zola was to describe the salvos of laughter that emanated from the Salon des Refusés, since its visitors regarded the exhibits as the works of self-deluded bunglers and as unintentional caricatures. But skilled tactician as he was, Zola proceeded to counter-attack: who were the distorters?

210

117. Honoré Daumier, *The Past, the Present, the Future*, from *La Caricature*, 9 January 1834

Surely not honest artists such as Manet, but rather the successful masters of
the Salon, who prettified and dolled up their models: '… we have neither
M. Gérôme's plaster Cleopatra, nor M. Dubufe's pretty pink and white
demoiselles … If M. Manet had at least borrowed M. Cabanel's rice powder
puff and applied a little make-up to Olympia's cheeks and breasts, the young lady
would have been presentable … All around them [Manet's canvases] are spread
the confections of the artistic sweetmeat makers in fashion, sugar-candy trees
and pie-crust houses, gingerbread men and women fashioned of vanilla frosting
… [the public] eagerly lap up all the nauseating sweets they are served.'[11]

'This', as they used to say in the cinema, 'is where we came in,' for where
have we first encountered this response? – surely it is the one I chose as the
motto for this investigation: Cicero's discovery that too much sweetness can cause
disgust.

I have called the attitudes of the opposing camps irreconcilable. They were so
because they relied on contrasting *mental sets*. Psychologists use this technical term
to describe the expectations which modify our perceptions. If we look at a string
of figures, the configuration 'O' will be read as zero. If we look at letters it will
stand for the vowel 'O'. We have to adopt different mental sets to deal with a
calculation or a printed text. The same applies to our commerce with images.
Looking at a photographic portrait we build up in our mind an idea of what a
person looks like. Presented with a caricature such as Daumier's *The Past, the
Present, the Future* (Fig. 117) we know that it is a distortion for the purpose of
fun or mockery. In *Art and Illusion* I quoted the reply by Matisse to a lady who
criticized his portrait of a woman because her arm was too long: 'Madame, you
are mistaken. This is not a woman, this is a picture.'[12]

Mental Sets

The bourgeois evidently arrived at the Salon with two mental sets he was ready
to apply: if a painting refused to look like reality it could only be interpreted as a
parody or caricature. For Zola, as we have seen, there was a third possibility: he
saw in the exhibition nothing but falsified or prettified reality contrived by slick
manufacturers to suit the taste of the multitudes – in other words what came to
be known as 'kitsch'.

Posterity was inclined for many generations to accept this third mental set, and
to turn away in disgust from exhibitions in the Salon guilty of showing nothing
but pseudo-art – art characterized by Zola as 'the theatrical tours de force of
this Monsieur and all the perfumed reveries of that Monsieur'.[13] The attitude of
official art history was little short of a *damnatio memoriae*, a verdict that has only
slowly and hesitantly been revised in the last few decades.[14]

And yet, to repeat, it seems to me that the development of modern art can
only be explained against the foil of that other camp, as a headlong flight from
'kitsch'. The subjective conception of art could only assert its character by acts

211

of defiance, of deliberate departure from what became known as 'photographic accuracy'.

Defiance

There is a remarkable letter by van Gogh written during the Summer of 1885, in which he refers to criticism a certain Serret had made of his *Potato Eaters* (Fig. 118): 'Tell Serret that *I should be desperate if my figures were correct*, tell him that I do not want them to be academically correct, tell him I mean: if one photographs a digger *he certainly would not be digging then* ... Tell him that my great longing is to learn to make these very incorrectnesses, remodellings, changes in reality, so that they may become, yes, lies if you like – but truer than the literal truth.'[15]

His description of his own procedure in painting a portrait is more familiar: 'I exaggerate the fair colour of the hair, I take orange, chrome, lemon colour, and behind the head I do not paint the trivial wall of the room but the Infinite. I make a simple background out of the most intense and richest blue the palette will yield. The blond luminous head stands out against this strong blue background mysteriously like a star in the azure. Alas my dear friend, the public will see nothing but caricature in this exaggeration, but what does this matter to us?'[16]

What marks the revolution ushered in by Gauguin and his friends is precisely that they refused to recognize this category. Thus Maurice Denis was to claim that what he had learnt from Gauguin was 'that all works of art are a transposition, a caricature'.[17] No doubt Rubin was right when he attributed one of the main impulses of twentieth-century primitivism to Gauguin, but his formal means were perhaps only the symptoms of his attitude to art. What he preached was the extreme of defiant subjectivism:

> We had to think in terms of a total liberation ... of smashing windows even if it meant cutting our fingers, leaving the next generation free and unfettered to find its own solution. Not a definitive solution, mind you, for we are talking about an infinite art, rich in all manner of techniques, fit to express everything that is in nature and in man ...
>
> To do this we had to hurl ourselves body and soul into the fray, taking on all the schools without distinction. Rather than run them down we would confront them: not just officialdom but Impressionists, Neo-Impressionists, and the public, old and new. Let our wives and children disown us. Never mind the insults, Never mind poverty. That was so far as a man's conduct was concerned.
>
> As for his work, a method of contradiction if you like ... To relearn, and once learnt, to learn again. To conquer all inhibitions even in the face of ridicule.
>
> Before his easel the painter is slave neither to the past, to the present, to

213

118. Vincent van Gogh, *The Potato Eaters*, 1885.
Van Gogh Museum, Amsterdam

nature, nor to his neighbour. [He is] Himself, himself again, and forever himself.[18]

Strictly speaking, this tirade does not stray far from the demands of Zola's *Mon Salon*, but it makes a difference when a critic writes so, or an artist shouts it through a megaphone. If Gauguin adopted the decorative values of Japanese art and occasionally incorporated in his prints echoes of Melanesian sculpture, he surely did not do so only for formal reasons: disgusted as he was by the conventions of the West, he wished to confront the world as the savage who had discovered an untarnished civilization in the South Sea Isles.

What Gauguin became to many young artists, who felt equally alienated from the world, was a role model they could follow in one way or another to assert their own independence. One of the buzzwords of the period was *expression*, a term so easily used in contrast with the aim of the Impressionists. We have seen its central role emerging in Zola's manifesto summing up the creed of the Romantics. In 1892 Walter Crane laid it down that 'art in the highest sense is but the faculty of Expression',[19] and four years later Leo Tolstoy lent his powerful prestige to this view in his fighting pamphlet *What is Art?* To the modern reader the views of the great novelist may be unpleasantly reminiscent of the Nazi and Communist attacks on modern art, but there is no denying that Tolstoy had done his homework. He is out to pillory such frivolous entertainments of the upper classes as opera and ballet, and to condemn the trend towards the esoteric in all recent artistic movements, largely blaming the misguided idea that art should strive for the beautiful. The definition he champions is precisely that art is the expression of feeling, an expression that must meet an immediate response in the mind of the beholder.

Sincerity

'To evoke in oneself a feeling one has once experienced, and having evoked it in oneself, then, by means of movements, lines, colours, sounds, or forms expressed in words, so to transmit that feeling that others may experience the same feeling – this is the activity of art. Art is a human activity consisting in this, that one man consciously, by means of certain external signs, hands on to others feelings he has lived through, and that other people are infected by these feelings and also experience them.'[20] It is this conviction that leads Tolstoy towards his version of primitivism, closely connected with his cult of the Russian peasant, and the new appreciation of folk art:

> People think that if there are no special art schools the technique
> of art will deteriorate. Undoubtedly, if by technique we understand
> those complications of art which are considered an excellence, it
> will deteriorate; but if by technique is understood clearness, beauty,
> simplicity, and compression in works of art, then, even if the elements

of drawing and music were not to be taught in the national schools, the technique will not only not deteriorate but, as is shown by all peasant art, will be a hundred times better [Fig. 119]. It will be improved, because all the artists of genius now hidden among the masses will become producers of art…

'It is impossible for us, with our culture, to return to a primitive state,' say the artists of our time. 'It is impossible for us now to write such stories as that of Joseph or the Odyssey, to produce such statues as the Venus de Milo, or to compose such music as the folk songs.'

And indeed, for the artists of our society and day it is impossible, but not for the future artist who will be free from all the perversion of technical improvements hiding the absence of subject-matter, and who, not being a professional artist and receiving no payment for his activity, will only produce art when he feels impelled to do so by an irresistible inner impulse.

The art of the future will thus be completely distinct, both in subject-matter and in form, from what is now called art. The only subject-matter of the art of the future will be either feelings drawing men toward union, or such as already unite them; and the forms of art will be such as will be open to everyone. And therefore, the ideal of excellence in the future will not be the exclusiveness of feeling, accessible only to some, but, on the contrary, its universality. And not bulkiness, obscurity, and complexity of form, as is now esteemed, but, on the contrary, brevity, clearness, and simplicity of expression. Only when art has attained to that, will art neither divert nor deprave men as it does now, calling on them to expend their best strength on it, but be what it should be – a vehicle wherewith to transmit religious, Christian perception from the realm of reason and intellect into that of feeling, and really drawing people in actual life nearer to that perfection and unity indicated to them by their religious perception. (pp. 175–80)

This emphatic rejection of acquired skills in favour of expression helped to pave the way to a new cult of subjectivity which Tolstoy would never have countenanced. In the context of the radical subjectivism preached by Zola and Gauguin 'expressive' was readily interpreted as self-expression, the defiance of tradition in order to shock, or at least to make an impact by doing the unexpected. Understandably the group of young artists who pursued this aim were dubbed 'the wild beasts' – *les Fauves* – though their leader Henri Matisse certainly did not fit the label. Commenting on their aims, Matisse emphasized that the starting point of Fauvism had been the courage to recover the purity of means. By purity he was alluding to the expressiveness of pure, luminous colour,

215

216

119. Details of sleeves from women's blouses from Soloiino, illustrated in S. Makovsky, *Peasant Art of Subcarpathian Russia* (Prague, 1926)

120. Ritual mask from Gabon. Musée National d'Art Moderne, Centre Georges Pompidou, Paris

121. Pablo Picasso, *Nude with Raised Arms (The Dancer of Avignon)*, 1907. Private collection

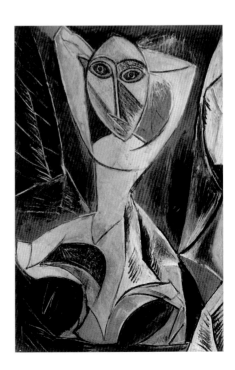

undimmed by the normal practice of shading to suggest volume. This, no doubt, they had discovered in Japanese and Islamic art, no less than from Gauguin.

The Discovery of Tribal Art

It is generally agreed that it was in these circles that 'Negro art' was discovered – first as collectors' pieces and soon also as striking motifs to be borrowed. In this respect it matters comparatively little whether it was Vlaminck who first purchased such a curiosity in the flea market (so he claimed), or whether Matisse had preceded him. In any case historians are agreed that the artefacts that first appealed to artists were ritual masks, like those from Gabon (Fig. 120), that came apparently from Vlaminck's collection. The radically simplified shapes and their sometimes arbitrary combinations resulted in an intense and intriguing expression that was bound to appeal to artists in search of striking effects.

I have sometimes in my writing referred to the observation, first made by Rodolphe Töpffer, that any visual configuration that is seen as a face will also be felt to have an expression whether intended or not. No doubt tribal artists who carved these masks may sometimes have intended a very different expression from the one we read into them, but no matter, here was a whole world of forms that Western art had neglected. It was finally Picasso's use of these masks in his *Les Demoiselles d'Avignon* that proved the effectiveness of those forms (Fig. 121).

Characteristically, however, Picasso himself is on record as having violently denied that he had resorted to this borrowing for formal reasons. He had clearly longed to escape his own insinuating style of the 'blue' period, which was not free from a touch of sentimentality, and he found this escape during a visit to the Ethnological section of the Trocadéro – at any rate Rubin is inclined to accept the account given to Malraux as authentic: 'When I went to the Trocadéro, it was revolting. A flea market! The smell! I was all alone. I wanted to get out. I didn't. I stayed there. I knew that it was vitally important: something was happening to me, was it not? ... All alone in that ghastly museum, with those masks, the red-skinned dolls, the dust-covered dummies. The *Demoiselles d'Avignon* must have come to me that very day, but certainly not on account of the forms: because this was my first canvas of exorcism, yes indeed!'[21]

Art or exorcism, voodoo was sufficiently far removed from the aestheticism of critics, whether traditional or progressive. Again we may remember Zola's founding document of modern art of 1866, where he writes: 'The word "art" displeases me. It contains, I do not know what, in the way of ideas of necessary compromises, of absolute ideals.'

In the Trocadéro Picasso had encountered artefacts which had nothing in common with the art he had been expected to practise under the tutelage of his father, a Professor at the Academy in Barcelona. They appeared to embody a mysterious menace or magic power which made all traditional works seem irrelevant. In short, I am inclined to accept Picasso's word that he did not

217

incorporate African masks in his composition 'because of the forms'. His assertion, or something like it, was no doubt aimed at the critics and historians, who wished to derive the movement of Cubism from African art.

This type of appreciation was certainly a departure from the traditional approach we found in J.P. Malcolm's history of caricature, which still lived on in such handbooks as Karl Woermann's six-volume art history (1900–11) which characterized African sculpture as follows: 'The imagination of the laughter-loving Negroes tends toward the grotesque, the comic, the weird. Their sculpture accordingly inclines to caricature, emphasizing the ugly, the abnormal, the indecent. Where wholly fantastic human images are created the intention to frighten, to create nightmares, no doubt also plays its part.'[22]

It was against this patronizing view that Roger Fry argued in his article on an exhibition of Negro sculpture: ' ... some of these things are great sculpture ... these African artists really conceive form in three dimensions (p. 100) ... the Negro scores heavily by his willingness to reduce the limbs to a succession of ovoid masses, sometimes scarcely longer than they are broad ... his plastic sense leads him to give its utmost amplitude and relief to all protuberant parts of the body and to get thereby an extraordinarily emphatic sequence of planes.'[23]

To those who accept this interpretation, the latest movement of primitivism was part of what Bernard Smith calls the 'formalesque' – the concentration on sculptural shapes, which we connected with the movement of 'truth-to-material'. We have seen that the author and organizer of the monumental exhibition of twentieth century primitivism follows a somewhat similar line. But surely, on William Rubin's own showing, 'conceptualization' was not what Picasso was after when he transformed the face of the prostitute into the semblance of a tribal mask. Here and elsewhere it seems to me that what the author describes as a 'fundamental shift' was not so much the result of an evolution as a radical revolt, a deep-going revolution destined to change the mental set with which art was intended to be perceived.

The Transformation of the Past

What Rubin described as 'the styles rooted in visual perception' were the styles aiming at an imitation of nature, an aim that had dominated the visual arts in classical antiquity, and again from the Renaissance to the Impressionists. The reaction of the Modernists also implied a rejection of the traditional interpretation of the history of the visual arts as a slow learning process, leading step by step to the successful evocation of appearances. Any deviation from this goal had to be seen as a lack of success, an unfulfilled promise for which allowances had to be made.

The preceding pages have amply shown, I hope, that the mental set did not prevent the more sophisticated among art lovers from preferring works which showed all the signs of effort to the fatal ease of accomplished mastery. Indeed

the 'awkwardness' of Botticelli, the refusal of Fra Angelico to go too far in the
rendering 'of the flesh' were experienced as those symptoms of spirituality which
endeared the so-called 'primitives' to the Victorians. But this benevolent tolerance
was limited to the Italian Masters whose contribution to the rebirth of the arts
had been foreshadowed by Giotto – the masters, that is, of the fourteenth and
fifteenth centuries – or, at the most, the second half of the thirteenth century,
the period of Cimabue and Nicola Pisano. What had gone before were the
Dark Ages, interesting to archaeologists but irrelevant to the tourist in search
of aesthetic enjoyment. I have quoted elsewhere[24] the comments made by the
nineteenth-century art historian Karl Schnaase on the bronze doors of San
Zeno in Verona (Fig. 122) – admittedly an extreme example: 'Here, for a fact,
we are confronted, with the extremes of shapelessness and ugliness. What one
might take to be the repulsive toys of vulgar boys or idols of some barbaric tribe
from the North Pole, if we did not spot the well-known sacred subjects. Even
the assumption that the sculptor intended to arouse terror by these extremes
of ugliness – the misshapen, dwarfish bodies and the enormous heads, the
gaping mouths and staring eyes – is an insufficient explanation … it is wholly
inconceivable that a man who was charged with such a commission could lack
all feeling, not only for beauty, but even for decency.'[25]

Contrast this verdict with the words of Max Hauttmann: 'An entirely novel
conception has broken with the vague existence of an ideal of beauty. The impact
of the images is entirely due to the intensity of a vision divorced from any spatial
framework.'[26]

A more objective appreciation was published by Albert Boeckler in
his monograph *Die Frühmittelalterlichen Bronzetüren*, who is aware of the
negative opinion of the nineteenth century, but is out to stress the subtlety of
psychological observations in the narrative scenes: 'The artist shows a remarkable
ability to visualize the scenes and enrich the account of the Bible with added
details.' He instances the man who, in his interpretation, 'turns in distaste from the
scene of the flagellation … moreover the master had a particularly sure instinct
for the expressive value of a gesture.'[27] Whether or not we share the author's
opinion, it surely exemplifies the change of mental set, a new willingness to make
allowances for distortions and to look for their positive value.

The selective attitude that had largely determined the purchases of museums
and the routes of travellers was bound to disappear with this transformation of the
mental set. Now distortion was seen as the result of expressive intention. Indeed,
it was the absence of such distortion, the 'photographic' rendering of nature,
which appeared to be devoid of all artistic value. Even historians of art who
chronicled the fact that mimesis had been the aim of certain traditions pleaded
for a revision of the history of art to take account of alternative aims. Objective
standards were now thrown to the winds in favour of the rejection of mimesis.

Perhaps the most influential of art historians to propagate this bias was the

220

122. *The Flagellation*, scene from bronze door,
San Zeno, Verona, 11th century

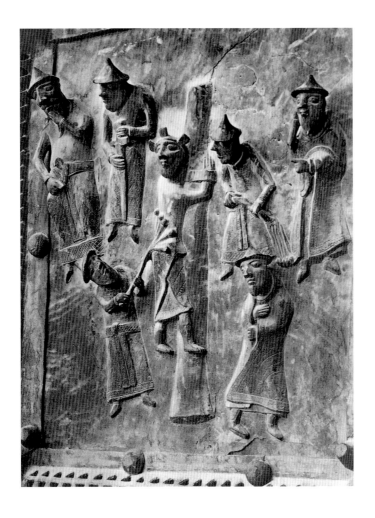

German, Wilhelm Worringer, whose book *Abstraction and Empathy*[28] (1908) grew out of his doctoral thesis written in 1906. Looking back after forty years at the origins of the book – a kind of manifesto of Expressionism – the author told of the remarkable fact that, like Picasso's conversion, the impulse to write it arose in him during a visit to the Trocadéro in Paris, that panoramic collection of artistic productions from all over the globe. There the young student of art history had perceived in a flash that the striving for mimesis, far from being the norm, was a very exceptional aim in world art. The pursuit of this aim that the Greeks had set to artists presupposed a civilization that was basically at peace with the phenomenal world. 'Primitive' man, so Worringer thought, was not granted this inner peace. He had learnt from Darwin that, for early man, reality must have been full of terror because what happened in the external world was wholly unintelligible to him. Hence what we call the 'imitation of nature' could not be the aim of their art – on the contrary, the signs and patterns which primitive man created were the result of his longing for permanence in the menacing flux of events: 'The pleasure they looked for in art was not that of contemplating the objects of the world but to prise them out of their apparent arbitrariness, to eternalize them by assimilating them to aesthetic shapes in order thus to find a still centre in the welter of appearances.'[29] We might say, to cast a spell on them, to render them innocuous.

In the account I mentioned, Worringer attributed his conversion to the dictates of the *Zeitgeist*. He claimed that, 'looking back, the compass needle of his instinct had been guided by the "Spirit of the Age". He had found unambiguous proof of the topicality of his views – views which he had merely intended to apply to the past – in the inspiration they provided on the battlefield of contemporary art.'[30]

Worringer was right that it cannot have been the content of this turgid book that secured its success. Its impact must have been due to the violent rejection of the demand for empathy that had dominated Western art for so long, and the plea that we must come to terms with the otherness of primitive styles which had been so thoroughly misunderstood. It was the same otherness that Picasso had intensely felt in the presence of the collection of tribal art at the Trocadéro.

When German artists and critics felt the need to describe that otherness more explicitly, they usually ended by resorting to the metaphysical vocabulary of the Neoplatonic tradition, attributing to the mode of art they hoped to emulate a revelatory character. 'Art', wrote Franz Marc in 1911–12, 'lies always in boldly striving for the greatest possible distance from Nature, it is our bridge into the world of the spirit, the necromantics of mankind.'[31]

By 1911 Worringer had advanced further and claimed he now found that 'otherness' not only in primitive art but in all significant products of 'Nordic man', that is in the whole of German medieval art. The opening chapter of his *Problems of Gothic Form* harks back to Riegl's rejection of skill as an explanatory

222

123. Detail of interlace from the Lindisfarne Gospels, British Library, London, Cotton MS. Nero D.IV, fol. 210b

124. Detail of altarpiece at Dettwang illustrated in Theodor Demmler, *Die Meisterwerke Tilman Riemenschneiders* (Berlin, 1936)

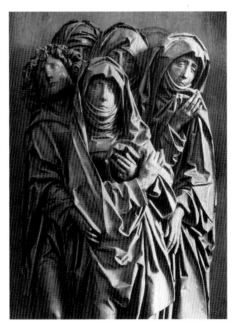

factor: 'It was really believed', he exclaims incredulously, 'that mankind had needed millennia in order to draw correctly, that is to say, to match natural appearances'.[32] Once this belief had been exposed as wholly erroneous, the reassessment of all values in art history was on its way.

This time Worringer does not go into the psychiatrist's consulting room for an illustration of the mentality of 'Nordic man', but appeals to an experience from daily life:

> When we take a pencil and scribble lines on paper, we can soon notice the difference between a kind of expression depending on us and the independent expressive character of lines ... If we feel a violent inner tension which we are only able to express on paper ... the pencil will mark the paper wildly and violently, and instead of the fine, rounded organically tempered curves, a rigid, angular, often interrupted harsh line, with the strongest expressive impact will result ... This difference between the beauty of expression and the power of expressiveness can be effortlessly applied to the contrast between classical and Gothic art. (pp. 33–4)

It will probably be clear to the reader that few if any works of medieval art fit this description of violent movement. In fact Worringer explicitly says that he refrained from using particular examples, but preferred to generalize as to the essence of medieval styles, which he connects with the intricate interlace of mythical creatures in the art of the migration period – more familiar to English readers from Anglo-Irish illumination such as the Book of Kells or the Lindisfarne Gospels (Fig. 123). To exemplify the survival of this tendency to linear tangles, the author refers to the drapery style of late Gothic sculpture of figures ensconced in ample garments with angular folds (Fig. 124).

Given the arbitrariness of this equation it is all the more remarkable to what extent Worringer's book succeeded in projecting a mental set on the study of medieval art which excludes comparison with nature and concentrates on expressive features as a symptom of emotional tension and religious ecstasy.

At the same time one cannot overlook the strong ingredients of chauvinism and racism that inform this book and were rarely quite absent from the utterances of German Expressionism. A statement from the German painter Emil Nolde is typical of this attitude:

> I was working on a book on the artistic expressions of primitive peoples (Kunstäusserungen der Naturvölker). I jotted down some sentences intended to be used as an introduction. (1912):
>
> 1. The most perfect art is found in classical Greece. Raphael is the greatest of all painters. This is what every art teacher told us twenty or thirty years ago.
>
> 2. Many things have changed since that time. We do not care for

Raphael, and the sculptures of the so-called classical periods leave us cool. The ideals of our predecessors are no longer ours. We are most fond of works which for centuries have been identified with the names of great masters. Artists wise in the ways of their times created sculptures and paintings for palaces and Popes. Today, we admire and love the simple, monumental sculptures in the cathedrals of Naumburg, Magdeburg, or Bamberg, carved by self-sufficient people working in their own stone yards, people of whose lives we know little, whose very names have not survived …

4. Not too long ago, the art of only a few periods was deemed worthy of representation in museums. Then others were added. Coptic and Early Christian art, Greek terracotta and vases, Persian and Islamic art swelled the ranks. Why then are Indian, Chinese and Javanese art still considered the province of science and ethnology? And why does the art of primitive peoples as such receive no appreciation at all?

5. Why is it that we artists love to see the unsophisticated artifacts of the primitives?

6. It is a sign of our times that every piece of pottery or dress or jewellery, every tool for living has to start with a blueprint. Primitive people begin making things with their fingers, with material in their hands. Their work expresses the pleasure of making. What we enjoy, probably, is the intense and often grotesque expression of energy, of life.

These sentences reach into the present, and perhaps even beyond it. The fundamental sense of identity, the plastic-colourful ornamental pleasure shown by 'primitives' for their weapons and their objects of sacred or daily uses are surely often more beautiful than the saccharinely tasteful decorations on the objects displayed in the show cases of our salons and in the museums of arts and crafts.

There is enough art around that is over-bred, pale and decadent.

This may be why young artists have taken their cues from the aborigines.[33]

This piece was written in the same year as *The Blue Horseman* (*Der Blaue Reiter*), the manifesto of German Expressionism that made such a considerable éclat in 1912, where we read in the contribution from August Macke: 'To hear the thunder means to feel its mystery. To understand the language of forms means: to be closer to their mystery, to live. Are not children creators who create directly out of the mystery of their emotions – more so, than the imitators of Greek forms – are not the savages artists who have their own forms, powerful like the sound of thunder, thunder like every flower, every force is expressed in form?'[34]

As far as this means anything, it appears to say that what counts for the Expressionist in forms – natural or created ones – is their effect on him. The very

comparison Macke uses excludes any rational idea of communication and, as we have seen, the elimination of intention also marginalizes the traditional notion of skill.

It fits in well with Macke's attitude that the authors of this manifesto also included in the almanach illustrations of a heterogeneous variety of images that they invoked as examples and justifications of their departure from nature. In the second edition of this almanach, a year later, Franz Marc wrote: 'We took our divining rod through the arts of the past and of the present. We only showed what was alive, what was untouched by the tyranny of convention. We surrendered lovingly to every kind of art that arises out of itself ... that can dispense with the crutch of habit ... we opposed whole centuries with a "No!"' (p. 56) (Fig. 125).

225 What Marc calls his 'divining rod' is precisely what we wish to describe as a novel mental set that looked at the whole of mankind's artistic heritage in search of intense expressiveness.

When Hans Tietze (whom I still count among my teachers) reviewed this publication, he singled out this tendency for critical comment. He regarded the search for allies from the past as proof that this movement did not really aim at something radically new, but continued the threads 'that lead back to the darkest depths of mankind, exotic works of genuine savages, the intense devotion of Gothic sculpture, the mystical art of El Greco, and in particular, the products of all kinds of folk art, which must testify to the fact that illusion was not always the aim ... that it had been the purpose of art before, and beside, to aid the manifestation of that mysterious power which rules our human emotions' (Fig. 126).[35]

Though Tietze had a good deal of sympathy for the Expressionist movement, he rightly objected to this invention of ancestors. But he admits that the very possibility of interpreting works of the past in this way demonstrates 'that there are treasures there which we have neglected so far, and that the new movement restores values which have been so thoroughly forgotten that they must first be won back again' (p. 548).

The technique pioneered by the *Blaue Reiter* almanach of juxtaposing a motley selection of exotic and primitive images next to the recent creations of Expressionist artists proved immensely effective as a means of propaganda. Its potentialities were soon discovered by the producers of art books, which came into vogue in the inter-war period. Technical improvements in the reproduction of photographs had added to their popularity, and it was in the illustration of expressive details that the real or pretended kinship of the moderns and the ancients was presented to the public.

In a book on the expression of emotion in ancient sculpture,[36] the great archaeologist Waldemar Deonna demonstrated to what extent the photographer is able to manipulate and modify this expression simply by changing the angle and

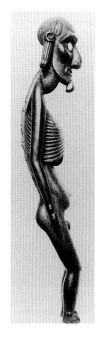

226

125. Sculpture from Easter Island, from Franz Marc et. al.,
Der Blaue Reiter (Munich, 1914)

126. Bavarian glass painting, from Franz Marc et. al.,
Der Blaue Reiter (Munich, 1914)

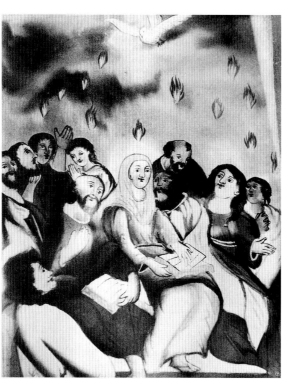

227

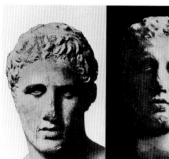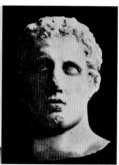

127. Photographic manipulation of a portrait of Agias of Delphi, 4th century BC, from Waldemar Deonna, *L'Expression des sentiments dans l'art grec* (Paris, 1914)

128. Head of the prophet Jonas, Bamberg Cathedral, from Max Dvořák, *Kunstgeschichte als Geistesgeschichte* (Munich, 1924)

129. Niche showing the prophets Jonas and Hosea, 1200–10, Bamberg Cathedral

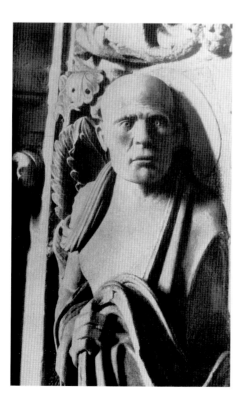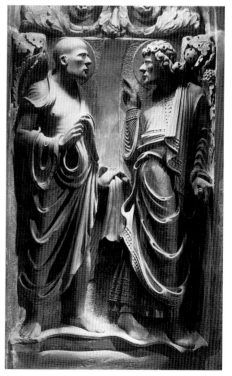

228

130. African mask from Wilhelm Hausenstein, *Barbaren und Klassiker* (Munich, 1923)

131. Torso from Ecuador, located in Chicago, Field Columbian Museum, from Wilhelm Hausenstein, *Barbaren und Klassiker* (Munich, 1923)

the lighting (Fig. 127). In this way illustrations were enabled to match the singularly ecstatic texts of the propaganda of Expressionists. Figure 128 is taken from Max Dvořák's posthumous book *Kunstgeschichte als Geistesgeschichte* (1924). It shows the head of the prophet Jonas, from Bamberg cathedral, with a hypnotic stare that much impressed me when I first read the book. I confess that when I later visited the cathedral I was disappointed to see that that view was impossible to obtain from the ground (Fig. 129). In fact I still wonder how the photographer squeezed his camera to the side to achieve this transformation.

I would not wish to place Max Dvořák's searching article on 'Idealism and Naturalism in Gothic Art' on a level with Worringer's effusions, but it is worth recording that he felt the need in the opening pages to refer to the 'favourable reception' that this 'brilliantly written' book had been accorded because 'it appeared to lift the veil behind which the world of medieval art had been previously hidden from the eyes of modern beholders'.[37] While he refers to the arbitrariness of Worringer's construction, he concedes that he was able to bring certain important aspects of medieval art closer to our understanding, and that no doubt he wished to refer to the artistic conception of a high spiritual power that dominates all events, which occasionally results in a harsh contradiction between the psychological and the physical aspects that must look to the modern beholder absurd and barbaric.

It was Dvořák's conviction that the contradiction was slowly eliminated in the course of the development of Gothic art, without however discarding what he calls the 'psychocentric conception of existence' (pp. 97–8). It is this ineradicable spiritual element which the photographer of the prophet Jonas brought out through the hypnotic look of his eyes.

The techniques used in Wilhelm Hausenstein's book *Barbaren und Klassiker*[38] of 1923 are less extreme, but the effect of his mixture of examples ranging from an African mask (Fig. 130) to a torso from Ecuador (Fig. 131) is again that of wrenching these works out of their cultural context in the interest of approximating them to the creations of twentieth-century art. The title of one such anthology, Ludwig Goldscheider's *Zeitlose Kunst* (*Art without Epoch*) (1937),[39] sums up the intended effect of the intermingling of tribal images with the most sophisticated creations of European and Western art (Figs. 132 and 133). The past master of these magical tricks was, no doubt, Christian Zervos, whose series of folio volumes began in 1935 with his photographs of early Mesopotamian art from the Louvre which strikingly recall the œuvre of Picasso (Fig. 134). His book on Catalan art was even more effective in the choice of memorable details (Fig. 135); or take his illustrations of Cycladic idols, cunningly animated and individualized by clever lighting (Fig. 136), which again approximate the ritualistic figurines to the work of modern primitivists.

No doubt it was this kinship that conditioned the public to respond to these images of a long forgotten culture with such immediacy. They were no longer

229

230

132. Portrait of Bishop Wolfhart Roth, 1302,
Augsburg Cathedral, from Ludwig Goldscheider,
Zeitlose Kunst (Vienna, 1937)

133. Yoruba mask, Upper Guinea, from Ludwig
Goldscheider, *Zeitlose Kunst* (Vienna, 1937)

231

134. Head of a marble idol found in Antiparos,
from Christian Zervos, *L'Art des Cyclades* (Paris, 1957)

135. Vase in the form of an angel, Louvre, Paris,
from Christian Zervos, *L'Art de la Mésopotamie* (Paris, 1935)

136. Virgin fresco from Apse of S. Clement de Tahull, 1123,
Musée d'Art de Catalunya, from Christian Zervos, *Catalan
Art from the Ninth to the Fifteenth Centuries* (London, 1937)

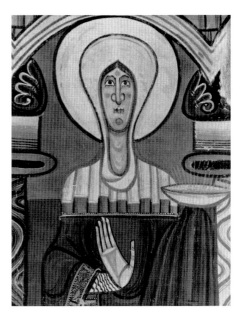

232

137. Illustration from Ludwig Münz and Viktor Löwenfeld, *Plastische Arbeiten Blinder* (Brunn, 1934)

138. Pre-Romanesque art: a capital from Payerne, Switzerland, and a capital from a church in Poitiers, from André Malraux, *Le Musée imaginaire*, trans. Stuart Gilbert, 'Museum without Walls' in *The Voices of Silence* (London, 1954)

PRE-ROMANESQUE ART: CAPITAL (PAYERNE, SWITZERLAND)

CAPITAL FROM POITIERS CHURCH

seen as archaeological remains but appeared to be charged with emotional content that directly addressed the beholder. The feeling arose that these visual images told us more about distant ages than we could ever learn from the study of texts.

It may not be quite easy for the present reader to appreciate the urgency these issues acquired in the period under discussion, since the Expressionist wave never engulfed the Anglo-Saxon world as it did post-war Germany. Having spent my formative years in this atmosphere I can testify to the heady enthusiasm which arose from the conviction that we had only to surrender to the impression the art of the past made on us to gain an intuitive contact with the life of bygone centuries.

233

Among the factors that caused my disillusionment was the publication, during my university years, of a book by Victor Löwenfeld and Ludwig Münz on *The Sculpture of the Blind*.[40] The plates of this striking publication showed extremely expressive heads and figures modelled by blind artists out of plasticine (Fig. 137). But the critical viewer was bound to ask himself to what extent the response of a sighted beholder corresponded to the intention of the blind artist. Once the question was raised it would not go away so easily. For could it not be generalized and applied to the shapes and colours that attract us in the products of exotic craftsmen or those of children? It was a doubt that struck at the very foundation of the Expressionist creed, for ultimately the creed postulated the equation of expression with communication.

We can still feel the importance of this issue for true historians such as the great Ernst Robert Curtius, who was moved to insert a heartfelt protest against this kind of shortcut in his book *European Literature and the Latin Middle Ages*: 'Knowing pictures is easy compared with knowing books. Now, if it is possible to learn the "essence of Gothic" from the cathedrals, one need no longer read Dante. On the contrary! Literary history … needs to learn from art history'.[41]

Nobody understood the problematic fascination of this new genre better than André Malraux, who yet used it to create his *Musée imaginaire*[42] – witness two plates from the book (Fig. 138) which transform the rather crude handiwork of medieval stonemasons into images of astounding modernity. As I have shown elsewhere,[43] Malraux knew precisely what he was doing. He deliberately replaced the past by what he called a 'myth' – indeed he went further, and claimed that the myth is all we can ever know of the past. Considering the period in which Malraux wrote we must not interpret the term 'myth' which he uses as meaning simply an untruth: Expressionism has surrounded this term with a special awe – what A.O. Lovejoy so fittingly described as 'metaphysical pathos'. Myth was close to mystery and mysticism, a hinting at a profound truth inaccessible to mere rational discourse. As we have seen, the same can be said about the term 'art', which was all but identified with a numinous voice from the depths, even if what it revealed was – a myth.

234

The Lure of Regression (1)

The notion of the 'primitive', as we have seen, derived its meaning from the idea of *progress*. The value attached to this idea has changed radically in the twentieth century, but this need not prevent us from recognizing the progress of technology, of science, and also warfare as inescapable aspects of our civilization. Nor can we deny the fact that individual members of our society are capable of making progress through the process of education and training. What we have learnt to our cost is only that these acquisitions tend to be less stable than was once hoped. The influence of strong passions, of strong drinks or states of collective madness can cause almost anybody to lose control of himself and return to a more primitive state.

235

Psychoanalysts speak in this context of our liability to *regress* to earlier stages of development in which we are no longer masters of ourselves. The most common of these phenomena is the dream, which Freud believed to be dominated by what he called the *id*, the most primitive layer of our mental life, identical with the instinctive drives which might also manifest themselves in insanity. It is well known that Freud regarded it as his mission to strengthen the forces of control, which he called the *ego*, over the anarchic tendencies of the unconscious, the *id*. As he put it at the end of his book on *The Ego and the Id*: 'Where there is *id* there must be *ego*, it is work for culture like the draining of the Zuider Zee.'

The strength Freud attributed to the influence of the unconscious radically changed the conception of the human mind and appeared to throw new light on phenomena previously considered mysterious. I am referring to the widespread belief in 'possession', which most ancient civilizations associated with the gift of prophecy and also with poetry. From what we know of these manifestations it appears that they involved deliberate states of regression induced by drugs, fumes or perhaps autohypnosis. None other than Plato believed that real poetry could only arise from such states of possession by the gods, and that it was in vain for anyone to write verse without the supernatural aid of inspiration. Poetry, in other words, was a kind of divine frenzy akin to madness.

The poets' creations, therefore, could hardly be called intentional. They flowed from an inner compulsion that eluded their maker's awareness. I am well aware of the fact that even in the visual arts the artist's conscious intention plays at best only a limited role. Whether he draws, paints or models in clay, the product of his hands will always tend to run ahead of his intention and require control by feedback. Yet, however complex this interaction may be, we know that in the majority of visual styles the artist remains firmly in charge, and ends up at least with the kind of image he had been required to create. Hence it turns out that the history of painting and sculpture offers comparatively little scope to the application of psychoanalytical interpretation. But there are exceptions, exceptions which appear to be governed by chance rather than by intention. Among them

we may count the art of children who have not yet acquired the skill to control their hand and their eye.

This at any rate was the opinion of William Hogarth, who went out of his way to distinguish such images of chance from those created by 'design', in both meanings of the term. As the leading purveyor of pictorial satire, Hogarth was irritated with the rising popularity of the genre of caricature, the comic portraits often produced by amateurs. He compared 'the fashionable genre of caricaturing' to the 'early scrawlings of a child':

> ... that which has of late years got the name of caricature, is or ought to be totally divested of every stroke that has a tendency towards great Drawing: it may be said to be a Species of Lines that are produced rather by the hand of chance than of skill: for the early scrawlings of a Child which do but barely hint an Idea of an Human Face, will always be found to be like some person or other, and will often form such a Comical Resemblance as in all probability the most eminent Caricaturers of these times will not be able to equal with Design, because their Ideas of objects are so much more perfect than children's that they will unavoidably introduce some kind of Drawing.
> For all the humorous Effects of the fashionable manner of caricaturing chiefly depend on the surprize we are under at finding ourselves caught with any sort of Similitude in objects absolutely remote in their kind. Let it be observed the more remote in their Nature the greater is the Excellence of these Pieces.[1]

The grudge which Hogarth bore caricaturing did not prevent him from anticipating, to a certain extent, the theory of humour Freud was to develop in his book on the verbal joke. These jokes, Freud thought, are the product of momentary surrender to the workings of the unconscious – in other words, to deliberate regression – or, as he put it, 'regression in the service of the ego'. What looks superficially like the kind of nonsense we may remember from dreams reveals an element of aggression or sexual innuendo that serves the speaker's intention. 'If you want to succeed as a caricaturist', Hogarth tells his countrymen, 'you must either lack any skill in drawing or at least jettison your skill and return to the stage of an untutored child.' Or, as Baudelaire was to put it: 'l'enfance retrouvée à volonté.'[2]

'Get rid of your skill, of all you have learnt.' We have seen that Hogarth's and Baudelaire's message certainly appealed to the twentieth century, and to no one more than to Pablo Picasso, whose art may serve us again as a paradigm. One of the best authenticated remarks by Picasso fits in well with Hogarth's views. Visiting an exhibition of children's drawings he said to his companions – who included Herbert Read: 'When I was a child I drew like Raphael. I have been trying to draw like these children ever since.' We do not have to take his remark

236

quite literally to catch its meaning. Picasso may not have drawn like Raphael as a child, but he had been thoroughly trained by his father in the academic tradition, a training he increasingly felt to be a burden in his search for originality and novelty.

In the enormous corpus of Picasso's drawings there is perhaps only one that genuinely resembles a drawing by a child (Fig. 139). It occurs among the sketches for the mural of *Guernica* he composed in 1937 for the Spanish Government Pavilion of the International Exhibition in Paris, when the wanton destruction of the small Basque town by German bombers was still in everybody's mind. Tracing the growth of his thought through many of his dated sketches has become a favourite exercise of art historians. His first idea, not surprisingly, harked back to a number of anti-Franco prints he had made earlier in the year (Fig. 140). His mural was to symbolize the Civil War in the fairly obvious emblem of a bullfight, something a newspaper cartoonist might also have done. The ultimate triumph of Good over Evil was to be symbolized by the soul of the gored horse, which escaped on its wings (Fig. 141) and which, in another rapid sketch, can be seen to perch on the back of its assailant (Fig. 142).

Picasso had often painted and drawn bullfights before, and he had the theme of the dying horse at his fingertips. Some of these compositions reach an intensity and poignancy in the image of the rearing creature in its death-agony that shows how much this theme must have meant to the artist. He clearly wanted to use this invention again, as is shown in another sketch for *Guernica* (Fig. 143), but he must have discarded it in exasperation. What he drew then was really a childish scrawl of a horse. It became the starting point at first for an even wilder distortion, which appears as an utter rejection of the skill that had crystallized in the earlier images.

I hope I am not over-interpreting if I suggest that Picasso tried to revert to primitive elementals precisely because he found his skill obtrusive. He wanted to get away from what threatened to become a somewhat facile stereotype – he wanted to learn from the methods of the child. His fury and grief at the violation of his country may have demanded from him something more genuine, more intense, than the repetition of a symbol, however moving. He returned from this effort with a new image of the dying horse, more naturalistic than the childlike scrawl though less so than the earlier version. It is not the least moving aspect of this search for an expressive symbol to communicate his grief and anger that in the end Picasso reverted to his earlier invention. He must have felt that he could not better it, and that the painting as such had meanwhile become so charged with strong and elemental emotions that he could afford this self-quotation.

Strangely enough, it turns out that Picasso, in his regression to child art, had a predecessor in none other than Michelangelo. 'Once in his youth', we read in Vasari: 'Michelangelo and some of his painter friends wagered a dinner to be stood to the winner in a competition for doing a figure completely devoid of

237

238

139. Pablo Picasso, sketch for *Guernica*, 1 May 1937.
Centro de Arte Reina Sofia, Madrid

140. Pablo Picasso, *The Dream and Lie of Franco*, 1937.
Etching and aquatint

239

141. Pablo Picasso, sketch for *Guernica*, 1 May 1937. Prado Museum, Madrid

142. Pablo Picasso, sketch for *Guernica*, 1 May 1937. Centro de Arte Reina Sofia, Madrid

143. Pablo Picasso, sketch for *Guernica*, 1 May 1937. Centro de Arte Reina Sofia, Madrid

240

144. Michelangelo, manuscript of poem no. 5 with
self-portrait, Casa Buonarroti, Florence

145. Albrecht Dürer, detail of letter with sketch, illustrated
in K. Lange and F. Fuhse, *Dürers Schriftlicher Nachlass*
(Halle, 1893)

draughtsmanship, one as clumsy as the mannikins scrawled by the ignorant who deface walls. It was here that his memory stood him in good stead, for he remembered having seen such a scrawl on a wall and he perfectly imitated it as if he had it in front of him, thus surpassing all the other painters ... a difficult feat', Vasari adds, 'for a man so steeped in design'.[3]

We have not got this prize-winning drawing by the great master, but we have at least his illustration of a humorous sonnet, in which he describes the aches and pains he had to suffer when painting the Sistine ceiling (Fig. 144). The large figure he represents himself as drawing is a primitive scrawl, not unlike the one described in Vasari's anecdote. If Vasari was right that it was quite indistinguishable from any clumsy scrawl by a child, it would only acquire interest or value if we knew it to be by Michelangelo. The joke rests on the comparison. I believe we have a little parable here of the problem of primitivism in art. In a joke we often relax our standards and return to more primitive ways. When Albrecht Dürer sent a chaffing letter from Venice to his friend in Nuremberg, he wrote: 'My panel sends its regards' and scrawled a funny head (Fig. 145).[4] It may not look quite like a child's drawing, but nearly so. Dürer's scrawl fits well with Freud's account of 'wit': the artist relaxed controls in the service of lighthearted chaff. For Picasso, the procedure was far from lighthearted. For him the intentional discarding of skill was a means of exploring strong effects that he felt to be beyond his conscious reach.

I have chosen these episodes of artists consciously resorting to regression as a paradigm, since they so vividly illustrate the transformation of humour into a device of passionate seriousness. That development appears to be of sufficient relevance to our topic to warrant a flashback tracing the transition from what I have called the 'zone of licence' to out-and-out regression witnessed in contemporary art.

241

242

The Lure of Regression (2)

From the Margin to the Centre: The rise of nonsense imagery

For Hogarth caricature was beyond the pale of art precisely because it achieved its aim unintentionally. The theoretical discussion of unintentional effect had to wait for the nineteenth century. I am referring once more to Rodolphe Töpffer, whose *Essai de physiognomie*[1] shows for the first time what the unintended image could teach the artist. Let him scrawl a face in any way and he will find he has created an expressive physiognomy to which he will respond as to a living character (Fig. 146). Töpffer extended this method of suspending conscious controls also to the humorous picture stories which he derived from his 'doodles'.

In a series of episodes from his *Dr Festus* of 1828[2] (Figs. 147 and 148) we see the hero seeking refuge from the pursuit of armed forces in a windmill, clinging on to one of its wings, predictably followed by the whole group, which is hurled into the air as the wings begin to turn, which also causes a herd of pigs to levitate, while the next sequence (Fig. 149) shows their descent after three weeks. In another episode a giant telescope, which had travelled through the air, finally splashes down (Figs. 150–2). We see the dream-like, but also the dream, where the Mayor enjoys his favourite fantasy of being in charge of a model commune, sitting on 26 volumes of files regarding the acquisition of three wells and similar major transactions (Fig. 153); after which he sees a set of minutes six feet long dancing a jig with the Goddess of Justice, who has meanwhile entrusted him with her scales (Fig. 154). He subsequently sees 300 hussars with peacock feathers behind their ears chanting the five lawbooks to the tune of *Marlborough s'en va t'en guerre* (Fig. 155); and then 3,504 legal texts, as yet unknown to him, boiling in a basin of parchment, while 62 clerks lick at the sides to catch the soup trickling down (Fig. 156).

In these funny picture stories, which were admired by none other than Goethe,[3] the doodle had graduated from a private indulgence to a genre of humorous art, the 'comic'. Needless to say, this further step from the margin to the centre also presupposed a shift in the demands and preferences of readers and the book-buying public. For not only did the age of Romanticism set a special premium on flights of fancy, it also witnessed the coming of a special literature for children and for family entertainment, soon to be satisfied by a number of serial periodicals.

In this kind of literature the nonsense imagery cultivated by Töpffer could settle down to a cosy existence. So widespread became this cult of whimsy and nonsense in Europe that we may be entitled to speak of a kind of proto-surrealism which enjoyed great popularity, though it was not yet admitted into the central sanctum of art.

One of the most characteristic of these works is a volume of 1844 by the French lithographer Jean-Ignace Gérard, who worked under the pen-name of

243

Voici Jean qui pleure, et il est trop juste qu'il s'y prenne tout au rebours:

146. Rodolphe Töpffer, doodle heads,
from *Essai de physiognomie* (Geneva, 1845)

147. Rodolphe Töpffer, refuge in windmill,
from *Dr Festus* (Paris, 1828)

148. Rodolphe Töpffer, hurled into the air,
from *Dr Festus*

149. Rodolphe Töpffer, descent after three weeks,
from *Dr Festus*

245

150. Rodolphe Töpffer, giant telescope,
from *Dr Festus*

151. Rodolphe Töpffer, travelling through air,
from *Dr Festus*

152. Rodolphe Töpffer, crashing down,
from *Dr Festus*

246

153. Rodolphe Töpffer, Mayor and commune,
from *Dr Festus*

154. Rodolphe Töpffer, dancing a jig,
from *Dr Festus*

155. Rodolphe Töpffer, chanting hussars,
from *Dr Festus*

156. Rodolphe Töpffer, boiling parchments,
from *Dr Festus*

Grandville. His sumptuously produced volume *Un autre monde* (Fig. 157) was in fact rediscovered by the Surrealists and frequently pillaged. The title may remind us of that ancient nonsense motif, the world-turned-upside-down, but some of the illustrations show a remarkable insight into the mechanisms of the dream, that source of all nonsense imagery. My late friend, Ernst Kris, who combined the study of psychoanalysis with the study of art, was delighted by an image of the dream: the metamorphoses of a night-light into a cupid's bow and a bird, above, and beneath, into a vase-and-flower, which turns into a woman, whose form finally trails off into that of a serpent (Fig. 158). Rapidly looking through the volume, we discover that metamorphosis is indeed the keynote of Grandville's invention: there is the ghost-like scene of a ballet danced by crabs and insects (Fig. 159), and a second act where hands without bodies – partly lobster claws or paws – furnish the applause (Fig. 160). In another famous scene a beautiful lady in a box at the Opera is ogled by a sea of eyes (Fig. 161); and there are the highly original sketches of birds-eye views of street scenes (Fig. 162) showing the world, if not upside-down, at least from up to down.

Grandville may have been the leading proto-surrealist, but he was by no means the only one. It is likely that he knew Töpffer, as we might infer from his versions of aerial travel, but most of all he must be seen in conjunction with the mainstream of graphic humour, that is, with the arts in England.

I am thinking in particular of England's leading graphic humorist of the early nineteenth century, George Cruikshank. Cruikshank never reached the high level of achievement that Grandville did in some of his works. Indeed, his sketches are likely to come as an anticlimax after the impact of *Un autre monde*, but I would argue that he inhabited the same world. He was in fact eleven years older than Grandville, but survived him by many decades. The son of a well-known caricaturist, he started work in this field as a mere boy and kept up an enormous output of book illustrations and humorous sketches for most of his life. Perhaps the most characteristic of his works, however, are albums of humorous fantasies for family entertainment, with no more than brief explanatory captions in which he followed his free associations. A page from the album of *Scraps and Sketches* (Fig. 163), dating from 1831, shows him playing the game of animation with that old-fashioned instrument of the English fireplace, the bellows.

An illustration from *Un autre monde* by Grandville, dating from thirteen years later, is not the only one which suggests that Grandville had looked to his English counterpart, but here Cruikshank is decidedly wittier and more imaginative. In the eight or nine variations on his simple theme, the bellows consults the doctor because it feels so puffed up, finds a rival in the tea-kettle who sings better and applauds it rapturously, is turned into a guitar and takes part in drunken revels. A faint sketch, below the picture of the medical consultation, shows how to compose a woman from four pairs of bellows.

Many of these sketches start off from a conventional topic of humorous satire,

248

157. Grandville, title page,
from *Un autre monde* (Paris, 1844)

158. Grandville, metamorphosis,
from *Un autre monde*

249

159. Grandville, ballet of crabs,
from *Un autre monde*

160. Grandville, hands without bodies,
from *Un autre monde*

161. Grandville, beautiful lady, from *Un autre monde*

162. Grandville, birds-eye view, from *Un autre monde*

251

163. George Cruikshank, bellows theme, from *Scraps and sketches*, 1831

164. George Cruikshank, ladies' bonnets,
from *Scraps and Sketches*,1831. British Library, London

165. George Cruikshank, odd fish,
from *Scraps and Sketches*

252

such as the follies of fashion – ladies' hats offering an inexhaustible subject. The centre of the page shows milliners engaged in bonnet building, while marginal sketches show some humorous incidents: a guard who has to lift a hat over some gates, a coach purpose-built for a hat, a view of hats in church, and, closer to wild fantasy, the *Fatal effects of tight lacing and large Bonnets (a cutting Wind)* (Fig. 164). Another page (Fig. 165) shows fantasies on the theme of odd fish: duelling swordfish above, on the left, a family of fish; and the fancy-dress ball of the moon and the globe, which could have found a place in *Un autre monde*.

The next two pages are from a similar publication entitled *My Sketchbook*. Again the central scene on the motif of *Ugly Customers* (Fig. 166) is rather conventional, but the ghostly scene in the right upper corner is a good exercise in flesh-creeping humour. There are also full pages in which Cruikshank's comment is given more scope, such as the famous one on the expansion of London: *London going out of Town, the March of Bricks and Mortar* (Fig. 167), where the haystacks of the countryside retreat in panic from building tools advancing under a black cloud belching from the smoking chimneys; or contrastingly, the fanatical teetotallers' vision of the cult of vice in the city: *The Fiends' Frying Pan or Annual Festival of Tom Foolery and Vice under the Sanction of the Lord Mayor and the Worshipful Court of Aldermen* (Fig. 168).

Like most humorous artists, Cruickshank harnessed his fertile imagination to the service of causes, social and political, but my earlier examples have no such purpose: nonsense had become an acknowleged category of harmless fun.

I should like to introduce another representative of that Victorian genre, who had a considerable reputation in his day, but whose chief contribution to nonsense humour is still unpublished. Richard Doyle (1824–83) was a prolific illustrator, but only one or two pages of the album of drawings dating from 1842, entitled *A Book Full of Nonsense*, have ever been reproduced. Dickie Doyle (as he was generally known) was of Irish Catholic extraction, and was the son of John Doyle, the most successful political cartoonist of his day, who signed his rather uniform lithographs with the invented initials 'H.B.'

John Doyle's children had intensive tuition in art and music, but their father frowned on any conventional academic training in the arts. The *Book Full of Nonsense* dates from Dickie's twentieth year and shows him in full command of his skill.

The title page (Fig. 169) introduces the reader to the main methods of this product of a freewheeling imagination. Dickie shows himself drawing an exceedingly pompous lion, adorned, among other decorations, with a Golden Fleece – an order never worn by a British sovereign. The goblins swarming round the painter's chair exploit the effects of contrast in scale, and their antics repay scrutiny: they fight in the air and carry a resisting Turk along, and down by the legs of the chair a damsel is abducted on a horse. Underneath, the scene changes even more surprisingly: a man appears to have fallen from a horse and the

253

166. George Cruikshank, *Ugly Customers*,
from *My Sketchbook*, 1834

167. George Cruikshank, *The March of Bricks and Mortar*,
from *My Sketchbook*

168. George Cruikshank, *Fiend's Frying Pan*,
from *My Sketchbook*

incident is watched by a crowd, while on the right there appears to be an open prison door from which there emerge a number of ruffians, but also a figure holding the cap of Liberty on a staff. It is the only straight political motif I could discover.

There are some seventy pages in this book, full of extraordinary incidents which follow each other with dream-like inconsequence. As with doodles, which these drawings resemble, one can detect recurrent fantasies and insistent variations on common themes, though there is no narrative thread to hold them together.

The setting is that of romance and tales of chivalry, of goblins and fairies, of evil ogres, of crusades against the infidel, and idyllic love. Walter Scott certainly fired the artist's imagination and Romanticism was in the air.

The second page of the book (Fig. 170) shows one of the typical ogre figures: he wears something that looks suspiciously like a cardinal's hat – I say suspiciously, because the artist was, and remained, a loyal son of the Church and actually refused to work for *Punch* when the policy of that paper turned too anti-clerical for his liking. We cannot tell who the unfortunate victims are who are being dragged through the air towards the ogre. Even more mysterious is the top-hatted man whose chariot, if you call it so, is pulled along by unfortunate prisoners. The crowd appears to be pointing to a picture, while high aloft there are horsemen fighting, not to mention other incidents. The next verso page is one of the few more unified compositions in the book. This time a cruel king, who is enthroned high up on a cliff, apparently commands his prisoners to be lowered painfully towards the sea, where demons await them; one of the damsels is seen to faint.

Among recurrent motifs we especially recognize the over-life-size symbol of power which is both dreaded and mocked. Page 12 seems to me most characteristic, with the men above saying 'boo' to the lion – something that sums up Dickie's formula of humour. The huge pagoda man below being again dragged by slaves directed by another stock figure, a top-hatted man, gives us another glimpse, and so do the scenes of battle and of wooing in between.

Doyle may have started the album with the idea of publishing it in the vein of Cruikshank's *Scraps and Sketches*, but must have abandoned this plan if it ever existed. He possibly realized that some of his sadistic and erotic fantasies went a little too far for it to be accepted.

Not that he could not make the step from his fantasy life to images sure of social acceptance. If any work of Victorian graphic humour can be documented to have found acceptance with a wide public for many generations, it is the cover of *Punch* (Fig. 171), which remained unchanged till long into the twentieth century. It is of course also the work of Dickie Doyle, dating from 1844, two years after the *Book of Nonsense*. Punch is seen to have portrayed the dog as King of the Beasts. One of Dickie's fairies descends from above, while goblins busy themselves around the palette under the chair. Analysing the teaming clouds of

256

169. Richard Doyle, title page from album of drawings, *A Book Full of Nonsense* (1842). Victoria and Albert Museum, London

170. Richard Doyle, *Ogre Figures*, from *A Book Full of Nonsense*

257

171. Richard Doyle, cover illustration for *Punch*
(London, 1844)

172. Richard Doyle, design for Dicken's *Chimes*
(London, 1845)

173. Richard Doyle, drawing for Oliphant's *Piccadilly*, (Edinburgh and London, 1871)

elves and imps, we still find many of the favourite motifs of Doyle's doodles, but they are now placed in the service of what might be called Victorian whimsy. As a method of visualizing the inner world of a troubled mind they served the artist well when he illustrated the work of a master, *The Chimes* (1845) by Dickens (Fig. 172), or *Piccadilly* (Fig. 173), a satirical novel by Laurence Oliphant, in which the hero who contemplates suicide is seen surrounded by his temptations and fantasies.

The full transition from dream-like regression to imagery still required the sanction of a literary text, but only just, for I need hardly remind the reader of Edward Lear – the painter of birds and topographical landscapes – whose *Book of Nonsense*, published in 1846, was written for the children of his patron. Lear knew how to combine his childlike scrawls with his limericks, which made children laugh, though the sophisticated adult may discover the sadness beneath the surface.

We may be reminded of Kafka's nightmare story in this lighthearted jingle:

> There was an Old Man who said 'Well!
> Will nobody answer this bell
> I have pulled day and night
> Till my hair has gone white
> But nobody answers this bell!' (Fig. 174)

Nor is it difficult to detect the double-edged humour of the comic in his drawing of *Nastiscreechia Krorluppia* (Fig. 175), the nasty creatures crawling up a stem.

I shall not dwell at length on the master of Victorian nonsense, Lewis Carroll, whose volume *Alice in Wonderland* was published in 1865, and its sequel, *Alice through the Looking Glass*, in 1871. It is not difficult to sense the link of that latter title with the perennial nonsense motif of the upside-down world, though here it is the world left-to-right; nor will we be surprised to encounter again the comic monsters of our dreams, such as Humpty Dumpty in Tenniel's illustrations (Fig. 176).

Historians of twentieth-century art are familiar with the process which I have here described as the move of nonsense imagery from the margin to the centre. Examples of the stages leading from the whimsicalities of Paul Klee to the deliberately outrageous titles of Dada and Surrealism should really find their place here, except, perhaps, that I have given such examples in my lecture on 'Image and Word in Twentieth Century Art' now printed in *Topics of our Time*.[4] The historian must seek to maintain a balance between the portentous and the light-hearted, nonsense as revelation and nonsense as fun. I believe there is one current of the latter tradition which is hard to chronicle, but still vital to our understanding: I mean the atmosphere of the *Bohème*, the life of the community of artists, with their feasts and mock rituals.

It is rare that we get a glimpse of these goings-on, but there are a few precious

260

There was an Old Man who said, " Well! will *nobody* answer this bell?
I have pulled day and night, till my hair has grown white,
But nobody answers this bell!"

174. Edward Lear, 'There was an old man …' from
A Book of Nonsense (London, 1846)

175. Edward Lear, *Nastiscreechia Krorluppia*, from
Nonsense Botany and Nonsense Alphabets, 1927

176. John Tenniel, *Humpty Dumpty*, from Lewis Carroll,
Through the Looking Glass and what Alice Found There
(London, 1871)

HUMPTY DUMPTY. 109

" I'm afraid I can't
quite remember it,"
Alice said very politely.
" In that case we
may start fresh," said
Humpty Dumpty, "and
it's my turn to choose
a subject——" (" He
talks about it just as
if it was a game!" thought Alice.) "So
here's a question for you. How old did you
say you were?"

accounts, such as the episode in Cellini's autobiography where he brings a boy dressed up as a girl to a beauty contest, who naturally gets the prize. We also hear of clubs or societies of Dutch artists in seventeenth-century Rome called the Bentvueghels, who enjoyed themselves in elaborate and occasionally pretty obscene initiation rituals to the cult of Bacchus, and who left us records of their taverns where graffiti sprouted on the walls (Fig. 177).

I hope and believe some of this tradition still lives on in our art schools. I certainly remember an annual event in my native Vienna at Carnival time, the so-called *Gschnasfest* – *Gschnas* being an untranslatable word somewhere between a lark and a spoof. Of course the school was decorated with a lot of nonsense imagery. What remained in my mind was a modern version of the world turned upside down: a room in which tables and chairs were screwed to the ceiling, while the chandelier rose from the floor. I believe if we do not want to be too solemn about developments in our century we must not forget this enjoyment of spoofs and larks. After all, artists tend to work very hard and undergo much strain, and they feel in need of these moments of regression and relaxation in which they can cock a snook both at art and at their public. There was surely much to enjoy in the ephemeral products of wit and tomfoolery, all the more as they laid no claim to the status of art.

What favoured the increasing attention to nonsense and its elevation to the status of art was the disillusionment with nineteenth-century rationality that was so widespread among artists and intellectuals of the *fin de siècle*. 'Be mysterious' – Gauguin's appeal to his disciples – found a widespread echo among artists who flirted with all kinds of occult and mystical sects (Fig. 178). Behind this lay the Platonic conviction that poets could, and should, be the mouthpieces of the gods, and that the muses could be adapted to any creator who was willing to surrender to voices and visions that arose more or less spontaneously.

I have suggested in these pages and elsewhere that certain developments in the history of art, and in other fields, can best be seen as the results of competition, with rivals outbidding each other, leading to the dominance of given aspects and the neglect of others. The preference for the primitive as manifested in the cult of regression is such an issue, which gives coherence to the most conspicuous trends in twentieth-century art. An entry by Paul Klee in his diary in 1912, the year of *The Blue Horseman*, reads:

> For these are primitive beginnings in art, such as one usually finds in ethnographic collections or at home in one's nursery. Do not laugh, reader! Children also have artistic ability, and there is wisdom in their having it. The more helpless they are, the more instructive are the examples they furnish us; and they must be preserved free of corruption from an early age. Parallel phenomena are provided by the works of the mentally diseased; neither childish behaviour nor madness are insulting words here, as they commonly are. All this is to be taken very seriously,

177. Anonymous, *Bacchus at the Bentvueghels' Party*, 1623.
Museum Boijmans van Beuningen, Rotterdam

178. Paul Gauguin, *Be Mysterious*, 1890.
Private collection

more seriously than all the public galleries when it comes to reforming today's art.[5]

Reading such a passage today we might think it strange indeed to find the art assembled in ethnographic collections so confidently equated with the art of children. Nothing, after all, is more characteristic of tribal art than its rigid adherence to convention. Clearly neither Klee nor his countrymen were in a mood to analyse these facts. What they aimed at was to shed the conventions they had acquired at art school and to regress to the carefree spontaneity they remembered from their childhood days, or even to the delirious states of the insane which may manifest extremes of regression.

In his seminal book *The Discovery of the Art of the Insane*[6] John MacGregor has provided such detailed documentation of these developments that it would be as redundant to go over the ground again as it would have been in the case of Rubin's catalogue of *'Primitivism' in Twentieth Century Art*.

MacGregor has shown how much the movement of Expressionism owed to the example of Van Gogh, whose mental breakdown and suicide appeared to justify the image of the mad painter. We have seen that Van Gogh, no less than Gauguin, cultivated the expansion of the zone of licence by adopting in his art devices that were previously confined to caricature. Moreover, his swirling brushstrokes and the strong, primary colours of his most striking canvases could easily merge with the popular idea of the mad artist working in the frenzy of creation. It is all the more important to remember that the artist himself emphatically rejected this interpretation. There had been rumours that he had been drinking too much, and he was eager to reassure his brother on this score: '… the mental labour of balancing the six essential colours, red, blue, yellow, orange, lilac, green. Sheer work and calculation, with one's mind strained to the utmost, like an actor on the stage in a difficult part, with a hundred things to think of at once in a single half hour.'[7] After that, Van Gogh admits, he must relax and drink and smoke: 'but I'd like to see a drunkard in front of a canvas, or on the boards … Don't think that I would maintain a feverish condition artificially, but understand that I am in the midst of a complicated calculation which results in a quick succession of canvases quickly executed but calculated long *beforehand*. So now, when anyone says that such and such is done too quickly, you can reply that they have looked at it too quickly' (letter 507).

It was a warning too frequently disregarded.

It is a matter of history that these tendencies of twentieth-century art produced the most violent reactions, particularly in Germany, where modern art was identified with degeneracy. The insanity of these charges need not conceal the fact that many artists of the era longed indeed to express such exceptional states that would inspire and inform their art.

263

The horrors and tragedies of the First World War notoriously sparked off the movement of Dadaism which hoped to defeat bourgeois solemnity and conventional values with noisy tomfoolery. This is not the place to trace the connections between this revolt and the post-war movement that has been known as Surrealism, a movement that systematically cultivated regression through automatic writing and the exploitation of what its proponents called 'paranoia', and other types of irrationality.

Interest in the art of the clinically insane led to the publication of a book in 1922 in Germany which approached the creations of mental patients along these lines. The psychiatrist Hans Prinzhorn published a large number of their products in his volume *Bildnerei der Geisteskranken*, which was to create an immense stir among artists and art lovers. In his introductory chapter, Prinzhorn put forward a theory of art which assigned only marginal importance to the idea of mimesis. Central to his approach was a vitalistic theory of expression that owed much to the influence of Henri Bergson and his German follower, Ludwig Klages:

> Only a fool could think that what is personal in the tone of a violinist could be established by measuring the soundwaves and the harmonic range, or that the expressive content of a late Rembrandt could be examined through comparison with a colour chart.
>
> We sum up by contrasting the sphere of measurable facts with the realm of expressive facts in which the psychic contents appear immediately and are grasped without the intermediary of an intellectual apparatus. All expressive movements serve no other aim than this: to incorporate the spiritual and so build a bridge from the I to the thou ... We find the roots of this in quite simple circumstances: with the child, who in the course of play invents a cheerful dance or makes a scribble, whose expressive value speaks clearly to the initiate; or with the primitive, who in his dancing mask somehow expresses his world view imbued with magic and demonic ideas ...[8]

The theory Prinzhorn here expounds with such assurance may be called the 'resonance' theory of expression, postulating that the symptoms or signs of emotion are contagious, as it were, and arouse the same emotion in the beholder. It is a theory that has a long history and had but recently been expounded by Tolstoy, who identified art with the communication of emotions (see pp. 214–15). As a general proposition this notion of expression can certainly not stand the test of reason.[9] But it would not have had such a long run if it did not contain an element of truth, and this element is closely related to the phenomenon of regression. Regressive behaviour can indeed prove contagious. We need only think of an excited mob, of revelling drunkards or other manifestations of crowd behaviour which Freud analysed in his study of mass psychology and the analysis of the *ego*. Here the manifestations of primitive emotion serve indeed as a bridge

between individuals. One of Prinzhorn's examples must suffice to illustrate to what extent this sharing of regression became identified in his mind with aesthetic experience (Fig. 179):

> As soon as the first startling reaction is overcome which made us ask whether the work is not simply the outcome of childlike incompetence, the impression of the enigmatic increasingly fascinates the beholder. Though the creation obviously resembles a cow only very remotely, we still get the compelling impression that the creature is not just a possible breed but a wholly convincing one. Beyond the impression of a quite particular animal we also experience something anthropomorphic in the gaze and posture, to which the kneeling position of the forelegs also contributes, which we would interpret in vain rationally as a kneeling movement prior to lying down. Speaking still more generally there emanates from this work a breath of that simplicity that makes us fall silent wherever we encounter it, be it in the eyes of an animal or a child. A sensation which is more frequent in front of the works of primitive and early cultures than in those of recent times, and more frequent in the East than in Europe.[10]

265

The link between Prinzhorn's response to primitive art and a preference for the primitive could not be more clearly documented. What matters in particular is the fact that, to this approach, a lack of manual skill no longer presents an obstacle to the values of a work of art. This attitude triumphed in the photographs of graffiti published in *Minotaur* during the 1930s (Fig. 180), which singled out the apparent spontaneity, and even brutality of these scrawls as a value to be opposed to academic art. From here there was only one step to the discovery of *l'art brut,* the celebration of the works of the untutored, to which the wine merchant Dubuffet devoted his life (Fig. 181).[11]

It may also be argued that this same appeal to regression led to the competition and escalation to which I referred at the opening of this chapter. If the abandonment of control intensifies the resonance, it appears to justify the recourse to extremes. What I have in mind is the unsettling effect that will be caused by the shock of the unexpected and the scandalous.

The traditional pastime of the nineteenth-century avant-garde to *épater le bourgeois* was innocent in comparison with the systematic breaking of social taboos witnessed by subsequent generations. Confronted with such deliberate outrages against decorum we are unlikely to remain unmoved. It is largely a matter of context whether we react with laughter, embarrassment, open hostility – or admiration.

One of the most discussed episodes of twentieth-century art history is the prank played by Marcel Duchamp in sending a urinal to an exhibition to figure as an abstract sculpture. Such a spoof might have occurred in one of the artists'

179. Cow, from Hans Prinzhorn,
Bildnerei der Geisteskranken (Berlin, 1922)

180. Graffiti, illustrated in *Minotaur*,
vol. 3, 1933

267

181. Jean Dubuffet, *Geste et Parole*, 1961.
Saint Louis Art Museum

carnivals without attracting more than passing attention, but as a move in the drive for regression it acquired the significance of a landmark because it appeared to change the rules of the game called 'art'. An installation known to everybody but rarely mentioned in polite society was mockingly singled out for the admiration of art lovers. The bourgeois, eager to keep up with the times, preferred not to be shocked, or to laugh, but dutifully to admire Duchamp's gesture, as he admired his painting of a moustache on the photograph of the Mona Lisa.

We still remember from our childhood that defacing posters and perpetrating scatological jokes is 'naughty', but for that very reason we are asked to appreciate the bold defiance of convention as an act of liberation.

We need not describe in detail how the regressive phenomenon in defying taboos escalated in the course of the century, in the movements of *l'art brut* or in certain 'happenings'. In what I have called the 'formative document' of modern art, Zola wrote that 'art is a human secretion'. He would have been surprised to see his metaphor taken literally in an exhibition of canned excrement displayed as *Merde d'artiste* (*Burlington Magazine*, June 1998).

> You are deaf to what I utter,
> To your meanings I am blind;
> Only meeting in the gutter
> Can we read each other's mind.
>
> (Selten habt ihr mich verstanden,
> Selten auch verstand ich euch;
> Nur wenn wir im Kot uns fanden
> So verstanden wir uns gleich.)
> – Heinrich Heine, *Die Heimkehr*, 1820–4

'Oh Freunde, nicht diese Töne!' – the call with which Beethoven in his Ninth Symphony interrupts the sequence of violent chords to entune Schiller's *Ode to Joy* may remind us not to equate the preference for the primitive altogether with this cult of outrage.

Chapter 7
Primitive – in what Sense?

In 1930 Herbert Read wrote that 'from the study of negro art and the Bushman we are led to an understanding of art in its most elementary form and the elementary is always the most vital' (Fig. 182).[1] He clearly shared the opinion discussed in the preceding chapter, that these artists and their kinsmen all over the world were unspoilt children of nature and that their creations could teach us what art meant to mankind before the academies had put it in straitjackets.

But by the time Read wrote this, the idea of primitive art as a spontaneous outpouring of vital energies was already somewhat obsolete, and even more obsolete was its corollary, the idea that tribal cultures showed us man in a former stage of development, a relic of the savage mentality through which our culture had had to pass before it reached its present state of civilized development.

I believe that, among students of art, the great anthropologist Franz Boas was the first to repudiate this picture of primitive man, in his classic volume on *Primitive Art*, first published in 1927. In the preface to that great book, he defines his position from the outset. He concedes that 'there must have been a time when man's mental equipment was different from what it is now, when it was evolving from a condition similar to that found among the higher apes.' But 'that period', he emphasizes, 'lies far behind us and no trace of a lower mental organization is found in any of the extant races of man ... Some theorists assume a mental equipment of primitive man distinct from that of civilized man. I have never seen a person in primitive life to whom this theory would apply ... The behaviour of everybody, no matter to what culture he may belong ... can be understood only as an historical growth ...'[2] Thus Boas dismisses any attempt to arrange all manifold cultural lines in an 'ascending scale' in which to each can be assigned its proper place.

By 'ascending scale', Franz Boas was, of course, thinking of the idea of progress that had also dominated the history of art since classical antiquity – the idea that artists got better and better in the imitation of nature, and that one could therefore assign a date to an image simply by measuring how close it had come to its model in reality.

270

182. Bushman art, from Hugo Obermeier and Herbert Kuhn *Buschmankunst Felsmalereien aus Südwestafrika* (Leipzig, 1930)

183. Carved head by Kwakiutl Indians. Staatliche Museen, Berlin

It is worth noting that Franz Boas was reluctant to accept this interpretation. He did not believe that the images of tribal art he had studied with such care could in any way be described as the product of a limited skill. Having analysed the immensely complex system of representation practised by the Indian tribes of the North West Pacific, he remarks that 'when the artist desires realistic truth he is quite capable of attaining it' (p. 185), and he instances a carved head made by the Kwakiutl Indians of Vancouver Island (Fig. 183) 'which is used in ceremony and intended to deceive the spectators who are made to believe that it is the head of a decapitated dancer'.

It is indeed an important example which should make those of us pause who have spoken or even written about the evolution of representational skill, for it reminds us of the dependence of such skills on the function the image is intended to meet. Only when illusion is demanded are artists likely to acquire the skill to create it.

271

Progress of Skill?

But was it wholly legitimate for Boas to generalize on the example he used, and to conclude that the skills of mimesis were always at hand for the asking? It is a question that naturally concerns me, because in *Art and Illusion* I argued the opposite, claiming that even given the will, mimetic skill was never developed overnight, but tended to progress in the course of several generations.

But the skill I was speaking of was that of drawing or painting on a flat surface; I should have remembered that the medium of sculpture is different. There are many examples testifying to this skill, such as the 'reserve heads' of ancient Egyptian sculpture (Fig. 184) and the realistic vessels of Peru (Fig. 185) or the bronze heads of Ife (Fig. 186), which can take their place by the side of the realistic achievements of Western sculpture. Yet we have come to realize that all skills have to be acquired in years of apprenticeship, and it would be foolish to see any increase in manual dexterity as a result of human evolution. It was wholly misguided of nineteenth-century evolutionists to equate the development of mimetic skill with mental growth – an equation that obscures rather than illuminates the matter in hand.

The fact that we have learnt to construct flying machines which overcome gravity certainly demonstrates that technology has made progress far beyond the boldest dreams of earlier ages. But is this undoubted achievement the result of our superior intelligence? Here Boas was certainly right that 'the behaviour of everybody ... is determined by the traditional material he handles.' Teach people to use a slide rule or a computer and they will create devices out of reach of those who lack these tools. These observations may by now seem commonplace, yet they have to be stressed to forestall a misunderstanding that is apt to cloud discussions relating to primitive art, and has notoriously led to the banishing of the term.

272

184. 'Reserve head' of a woman, Giza, Egypt, 2585–2560 BC. Museum of Fine Arts, Boston

185. Vessel in the form of a one-eyed man, found in the Chicanna Valley, Peru, c.250–550 AD. The Art institute of Chicago

186. Head of an Oni, 12–15th century, Museum of Ife Antiquities, Nigeria

Having committed myself in the very title of this book to the opposite point of view, I must devote this last chapter to the qualified justification of the term in relation to image-making – it being understood that makers of primitive images should not be characterized as primitive species of the human race. What I propose to argue is that mimetic art shares certain characteristics with the skill of flying. It involves surmounting the natural pulls that have dominated image-making in all 'primitive' cultures.

The nature of these pulls has often been described in the past in a variety of terms when speaking of the art of children or of the untutored. Their evident departure from visual reality is explained by reliance on knowledge rather than perception.[3] But what is 'visual reality'? After all, it is only a few years since techniques were developed to create the perfect illusion of a visual experience – I am referring to one of the early devices of 'virtual reality', which necessitated the wearing of a helmet by means of which two different moving films fed information into the wearer's two eyes. It may be an open question how far even this contraption could replicate our visual experience, but at any rate it would be interesting to trace its development, a story in which the invention of the stereoscope and that of the movie camera would certainly figure largely. Each of these stages might be described as 'primitive' in relation to the progress subsequently achieved. It would not be hard to find analogies between this technical drive towards such perfection and such episodes in the history of illusionistic painting as the invention of foreshortening or of one-point perspective. Such devices 'caught on' among painters because they constituted a move towards illusion, relegating earlier procedures nearer to the primitive.

What is noteworthy in this development (and possibly justifies comparison with human flight) is the fact that some of these devices are counter-intuitive. This applies most of all to one-point perspective, which demands that of two objects equal in size, the one twice the distance from us has to be represented at half the scale of the other, a fact easily confirmed by measurement but contrary to our awareness. What are called the 'perceptual constancies' that stabilize our visual world so influence our judgement that once the diminished scale is placed into the right context on the picture plane it will appear to be correspondingly larger. It is this unexpected hurdle that mimesis had to overcome in order to move closer to illusion.

However, Franz Boas was right in reminding us of the fact that this gamut of progress will never encompass all varieties and media of images. The craft of sculpture has generally followed different ways, frequently excluding that of creating an illusion. In *Art and Illusion* I failed to take account of this radical difference between 3-D and 2-D. While painting since classical antiquity has aimed at creating the illusion of 3-D on a flat surface, the sculptor has always been given the third dimension from the start. We need think of nothing more solemn than a snowman, sandcastles, hollowed-out pumpkins or pots made of

clay. In each of these cases the sculptor will see it as his prime task to transform the shape in front of him into a recognizable object, giving the snowman two eyes and perhaps a pipe, the sandcastle a moat and a keep, the pumpkin slits for eyes and mouth, and transforming the pot into a recognizable head.

Linguists call those elements which enable us to recognize a word or a phoneme 'distinctive features'. Similarly, the sculptor uses 'distinctive features' in his task of transforming his medium into an image or a model approximating reality to any desired degree. It is a feat that has been performed by craftsmen of many regions and traditions. The difference between this achievement and that of creating the illusion of 3-D reality on a flat surface can never be sufficiently stressed. I once wrote an essay which I called 'Meditations on a Hobby Horse' in which I postulated that the stick becomes a horse in the act of riding it. I would have to write that essay all over again to make it clear that the hobby horse represented in a drawing or painting will never serve me for riding. Why, then, do we so readily accept it as the picture of a hobby horse? What prompts us to see it as a 3-D object? I do not propose to return to *Art and Illusion* at this point to discuss once more what in that book I called 'the beholder's share'. Suffice it to say that even flat images operate with the distinctive features that serve a sculptor so well, and make us recognize a face or an animal when we are shown a single aspect. The discovery of this mental operation must go back at least to the age of the cave painters who mastered the skill of conjuring up the image of a mammoth or a rhinoceros by showing us one aspect of the animal. Conceivably this astonishing trick was preceded in the caves by the imprinting of human hands which frequently cover the walls of such caves. Are they not also intended to be seen as 3-D hands, rather than as flat impressions?

Be that as it may, we must admit that 2-D representations always and inevitably require the beholder's share to be turned into 3-D reality. What mental operations are demanded will differ with the styles and conventions of different periods. The Egyptian style is notorious for its creation of a fixed system of conventions to select and position the distinctive aspects of objects to turn them into legible images. Its systematic character has helped art history to see and appreciate the problem involved on the road to the illusion of 3-D.

What I have tried to stress in this digression is of a more general character; I am concerned with the justification of applying the term 'primitive' to certain phases in the development of techniques of drawing and painting.

Untutored Art

It seems to me safer to select for renewed analysis neither a work of tribal art nor even a product of children, but rather a drawing by an untutored person which came my way many years ago. Its meaning could hardly be clearer nor could its distance from mimetic methods be more pronounced. In those distant days middle-class families in central Europe still had servants who usually had little

formal schooling, and it was Elise, the cook, who touchingly presented me with this work of hers in 1923, on the occasion of my fourteenth birthday (Pl. XI). The subject of her drawing is my 'cello lesson. I am standing on the left, with the 'cello bow in my left hand (where it would not have been much good). She drew me from memory, of course, in a strictly frontal view wholly recognizable as the image of a boy, but since she had difficulty with the shape of the feet seen from in front, my legs end in stumps. Since she could not make me hold the 'cello, she simply drew it next to me, but she evidently did not go to check it. The half figure in profile with the pipe is labelled '*Herr Professor*', my teacher, who is turned towards me raising a bow or stick by way of instruction. The turning of the head came less easily to Elise than my frontal face, and its proportions therefore grew in relation to the body – not to mention the two arms. Above 'The Professor', she drew the music stand, marked '*Noten*', seen, perhaps, from both sides. But the purely narrative content does not appear to have satisfied her, so she filled in the blank patches of the sheet, slightly incongruously: on the right there is the somewhat fumbled attempt at a four-leaf clover (for luck); in the left corner, a bird. Its nest departs from the two-dimensional method she had adopted since she probably remembered images from calendars or Christmas cards.

I cannot see any harm in calling this image 'primitive' as long as we do not call the artist so. Elise evidently could wield the pen: her writing is firm and correct and the strokes of her drawing determined and quite self-assured. Only her method precluded her from matching what she would have seen if she entered the room where I had the lesson – and presumably produced agonizing noises. To emulate the camera she would have needed a lengthy training.

I have been looking out for a photograph of a 'cello lesson and I must admit that the comparison looks a little vainglorious. It represents the great Casals teaching his excellent student Leslie Parnas (Fig. 187).[4] My teacher was no Casals but he shared with the master the habit of smoking a pipe. In any case the photograph gives us what I would like to call an 'eye-witness' record. This is what we would have seen entering the room, and, barring the differences, what Elise would have seen in our house. We must be careful though before we accept this statement at its face value. What we would have seen would not have been a frozen image but an event going on in a room. On entering, the room would have opened up before us and we would have been aware of the level floor and the enclosing walls. We would have seen two people inside, in the round as it were, for they moved and offered to our eyes a variety of changing aspects. Even if we were not endowed with two eyes which provide us with stereo vision, we would have therefore sensed our and their location in the room. But in taking the camera we would have tried to select a viewpoint and a moment which would have allowed those who looked at the picture to read it with ease. There is the speaking profile of the master and the pupil's eager glance towards him. How easily that telling moment could have been missed with a rather meaningless or

276

187. Pablo Casals with his pupil Leslie Parnas

188. Jan Vermeer, *The Music Lesson*, c.1662–65, Royal Collection

189. Photographic re-creation of *The Music Lesson*, illustrated in Richard Gregory (ed.), *The Artful Eye* (Oxford, 1995)

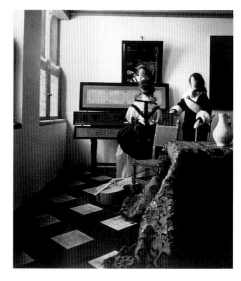

messy snapshot resulting. Even the photographer must have been selective. Elise was more so.

She decided where to put her individual shapes and then endowed them with the necessary distinctive features, the 'cello with four pegs, the people with eyes and hands; turning them into what I have called 'minimum models of the motif'. Where her technique let her down was in relating the individual objects in space and in action. She could not make me hold my 'cello, for it would have partly obscured my body, and she could not make me look at my teacher, for the frontal view came much more easily to her. Even less could she relate my posture to that of the teacher, for she drew one item at a time.

The 'Perceptual Constancies'

277 Long before photography was invented a great master of the Western tradition such as Vermeer was indeed able to represent a similar music lesson (Fig. 188) which actually shows a 'cello deposited in the foreground. It is easy to show why Elise could not have done so, if we merely look at the tiled floor which both images have in common, and which from the fifteenth century on has served as a standard example of perspective construction. What she would have seen, as would any one of us, is that the tiles are of equal scale even though they diminish in apparent size as they recede in the background. So much is commonplace. What we have learnt from the psychology of perception is that, if asked, we would all underrate the degree to which they appear to diminish. Trace the distant one and transfer it to the front and you will be surprised by the difference in scale. We are surprised because the objects in our proximity appear to be relatively constant in size regardless of their distance. These so-called 'perceptual constancies' which influence the way we see our environment are in conflict with the optical laws of perspective which govern the images created by mimetic art, no less than those recorded by the camera. At this point we must proceed with some caution to avoid the trap of misjudging the function and achievement of optical perspective as untrue to our visual perception. We are free to say that we do not see a tiled floor as it must be drawn in perspective, but it remains also true that if it is not so drawn it fails to look like a level floor paved with tiles of identical size. To come to the point at last: what the mimetic artist must learn is not to concentrate on how he sees the world, but to ignore his visual experience in favour of a geometrical construction based on the laws of optics which tell us that light rays are propagated in straight lines and will result in an orthogonal projection on our retinas.

Only if an artist applies these laws will his image convey the correct information to any viewer. It is easy to test this assertion, because applying the same laws we can retranslate the flat, perspective image into the 3-D motifs the artist had in front of him. In the case of Vermeer's painting this experiment has actually been made[5] (Fig. 189), and though one might find fault with certain

278

190. Jan Vermeer, *The Astronomer, c.*1668.
Louvre, Paris

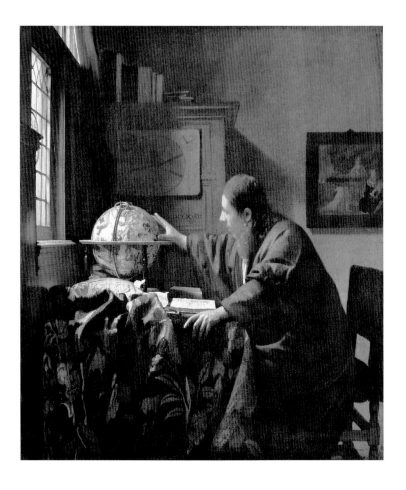

aspects of the reconstruction the minor mistakes only confirm that there is one, but only one correct solution – at least, if we observe the commonplace rule that the floor of the room must be level and the persons in the room must be represented in the right scale and proportion. Admittedly that is no trivial demand, for if we accept the need to correct the 'perceptual constancies' we must also acknowledge that these perceptions may play havoc with the correct proportions. It is notorious that we mostly misjudge the relationship of height to width, over-estimating the first and under-estimating the second. Many of these systematic misjudgements are listed in psychologists' primers under the rubric of 'optical illusions', but if we transfer these illusions onto the canvas the image will look hopelessly awry. Here it turns out that even the sculptor easily falls victim to errors in carving or modelling the human body – witness those tribal figures in which the head tends to dominate in size. Indeed, if the painter must be aware of the laws of optics, the sculptor must rely on a system of *a priori* proportions to avoid what will be felt as distortion. Without this framework the ancient Egyptians could not have carved their impressive statues.

279

Perspective and Proportion

To complicate matters further it turns out that for the painter, perspective and proportion are inextricably linked. We all know of photographs in which a person's hands or feet look monstrously distorted because the camera has recorded their perspectival appearance. A moment's reflection will show that this influence of perspective will diminish, but not disappear, at a greater distance. It was precisely Vermeer who took account of this effect in his painting of *The Astronomer* at the Louvre (Fig. 190), where the left hand, closer to the observer, is represented considerably larger than the right hand. For figures as far removed as they are in *The Music Lesson*, the effect may not be noticeable, but theoretically it remains true that, when projected onto a plane, proportions must fluctuate with the perspectival setting.

It is well known that these unexpected deviations from our visual experience can only be registered by the artist through the device of measuring – that is, by comparing the apparent shape of a distant object with one close by, either by looking through a grid or screen close to the observation point, or at least by using the handle of a brush held in the outstretched hand. True that mimetic artists can train themselves to do without such artificial devices, but the fact is that mimetic rendering is based on an art of construction – we may even call it of reconstruction – that by-passes the perceptual experience.

Once we understand the true complexity of this achievement we shall cease to be surprised that it was the fruit of gradual developments. We can no more expect every human being to be born with this capacity than we can expect everybody to be able to construct and use a photographic camera.

It is an accident of history that we tend to view earlier styles through the

wrong end of the telescope, as it were, and look for explanations for their deviation from mimesis. What requires explanation is not the absence of mimesis but its invention.

It is obvious that Elise in her drawing failed to do justice to this intricate complexity and that the same is true of the majority of pictorial styles anywhere on the globe. Indeed, if we focus on this need of the mimetic artist to observe and record the hierarchy of interdependent features that dominates our vision, we may be less reluctant than Boas was to group the methods of representation in what he calls the 'ascending' order.

Language

It was in particular in a study of language that the idea of an 'ascending scale' of complexity was found to be inadequate. To quote Edward Sapir, 'the lowliest South African bushman speaks in the forms of a rich symbolic system that is in essence perfectly comparable to the speech of the cultivated Frenchman'.[6] We might say that, in human language, complexity is the norm. But we also know that this universal feature of complexity presents an obstacle to the beginner and the mentally impaired, and that there are degrees of difficulty encountered in trying to master the full range of any language. Granted that we cannot arrange the languages of the world in an ascending scale, there is nevertheless a recognizable descending scale as speakers variously simplify and dismantle the structures of language while trying to communicate their thoughts. What happens in such a case has been succinctly formulated by Roman Jakobsen as 'the disappearing of relational spatio-temporal markers'.

Almost any sample of a fully developed statement will serve to explain this term – I have taken the opening sentence of Henry James's novel *The Europeans*: 'A narrow grave-yard in the heart of a bustling, indifferent city, seen from the windows of a gloomy-looking inn, is at no time an object of enlivening suggestion; and the spectacle is not at its best when the mouldy tombstones and funeral umbrage have received the ineffectual refreshment of a dull, moist snowfall.' Regarding the spatial markers, we find that the graveyard is placed in the heart of a city and that it is seen from the windows of an inn. The temporal dimension is marked by the implicit comparison of this sight at other times, particularly when it is seen without the 'ineffectual refreshment' of snow.

We may here pause to consider in which respect the resources of language surpass those of the visual image. A painting or photograph might perhaps show the 'mouldy' tombstones and the 'dull, moist' snowfall, but could not convey that their location is in a city, nor that we see them from the windows of a gloomy inn – even less could it make us aware of the variations in the appearance of the motif at other times or in other conditions. It needs a virtuoso of language to convey so much in a string of no more than fifty-five words, and those who are not virtuosi will not attempt to weave all these facts and ideas into one linguistic fabric.

A new immigrant might perhaps have told the innkeeper: 'view not nice, dead people sad, snow not like, other room please!' Such an utterance will surely have more in common with the piecemeal methods employed by Elise, though we must not forget that at least in one respect her medium is more flexible than language: the elements of language are words which must remain reasonably intact to be recognizable, as they are in the hypothetical sentence of the immigrant. Elise felt free to draw only half of my teacher and to change the proportions of his and my limbs without fearing to become unintelligible.

Systematic Reduction

Even so, I hope to show that methods of representation, no less than those of linguistic communication, can indeed be arranged in a descending order, though what amounts to a breakdown in the case of language may be described as a normal trait in the production of images. When I was writing *Art and Illusion* I asked a child of twelve to copy a reproduction of John Constable's view of Wivenhoe Park (Pls. VII and VIII). What I had expected of this little experiment happened: the child translated the picture into a simpler language of pictorial symbols. I cannot claim that I also expected an art student to actually prefer the child's copy to the artist's masterpiece – an experience which helped motivate me to write this book. A few years after *Art and Illusion* came out, but surely quite independent of it, a schoolteacher in Milan had the pleasant idea of publishing the copies made by her pupils in the Brera Gallery. Here is the transformation of Luini's famous painting *The Burial of Saint Catherine* (Pls. IX and X). The simple code used by this child only contains 'nouns', as it were, and no adjectives. Every agent taking part in the narrative can only be shown from in front, as if the language did not contain any terms denoting other aspects. The scheme is geometrically simple and distances are standardized. The result is a pleasing, regular pattern, which would be even more pleasing if the child had had the patience to carry it to the end. Or take the transformation by a younger and even messier child of Francesco Albani's *Dance of the Amorini around a Tree* (Figs. 191 and 192). No doubt some will find it a great improvement. Again we notice the frontality of the simplified figures, the lack of articulation, the sense of balance and symmetry in which the few simple forms are distributed on the page. What the child has done is to restate the message of Albani's composition in the simplest pidgin language, and to reduce the complex information to a lapidary account of a tree with hand-holding imps, quite close to what I may call the 'base line' of image-making.

A 'Law of Gravitation'

What I want to bring out with these examples is the fact that the field of image-making is indeed structured like our space. There is a law of gravitation here which pulls the untutored artist away from the higher zones of mimetic

282

191. Francesco Albani, *Dance of the Amorini around a Tree*, *c*.1640. Brera, Milan

192. Child's copy of Albani's *Dance of the Amorini*

283

193. Albrecht Dürer, *Apocalypse, Saint John Devours the Book,* *c.*1498, woodcut

194. Russian woodcut copy of Dürer's *Apocalypse,* 18th century

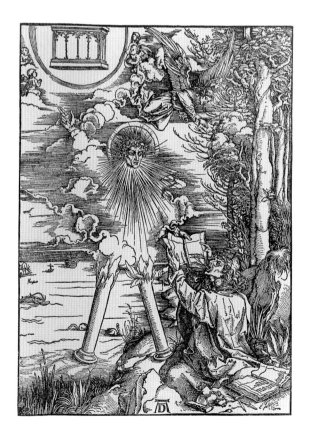

284

195. Chinese woodcut of the Nativity, copied from fig. 196

196. *The Nativity.* Italian engraving, 1595

relationships towards the piecemeal and schematic, towards the base line.

I cannot claim to have discovered this law. Rather I should like here to pay tribute to Wilhelm Fraenger, the art historian who first described it, whose paper on 'The Essence of Folk Art' deserves to be better known.[7] Fraenger took as his example a set of Russian eighteenth-century woodcuts illustrating the Apocalypse, all of which were copies – or rather transpositions – of Dürer's great series of prints from the end of the fifteenth century. My illustration (Figs. 193 and 194) shows the episode from Revelation where the apparition with a face of the sun and pillars as feet commands Saint John to devour the Book. Fraenger has shown in a masterly analysis to what extent the copyist has eliminated the indications of the third dimension, how he has brought the distant ship forward, and how this transformation results in a flat but satisfying design in which the whole page is filled with shapes disregarding natural proportions. Mark that the Russian woodcut is not really two-dimensional, much less a child's drawing. It only follows the gravitational pull in that field of force I am trying to describe. It can be exemplified from as far as China, where we can see how a Chinese woodcut remodels an Italian sixteenth-century print of the Nativity (Figs. 195 and 196), brought there, no doubt, by missionaries. The main tendencies are again manifest in a reduction of depth or distance, the filtering away of the chiaroscuro and the decorative filling of the page with shapes such as the clouds of typically Chinese vintage.

It is in this reduction of depth, this filling of the surface regardless of proportion which we also know from portraits of the folk tradition. It is not uninstructive here to compare these woodcuts with the work of a late nineteenth-century primitive, Henri Rousseau – 'Le Douanier' (Fig. 197) – whom, as you know, Picasso helped to discover. What they share is precisely the yielding to the pull away from the third dimension, the absence of convincing modelling in favour of constant tones, and the absence of complex aspects, though it may be argued that Rousseau's superior talent shows in the poetic qualities of his work which transcend the more primitive mode.

Once we have established this uniformity or law in the transformation of mimetic images, nothing prevents us from speaking of a structural kinship between various images which we can call less sophisticated or more primitive. W.P. Belknap[8] has collected many examples of American portraits of the early nineteenth century which are in fact adaptations of English mezzotints (Figs. 198 and 199), where the story repeats itself. It also does this on a New England tombstone (Fig. 200), where the problem of defining the aspect of the eye in half profile landed our sculptor in trouble. But knowledge of the most interesting transformation in American folk art I owe to Professor Nelson of the University of Minnesota. He investigated an altar carved by a Norwegian immigrant at the beginning of the twentieth century (Fig. 201), which is a masterpiece in its own right. Yet it turns out that Christenson, the craftsman, did not invent the biblical

286

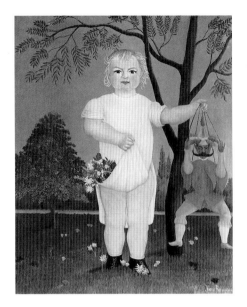

197. Henri Rousseau, *Portrait of Child with Puppet*, 1903. Kunstmuseum, Winterthur

198. *Sir Isaac Newton*, mezzotint by J. Faber junior, 1726

199. Anonymous, *Portrait of a Man*, c.1725–40. Mellon Collection, National Gallery of Art, Washington DC

287

200. Detail of tombstone of Rev. Grindall Rawson,
dated 1715, cut in 1744, Mendon, Massachusetts

201. Lars Christenson, carved altar, early 20th century.
Vesterheim Norwegian-American Museum

202. The Crucifixion from the Doré Bible
(Chicago, 1889)

scenes represented. He took them from a Bible illustrated by the once fashionable French master Gustave Doré (Fig. 202), whose dramatic and theatrical plates he again reduced in the predictable direction, into regularly patterned, rather flat relief.

I am convinced that this common fate of three-dimensional works in the hands of primitive craftsmen has a bearing on one of the most hotly debated issues in the history of Western art: the transition from antiquity to the Middle Ages. The reduction of the individual figures to types – not to say stereotypes – arranged in serried ranks, the filling of the whole area and the lack of articulation in Christenson's relief bear a more than superficial resemblance to that much-discussed monument of late antiquity, the Arch of Constantine, from the early fourth century of our era – or more precisely, to the reliefs which date from the time of Constantine. For this hastily erected triumphal arch also shows reliefs of earlier periods put to novel use in this victory monument. The contrast between these earlier, naturalistic reliefs and the squat, immobile figures of the later ones (Figs. 13 and 14) could not, and did not, escape early observers, and thus the Arch of Constantine became the prime witness from the days of the Renaissance on to what was considered the decline of ancient art and the coming of medieval barbarism.

It was only this century which challenged this interpretation of the reliefs as symptoms of decline. Were they not rather symptoms of a deliberate abandonment of classical standards and the expression of a preference for the primitive, comparable to the works of twentieth-century masters? I have come to think that the question has been wrongly put, and that the parallel between the art of the twentieth century and that of the fourth century AD – as far as it exists – does not justify us in celebrating the Arch of Constantine as a precursor of modern primitivism. If the craftsmen of the period followed the natural pull towards the two-dimensional base line they were neither to blame nor to praise. They had no use for flying, and so their art stays closer to the ground. The social and historical reasons which led to this shift of function and of style, also exemplified in Roman provincial tombstones (Fig. 203), cannot concern us here. All I want to emphasize is the uniformity of structure between their art and other two-dimensional products in folk art of the kind we have briefly reviewed. It was that perceptive student of late antique art, Ernst von Garger, who once observed in this context that 'gingerbread figures should not be regarded as great works of art, even when they happen to be of stone.' A comparison between a sculpture from Dura Europos and real moulds for gingerbread shows that he was not exaggerating (Figs. 204 and 205).

I am convinced that one can be an admirer of late antique and medieval art without losing sight of the fact that the skill of high flying was no longer needed or practised in that period. Not that this tendency towards reduction of naturalistic images implies a lack of skill in other directions. There is no more

288

289

203. Roman provincial tombstone, 2nd century AD,
reused on the Arch of Constantine, Rome

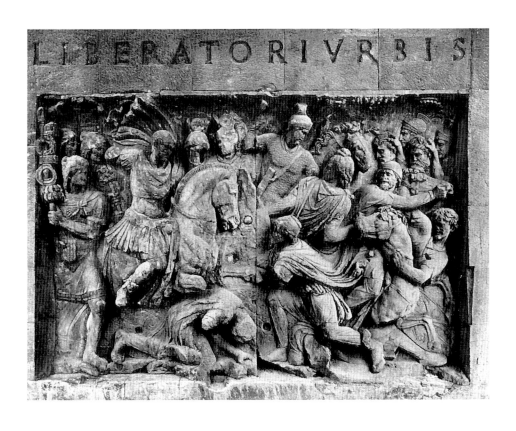

290

204. *The Three Holy Virgins: Katharina, Ursula, Barbara.*
Gingerbread moulds,
Osterreichisches Museum für Volkskunde, Vienna

205. Early relief showing Heracles with dieties,
Dura Europos, Palmyra

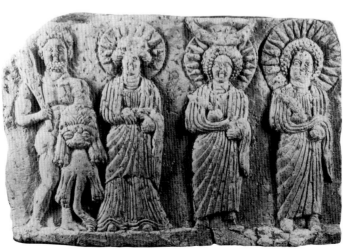

astounding a monument to the skill of hand and mind than the marvellous pages of the Lindisfarne Gospels of the late eighth century of our era. The sureness of hand and eye to which these pages bear witness needs no emphasis. And yet, when the artist of that gospel book copied a naturalistic model (Fig. 206) he followed the same pull we have now observed so often. The famous image of the Prophet Esdra in the sixth-century Codex Amiatinus (Fig. 207), or another very much like it, served as a model for his Evangelist. Once more the psychological law of reduction can be seen to have been in force: the rounded, plausible figure of the scribe has been flattened out as if it were composed of strips of paper, the head has been reduced to a formula. All indications of the setting have been dropped.

Admittedly the style or styles of what we call 'medieval art' extended over more than five hundred years and over the whole of Europe. Generalizations about such a range of monuments are therefore bound to be superficial, if not misleading. And yet we can say that the action of gravitational pull, the problem of reduction from three-dimensional to two-dimensional, can never be left out of account when examining and assessing these monuments. For even within medieval art there is a gamut of styles from a classical, individualizing, eye-witness conception to a two-dimensional manner – witness two fonts decorated with reliefs. The one from Liège, by Reiner van der Huy, of the early twelfth century, shows the Baptism of Christ (Fig. 208) in a highly articulate classical manner. The other font, from a small English church (Fig. 209), shows all the marks of reduction I have discussed. Surely we have a right here to call the one more primitive than the other.

This kinship of structure between various medieval styles and other monuments from other periods confirms the need to pay attention to these modes of reduction. The Romanesque relief from Gmünd in Germany (Fig. 210) does not look all that distant from a sculptured Pietà (Fig. 211), but the latter was carved around 1800 by an Italian peasant – it is a piece of folk art. Or take this Maori statuette (Fig. 212), a work of missionary art showing the Virgin Mary entangled in ornamentation. Is it all that different from the sacred figures of the Book of Kells? (Fig. 213). Both are products of traditions which mastered the art of complex patterns but were new to the task of rendering the human figure.

I hope this series of examples, however cursory, has tended to confirm my claim of what might be called the 'law of gravitation' in image-making. Given the fact that there are very few psychological laws of any validity, I think we must regard it with some interest. It justifies, does it not, speaking of certain structural features in images which we are entitled to describe as 'primitive'? The reader will not find it hard to recognize these features in the late antique ivory plaque representing the Holy Virgin enthroned between the three adoring Magi and an angel, all arranged in a symmetrical pattern (Fig. 214). Obviously the version of the same theme by Leonardo da Vinci (Fig. 215) is further away from that base

292

206. Saint Matthew, Lindisfarne Gospels, fol. 25b.
British Library, London

207. Ezra, Codex Amiatinus, fol. 1v.
Biblioteca Medicea-Laurenziana, Florence

293

208. Reiner van der Huy, brass font, 1107–18.
Church of St Bartholomew, Liège

209. Font, *c.*1170. Castle Frome parish church

294

210. Madonna and Child, Johannes kirche, Gmünd

211. Tombstone of Francesco Gugale, *c.*1800

295

212. Maori Virgin, Auckland Museum, New Zealand

213. Virgin and Child with Angels, Book of Kells, fol. 7v. Trinity college, Dublin

296

214. The Adoration of the Magi, ivory plaque, 5th–6th century, British Museum, London

215, Leonardo da Vinci, *Adoration of the Magi*, 1481. Galleria deglia Uffizi, Florence

line. That marvellous panel is unfinished, and therefore not easily legible, but when you stand in front of that work in the Uffizi in Florence you soon come to recognize that, in my terminology, the composition is not only three-dimensional in space, but extends the psychological and emotional depth through the way Leonardo explores and renders the relationship and the reactions of each of the participants in the miraculous event. The master's many studies for this composition convince me of the choices he pondered and of the efforts he made to evoke the sacred story in all its mystery, showing the Kings humbling themselves before the Christ Child, and the Virgin smiling her gracious smile.

The Expressive Gamut

I know there are plenty of people who deny that there are standards by which to judge quality. I am not one of them. I believe that great art is rare in painting as it is in music or poetry, but that where we find it we confront a wealth and mastery of resources which transcends ordinary human comprehension. Even so, the preference for the primitive is an understandable reaction, for the increase of artistic resources also increases the risk of failure. Base line art is safer and all the more lovable for that. Yet it is human to want to transcend such limitations and to improve the language of art, the instruments of expression, towards ever more subtle articulation. This is, I think, what the twentieth century attempted to achieve by absorbing into its resources the modes and methods of primitive image-making. It extended the range of the expressive gamut to include both regression and refinement. Let me recall the two great artists of the twentieth century mentioned in the preceding pages: Picasso, who played on the resources of style as on a grand organ, using classical and primitive conceptions as the spirit moved him, and Paul Klee, the more gentle explorer of the means of artistic expression, who indeed made good his intention of learning from the art of children, without ever becoming childish. The more you prefer the primitive, the less you can become primitive.

297

Appendix
The Study of Antiquities

298 This book has been concerned with one psychological source for the preference for the primitive which I have exemplified with episodes in the taste and style of Western art history. I am far from claiming that this particular hypothesis applies to all trends and movements involving an interest in antiquities.

There can be few civilizations on the globe which lack an oral tradition telling of the origins and early events in the past of the tribe, few also in which some of these stories do not become associated with certain objects or heirlooms regarded with awe by the population. Certain elders may acquire the reputation of being experts in ancient lore which may well have a bearing on social privileges, on religious rituals or claims of ownership. Such expertise, as we know, occasionally turned into a hobby of the leisured classes, who saw themselves as the keepers of traditions. I am referring to the growth of antiquarian studies in ancient Rome, where men like Varro acquired a high reputation for their knowledge. In the Middle Ages these studies were often associated with the heralds – experts in genealogy and coats of arms – and, of course, with the antiquarian movement in England that culminated in the foundation of the Society of Antiquaries, and with parallel developments discussed by Francis Haskell in his book on *History and its Images*.[1]

These studies bear a striking resemblance to the topic of this work, the Preference for the Primitive. I refer to a seventeenth-century piece of ridicule quoted in Stuart Piggott's book *Ancient Britons and the Antiquarian Imagination*[2] describing the *Antiquary* as follows: '… Hee is one that hath that unnatural disease to bee enamour'd of old age and wrinckles, and loves all things (as Dutchmen doe Cheese) the better for being mouldy and worme-eaten … A great admirer is he of the rust of old Monuments … Hee will goe you forty miles to see a *Saints Well* or a ruin'd Abbey … His estate consists much in shekels, and Roman coynes … Beggars coozen him with musty things they have rak'd from dunghills … His chamber is commonly hung with strange Beasts skins, and is a kinde of Charnel-house of bones extraordinary … His grave do's not frighten him, for he ha's bene us'd to Sepulchers, and he likes Death the better, because it gathers him to his Fathers' (p.16).

299

216. Louis Majorelle, three piece mahogany salon suite, *c.*1900

217. Decorated wardrobe, 1813. Bayerisches Nationalmuseum, Munich

218. Wedding chest with carved arcades, 1820. Tiroler Volkskunstmuseum, Innsbruck

It seems to me all the more important to explain why antiquarian studies have been excluded from these pages. The *Preference for the Primitive* is concerned with a movement of taste, rather than one of intellectual interest. The distinction is well summed up in a letter by Horace Walpole quoted by Joseph Levine in his excellent study of the Antiquarian Movement: 'Bishop Lyttleton used to plague me to death with barrows and tumuli and Roman camps, and all those things in the ground … but in good truth I am content with all the arts when perfected … and care less for remains of art that retain no vestiges of art.'[3]

To Walpole the early monuments may have looked primitive, but they offended his refined taste, though he boasted in an earlier letter that he was 'the first that endeavoured to introduce a little taste into English antiquities, and had persuaded the world not to laugh at our Hearnes and Holingsheads' (p. 104).

300

To be sure, there are moments in history when antiquarian interests and trends in taste meet. One of these has been mentioned in chapter 3 – the interest in folklore and early poetry that motivated antiquarians such as Thomas Percy (1729–1811) in his *Reliques of Ancient English Poetry*, a book which promoted with lasting effect the revival of interest in older English poetry. It was this movement that stimulated Herder, and through him Goethe, to collect folksongs, and culminated in the fashion for the poetry of 'Ossian' that swept over Europe.

A corresponding interest in what is now called 'Folk Art' had to wait for another century. An episode in the history of interior decoration which I remember from my early days in Vienna may fittingly conclude this digression. The period I have in mind witnessed a revolt in the decorative arts known as 'Art Nouveau' (Fig. 216), with its emphasis on frail structure and sinuous lines, a revolt intended to oust the stuffy, opulent Victorian style of the typical middle-class interior. But a minority of the intellectual middle classes opted instead for real folk art, the products of the rustic crafts that flourished in the agricultural areas of Austria, Bavaria and Switzerland – sturdy chests originally intended to contain the dowry of the bride, and massive wardrobes, often decorated with carvings or paintings (Figs. 217 and 218)[4] – thereby evading the choice between traditionalism and fashionable affront.

Notes

Preface

1

For the full quote see p. 27.

2

Giorgio Vasari, *Le Vite de' più eccellenti pittori, scultori ed architettori*, ed. Milanesi, Florence, 1878-85.

3

Arthur O. Lovejoy and George Boas, *Primitivism and Related Ideas in Antiquity*, Baltimore, 1935.

4

See Dennis Mahon, 'Studies in Seicento Art and Theory', *Studies of the Warburg Institute*, 16, 1947.

5

See John Rewald, *The History of Impressionism*, New York, 1946; also Albert Boime, *Art Pompier: Anti-Impressionism, Nineteenth Century French Salon Painting*, New York, 1974.

6

Bologna, 1926.

7

Turin, 1964.

8

Journal of the Warburg and Courtauld Institutes, 29, 1963, pp. 24-38.

9

The Essential Gombrich: Selected Writings on Art and Culture, ed. Richard Woodfield, London, 1996.

10

'From Archaeology to Art History: Some Stages in the Rediscovery of the Romanesque', in Marja Terttu Knapas and Åsa Ringbom (eds.), *Icon to Cartoon: A Tribute to Sixten Ringbom*, Helsinki, 1995.

Chapter 1

1

Trans. Paul Shorey, London, 1943. Quotations in translation are from the Loeb Classical Library or other sources where stated. On occasion I have felt free to amend the translation given or to use my own.

2

This quotation is from trans. A.E. Taylor, London, 1960. The following is my own.

3

See Erwin Panofsky, 'Idea': *ein Beitrag zur Begriffsgeschichte der älteren Kunsttheorie*, Leipzig and Berlin, 1924.

4

See W.K.C. Guthrie, 'Potentiality and Actuality', in *A History of Greek Philosophy*, Cambridge, 1981, vol. 6, pp. 119–29.

5

Poetics, 1449a13-16, trans. W. Hamilton Fyfe, Loeb Classical Library, London, 1927.

6

Poetics, 1449a7-9, trans. Stephen Halliwell, Loeb Classical Library, London, 1995.

7
Indeed, it was the idea of a canon of perfection, drawn up in Hellenistic times and later identified with the 'classic' (that is, the exemplary form of the art) that alone secured for us the survival of some of these canonic masterpieces when so much else was lost.

8
Arthur O. Lovejoy and George Boas, *Primitivism and Related Ideas in Antiquity*, Baltimore, 1935, pp. 23f.

9
See Eric Csapo and William Slater, *The Context of Ancient Drama*, Ann Arbor, 1994, pp. 3-4.

10
See Johannes Overbeck, *Die antiken Schriftquellen zur Geschichte der bildenden Künste bei den Griechen*, Leipzig, 1868, and Hildesheim, 1959.

11
Pliny, *Natural History*, XXXV.xxxvii.112.

12
See Larue van Hook, *Metaphorical Terminology of Greek Rhetoric*, Chicago, 1905.

13
On Style, I.12-14, trans. W. Rhys Roberts, Loeb Classical Library, London, 1953.

14
On Ancient Orators, trans. W. Rhys Roberts in J.D. Denniston, *Greek Literary Criticism*, London, 1924, pp. 146-8.

15
See Eduard Norden, *Die Antike Kunstprosa vom 6. Jahrhundert vor Christus bis in die Zeit der Renaissance*, Leipzig, 1915-18; also A. D. Leeman, *Orationis Ratio: The Stylistic Theories and Practice of the Roman Orators, Historians and Philosophers*, Amsterdam, 1963.

16
Dionysii Halicarnasei Opuscula, ed. H. Usener and L. Radermacher, vol. 1, Leipzig, 1899, pp. 3-5. For a full and more literal translation of the *Proemium* see J.D. Denniston, op. cit., pp. 150-2.

17
Brutus, trans. G.L. Hendrickson; *Orator,* trans. H.M. Hubbell, Loeb Classical Library, London, 1952.

18
Quintilian, *Institutio Oratoria*, XII.x.12.

19
See my 'Vasari's Lives and Cicero's Brutus', *Journal of the Warburg and Courtauld Institutes*, 23, 1960, pp. 309-11.

20
See Franz Quadlbauer, 'Die Genera dicendi bis Plinius den Jüngeren', *Wiener Studien*, 71, 1958, pp. 55-111.

21
Vitruvius, *The Ten Books on Architecture*, trans. M.H. Morgan, Cambridge, Mass., 1914, pp. 103-4 and 14-18.

22
See Emanuel Löwy, *Neuattische Kunst*, Leipzig, 1922.

23
'Quorum simplex color tam sui studiosos adhuc habet, ut illa prope rudia ac velut futurae mox artis primordia maximis, qui post eos exstiterunt, auctoribus praeferant proprio quodam intelligendi, ut mea opinio est, ambitu.' Quintillian, *Institutio Oratoria*, XII.x.3.

24
Seneca, *Ad Lucilium Epistulae morales,* XIX.v.114.

25
See Samuel H. Monk, *The Sublime: A Study of Critical Theories in Eighteenth Century England*, New York, 1935.

26
See my *The Sense of Order*, London, 1998, p. 20.

27
Vitruvius, *The Ten Books on Architecture*, VII.v.7

28
De Isaeo, ed. H. Usener and L. Radermacher, Leipzig, 1899ff., vol. 4, p. 96.

29
Themistius, *Orationes*, XXXIII, ed. D. Petavius, Paris, 1684, p. 281.

30
Porphyrius, *De Abstinentia*, II.

31
Pausanias, 'On Corinth', *Description of Greece*, II.iv. 5.

32
Silius Italicus, *Punica*, XIV. 653.

33
Franciscus Junius, the Literature of Classical Art and the Painting of the Ancients: de pictura veterum, according to the English Translation, 1638, ed. Keith Aldrich, Philipp Fehl and Reina Fehl, Berkeley, 1991, pp. 350-1

Interlude

1

Stilfragen, Berlin, 1893. Among the growing literature on Alois Riegl, I should like to single out Margaret Olin, *Forms of Representation in Alois Riegl's Theory of Art*, Philadelphia, 1992; also the excellent essay by Joaquin Lorda, '*Problems of Style*: Riegl's Problematic Foundations', in Richard Woodfield (ed.), *Framing Formalism: Riegl's Work,* Amsterdam, 2000, Chapter 5.

2

As described for example in Margaret Olin, op. cit.

3

Kunstgeschichte als Geistesgeschichte: Studien zur abendländischen Kunstentwicklung, Munich, 1924, pp. 31-2.

4

Pliny the Elder, *Natural History: A Selection*, trans. John F. Healy, London, 1991, XXXVII.5.

5

See the title essay in *The Heritage of Apelles*, London, 1976, pp. 3-18.

6

Pliny praises the 'painters of old' who 'were satisfied with four pigments'. 'Now', he says, 'since purple dominates the walls and we import from India the silt of their rivers, the blood of their dragons and their elephants, painting has lost its dignity. What is esteemed is the value of the material product rather than the thought behind it.' (XXXV. 7)

7

See 'Images as Luxury Objects', in *The Uses of Images*, London, 1999, p. 90.

8

Jean Gimpel, *The Cathedral Builders*, New York, 1961, pp. 126-38, quoted in my *Ideals and Idols*, London, 1979, p. 64.

9

See Ernst Kitzinger, 'The Hellenistic Heritage in Byzantine Art', *Dumbarton Oaks Papers*, 17, 1963, pp. 95-115.

10

Il Decamerone, Giornata VI, Novella 5, quoted in my *The Uses of Images*, p. 91.

11

See *The Life of Tafi* in Giorgio Vasari, *Le Vite de' più eccellenti pittori, scultori ed architettori*, ed. Milanesi, Florence, 1878-85, vol. 1, pp. 331-8.

12

See my 'From Archaeology to Art History: Some Stages in the Rediscovery of the Romanesque', in *Icon to Cartoon: A Tribute to Sixten Ringbom,* Helsinki, 1995.

13

Francis Haskell, *History and its Images: Art and the Interpretation of the Past*, New Haven and London, 1993, p. 138.

14

See Elizabeth G. Holt, *A Documentary History of Art,* New York, 1958, vol. 2, pp. 177-87.

Chapter 2

1

Oxford, 1953.

2

Reprinted in his book *Doing Things with Texts*, New York and London, 1989, pp. 135-58.

3

Anthony Ashley Cooper, 3rd Earl of Shaftesbury, *Characteristicks*, 1749, vol. 3, p. 272.

4

'A Discourse on the Dignity, Certainty, Pleasure and Advantage of the Science of a Connoisseur', in *The Works of Jonathan Richardson,* London, 1773, pp. 173-4 and p. 193.

5

'Von den Zeichen', in *Martin Luthers Deutsche Schriften*, Vienna, 1927, p. 467.

6

See 'The Supposed Primitivism of Rousseau's *Discourse on Inequality*', in Arthur O. Lovejoy, *Essays in the History of Ideas*, Baltimore, 1948, pp. 14–37.

7

The Confessions of Jean-Jacques Rousseau, trans. J.M. Cohen, London, 1953, p. 67.

8

Collection complète des œuvres de J.J. Rousseau, Geneva, 1782, vol. 7, pp. 47–8.

9

'Discours sur les Sciences et Les Arts', in *Oeuvres complètes*, Paris, 1964, vol. 3, p. 21.

10

Dramatic Essays by John Dryden, London, 1912, p. 4.

11

Shaftesbury, op. cit., vol. 3, p. 255.

304

12
See 'The Chinese Origin of a Romanticism',
in Arthur O. Lovejoy, op. cit, pp. 99-135.
13
Shaftesbury, op. cit., vol. 1, p. 147.
14
Vico and Herder, London, 1976, pp. 147–8.
15
Richardson, op. cit., p. 96.
16
Facsimile of second edition (1759), Menston,
1970.
17
The Complete Poems of Thomas Gray, ed. H.W.
Starr and J.R. Hendrickson, Oxford, 1966,
p. 19.
18
See Explanatory Notes to ibid., p. 209,
note 19.
19
See Henry Okun, 'Ossian in Painting', *Journal
of the Warburg and Courtauld Institutes*, 30, 1967,
p. 332.
20
The New Science of Giambattista Vico translated
from the third edition by Thomas Goddard
Bergin and Max Harold Fisch, Ithaca, 1970.
21
Summarized in the Introduction to the edition
quoted (p. xl).
22
'*Gedanken über die Nachahmung der griechischen
Werke in der Malerei und Bildhauerkunst*', in
Johann Joachim Winckelmann, *Antike und
Deutsche Klassik: Studien zur Bildenden Kunst*,
ed. Wilhelm Senff, Leipzig, 1961, p. 23.
23
Winckelmann *Geschichte der Kunst des
Alterthums*, Dresden, 1764, p. 3.
24
New Science, Propositions LXII–LXIII.
25
Winckelmann, *Geschichte der Kunst des
Alterthums*, p. 221.
26
*Anmerkungen über die Geschichte der Kunst des
Alterthums*, Dresden, 1767, p. 32.
27
'Auszug aus einem Briefwechsel über Ossian
und die Lieder alter Völker', in B. Suphan (ed.),
Herders Sämtliche Werke, Berlin, 1877-1913, vol.
5, p. 168.

28
'Ursachen des gesunknen Geschmacks bei den
verschiednen Völkern, da er geblühet', in B.
Suphan (ed), op. cit., vol. 5, pp. 595-655.
29
'Von Deutscher Art und Kunst, einige
fliegende Blätter 1773', in B. Suphan (ed.), op.
cit., vol. 5, pp. 159-257.
30
'Von Deutscher Baukunst (1772)' in Elizabeth
G. Holt, *A Documentary History of Art*, vol. 2,
Princeton, 1982, pp. 361-9. The translation
used is my own – see 'Äesthetische Schriften
1771-1805', 1, 18, in *Goethe Sämtliche Werke*,
Frankfurt, 1998, pp. 110-18.
31
Ibid., p.111.
32
See Paul Frankl, *The Gothic: Literary Sources and
Interpretations through Eight Centuries*, Princeton,
1960.
33
See 'The First Gothic Revival and the Return
to Nature', in Arthur O. Lovejoy, op. cit., pp.
136-65.
34
Quoted in Johannes Dobai, *Die Kunstliteratur
des Klassizismus und der Romantik in England*,
vol. II, *1750-1790*, Bern, 1975, pp. 274-5.
35
See J. Mordaunt Crook, *The Dilemma of Style*,
London, 1987.
36
Reynolds, *Discourses on Art*, ed. Robert R.
Wark, San Marino, 1997, Discourse IX, 16
October 1780, p. 171.
37
Frederick W. Hilles (ed.), *Portraits by Sir Joshua
Reynolds*, Appendix II, London, 1952, pp.
136–8.
38
From 'Der Streit der philosophischen Fakultät
mit der juristischen. Erneuerte Frage, ob das
menschliche Geschlecht im beständigen
Fortschreiten zu Besseren sei', part 6: 'Von
einer Begebenheit unserer Zeit, welche diese
moralische Tendenz des Menschengeschlechts
beweiset', in *Immanuel Kants Populäre Schriften*,
Berlin (undated), p. 239.

39

'Jacques-Louis David, the Painting of the Sabines', in Elizabeth G. Holt, *From the Classicists to the Impressionists*, vol. 3 of *A Documentary History of Art*, New Haven and London, 1966, pp. 4-12.

40

Two famous Greek courtesans.

41

Maybe the word was given currency in that long rambling work by Court de Gébelin, *Le Monde primitif*, which, however, nowhere denied the facts of progress. – See Frank E. Manuel, *The Eighteenth Century Confronts the Gods*, Cambridge, Ma., 1959, pp. 250-8.

42

'Les Barbus d'à Présent et les Barbus de 1800' (Appendix, publ. 1832), in E.J. Delécluze, *Louis David, son école et son temps*, Paris, 1855, p. 421.

43

See George Levitine, *The Dawn of Bohemianism: The* Barbu *Rebellion and Primitivism in Neoclassical France*, Philadelphia, 1978, pp. 55-72.

Chapter 3

1

Goethes Tagebuch der Italienischen Reise, ed. Heinrich Schmidt, Jena and Leipzig 1925, pp. 84-5.

2

Storia pittorica della Italia dal Risorgimento delle belle arti fin presso al fine del XVIII secolo, 6 Books in 3 vols., Bassano, 1809; English translation by Thomas Roscoe, *Luigi Lanzi, The History of Painting in Italy from the Period of the Fine Arts to the End of the Eighteenth Century*, London, 1847. The translation of the first extract is my own, the second is from the London edition.

3

Seroux d'Agincourt, *Histoire de l'art par les monumens depuis sa décadence au 4me. siècle jusqu'à son renouvellement au 16me.*, Paris, 1811–20.

4

Lectures on Sculpture, London, 1829, pp. 15–16.

5

See Francis Haskell, *History and Its Images: Art and the Interpretation of the Past*, New Haven and London, 1993, pp. 236–52.

6

'Über naive und sentimentalische Dichtung', *Schiller: Sämtliche Werke*, vol. 12, *Philosophische Schriften 2*, Stuttgart and Berlin, pp. 161-263.

7

See A.O. Lovejoy, *Essays in the History of Ideas*, Baltimore, 1948.

8

'Herzensergiessungen eines kunstliebenden Klosterbruders' in F. von der Leyen (ed.), *Wilhelm Heinrich Wackenroder. Werke und Briefe*, 2 vols., Jena, 1910, vol. 1, pp. 49-50.

9

Stimmen der Völker in Liedern, Leipzig, 1880.

10

'Über die Legende', vol. 6 of *Zerstreute Blätter*, Gotha, 1797.

11

Leyen (ed.), op. cit., vol. 1, pp. 95-6.

12

The Analysis of Beauty, ed. Joseph Burke, Oxford, 1955, p. 38.

13

See Caecilie Weissert, *Reproduktions-stichwerke, Vermittlung alter und neuer Kunst im 18. und frühen 19. Jahrhundert*, Frankfurt, 1999, pp. 126-30.

14

Mrs Bray, *Life of Thomas Stothard, R.A., with Personal Reminiscences*, London, 1851, chapter V, p. 78.

15

English portrait painter, 1758–1810.

16

See my 'A Primitive Simplicity', in C. Beutler, P.K. Schuster and Martin Warnke (eds.), *Kunst um 1800 und die Folgen, Werner Hofmann zu ehren*, Munich, 1988, pp. 95-7.

17

See 'A Descriptive Catalogue', in Geoffrey Keynes (ed.), *William Blake: Complete Poetry and Prose*, London, 1948, p. 593.

18

Mémoires d'outre-tombe, ed. Pierre Clarac, 3 vols., 1849, reprinted by the Librairie Générale Française, 1973, vol. 1, p. 428.

19

See 'L'Art gothique dans *Le Génie du Christianisme*', in Alice Poirier, *Les Idées artistiques de Chateaubriand*, Paris, 1930, pp. 112-26.

20

Clarac (ed.), op. cit., vol. 1, p. 461.

21
In the Preface to the 1828 edition of the
Mémoires (p. 1).

22
'Gemäldeschreibungen aus Paris und den
Niederlanden', in Hans Eichner (ed.), *Kritische
Schlegel Ausgabe,* Paderborn, Munich, Vienna,
1959, vol. 4, p. 13.

23
'Vom Raffael', in Eichner, op. cit., vol. 4, pp.
48-60.

24
George Levitine, *The Dawn of Bohemianism: The
Barbu* Rebellion *and Primitivism in Neoclassical
France*, Philadelphia, 1978, note 113.

25
Ibid., p. 221

26
Fritz Herbert Lehr, *Die Blütezeit romantischer
Bildkunst: Franz Pforr, der Meister des
Lukasbundes*, Marburg, 1924, pp. 37-8.

27
The Habsburg collection, which forms the
nucleus of the picture galleries of the
Kunsthistorisches Museum, was never rich in
paintings of the German school, and it is not
easy to establish which examples the writer
could have had in mind. Most likely he was
referring to paintings by Cranach. See Lehr,
op. cit., footnote to pp. 37-8.

28
Cornelius Gurlitt, *Die Deutsche Kunst des 19.
Jahrhunderts*, Berlin, 1899, p. 214.

29
Hermann Uhde-Bernays (ed.), *Künstlerbriefe
über Kunst*, Dresden, 1926, pp. 350-1.

30
'A descriptive catalogue of pictures, poetical
and historical inventions, painted by William
Blake in water colours, being the ancient
method of fresco painting restored: and
drawings, for public inspection, and for sale by
private contract', in Geoffrey Keynes (ed.),
William Blake: Complete Poetry and Prose,
London, 1948, p. 595.

31
Cited in André Chastel, 'Le Goût des
"Préraphaelites" en France', *Fables, figures,
formes*, 2 vols., Paris, 1978, vol. 2, pp. 227-39.

32
Anton R. Mengs (1728–79), neo-classicist
painter and an earlier reformer, whose fresco
'Parnassus', may be regarded as a reconstruction
of Raphael's earlier version, but purged of any
features in which Raphael had strayed ever so
slightly from classical principles.

33
Keith Andrews, *The Nazarenes: A Brotherhood of
German Painters in Rome*, Oxford, 1964, p. 53.

34
Hermann Uhde-Bernays (ed.), op. cit., p. 402.

35
See Frédéric Lachèvre, *Bibliographie sommaire
des Keepsakes*, 2 vols., Paris, 1929. The author
introduces Keepsakes as '… souvenirs from
contemporary literature and similar collections
in prose or verse, published between 1823 and
1848', and traces their origin to England in
1820, vol. 1, p. xii.

36
The translation is my own.

37
See my 'The Values of the Byzantine Tradition:
A Documentary History of Goethe's
Responses to the Boisserée Collection', in
Gabriel P. Weisberg and Laurinda S. Dixon
(eds.), *The Documented Image: Vision in Art
History*, Syracuse, 1987, pp. 291-308.

38
See my 'Goethe and the History of Art: The
Contribution of Johann Heinrich Meyer',
Publications of the English Goethe Society, NS 60,
1991, pp. 1–19.

39
'Neu-deutsch religiös-patriotische Kunst' in
Bernhard Seuffert (ed.), *Meyers kleine Schriften
zur Kunst*, Heilbronn, 1886, p. 97.

40
See Julius von Schlosser's introduction, 'Carl
Friedrich von Rumohr als Begründer der
neueren Kunstforschung', in his edition of
Rumohr's *Italienische Forschungen*, Frankfurt-
am-Main, 1920.

41
The Analysis of Beauty, ed. Burke, op. cit., p. 25.

42
Lecture III, 'On Design', in Ralph N. Wornum
(ed.), *Lectures on Painting by the Royal
Academicians Barry, Opie and Fuseli*, London,
1889, p. 139.

43

C.R. Leslie, *Memoirs of the Life of John Constable*, ed. Jonathan Mayne, London, 1951, p. 15.

44

The Poetical Works of Wordsworth, London, 1851, vol. 2, p. 311.

45

Du vandalisme et du Catholicisme dans l'art, Paris, 1839, pp. 159-204.

46

Lecture IV, delivered 18 November 1853. See Cook and Wedderburn (eds.), *The Works of John Ruskin*, London and New York, 1903-12, vol. 9, pp. 157–8. Also Joan Evans, *John Ruskin*, London, 1954, p. 194.

Chapter 4

1

Giorgio Vasari, *Proemio delle Vite*, in *Le Vite de' più eccellenti pittori, scultori ed architettori*, ed. Milanesi, Florence, 1878-85, vol. 1, p. 243.

2

Carl Friedrich von Rumohr, *Italienische Forschungen*, ed. von Schlosser, Frankfurt, 1920.

3

See *G.W.F. Hegels Werke*, 20 vols., Frankfurt-am-Main, 1970, vols. 13, 14 and 15, *Vorlesungen über die Ästhetik.*

4

See Sister Mary Camilla Bowe, *François Rio, sa place dans le renouveau catholique en Europe, 1797-1874,* Paris, 1938; also my 'Aby Warburg and F. Rio', in *Studi in onore di G.C. Argan*, Florence, 1994, pp. 48-52.

5

Pierre-Louis-Auguste Ferron, Comte de la Ferronays, 1777-1842.

6

De la poésie chrétienne – dans son principe, dans sa matière et dans ses formes, 2 vols., Paris, 1836-55, vol. 1, p. 5. (This was later expanded and published in four volumes entitled *De l'art chrétien*, Paris, 1861-8.)

7

De l'art chrétien, op. cit., vol. 2, p. 319.

8

Bruno Foucart, 'La Pieuse Légende d'un nouvel Angelico, Hippolyte Flandrin', in *Le Renouveau de la peinture religieuse en France (1800-1860)*, Paris, 1987, p. 205.

9

See Nicolas Barker, Hugh Brigstocke and Timothy Clifford, *'A Poet in Paradise': Lord Lindsay and Christian Art*, Edinburgh, 2000.

10

London, 1846.

11

Sir Coutts Lindsay, Bart., *Sketches of the History of Christian Art*, 2 vols., London, 1885. (First published in 3 vols., London, 1847.)

12

'North of the Alps', *Sketches*, vol. 2, p. 381.

13

Lorenzo Monaco.

14

Cook and Wedderburn (eds.) *The Works of John Ruskin*, London and New York, 1903-12, vol. 12, p. 247.

15

See *The Sense of Order: A Study in the Psychology of Decorative Art*, Oxford, 1979, pp. 38-46.

16

London, 1949, p. vii.

17

Aratra Pentelici, in Cook and Wedderburn (eds.), vol. 20, p. 254.

18

Eine Einleitung zum Genuss der Kunstwerke Italiens, Stuttgart, 1964, p. 690.

19

The Civilization of the Renaissance in Italy, trans. S.G.C. Middlemore, Vienna and London, 1938, p. 292.

20

Rio, op. cit., vol. 2, p. 379.

21

2 vols., Paris, 1898, vol. 2, p. 122.

22

See my *Aby Warburg: An Intellectual Biography*, London, 1970, p. 106.

23

London, 1873, p. xii.

24

Renaissance in Italy, 6 vols., London, 1898-1901, vol. 3, p. 23.

25

Die klassische Kunst: eine Einführung in die Italienische Renaissance, Munich, 1901, p. 1.

26

'Die Erneuerung der heidnischen Antike', in *Aby Warburg: Gesammelte Schriften,* Leipzig, 1932, vol. 1, p. 65.

27
'Renaissance en realisme', in *J. Huizinga: Verzamelde Werken*, vol. 4, Haarlem, 1949, pp. 276-97.
28
Alfred Frazer's preface in Kurt Weitzmann (ed.), *The Age of Spirituality: Late Antique and Early Christian Art, Third to Seventh Century*, New York, 1979, pp. 20-1.

Chapter 5

1
Bernard Smith, *Modernism's History: A Study in Twentieth Century Art and Ideas,* New Haven and London, 1998, p. 8.
2
See Thomas Puttfarken, 'Composition, Perspective and Presence: Observations on Early Academic Theory in France', in John Onians (ed.), *Sight and Insight: Essays on Art and Culture in honour of E.H. Gombrich at 85*, London, 1994.
3
See my 'The Values of the Byzantine Tradition: A Documentary History of Goethe's Responses to the Boisserée Collection', in Gabriel P. Weisberg and Laurinda S. Dixon (eds.), *The Documented Image: Vision in Art History*, Syracuse, 1987, pp. 291-308.
4
'Aus einer Reise am Rhein, Main und Neckar in den Jahren 1814 und 1815', in *Goethes Sämtliche Werke*, Jubiläumsausgabe in 40 Bänden, Stuttgart and Berlin, no date, vol. 29. The translations are my own.
5
Lecture VII, 'Style', in John Flaxman, *Lectures on Sculpture*, London, 1829, pp. 198–202.
6
See Frances S. Connelly, *The Sleep of Reason: Primitivism in Modern European Art and Aesthetics, 1725-1907*, Philadelphia, 1995, p. 94.
7
For a detailed discussion of this movement, see my *The Sense of Order*, Oxford, 1979.
8
See Alf Bøe, *From Gothic Revival to Functional Form: A Study in Victorian Theories of Design*, Oslo, 1997 (Facsimile of 1957 edition, with new preface by E.H. Gombrich), p. 63.

9
Quoted in *The Sense of Order*, p. 51.
10
See ibid., p. 45.
11
Paris, 1854–68, vol. 7, pp. 60-1.
12
Ibid., vol. 9, pp. 373-462, pp. 441-2.
13
Cook and Wedderburn (eds.), *The Works of John Ruskin*, London and New York, 1903-12, vol. 20, p. 175.
14
Zeitschrift für bildende Kunst, 1, 1866, p. 97.
15
'Painting at the Present Day: From a Decorator's Point of View', in *The Claims of Decorative Art*, London, 1892, p. 93.
16
'Design in Relation to Use and Material', ibid., p. 95.
17
'On Realism and Impressionism', in *Six Lectures on Painting*, London, 1904, pp. 130-2.
18
See Klaus Berger, *Japonismus in der westlichen Malerei 1860-1920* (Studien zur Kunst des neunzehnten Jahrhunderts, Bd. 41), Munich, 1980.
19
See my 'From Archaeology to Art History: Some Stages in the Rediscovery of the Romanesque', in Marja Terttu Knapas and Åsa Ringbom (eds.), *Icon to Cartoon: A Tribute to Sixten Ringbom*, Helsinki, 1995.
20
See 'Wilhelm Vöge und die Anfange der kunstgeschichtlichen Lehre in Freiburg', in Willibald Sauerländer, *Geschichte der Kunst: Gegenwart der Kritik*, Cologne, 1999, pp. 190-212.
21
Wilhelm Vöge, *Die Anfänge des monumentalen Stiles im Mittelalter: eine Untersuchung über die erste Blütezeit französischer Plastik*, Strasbourg, 1894, ch. I, pp. 1-8.

Interlude

1
Roger Fry, *Vision and Design*, London, 1923, p. 99.

2
Tom Phillips (ed.), Royal Academy of Arts, London, pp. 28-9.
3
Quoted in Elizabeth Gilmore Holt, *The Art of all Nations, 1850-73*, New York, 1981, pp. 145-6.
4
See Alexander Murray (ed.), *Sir William Jones 1746-94: A Commemoration*, Oxford, 1998, p. 120.
5
Siegfried Otto Julius Levinstein *Das Zeichnen der Kinder,* Leipzig, 1904.
6
George Boas, *The Cult of Childhood*, London, 1966, p. 87.

Chapter 6

1
William Rubin (ed.), *Primitivism in Twentieth-Century Art: Affinity of the Tribal and the Modern*, exhibition catalogue, 2 vols., Museum of Modern Art, New York, 1984, p. 11.
2
Given in 1953, published in *Meditations on a Hobby Horse*, London, 1963, pp. 30-44.
3
See my 'Aby Warburg: His Aims and his Methods', lecture given 26 October 1999, published in *Journal of the Warburg and Courtauld Institutes,* 62, 1999, pp. 268-82.
4
Reynolds, *Discourses on Art*, ed. Robert R. Wark, San Marino, 1997, Dicourse XV, p. 276.
5
The Sense of Order, Oxford, 1979, p. 37.
6
Elizabeth Gilmore Holt, *The Art of All Nations: 1850-1873*, New York, 1981, pp. 467-9.
7
M.H. Abrams, *The Mirror and the Lamp: Romantic Theory and the Critical Tradition*, New York, 1958.
8
Holt, op. cit., p. 469.
9
An Historical Sketch of the Art of Caricaturing, London, 1813, pp. 6-7.
10
See also Frances S. Connelly, *The Sleep of Reason: Primitivism in Modern European Art and Aesthetics 1725-1907*, Philadelphia, 1999.
11
Holt, op. cit., pp. 470–1.
12
Oxford, 1960, p. 98.
13
Holt, op. cit., p. 468.
14
See Mariëtte Haveman, *Het feest achter de gordignen: schilders van de negentiende eeuw, 1850–1900*, Amsterdam, 1996.
15
Letter 418 in *The Complete Letters of Vincent van Gogh*, London, 1999, vol. 2, p. 401.
16
Letter quoted in *The Story of Art* (16th edn.), London, 1995, p. 564. See also Meyer Schapiro, *Van Gogh: 50 Reproductions in Full Colour*, London, 1968.
17
Maurice Denis, *Du Symbolisme au Classicisme: Théories*, ed. Olivier Revault d'Allonnes, Paris, 1964, p. 51.
18
Quoted in H.R. Rookmaaker, *Synthetist Art Theories: Genesis and Nature of the Ideas on Art of Gauguin and his Circle*, Amsterdam, 1959, p. 242.
19
Walter Crane, *The Claims of Decorative Art*, Boston, 1892, p. 17.
20
First published in 1896; trans. Aylmer Maude, New York, 1960, p. 51.
21
André Malraux, *La Tête d'obsidienne*, Paris, 1974, pp. 17-19, discussed in W. Rubin, op. cit., vol. 1, p. 254.
22
Karl Woermann, *Geschichte der Kunst aller Zeiten und Völker* (2nd, expanded edn.), Leipzig and Vienna, 1915, vol. 2, p. 59.
23
Roger Fry, *Vision and Design*, London, 1923, p. 102.

24
See my paper on 'From Archaeology to Art
History: Some Stages in the Rediscovery of
the Romanesque' in Marja Terttu Knapas and
Åsa Ringbom (eds.), *Icon to Cartoon: A Tribute to
Sixten Ringbom*, Helsinki, 1995, pp. 103-4.
25
Karl Schnaase, *Geschichte der bildenden Künste*,
vol. 4, Düsseldorf, 1871.
26
Die Kunst des Mittelalters, vol. 6, Berlin, 1929, p.
20. (We are told in the preface that the author
died in 1926, and that his text was
subsequently edited.)
27
Albert Boeckler, 'Die Bronzetüren von Verona',
Die Frühmittelalterlichen Bronzetüren, vol. 3,
Marburg, 1931, p. 23.
28
Wilhelm Worringer, *Abstraktion und Einfühlung:
ein Beitrag zur Stilpsychologie*, 5th edn., Munich,
1918.
29
See Wilhelm Worringer, 'Fragen und
Gegenfragen, Schriften zum Kunstproblem',
foreword to the new edition of *Abstraktion und
Einfühlung* [1948], Munich, 1956, p. 21.
30
'In rückschauender Objektivität vermerke ich
… Ein unzweideutiger Beweis für seine
zeitaktuelle Fälligkeit liegt ja auch in der
Umsetzung vor, die seine Theorien, die nur
geschichtlicher Deutung galten, gleich in der
Praxis der zeitgenössischen
Kunstkampfbewegungen fanden.' Ibid., p. 23.
31
Quoted in *Künstlerschriften I: Manifeste Manifeste
1905-1933*, Dresden, 1964, p. 48.
32
Formprobleme der Gotik, Munich, 1927, p. 7.
33
Quoted in Herschel B. Chipp, *Theories of
Modern Art*, Berkeley, 1961, pp. 150-1.
34
Künstlerschriften I, op. cit, p. 49.
35
Hans Tietze, 'Der Blaue Reiter', *Kunst für Alle*,
27, 1912, p. 547.
36
*L'Expression des sentiments dans l'art grec: les
facteurs expressifs*, Paris, 1914.

37
'Idealismus und Naturalismus in der gotischen
Skulptur und Malerei', in Max Dvořák,
Kunstgeschichte als Geistesgeschichte, Munich,
1928, p. 47.
38
Wilhelm Hausenstein, *Barbaren und Klassiker:
ein Buch von der Bildnerei exotischer Völker*,
Munich, 1923.
39
Ludwig Goldscheider, *Zeitlose Kunst*, Vienna,
1937; English edn., *Art Without Epoch*, London,
1937.
40
Ludwig Münz and Viktor Löwenfeld, *Plastische
Arbeiten Blinder*, Brünn, 1934.
41
Ernst Robert Curtius, *European Literature and
the Latin Middle Ages*, trans. Willard R. Trask,
Bollingen Series XXXVI, Princeton, 1990,
p. 15.
42
André Malraux, 'Le Musée imaginaire', vol. I of
Psychologie de l'art, Geneva, 1949. Translated as
'The Museum without Walls' in Stuart Gilbert
and Francis Price, *The Voices of Silence*, London,
1954.
43
See 'André Malraux and the Crisis of
Expressionism', in *Meditations on a Hobby Horse*,
London, 1963.

Lure 1

1
The Bench, 1758, quoted in 'Looking back on
Laughter', my Foreword to the exhibition
catalogue, *The Art of Laughter*, Cartoon Art
Trust, 1992, pp. 9-10.
2
See Marja Warehime, 'Brassaï: Images of
Culture and the Surrealist Observer', in Rima
Drell Reck (ed.), *Modernist Studies*, Baton
Rouge, 1996, p. 100.
3
Giorgio Vasari, *Le Vite de' più eccellenti pittori,
scultori ed architettori*, ed. Milanesi, Florence,
1878-85, vol. 7, pp. 135-317.
4
See K. Lange and F. Fuhse, *Dürers schriftlicher
Nachlass*, Halle, 1893, p. 35 and illustration.

Lure 2

1
Oeuvres complètes de Rodolphe Töpffer, Édition du centenaire, vol. 11, *Caricatura*, Geneva, 1945.
2
See *Les Amours de M. Vieux Bois, Les Voyages et aventures du Docteur Festus, M. Cryptogame,* Club des Libraires de France, 1962.
3
See David Kunzle, 'Goethe and Caricature: From Hogarth to Töpffer', *Journal of the Warburg and Courtauld Institutes*, 48, 1985.
4
London, 1991, pp. 162-87.
5
Felix Klee (ed.), *The Diaries of Paul Klee 1898-1918*, Berkeley, 1964, pp. 265-6.
6
Princeton, 1989.
7
Letter 507 in *The Complete Letters of Vincent van Gogh*, London, 1999, vol. 2, p. 606.
8
Berlin, 1922, p. 17.
9
There is an astringent page refuting the 'fable convenu' identifying expression with communication in Julian Bell, *What is Painting?*, London, 1998, p. 170.
10
Prinzhorn, op. cit., pp. 136–7.
11
See John MacGregor, *The Discovery of the Art of the Insane*, pp. 292-308.

5
See 'In the Shadow of Vermeer', in R. Gregory, J. Harris, P. Heard and D. Rose (eds.), *The Artful Eye*, Oxford, 1995, pp. 353-72.
6
Language, New York, 1921.
7
'Vom Wesen der Volkskunst', in Wilhelm Fraenger (ed.), *Jahrbuch für historische Volkskunde*, vol. 2, Berlin, 1926.
8
Waldron Phoenix Belknap Jr., *American Colonial Painting: Materials for a History*, Cambridge, Mass., 1959.

Postscript

1
Francis Haskell, *History and its Images: Art and the Interpretation of the Past*, New Haven, 1993.
2
Stuart Piggott, *Ancient Britons and the Antiquarian Imagination: Ideas from the Renaissance to the Regency,* London, 1989.
3
Joseph M. Levine, *Humanism and History: Origins of Modern English Historiography*, Ithaca and London, 1987.
4
Leopold Schmidt and Armin Müller, *Bauernmöbel im Alpenraum*, Innsbruck, 1982.

Chapter 7

1
'Bushman Art', *The Listener*, 27 August 1930, p. 329.
2
Harvard University Press, 1927, reprinted by Dover Publications, New York, 1955, pp. 1-4.
3
Cf. J.D. Fineberg, *The Innocent Eye*, Princeton, 1977.
4
In *Joys and Sorrows: Reflections by Pablo Casals as told to Albert E. Kahn,* New York, 1970, plate among A.E. Kahn's 'Portfolio of contemporary photos', pp. 182-206.

Index

Figure and plate references are in **bold**

317

321

Photographic Credits

the Lillie P. Bliss Bequest 113

National Gallery, London 48, 87, 97

National Gallery of Art, Washington, Pl. VII (Widener Collection), 199
 (Andrew W. Mellon Collection)

National Swedish Art Museums 17

New York Metropolitan Reference Library 44

Österreichisches Museum für Volkskunde (photo Leutner Fachlabor) 204,

Philadelphia Museum of Art, The Louise and Walter Arensberg Collection 108

Réunion des Musées Nationaux 24, 35, 36, 112, 120, 140, 190,

Roger-Viollet 31

Royal Collection ©2002, Her Majesty Queen Elizabeth II 188

The St Louis Art Museum, gift of Richard K. Weil 181

Schweizerisches Institut für Kunstwissenschaft, Zurich 197

Soprintendenza per il Patrimonio Storico di Firenze 86

Soprintendenza per il Patrimonio Storico di Milano Pl. IX, 191

Soprintendenza per il Patrimonio Storico di Parma e Piacenza 21

Städelsches Kunstinstitut und Städtische Galerie, Frankfurt 58, 59, 60

Staatliche Museen, Berlin (Photos Jorg P. Anders) 38, 54, 183

From 'In the Studio of Vermeer' by Philip Steadman, photograph by Trevor Yorke and
 Richard Hearne 189

Tate Britain, London 46,

Thorvaldsen Museum, Copenhagen 73

Trinity College, Cambridge Pl. IV

Trinity College Library, Dublin 213

Tiroler Volkskunstmuseum, Innsbruck 218

Van Gogh Museum, Amsterdam 118

Vesterheim Norwegian American Museum, Iowa 201

Victoria & Albert Museum 16, 18, 23, 90

Werner Forman Archive Pl. II,

Wesleyan University Press, Middletown, Connecticut 200